COLOUR
Its Principles and
Their Applications

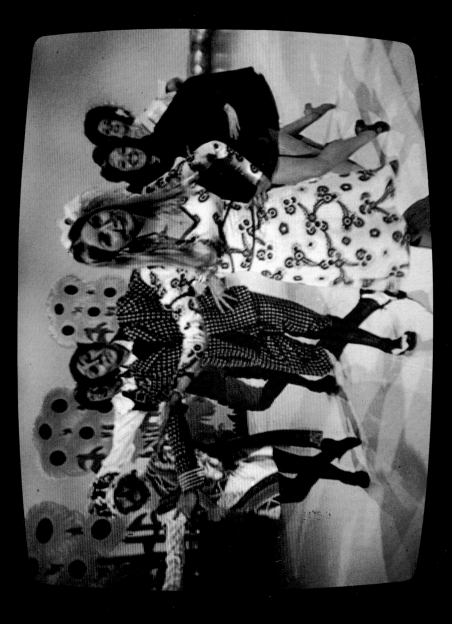

Frontispiece Reproduction of a typical picture on the screen of a domestic colour television receiver. The scanning lines, by which the electron beams build the picture, are visible (see chapter 7). *Colour photograph by Dr. G. L. Wakefield, MScTech, FRPS, FIIP*

COLOUR
Its Principles and
Their Applications

Frederick W. Clulow

B.Sc.(Lond.), Ph.D.(Leeds), F.R.I.C., F.I.O.P.

Formerly Head of the Department of Science and Management,
London College of Printing
Lately Director of the Department of Printing and Photographic
Technology, University of Manchester Institute of Science and
Technology, and
Head of the Department of Printing Technology, Manchester
Polytechnic.

FOUNTAIN PRESS

Fountain Press
46/47 Chancery Lane
London WC2A 1JU

First Published 1972

ISBN 0 852 42098 6

Colour Originated in England by
Sun Litho, Ruislip, Middlesex

Colour Printed in England by
Offset Litho at Grange Press, Brighton

Text Printed in England by
Offset Litho at Page Bros. (Norwich) Ltd.

Bound in England by
Mansell (Bookbinders) Ltd., London

CONTENTS

	Page
PREFACE	vii
INTRODUCTION	1

1 LIGHT AND COLOUR 4
Light. Wavelength. Frequency. Sight and the nature of colour. Reflection, transmission and refraction of light. The spectrum of white light. Spectra of artificial light sources. Colour temperature. Polarized light.

2 GENERAL PROPERTIES OF COLOURED MATERIALS 18
Absorption of light. White and black materials. Coloured materials: Selective absorption; Complex reflection; Incomplete reflection; Incomplete absorption. Absorptivity —dichroism. Summary of properties of coloured materials— hue, lightness, saturation. Fading. Influence of type of illumination on apparent colour of materials. Colour matching—metamerism.

3 SPECIAL CASES 36
Complementary colours. Colour contrast. Metallic reflection. Bronzing. Colours of thin films (interference colours). Applications of interference effects. Colours of the sky (light scattering). The rainbow. Fluorescence and applications. Phosphorescence.

4 COLOUR VISION 53
The eye—retinal rods and cones. Three-colour vision. Defective colour vision (colour blindness). Lightness (visual

sensitivity) and wavelength. Adaptation of the eye: Adaptation to intensity of illumination; Adaptation to colour (colour fatigue). After-images. Simultaneous contrast of tone (lightness) and colour—fine patterns. Chromatic aberration. Colour harmony.

5 COLOUR MIXING PROCESSES 72
Additive colour mixing. Subtractive colour mixing— relationship of trichromatic additive and subtractive methods. Visual limitations of trichromatic colour reproduction.

6 COLOUR MEASUREMENT 85
Introduction. Terminology. Methods of colour measurement. Matching methods: The Ostwald system; The Munsell system; Colorimetry. Additive colorimeters: Visual; Photoelectric; Fibre optics. Subtractive colorimeters. Spectrophotometry: Photoelectric spectrophotometers; Recording spectrophotometers; Abridged spectrophotometers. Typical spectrophotometric curves. The C.I.E. System: Standard observer; Standard illuminants. The chromaticity triangle; Chromaticity coordinates. The spectral locus. The C.I.E. chromaticity chart. Tristimulus values. Dominant wavelength and purity. Luminance factor (reflectance or transmittance). Typical C.I.E. values. Colour discrimination and the C.I.E. chart. Colour mixture on the chromaticity chart. Definitions of the primary stimuli. Calculation of C.I.E. values from colour measurements.

7 ADDITIVE REPRODUCTION METHODS 143
The successive frame method. The lenticular screen method. The mosaic screen method: The separate colour screen process; Random mosaic processes; Regular mosaic processes. Colour television: Television cameras; Colour transmission; Colour receivers (display devices); The shadow mask tube; Standard colour television systems. Two-colour reproduction. Deficiences in additive methods.

8 SUBTRACTIVE REPRODUCTION METHODS 170
Deficiencies of practical subtractive primaries. Correction by colour masking. Colour photography: Gelatin relief methods; Gelatin dye imbibition methods; Colour derivations. One-shot cameras. Integral tripacks and colour development: Processes using couplers in developers;

Contents

Processes using couplers in the film; Masking by coloured couplers. Colour printing: Letterpress; Lithography; Photogravure; Screen printing; Collotype. Photomechanical processes: The half-tone principle; Screen angles; Colour printing plates. Colour printing presses. Colour rendering in printing methods. The influence of paper. Colour correction in printing methods. Electronic colour scanners. Four-colour printing. Visual appraisal of a colour picture.

BIBLIOGRAPHY FOR FURTHER READING 223

INDEX 225

PREFACE

THROUGHOUT NEARLY FORTY YEARS of teaching experience, most of it specially concerned with science related to printing and photography, the subject of colour and its reproduction has been of particular interest to the author both personally and with students. This book is based on that interest and experience. It was frequently found that the scientific aspects of colour were not at all easy for technical students to comprehend, their difficulties being by no means entirely due to the fact that colour is essentially a visual sensation. Too many textbooks, including the more elementary treatises on physics, deal with colour so cursorily or oversimplify the topic to such an extent as to give erroneous first impressions which are always difficult subsequently to correct. Yet colour is a conspicuous part of our everyday world and affairs, students in numerous art and technological college courses are much involved with the subject and it is important in many forms of employment. There is also an increasing popular interest in colour reproduction now that colour pictures are so general in photography, in magazines, in the cinema and on the television screen and black-and-white reproductions hold diminishing esteem. The colours of nature are of everlasting interest and a more informed appreciation by the layman of the technical intricacies entailed in providing the 'manufactured' colour that enlivens business and leisure can be nothing but beneficial.

The simpler kind of information about the physical basis of colour and its various applications tends to be scattered among diverse publications; advanced textbooks, because of their nature, deal with specialized branches. So far as the author is aware no comprehensive explanation of the principles of colour, the properties of materials and natural colour phenomena, the fundamentals of colour vision and three-colour mixture and their several applications to the trichromatic systems of colour measurement and colour reproduction has been

published. This book is an attempt to fill the gap, particularly for readers who are not scientists.

While covering a wide field on a theme of considerable complexity, the text is not claimed to be completely comprehensive. It includes little more than brief references to the artistic uses of colour and those mental and psychological reactions which the artist has to consider. But the emphasis on the physical and physiological features and on methods of colour reproduction and measurement may be of assistance to artists and designers, not least as a contribution to greater mutual understanding with technologists and scientists. In the science field, no account is given about the influence of the chemical composition of materials upon their colour, for this is a matter of advanced chemistry and therefore mainly of specialist interest only, although we owe to the relationship between colour and chemical constitution, so far as it has yet been established, the discovery of numerous new colouring substances, many of them dyes now in common use.

Some of the explanations may be considered to be laboured, but long experience in teaching has proved the advantage of repetition, with some variation in the approach especially to a fresh subject, in order to render the meaning quite clear. So no apology is tendered on this score.

There are two well-known and authoritative specialized textbooks of long standing that have had the success of reprinted and up-dated editions, viz, *The Measurement of Colour* by Professor W. D. Wright and *The Reproduction of Colour* by Professor R. W. G. Hunt. The author is much indebted to both these texts which have been broadly drawn from in writing this book.

That this work is as extensive as it is, particularly with reference to colour measurement, Chapter Six, is gratefully acknowledged to the encouragement and helpful comments of Dr. G. L. Wakefield, M.Sc.Tech., F.R.P.S., F.I.I.P., of the Manchester Polytechnic. Advice on a number of.points from Dr. L. C. Spark, A.Inst.P., of the University of Manchester Institute of Science and Technology, is also greatly appreciated.

Further acknowledgement is due to Drs. L. C. Spark and G. L. Wakefield for producing on the Hardy recording spectrophotometer most of the spectral reflection curves for Plates 17 to 24, and to Dr. Wakefield for the original illustrations of the frontispiece, Plates 8 and 29 and Fig. 6.4.

Acknowledgements must likewise be made to Mr. H. G. Mackenzie-Wintle, of Leres S.A., a subsidiary of the Kollmorgen Corporation, and now of Kollmorgen (UK) Ltd., Reading, for the photographs for Figs. 4.3, 6.5 and 6.12 and other information concerning current measurement instrumentation; to Mr. G. J. Chamberlin of The Tintometer Ltd., Salisbury; Instrumental Colour Systems Ltd., Reading; the

Preface

Diano Corporation, Massachusetts; the Neotec Corporation, Maryland; and Pye Unicam Ltd., Cambridge, for literature and the photographs for Fig. 6.9; 6.11(a) and 6.15; 6.11(b); 6.6; and 6.13 respectively; to Kodak Ltd. for the original of Plate 1; to the Director and Dr. I. H. G. Ishak of the Paint Research Association, Teddington, for information and permission to reproduce the diagrams of Fig. 6.8; and to the Director and Miss M. Sawbridge, Publications Officer, of the Cotton, Silk and Man-made Fibres Research Association, Shirley Institute, Manchester, for the loan of the original artwork for Plate 12.

Finally, the author would like to thank many of the authors named in the Bibliography for Further Reading, from whose studies data have been gathered.

September, 1971

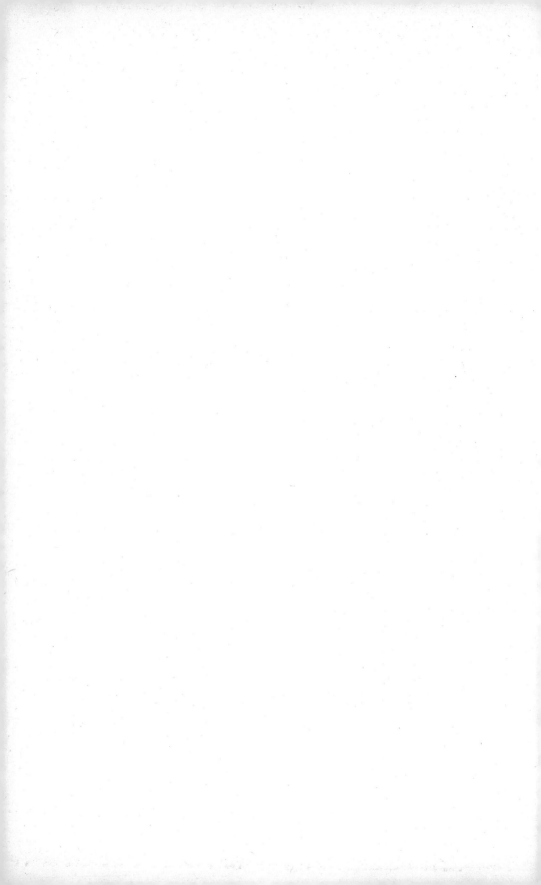

INTRODUCTION

COLOUR IS ALWAYS WITH US except in darkness, being so much a part of our everyday lives that we tend to take it for granted. Yet life in terms of only white, black and grey would be extremely drab and possibly unbearable. Colour constitutes three-quarters of beauty and a large part of every language. It is highly important, sometimes vitally so, as in the cases of traffic signals, symbols, flags, the marketability of goods, including both the articles themselves and their packaging, and even to political parties. Colour adds enormously to aesthetic appreciation, particularly of pictures, objects and materials of all kinds, and gives great pleasure, especially in the beautiful colours of nature.

Man's love of colour is independent of age or period, richness or poverty, and knows no frontier. The ancient Britons dyed themselves blue with woad. From his early history man has sought more and more to introduce colour into his life and his religion; he has used it for his banners and dress in warfare and his ceremonials and pageantry in peace. The discovery of the dye called 'aniline mauve' in 1856 by the young English chemist, William Henry Perkin, while still a student and who later received a knighthood, led amazingly quickly to the great new industry of synthetic dyestuffs and the displacement of natural colouring matters by the new products, which are now vastly more numerous and have widely extended the range of available colouring materials.

Colour is not merely a human possession. Over a wide assortment of the animal world it is the basis of preservation, in that many animals and birds assume the colourings best suited to match their surroundings, and it forms part of the sex life of insects and birds by acting as an auxiliary appeal in courtship. Of the latter function, the bird of paradise is an excellent example; the male has brilliantly coloured, highly decorative plumage, whereas that of the female is simple and comparatively plain.

We are all concerned with colour, as when choosing clothes,

decorations or furniture, viewing a picture or flowers, in the attractiveness of foodstuffs and in many other ways. The practical use of colour gives delight and calls forth skill; the experimental and theoretical study of colour with the numerous factors involved in its production and reproduction is a broad field of stimulating discovery.

We all enjoy colour but how much do we know about it? It is not one of the easiest subjects for study because fundamentally colour is an optical sensation. Being dependent upon light bases the subject on physics but, as the sense of sight is involved, physiology and psychology must be considered. Moreover, the properties and compositions of materials as sources of light, by reflection, transmission or emission, play an essential role in the production of colour, so chemistry comes in. The reproduction of colour implicates many technologies and often an appreciation of design. The study of colour is both a science and, sharing with form, an art, and is, therefore, fascinatingly complex.

Through the centuries a good deal of empirical knowledge about coloured materials and their use was acquired, often laboriously, by artists and craftsmen, and some of this knowledge was not always passed on. The much wider use of colour, as in photography and present-day printing and dyeing, only became possible when the foundations of modern science were established, mainly during the nineteenth century, especially in connection with optics, photography and 'coal-tar' dyes. The intensifying use of colour in most arts and industries, the production of better coloured materials and improvements in the methods, quality and speed of processes for colour reproduction, all stem from a greater scientific knowledge about the various features of colour. Modern technical developments depend in the first place upon the growth of this scientific knowledge, which at the same time widens the artist's field of work and contributes to the fuller understanding of his subject. Measurements and accurate specifications for colours are being employed to an increasing extent for both industrial and artistic purposes.

The names and terms used when speaking about colour are often confusing because the same words are used with different meanings in one industry compared with another, or in the arts and the sciences. Difficulties of this kind may be overcome through a knowledge of the underlying principles of colour. Such difficulties have long been recognized so that there is now fairly general agreement on and some standardization of colour terminology through, for example, the Commission Internationale de l'Eclairage (C.I.E.) in Paris and the British Standards Institution in London (see Chapter 6).

The object of this book is to explain the basic scientific or technical facts and theories about the nature of colour, including an outline of the principles of colour vision and their main effects, about the properties of coloured materials, the methods of colour measurement, and the

processes by which colour may be reproduced in painting and similar colour mixing techniques, printing, photography and television. It is intended to provide a comprehensive yet reasonably concise introduction to the very extensive subject for the student and layman and is, therefore, written as much as possible in non-scientific language and with virtually no mathematics other than graphs, except for a little arithmetic and simple algebra in Chapter 6. Wherever scientific terms are introduced as being necessary to the purpose of the book, they are explained. Indeed, for the sake of clear and generally correct explanation, there may be a little sacrifice of strict scientific accuracy on a few points. An elementary knowledge of photography is assumed.

No apology is offered if the phraseology is deemed to be pedantic or elaborated in places, in view of the complexity of the subject and the loose, often vague, everyday terminology of colour previously mentioned, in which words such as 'bright', 'rich', 'pure', 'full', 'clean', 'deep', 'strong', 'weak', 'dull', 'dirty', 'tint', 'tone', 'shade', etc., are used inconsistently and without definite meanings. Such terms have to be avoided in technical discussions unless they are given precise and generally-accepted definitions.

It is hoped that the book will be helpful to sixth-form pupils and undergraduates in science, to art students and artists, to photographers, to craftsmen and technicians in the printing, paint, photographic, television, recording and optics industries, to dyers and colourists in the textile, papermaking, plastics and other industries, and to technologists who require no more than a general knowledge of colour and its applications. The presumption is that this introduction will be of interest and assistance to all who are concerned with colour as seen in nature, in materials, objects and designs and in pictures, including their mass reproduction, as well as, perhaps, to readers of elementary science.

There are some excellent, highly erudite books on advanced technological aspects of colour, as listed in the Bibliography for Further Reading, and if this introductory attempt to survey the whole subject encourages readers to consult these more detailed and specialized works it will have achieved its purpose.

LIGHT AND COLOUR

COLOUR AND LIGHT are inseparable and therefore a study of the physical basis of colour requires a preliminary understanding of some of the fundamental properties of light.

LIGHT

What is light? We know that light travels, though at enormous speed which can, nevertheless, be measured accurately, and in the physical universe the only things that travel are material substances (matter) and energy. About a couple of centuries ago it was thought that a ray of light consisted of a hail of tiny particles. Since then it has been found that light is actually a form of energy, which travels, or is transmitted, through space and transparent materials in a wave-like manner. The energy present in quite a powerful beam of light is too small to do much real work for practical purposes. However, light is capable of doing some work, a fact that can be demonstrated, for example, by the conversion of light when it falls on a photoelectric cell into electrical energy that can be used to operate some mechanism, and the effects of light upon materials and the eye are very considerable. Moreover, it can be shown that light is closely similar in several respects to other forms of energy all of which travel as waves or rays. Some of the other varieties of radiant energy are well-known, such as radio or wireless waves and similar electrical radiations, heat and infra-red rays, ultra-violet rays, X-rays and cosmic rays. All of these are produced by a combination of electric and magnetic processes and are believed to consist of electro-magnetic waves or rays, originating from the electronic structure of matter. It is remarkable that the various forms of electromagnetic energy all travel through space at the same speed—about 186000 miles or 300000 kilometres a second—but they differ from one another in wavelength and

frequency of vibration. The latter terms are so fundamental and frequently used with reference to waves of all kinds that we must define them.

WAVELENGTH

The wavelength of any disturbance (energy) which is of a regular periodic, undulatory or vibratory character is defined as the distance between any two corresponding points, such as the crests or the troughs of adjoining waves. See Fig. 1.1.

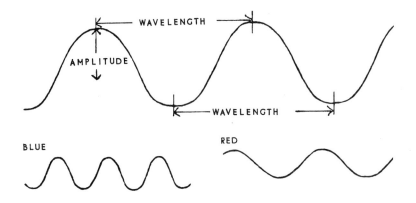

Fig. 1.1 A simple wave diagram to indicate the meaning of wavelength. Blue light has a shorter wavelength of about 470 nm than red light which has a wavelength of about 670 nm. The amplitude of a wave is half the height from trough to crest and is a measure of its energy or intensity.

Long radio waves measure several hundred metres from crest to crest. Radar makes use of rays with a wavelength of less than one metre. Infra-red rays are very much smaller. Light-waves measure about 1/50000 in. or 1/2000000 m, while among X-rays wavelengths of around 1/2500000 in. or 1/100000000 m are produced and cosmic rays are incredibly small.

Each of the terms, radio waves, heat rays, light, X-rays, etc., covers a wide band of waves, and long, medium and short radio wavelengths are quite familiar, but likewise, there are long and short light waves and X-rays. In fact, these bands of electromagnetic energy merge gradually one into another. Out of this gamut of electromagnetic vibrations the visible light band is but a small part and it is worth noting, because of practical applications in, for example, photography and fluorescence,

that infra-red rays and ultra-violet 'light' occur just beyond the two ends of the visible light band, the longest light waves merging into the infra-red and the shortest into the ultra-violet.

For technical and scientific purposes and because of the smallness of the dimension, it is now customary and convenient to refer to the wavelength of light in terms of either the nanometre, nm, which is one thousand-millionth (10^{-9}) of a metre, or the Ångström unit, Å, which is one ten-thousand-millionth (10^{-10}) of a metre and therefore ten times smaller than the nanometre. The nanometre is the same as the recently outdated millimicron, mμ, that has often been used, the micron, μ, being one thousandth of a millimetre and the millimicron one thousandth of a micron, that is, one millionth of a millimetre or one thousand-millionth of a metre. Of the two units, nanometre and Ångström, the nanometre appears to be the simpler, and, expressed in this unit which is 'preferred' in the International System (SI) units, the wavelength of light ranges from about 400 nm to 700 nm. It is not possible to give precise limits because light has a visual effect that varies somewhat with the intensity of the light, and the eyes of some people are sensitive to slightly shorter or longer waves than those of others.

FREQUENCY

This is the name given to the number of vibrations (waves) per second which travel past any given point. For example, the frequency of light is around 600000000000000, or 6×10^{14}, waves per second. The frequency is numerically equal to the velocity (speed) of the wave-motion divided by the wavelength. A simple example will suffice to prove this. Suppose the waves on a lake were travelling at 10 kilometres per hour and their crests were 4 metres apart, that is, the wavelength equals 4 metres. There would be $10 \times 1000/4 = 2500$ crests per ten kilometres, so 2500 crests would pass in an hour or 0·7 waves per second, which is the frequency. Since the velocity in free space of electromagnetic radiations is constant (300000000 metres per second) it follows from the relationship between wavelength and frequency that the shorter the wavelength the higher the frequency.

The frequency is a basic characteristic of all forms of radiant energy and, as stated, is closely related to the wavelength. In technical publications on most of the other forms of radiant energy, frequencies are often quoted rather than wavelengths, but the wavelengths of light can be accurately measured more easily and directly and are extensively used in the literature on light and colour, so that frequencies of vibration will not usually be mentioned in this book except in connection with colour television.

SIGHT AND THE NATURE OF COLOUR

Light differs from the other forms of radiation in the important property of stimulating the nerves of the eyes and producing the sensation of sight. It has been established that sunlight consists of a complete mixture of all the electromagnetic waves which affect the eye, the sensation produced being that of whiteness. Hence daylight is referred to as 'white light'.

Coloured sensations are usually evoked when less than the complete mixture of light rays strike the eye. Separately, the longest light waves normally produce on the eye the sensation which we have learnt to call 'red' and the shortest waves appear 'violet' to the eye. If the constituent waves of sunlight are separated one from another progressively from the shortest to the longest, by means of a prism, for example, the corresponding optical effects merge gradually from violet into blue, green, yellow, orange and red. See Plate 1.

Colours are therefore no more than the visual sensations produced by light of particular wavelengths. In support of this statement the Oxford English Dictionary may be quoted which defines colour as 'the sensation produced on the eye by rays of decomposed light'. An appreciation of the fact that colour is essentially an optical sensation is vital to a proper understanding of our subject. Colour, as such, has no *material* existence. The wavelength of the light is the physical reality (the stimulus) which is responsible for the perception of colour. For instance, a light beam of wavelength about 550 nm is not in itself green but the reaction caused by it on the eyes of a normal person is that which we call green. An instrument for recording or measuring colour will determine the wavelength of a beam of light but not the apparent colour of it. We have learnt from experience the colour sensations which are normally produced by the various wavelengths of light.

The limits of the light wave-band which affect the eye are not well defined, because they depend on the intensity of the light and the sensitivity of the observer's eye. With intense illumination light rays as short as 350 nm and as long as 900 nm can produce effects which are just visible. For most practical purposes, however, the light wave-band is regarded as extending from 400 nm to 700 nm, since the eye is only very slightly sensitive to radiation beyond these limits.

The subject of colour vision is more fully discussed in Chapter 4.

REFLECTION TRANSMISSION AND REFRACTION OF LIGHT

So long as a light wave is travelling through the same medium, such as air only or water only. then, for all practical purposes, the wave travels

in a straight direction. For this reason we cannot see round corners, and the edges of a broad beam of light, for example, a searchlight or car headlamp beam, when viewed from a position outside the beam, are straight, never bent in any way. Indeed, it is a commonplace to say that light travels in a straight line and the expression 'ray of light' usually conveys light travelling in one direction.

However, when a ray of light strikes or enters the surface of a second medium, for instance in passing from air to polished metal or from air to glass or water, it is usually bent from its original path, either by reflection or refraction. Many of the effects of these phenomena in everyday life are well-known.

Reflection is the effect whereby the light rebounds from the surface, as in the familiar case of a mirror. See Fig. 1.2. If the light reflected from a surface falls on our eyes, we get an impression of the object which is causing the reflection. In fact, we see all objects in this way except for the few which themselves *emit* light. That is, light, either daylight or artificial, falls on an object (this is termed the incident light) and we see the object by the portion of this light which reaches our eyes after being reflected from it.

With a smooth surface like that of glass or a highly-polished material, a ray of light is largely reflected in one direction so that a clear image of an object is seen in the surface. Such directional reflection is said to be *specular*. Specular or regular reflection is the kind dealt with in the well-known law of reflection that the angle of reflection is equal to the angle of incidence.

Rougher surfaces, for example, white paper, also reflect light but, because of the irregular surface, light strikes the irregularities and is therefore reflected at almost all angles. In other words, the light is scattered in all directions although the constituent waves follow the rules of reflection. This kind of reflection is termed *diffuse*. If white materials such as paper did not scatter the light they would appear either as a mirror, like aluminium foil, or transparent, like cellulose film. With many papers and textiles there is some internal scattering within the surface (see p. 209). A thick layer of fresh snow, unlike a layer of water, forms an almost perfect reflecting surface, involving internal reflections, from the vast number and variety of reflecting crystals randomly arranged in it, so that it appears white and bright from all directions.

A surface from which a high proportion of light is specularly reflected is glossy or lustrous, the best example being a mirror. A surface like that of unpolished white paper from which the light is diffusely reflected appears *matt*. The two cases are illustrated diagramatically in Fig. 1.3. The subject of *gloss* is complicated, however, by the fact that most materials give rise to mixtures of specular and diffuse reflection. Polished wood does so, the top wax layer acting more or less like a

mirror whereas any light penetrating the wax is diffusely reflected from the wood underneath. Similarly with glossy paint and printing ink films, the smooth varnish layer produces specular reflection and the pigment particles within the film scatter the light. In general, the relative proportion of specular and diffuse reflections determines the degree of apparent glossiness or mattness of a surface.

Gloss depends largely upon specularly, that is, regularly reflected light and usually tends to become more obvious at oblique angles of illumination and viewing. Hence many materials that are normally regarded as matt, such as so-called matt paints and distempers and some paper surfaces, exhibit sheen when viewed at almost grazing angles.

There are other cases of glossiness like that of metallic lustre which require special consideration and this is discussed later, in Chapter 3, p. 38.

When light is able to enter a substance and pass through it, we say that the substance transmits light and is transparent. Translucent materials scatter and transmit light, giving diffuse transmission. Substances which do not transmit light are said to be opaque.

If a substance is perfectly transparent, it is invisible, for example, air; but no such liquid or solid substance is known. Even an apparently clear material such as glass *reflects* a little of the light falling upon it, which renders it visible and glossy when viewed in certain directions.

Refraction occurs when an oblique ray of light enters, or leaves, transparent materials. In this case the light continues in a forward direction but an oblique ray is bent out of its original path in the way shown in Fig. 1.4. The reason is that the speed of light changes when it passes from one medium to another. Light travels fastest through space (a vacuum), very slightly slower through air and decidedly slower through glass or water or other transparent solid or liquid material. When a ray of light enters a surface at an angle other than the perpendicular, the waves on the inside or acute side of the angle reach the surface a tiny fraction of a second before the other waves and the alteration in the speed of the waves one after the other causes the ray to slew into a different direction. Thus, when light enters a material in which it goes slower the rays are slewed towards the perpendicular or 'normal' to the surface. On passing at an angle into a medium in which light travels faster, the consequent acceleration of the waves one before another deflects the rays away from the normal at the surface.

It is refraction which causes a stick half-immersed in water to appear bent at the surface of the water and for the bottom of a pond to appear nearer, that is, the pond shallower, than it really is. The degree to which light is refracted depends somewhat upon the wavelength of the light but mainly upon the nature of the material the light is entering. In fact, the extent to which light is refracted by it is a characteristic property of a

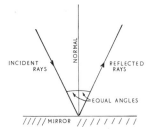

Fig. 1.2 How light is directionally reflected from a mirror or a polished surface.

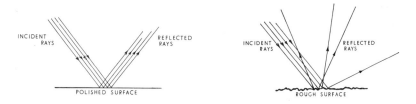

Fig. 1.3 *Left* Specular reflection from a highly polished surface is regular or direct and gives gloss. *Right* Diffuse reflection from an unpolished or rough surface is irregular, the rays of light being scattered in all directions although they obey the laws of reflection, and the surface appears matt.

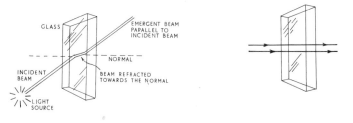

Fig. 1.4 *Left* Refraction of an oblique ray of light on passing through a transparent material. If the two surfaces of the material are parallel, as shown, the emergent ray is parallel to the incident ray. *Right* When light enters a transparent material at right angles to the surface it passes straight through without refraction.

substance and is expressed numerically as the refractive index of the substance.

The facts concerning reflection and refraction are well-established and stated as scientific laws. These laws have numerous highly important applications, and interested readers who are unfamiliar with them are advised to study at least their more elementary aspects which will be found in any physics text-book dealing with 'Light'.

THE SPECTRUM OF WHITE LIGHT

When a narrow beam of white light (obtained by placing a slit in an opaque screen in front of a sunbeam or an opal electric light) is passed through a glass prism arranged as shown in Fig. 1.5, the light is dispersed into a series of coloured bands, termed a spectrum, in which the colours blend gradually into each other from red at one end to orange, yellow, green, blue and finally violet.

The reason for this dispersion of white light lies in the fact that the degree of refraction of light by a transparent material depends not only upon the substance of the material but also upon the wavelength of the light—short waves, for example, violet, being refracted more than longer waves, such as red. This dispersion occurs therefore to some extent whenever white light is refracted, but the separation of the waves is small and a clear spectrum is most easily obtained by means of the two refractions produced by light entering and leaving a glass prism.

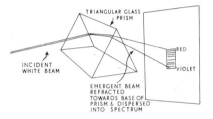

Fig. 1.5 How a narrow beam of white light is dispersed by a glass prism into a spectrum. The best position for the prism is that of minimum deviation obtained by slowly rotating the prism round its axis when the spectrum will stop moving in one direction and start to retrace its path.

If, in place of the glass prism, a material with a greater dispersive power than glass is used, then a greater separation of the violet from the red and intermediate rays, that is, a longer spectrum, is obtained. This may be done by means of a prism-shaped bottle filled with carbon disulphide.

Whilst the spectrum produced by a prism is bright, the greater refraction of the violet rays compared with the red and others yields a spectrum in which the violet and other bands are spread out more than they should be by comparison with the red band. This distortion of the true spectrum is overcome by substituting a *diffraction grating* for the prism. A diffraction grating is usually a transparent cast taken from an original and expensive grating consisting of a piece of speculum metal or a layer of aluminium finely scribed by a diamond point with

about 15000 parallel lines to the inch (6000 per centimetre). These fine lines act as narrow opaque obstacles to a beam of light, causing rays to be slightly deflected or bent in such a way that the longer the wavelength the greater the deviation. Thus a diffraction grating produces a true spectrum in which the dispersion of the colours is directly proportional to the wavelength of the light. Such a spectrum is known as a 'normal' spectrum. Diffraction is a rather complicated case of interference and spectra are produced mainly by the interference caused by a grating. See Interference Colours, Chapter 3, p. 45.

Diffraction is a consequence of the wave character of light, this exceptional bending occurring when the waves pass through a very small aperture or past the edge of an obstacle and it accounts for the slight lack of sharpness of the edge of shadows. It is worth noting that longer waves are diffracted more than shorter ones whereas refraction deflects the shortest waves most.

A reproduction of the spectrum of white light is shown in Plate 1. For reasons which are given later (Chapter 8, p. 171), it is particularly difficult to reproduce by printing the brilliance and the true colours of an actual spectrum. But this spectrum is the basis of the whole subject of colour, for if white light (daylight) were not a mixture of all the coloured spectrum rays then colour as we know it would not occur. Some representation of the spectrum of white light is, therefore, essential in any account of the physical basis of colour. It will aid many of the explanations in the following pages if this spectrum is memorised, noting especially the order of the coloured bands according to the wavelength, that is, violet merging into blue, green, yellow, orange and red from short waves to long waves, the yellow band being much narrower than the others and the orange band fairly narrow.

Sir Isaac Newton is famed for his proof in 1666 (when only 24 years of age) of the composite nature of white light. The spectrum was described by Newton in terms of seven colours, the seventh being rather vaguely labelled indigo between the blue and the violet, and this description has been copied ever since. A complete verbal description of the spectrum by means of the names of colours is well-nigh impossible for it has been estimated that there are about 150 different spectrum colours, each just distinguishable from its neighbours. For descriptive purposes the fewer the colour names used for the spectrum the better, on the grounds of simplicity. There are at least six distinct coloured bands in a bright spectrum, so that it is now common practice for scientific purposes to describe the spectrum of white light by the names of the six colours already stated, viz., violet, blue, green, yellow, orange and red.

Bearing in mind the gradual transition from one coloured spectrum band to the next, which renders the boundaries between them uncertain,

the following are the approximate wavelength bands of the spectrum corresponding to the predominant colour sensations:

400–450 nm Violet.
450–500 nm Blue.
500–570 nm Green.
570–590 nm Yellow.
590–620 nm Orange.
620–700 nm Red.

SPECTRA OF ARTIFICIAL LIGHT SOURCES

The widespread and often essential use of artificial lighting makes it necessary to consider such light, it being common experience that fabrics, posters and decorated surfaces look different under different kinds of lighting and that the colours of some materials may match under one light but not under another type of illumination.

Indeed, daylight may vary from slightly bluish under a clear north sky to pale orange in the evening when the sun is low in the sky, or even reddish when there is haze or dust about, and direct noon sunlight is of a bright yellowish hue. Although the continuous spectrum of daylight covers all wavelengths, the distribution of energy over various wavelengths depends upon circumstances. The colour of the sky is discussed in Chapter 3, p. 46.

It is well known that the colour of artificial light differs from that of good daylight, for example, that gas lighting and most forms of electric lighting, particularly that from the familiar tungsten filament lamp, are noticeably 'yellow'. The reason lies in the fact that the relative intensities (amplitudes or energies) of their light waves over the range of wavelengths are not the same as those of daylight. The ordinary forms of gas and electric filament light are deficient in violet and blue rays and the general character of the illumination veers, therefore, towards the long wave end of the spectrum, although a continuous spectrum is radiated.

Plate 2 illustrates the spectra of the more important artificial light sources which do not produce continuous spectra. These are electrical discharge lamps or tubes, (a) *Sodium* vapour, as used in the brilliant yellow road lighting which has been adopted in many urban areas. The spectrum of sodium consists almost entirely of two intense lines in the yellow, at wavelengths of 589·0 and 589·6 nm, known as the D-lines. It is a discontinuous, so-called line spectrum. This lighting, due to its pure yellowness, tends to makes things look yellow or brown or black, as is explained later (p. 31). (b) *Mercury* vapour, the light from which is intensely bluish-white but the visible line spectrum is composed mainly

of violet, green and yellow bands only. The energy emitted by mercury vapour is also rich in ultra-violet rays. Mercury vapour lamps of different patterns are employed for a variety of illuminating purposes. For general illumination the chief fault of direct mercury-vapour lighting is the absence of red rays, which causes red objects to appear more or less black. See p. 32. This fault is largely overcome, however, in the modern 'fluorescent' lighting based on mercury vapour and explained on p. 50. (c) *Neon* gas, used in the familiar bright orange-red advertising and display signs. The line spectrum in this case is mainly restricted to the wavelengths 724, 717, 651, 640 and 627 nm in the red-orange region.

It may be noted here that the spectrum of any of the 90-odd chemical elements is distinctly characteristic of each element—a sort of fingerprint by which an element may be recognized whenever it is made to give out light. A few simple cases are common experience. For instance, if sodium chloride (common salt) or any other sodium compound is heated in a flame the latter becomes intensely yellow. If a compound of potassium is used the flame is lilac, with copper metal or a compound it is green, with calcium brick-red, with barium yellow-green and with strontium crimson. This is the basis of colours in fireworks. The characteristic line spectra of the elements form the basis of the technique of chemical analysis by spectrography which has been developed to a high degree of accuracy and is termed spectrochemical analysis. Spectrography also enables astronomers to analyse the light emitted by the stars and planets and thereby to determine the kind of elements in them together with other information such as the surface temperature.

COLOUR TEMPERATURE

Because of the wide variations in the intensity and energy distributions of light sources, a relatively simple means of indicating or measuring these differences is required, especially where light sources are being used in connection with colour as in colour photography and colour re-production. The concept of colour temperature is convenient and much used for such purposes.

It is a familiar experience that when a piece of iron is heated it first glows a dull red and, as the temperature is increased, the glow turns to orange then yellow and finally it becomes white-hot. Colour temperature is often defined as that temperature at which a perfect black body emits light of the same colour as the source in question. A perfect black body is a theoretical ideal, being one which emits full or complete radiations of all wavelengths when heated and completely absorbs

Footnote: In accordance with the S.I. system, degrees Kelvin are now 'kelvins'—note the use of lower case k—and colour temperatures are written '3000K'—note now the upper case K.

all external radiations, such as light, falling upon it. Strictly, therefore, colour temperature is that at which the radiation emitted by a black body has the same spectral composition, that is, energy distribution as a given light source. However, the spectral energy distributions of most sources of whitish light, including daylight, only approximate to those of a black body, and the figures commonly quoted are 'correlated' colour temperatures, although this term is rarely used. Our first definition, as the temperature at which a black body produces light most closely matching the colour of a particular source, correctly applies to 'correlated' colour temperature. It provides a useful indication of the relative yellowishness or bluishness of a light source, even though the spectral composition of the radiation may differ from that of a perfect black body. See Fig. 1.6.

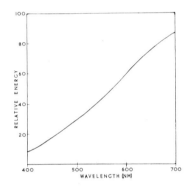

Fig. 1.6 (*a*) Spectral energy distribution of a 250 watt tungsten filament lamp operated at a colour temperature of 3 000°K. The curve is almost identical with that for a heated black body (full radiator) at this temperature.

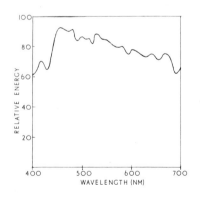

Fig. 1.6 (*b*) Spectral energy distribution of average daylight. This differs appreciably from that of a heated black body which at 6 500°K has a nearly matching colour. Hence average daylight is given a correlated colour temperature of 6 500°K. No real source of white light is known which produces an equal or uniform distribution of energy throughout the spectrum.

The figures for colour temperature are those of the absolute or Kelvin scale of temperature (°K), which exceed the figures of the Centigrade (Celsius) scale by 273, the absolute zero of the Kelvin scale corresponding to $-273°C$. For example, 3000°K, the colour temperature of a 250 watt tungsten filament lamp, is equal to $2727°C + 273°$. The light emitted by a perfect black body at 2000°K is low in blue energy and high in red, but at 10000°K the position is reversed.

Colour temperature is a measure of the hue of a source of illumination. It is not used as a measurement of the colours of materials that do not emit light, for example, paints, fabrics, flowers, etc., nor is it necessarily a measure of the actual temperature of a source of light. An 'Artificial Daylight' fluorescent lamp may have a colour temperature of 6500°K, which is the figure attributed to average daylight, but a fluorescent tube generates less heat than a tungsten lamp of 3000°K.

Colour Temperatures of Common Light Sources

Source	°K (approx).
North-sky light	7500 or higher
Sunlight	5500
Photographic blue flash-bulb	5500
Photographic clear flash-bulb	3800
'Warm White' fluorescent lamp	3000
Tungsten lamp (100–200 watts)	2900
Candle	1900

Colour temperature is chiefly applicable to a source of light giving a continuous spectrum, so that it is not really suitable or gives no more than a very approximate indication with electrical discharge lamps. For sources yielding largely single line spectra (monochromatic light) such as a sodium vapour lamp it is quite unsuitable. Because of the limitations imposed by the general use of correlated figures, two sources of illumination of the same colour temperature may not give the same colour rendering. This can arise if a fluorescent tube is compared with another source that gives a truly continuous spectrum, because, while modern fluorescent lamps have a fairly continuous spectrum, the strong emission bands of mercury vapour are superimposed on it, resulting in some distortion in the appearance of colours (see p. 50).

Despite their limitations, however, colour temperatures are of considerable technical assistance. Photographic sensitized colour materials are made to give true colour rendering with light of specified colour temperatures.

For measuring colour temperatures, meters similar in principle to photoelectric exposure meters are available.

POLARIZED LIGHT

Some interesting colour effects can be produced by using what is called 'polarized light'. The waves in a ray of light travel in a straight direction but because they are waves, that is, vibrations, the wave motion is across and at right-angles to the direction of the ray. If a length of rope is held at one end and the hand moved sharply up and down, the free end of the rope is projected forwards towards the horizontal but the rope takes up the form of a vertical wave. In a beam of ordinary light this transverse movement of the vibrations takes place in all directions or planes; thus in a horizontal parallel beam at any particular instant some of the waves will be moving upwards, some downwards, some to the right and some to the left, and so on in every direction perpendicular to the rays. When such a beam of white light is passed through suitable polarizing material, the vertical vibrations upwards and downwards are stopped whereas the vibrations in the plane to the right and left pass through, or vice versa. The intensity of the beam transmitted by the polarizing material is reduced since only some of the vibrations pass through and the transmitted beam is said to be 'plane-polarized'.

A very suitable material is the plastic film known as 'Polaroid' which consists of myriads of needle-shaped crystals arranged with their long axes parallel to one another. If a sheet of Polaroid is placed in a particular position in the path of a light beam, the transmitted light will be plane-polarized, say to right and left. When a second sheet of Polaroid is rotated round the axis of the transmitted beam a position will be found in which the plane-polarized light produced by the first Polaroid is passed unimpeded by the second, and if the second Polaroid is then rotated through a right-angle the light will be completely extinguished. In the latter case, the vibrations to right and left are extinguished by rotating the second Polaroid through a right-angle, in which position it would transmit upward and downward vibrations but these have been extinguished by the first Polaroid. Two sheets of Polaroid or other polarizing material arranged in this way at right-angles are said to be 'crossed'.

Quite a number of transparent substances placed between crossed Polaroids, when the light has been extinguished, cause it to be transmitted again by the second Polaroid. Many such substances are optically active, for example, quartz and sugar solutions, and when viewed between crossed Polaroids they often produce strongly coloured patterns. Sheets of cellophane and mica, silk, flax, cotton, white hair and wool fibres frequently show optical properties of this kind, due to their double refraction of light, and yield beautiful and varied colour effects on rotation between crossed Polaroids.

GENERAL PROPERTIES OF COLOURED MATERIALS

'...ANYONE MAY APPLY ready-mixed paint to canvas as his fancy flies without much display of technical competence or craftsmanship and be considered an artist, seeing that on modern standards he is not expected to render his effects intelligible to other people. Certainly there is a great deal of such work which has no interest to other people, but in our modern way we accept the tolerant convention that at least the effect produced must have some psychological significance for the painter, if only by disclosing the shortcomings of his social and mental environment. It is not for me to debate the lack of discipline in some of these manifestations, if they may be so called, but I am critical that too little appreciation is so often shown of the properties of materials...'— Dr. L. A. Jordan, Society of Chemical Industry Jubilee Memorial Lecture, 'Paint: The Art and the Science'. 1945.

This chapter deals with the factors which determine the colour of ordinary, everyday material substances such as pigments, dyes, paints, printing inks, coloured liquids, crystals, glass, fabrics, flowers. leaves. skin, hair, fur, etc., all of which depend for their visibility and colour upon illumination from some external source, and are far more numerous and important in the colour world than self-luminous objects, that is, objects which emit their own light, either naturally or under artificial stimulation.

ABSORPTION OF LIGHT

It has been stated on p. 8 that most objects are rendered visible by the light reflected from them. If we look directly through a coloured transparent material, such as glass or liquid, then we see its colour by

means of the light transmitted through it. But, in addition to reflecting and/or transmitting light, all material substances absorb light, that is, a portion of the light energy which strikes or enters a material is retained by it. This absorbed light is usually converted into heat and lost in that way. The absorption of light and likewise the reflection and/or transmission of light varies very considerably between different materials. The absorption of light by a substance is just as important as the light which is reflected or transmitted by it. In studying the properties of materials we have, therefore, to consider the light which is reflected and/or transmitted in conjunction with the light absorbed by a substance.

WHITE AND BLACK MATERIALS

Since surfaces are visible by the light reflected from them, it is to be expected that a surface which reflects white light will itself appear white. On the other hand, a material which reflects no light, that is, absorbs it all, will produce no sensation of sight in the eye and a mental impression of blackness is obtained. Absence of light implies darkness or blackness. It is often stated that white substances reflect *all* the light falling on them and that black materials absorb it all. But this statement is not strictly true, for no material substance completely reflects or completely transmits or completely absorbs the whole of the light falling on it, although certain materials give a sufficiently close approach to complete reflection or absorption to serve practical purposes. Even the whitest materials, like freshly-fallen snow or a layer of magnesium oxide, absorb 3–5% of the incident light, whereas the blackest substances, such as carbon black or black velvet, reflect at least 3% of the incident light. Absorption or reflection as small as this is usually negligible, but with other so-called 'white' materials, for example, paper, the proportion of light absorbed is often appreciable, as is the proportion of reflected light from some materials which are commonly regarded as black. It follows that there are degrees of whiteness and blackness. In certain industries, notably paper manufacture, it has become necessary to measure the reflectivity of white and near-white surfaces, since the eye is quite sensitive to small differences in whiteness or lightness when such surfaces are compared with one another.

A white substance may be described as one which reflects most of the white light falling on it, or, more precisely, which has a high degree of reflection at all wavelengths through the spectrum. Similarly, so-called 'colourless' materials, such as water and glass, transmit a high proportion of light throughout the spectrum. A black material possesses a high power of absorption at all wavelengths of the spectrum. Grey materials lie between these extremes, because they reflect and absorb more or less

equal quantities of the incident light throughout the spectrum, a dark grey object obviously reflecting less and absorbing more light than a light grey object.

As regards reflection, these statements refer to the whole of the light reflected by materials irrespective of whether it is specularly or diffusely reflected (see p. 8), that is, the sum of the directionally reflected and the scattered light is implied. The ratio between the quantity of light reflected from a surface and the total light incident on it is termed the 'reflection factor'. Similarly, the proportion of the incident light that is transmitted through a material is termed the 'transmission factor', and the proportion of the incident light absorbed in a substance (not reflected or transmitted) is the 'absorption factor'. If this last ratio is related to unit thickness of the material it is known as the 'absorptivity' or, perhaps, as the 'absorption coefficient' of that material, (see p. 27).

COLOURED MATERIALS

(a) Selective Absorption

Substances which absorb more light from one part of the spectrum than from another become coloured. In other words, a coloured material separates the components of white light by the process of selectively absorbing certain constituent parts and reflecting the others. The reflected portions of the spectrum produce the apparent colour of the material. For example, a red object may absorb most of the violet, blue, green and yellow light and reflect mainly red light.

(b) Complex Reflection

It is often stated that a coloured material reflects light of its apparent colour and absorbs all light of other colours, for instance, a poppy is said to reflect only red light, a statement which is a gross over-simplification. No normal coloured substance is known which reflects (or transmits) light of one colour only, that is, light of about a single wavelength (monochromatic). One of the most important properties of coloured substances is that they invariably reflect (or transmit) a *mixture* of various light waves. This may be demonstrated by placing a piece of yellow glass in the path of a beam of white light, when, of course, the colour of the beam changes to yellow on passage through the glass; now by placing a piece of red glass in the yellow beam it will be seen that the colour of the light changes to red; and if the red glass is then replaced by green glass the transmitted beam changes again this time to green; thus showing that the original yellow beam contains both red and green light. Indeed, pure monochromatic yellow light of 580 nm.

like other pure monochromatic light of any wavelength within the visible spectrum, is not normally met with in Nature at all.

No blue substance is known which reflects only blue light and absorbs completely the light of all other colours. All ordinary blue materials reflect a mixture of at least violet, blue and some green light. Similarly, red substances reflect at least orange light in addition to red light; and green materials reflect at least yellow light and some blue light in addition to green light. Yellow substances reflect a mixture of red, orange, yellow and green light; and so on.

As a rough generalization it may be taken for granted that any particular coloured object will reflect a mixture consisting of light of its apparent colour together with some light of at least the colours adjacent to the apparent colour in the order of the spectrum. Such mixed reflection (or transmission) of a band of spectrum colours around the apparent colour is the minimum returned by any material substance. This generalization may often be helpful, in an elementary way, to explain some effects obtained by the use of coloured materials or to enable an approximate estimate to be made beforehand of the probable result from mixing coloured materials. Nevertheless, for all exact purposes the detailed reflection and absorption of any coloured substance must be carefully and accurately measured by means of a suitable scientific instrument, such as a spectrophotometer, which is based on the use of a prism or diffraction grating for producing a spectrum. See Colour Measurement, Chapter 6, p. 107.

It may be rightly inferred from the above generalization that light of about the apparent colour of a substance usually predominates in the mixture of rays reflected or transmitted by the substance. That is, most red materials reflect more red light than light of other colours, green substances reflect mostly green light, and blue light predominates in the reflection from most blue materials. At the same time, however, the quantity of reflected light of colours other than that which predominates is often appreciable with normal coloured substances. Crimson dyes and pigments reflect considerable blue light along with red and the greater the proportion of blue compared with red light the more violet or purple the dye or pigment appears, as may be expected. In describing colours, one of the technical terms which has been generally adopted and given a precise definition is that of HUE. Broadly speaking, the hue of a substance is determined by the predominating wavelengths in the reflection from that substance. Hue distinguishes one colour from another, it denotes whether the colour appears red, orange, green or blue, etc. See Plate 3.

Yellow materials are an important exception to the general statement at the beginning of the last paragraph. Such materials selectively absorb the violet and most blue light from white illumination and reflect or

transmit the green, yellow, orange and red rays. Because of the comparative narrowness of the yellow band in the spectrum and the much broader bands of red and green, it follows that the total quantity of red and green lights reflected or transmitted by yellow materials is considerably in excess of the quantity of essentially yellow light. The immediate question is, 'Then why does such a material appear yellow?'. The answer is that a *mixture* of red light with green light produces the visual sensation of yellowness (see Chapter 4 on Colour Vision, p. 56), so that the red and green light reflected (or transmitted) by yellow materials serve to increase the yellow sensation caused by the genuine yellow light which is reflected.

The reflection (or transmission) of a mixture of several light rays by coloured materials is important because on it depend the common processes for reproducing colour, which are explained in Chapters 5, 7 and 8. The production of the so-called 'secondary' and 'tertiary' colours of the artist is due to the complex reflection of various coloured rays of light by each of the so-called 'primary' coloured substances. When a painter mixes his pigments, he is mixing all the spectrum colours minus those absorbed by the pigments. For instance, the familiar production of green effects by the blending of yellow and blue paints or inks is only possible because green light is common to the complex reflections or transmissions of both materials, though the rest of the light of the spectrum may be collectively absorbed by the yellow and blue pigments.

On the other hand, it follows that 'pure' colour, meaning by that light of about one wavelength, is practically never obtained from material substances, as already mentioned on p. 20. Fortunately, materials of pure colour are not required for the great majority of practical purposes; indeed, as suggested in the preceding paragraph, it is usually very much otherwise.

(c) Incomplete Reflection

So far we have been mainly concerned with the nature, that is, the wavelength or colour of the light reflected or transmitted by material substances, but we must also consider the *quantity* of coloured light radiated by materials. Here again there are certain general facts which should be borne in mind.

In the first place, the absolute amount of light reflected by a surface is *not* a characteristic of the material, for the absolute quantity of light reflected depends primarily upon the intensity of the incident illumination, that is, upon the amount of light falling on the material. The characteristic property of a coloured substance, in the quantitative respect, is the *proportion* of the incident light which is reflected from

the surface; in other words, what fraction, $\frac{3}{4}, \frac{2}{3}, \frac{1}{2}$, etc., of the incident light is reflected, or transmitted, by the material. This fraction of reflected or transmitted light is usually expressed as a percentage of the incident light and may be termed the reflection or transmission factor, as stated on p. 20.

In general, it can be stated at once that the reflection or transmission of light by material substances is never wholly complete. It has been explained in the preceding section that the whitest substances do not reflect the whole of the incident light, nor do the most transparent or colourless materials, such as optical glass, transmit 100% of the light falling on them. Likewise, no coloured material reflects or transmits the whole of the incident light of its own colour. Indeed, coloured substances often absorb a serious proportion of the light of their own colour, with a consequent loss of brilliance. For example, most green materials, in addition to absorbing most of the red and violet light falling on them, also absorb a large part of the blue, green, yellow and orange light. Consequently most green materials, provided they are not pale green tints, are dull and rather dark in appearance. Similarly, blue substances, other than tints, tend to be dark because they absorb considerable proportions of the violet, blue and green rays as well as large proportions of the yellow, orange and red. Green and blue materials rarely reflect or transmit more than about 50% of the incident light in the green or blue regions respectively.

Yellow and red substances usually perform better in this respect by reflecting or transmitting between 70% and 90% of light in the yellow, orange and red regions. Hence a further generalization may be made here, that, under the same conditions of white light illumination, the quantity of coloured light reflected by violet, blue and green substances is usually less than the quantity of coloured light reflected by yellow, orange and red materials. Largely for this reason, objects having the latter colours are normally brighter than those of the former colours.

It appears that light of the longer wavelengths is more readily reflected (or transmitted) by solids and liquids than light of the shorter wavelengths. This is in accordance with the scattering of light by fine particles (see p. 46), and is well illustrated by crimson, magenta, and purple (or mauve) materials. Many substances which are often described as 'red' but are more precisely labelled 'crimson' or 'magenta', have some violet and blue in their mixed light reflection or transmission. But the quantity of red and orange light radiated by these materials is much greater than the amount of violet and blue light. If a markedly blue-red, that is, purple or mauve substance is required, reflecting about equal proportions of violet, blue and red, orange light, then because of the inherent low reflectance in the violet and blue, a substance must be selected with a correspondingly low reflectance in the red and orange

region. As a consequence, purple materials, like blues and greens, are comparatively less bright than yellow, orange and really red substances.

A point worth noting here is that a purple or mauve coloured material should not be confused with the violet of the spectrum. The sensation of 'purple' is produced by the mixture of red and orange with blue and violet rays from the material, whereas the violet of the spectrum is produced by the shortest light waves without any red or long waves at all. Because of the poor reflection of violet light by material substances in general, the brilliant violet of the spectrum is unique.

One of the practical difficulties arising from the incomplete reflection of light by materials is that of imitating by means of inks or paints on paper or canvas the comparative brilliance of a beam of light in real life.

Brown, russet, citrine, olive green and other dull-coloured surfaces are really dark yellow or dark orange or dark green materials and so on. Such substances absorb a high proportion of light in all regions of the spectrum, but tend to reflect rather more light in the yellow, orange, red or green as the case may be. They may, therefore, be regarded as degraded yellows, oranges, or reds or degraded greens in much the same way that grey surfaces may be considered to be degraded whites.

It is only with the brightest coloured substances that any of the various rays of white light are anything like completely reflected. As a general rule there is a certain amount of absorption from end to end of the spectrum, resulting in the apparent colour being dulled or saddened by a certain amount of black, that is, absence of light. The greater the amount of this overall absorption the darker the colour or 'shade' of the colour.

The intensity of visual sensation produced by a surface, usually termed the LIGHTNESS or BRIGHTNESS, is proportional to the fraction of the incident light which is reflected by the surface. Due to the powers of adaptation of the eye to varying conditions of illumination (see p. 64), there is little connection between the apparent brightness of a surface and the absolute intensity or quantity of the reflected light— it is the reflected *fraction* of the incident light which is all important. The absolute intensity of light determines the intensity of visual sensation only when a comparison is being made between different light sources such as lamps, and, in this case, the term 'luminosity' or 'luminance' is preferable in order to avoid confusion with the apparent lightness or brightness of normal, non-luminous, objects. Lightness indicates how brilliant a colour is; a cherry red has greater lightness than a dark red. See Plate 4.

(d) Incomplete Absorption (Reflection of White Light)

In order that light may be absorbed it must penetrate, at least to a small

extent, into the surface of the material on which it impinges. However, as already mentioned in connection with black and white materials, the absorption of light, like the reflection or transmission of it, is never entirely complete. Some light is thrown back, that is, is reflected from all surfaces, even those which are transparent, without any penetration and therefore without any separation or change. In other words, none of the coloured constituents of white light is ever quite completely absorbed by material substances. The amount of light which is thus reflected unchanged by coloured substances varies considerably with different materials.

If objects are viewed as normally under white light illumination, then some unchanged white light is reflected and this will be mingled with the reflected coloured rays and will tend to produce a tint of the coloured rays. With many coloured materials the amount of white light reflected is comparatively small (about 5 to 10% of the incident light) and may almost be neglected by comparison with the much larger quantities of the predominating coloured rays which are reflected. For instance, a yellow pigment may reflect 90% of the red light, 90% of the orange and yellow lights and about 90% of the green light, but only 5 to 10% of the violet and blue out of the incident white light. This 5 to 10% of reflected violet and blue lights will blend with 5 to 10% of the green, yellow, orange and red lights to constitute 5 to 10% of white light. Hence this yellow pigment might be said to reflect about 80 to 85% of red, orange, yellow and green lights together with 5 to 10% of unchanged white light. If the violet and blue rays are less effectively absorbed, then a higher total of white light will be reflected and the material will appear to be a pale yellow. It follows that pink or pale blue or other tinted materials reflect a large proportion of white light together with coloured rays and the paler the apparent colour the greater the proportion of the incident white light which is reflected unchanged.

Since this reflection of unchanged white light is a surface effect due, in a sense, to the light skimming off the surface, it is to be expected that an increase in the surface area of a coloured material will tend to increase the proportion of white light reflected by it. It is for this reason that a powdered substance often has a paler colour than the same substance in lump form. A good example is provided by copper sulphate which is pale blue when powdered compared with the deep blue of lump copper sulphate. Similarly, if the surface of a glossy plastic article is roughened with sand paper it will appear as a tint of the original colour. Many pigments when finely powdered and observed dry are pale in colour, but the surface reflection of white light from the particles is reduced if a pigment is immersed in water, or even more in oil, and the colour becomes deeper—a fact of considerable practical importance to the artist and the paint manufacturer. If, however, the size of the

powder particles is so small as to approach the wavelength of light, then the reflection and the apparent colour of the powder will be considerably modified by the scattering of the light, see p. 46 (Light Scattering). Another interesting example is the effect of fibre fineness in fabrics, which has to be taken into account by the colourist in the textile industry; the finer the fibres the more is the colour of the dye diluted by reflected white light. Indeed, it has been said that the difference between light and dark brown hair amongst Europeans is produced by variations in hair diameter to a greater extent than by the amount of pigment present.

In the case of polished or glossy coloured materials a high proportion of unchanged white light is reflected at oblique angles, so that, if such materials are viewed obliquely instead of at right-angles, the amount of specularly reflected white light may be large enough to cause the materials to appear almost white. See p. 8 (Specular and diffuse reflection).

From the practical point of view these facts apply particularly to opaque substances and to materials which are normally viewed by reflected light, such as a pigment painted or printed on paper. Where transparent materials are involved it is necessary to distinguish between the unchanged light which is reflected and the light which is transmitted.

Materials differ considerably in degree of transparency, but if we consider highly transparent substances like coloured glass and plastic film, then it is the transmitted light which is important for practical purposes. When light is transmitted by an absorbing material the whole of the light within a certain range of wavelengths may be selectively absorbed. For example, a piece of good orange-red glass will tend to *reflect* a little unchanged white light, but it will *transmit* large proportions of red and orange lights, and *no light at all of the other colours*. If this glass is used as a light filter in front of a camera, for the purpose of restricting or correcting the colour of the light entering the camera, it is only the *transmitted* light which matters, so that we can say, briefly, that this glass transmits red and orange light only.

On the other hand, a piece of pale coloured glass will *reflect* a little unchanged white light, and also *transmit* appreciable though different proportions of light of all the spectrum colours, and hence its pale or whitish colour.

The white light which is mixed with the coloured rays reflected or transmitted by a material produces a diluted or 'desaturated' colour. In more general terms and particularly with reference to transmitted light, the more the pre-eminent coloured rays are admixed with rays of other colours, the more diluted or desaturated the colour of the light tends to become. Light from which a narrow wave-band of the spectrum is absent contains no white light but its colour will appear desaturated because it approaches white. The less the proportion of white light received from a coloured substance, or the more the main coloured rays

from it predominate in relation to the remainder of the spectrum, the less tinted or the more colourful or 'saturated' the appearance of it. It has been mentioned on p. 21 that, in describing colours, the term 'hue' refers to the colour of the dominant constituents of the spectrum which are disseminated by a material. Also for the description of colours, the term SATURATION is used in reference to the extent to which the dominant wavelengths predominate over the others, or, the degree to which the essentially coloured rays from a substance exceed the diluting white rays; in other words, the strength of a colour or how much of that colour. A red material is said to have a more saturated colour than a pink substance. See Plate 5.

Finally, it may be noted that in general the absorption of light by materials tends to be sharper towards the short wave end of the spectrum. This is shown, for example, by many transparent red materials the transmission of which stops sharply at the yellow end of the orange band and includes only a very small amount of yellow, whereas the transmission of most blue substances extends well beyond the violet and blue, that is, well into the longer-wave green band or further. It is easy, therefore, to find a substance transmitting practically no more than red and orange light, but not one which will serve as a filter for blue and violet light only without any green.

ABSORPTIVITY (ABSORPTION COEFFICIENT)

The fraction of the incident light of a particular wavelength which is absorbed by a known thickness of a substance is referred to as the absorptivity or, sometimes, as the absorption coefficient of that substance. The latter term applies, strictly, to the fraction of the incident intensity absorbed per unit thickness when the thickness is very small, this being a constant, which depends upon the substance, in a general mathematical expression for the absorption of light by materials. Furthermore, a statement of fact in physics, known as Lambert's Law, tells us that the fraction of light which is absorbed by a substance is independent of the intensity of the incident light. It follows from this that, when light of any given wavelength enters an absorbing medium, each successive layer of the medium will absorb the same proportion of the light passing through it.

Consider white light entering a thick piece of yellow glass the first millimetre of which absorbs 90 % of the blue and violet light, then the remaining 10 % will enter the next millimetre of glass which will absorb 90% of this remainder, leaving a mere 1% of the original blue and violet light to enter the third millimetre of glass, and this in turn will absorb 90 % of these lights now leaving only 0·1 %, that is, 1/1 000 of the

original light to pass on. Thus the blue and violet rays are rapidly extinguished. On the other hand, this glass may absorb only 10 % of the red, orange, yellow and green light in the first millimetre thickness, so that 90 % passes into the second millimetre, 81 % into the third millimetre, about 73 % into the fourth millimetre, and so on, with the result that a considerable intensity of red, orange, yellow and green rays will continue to be transmitted by a very thick piece of this glass.

In general terms, the thinner the layer or concentration of a coloured medium the more light will tend to be transmitted at all wavelengths, but the increase is comparatively much greater at those wavelengths for which the medium has the highest absorption. If a substance freely transmits light around one wavelength and strongly absorbs rays of another wavelength, a thick layer of it will transmit only the light of the former wavelength in any quantity and the hue will depend on these rays—the dominant wavelength. But in a thin layer, light of wavelengths on both sides of the first-mentioned and beyond will be transmitted while rays of the other wavelengths will be only partially absorbed and the colour or hue becomes desaturated. Indeed, the thin layer will be tinged with the hue complementary (see p. 36) to that of the strongly absorbed light.

Here then is the reason that, in painting or printing, a very thin film of yellow paint or ink will remove most of the violet and blue light, and therefore appear distinctly yellow, and an increase of the film thickness produces only a slight deepening of yellowness, due to the very gradual absorption of the red, orange, yellow and green light. Whereas, using a blue paint or ink, a thin film may appear pale blue because the absorption coefficient for red, orange and yellow light may not be high enough, leaving some white light mingled with the predominating blue rays, yet a thick film will be a dark blue because the absorption coefficient at the blue end of the spectrum will be appreciable, that is, light of every wavelength, even blue, suffers considerable absorption.

In certain cases, different coefficients of absorption in different parts of the spectrum will produce noticeable changes of colour (hue) with varying thicknesses or concentrations of a transparent absorbing medium, a phenomenon termed *dichroism*. When a substance freely transmits light around one wavelength and moderately around another quite different wavelength, the relative proportions of light transmitted at the two wavelengths will alter with the thickness or concentration of the substance and a change of hue will ensue. An example is provided by the well-known red pigment madder lake, with which the chief absorption is in the green but the rate of absorption of blue and violet is greater than that of red light. Consequently, a thin layer of madder lake in the form of an ink or paint has a purple tinge, the blue-violet tone of which is lost in a thick layer. This also applies to the magenta (purplish-

red) ink used in colour printing (Chapter 8) which becomes bluer in thinner films. Similarly, the dye malachite green changes from blue-green in a thin layer, or dilute solution, to a reddish-purple in a thick layer, or concentrated solution, and the colour of chromic chloride varies from green in a thin layer to red in a thick one.

Dichroism has been known as the 'chartreuse effect' because it was first observed with the famous liqueur which in the flagon or decanter is a deep ruby red but appears a brilliant emerald green when poured into a slender glass. Just as materials in general reflect or transmit light of the longer wavelengths more readily than the shorter waves (section (c)), it will be noticed that dichroic substances extinguish the shorter green-blue-violet rays when used in thicker layers or more concentrated solutions.

Effects of the kinds explained above, that is, changes in hue, saturation and lightness caused by variations in the thickness of the layer of coloured material, make it necessary along with other reasons in some high quality colour reproduction processes, colour printing for example, to control or measure the ink or other film thickness.

SUMMARY OF PROPERTIES OF COLOURED MATERIALS

It is common practice to speak of coloured articles or of coloured light, for example, 'green glass' and 'green light'. In actual fact neither the articles nor the light are coloured, but the light reflected or transmitted by an article produces a colour sensation in the eye; for instance, the optical sensation of 'green' is produced by the light which passes through the glass just mentioned.

Clear distinctions should be drawn between (i) the material substance which is reflecting or transmitting light, that is, the light source; (ii) the light energy which is thereby reflected or transmitted, that is, the stimulus; and (iii) the visual sensation produced by this stimulus. It is more than confusing to make the following kind of statement as is done sometimes, that 'Many reds have some violet and blue in their composition'. Such a statement is a vague way by which to convey that many apparently reddish materials reflect or transmit some violet and blue light as well as red light yet the overall visual sensation is red.

The following is a brief recapitulation of the three most important colour properties possessed by material substances generally:

(b) Coloured materials reflect a mixture of coloured light rays composed, as a rule, of light of the apparent colour of the material together with at least lights of the colours adjacent to the apparent colour in the order of the spectrum. The remaining coloured constituents of white light tend

to be absorbed. It is the position in the spectrum of the rays reflected in markedly greater degree than the remainder which determines the *hue* of a material.

(c) Coloured materials never reflect the whole of the light of their respective colours in the incident daylight or other illumination. The quantities of coloured lights reflected by materials vary considerably according to the nature of the material. In general, red, orange and yellow substances reflect more light of the colours concerned than do green, blue or purple substances. The proportion of the incident light which is reflected by a material governs its *lightness* or brightness.

(d) Coloured materials tend to reflect some unchanged white light along with the predominating coloured rays. Just as materials never reflect the whole of the predominating coloured rays from white daylight, neither do they completely absorb the whole of the remaining rays of the spectrum. The term *saturation* implies the extent to which the dominant coloured rays predominate over the remaining spectrum rays, or the extent to which the colour of a material is *not* diluted with white, that is, its freedom from white, or, to a certain extent, the purity of a colour. Transparent substances in many cases do not *transmit* any light of certain colours so that, for practical purposes, they may be said to absorb completely the specific light rays which are not transmitted, that is, their colours are highly saturated.

It must be borne in mind that these three properties do not operate separately but collectively. Lightness is a relative measure of *quantity* of light or magnitude of optical sensation; hue and saturation control the *quality* of the sensation. All three attributes of colour sensation must be considered together, since the actual colour perceived in any particular instance is an intimate blending of both the quality and magnitude of the sensation. Property (b) is particularly important because on it are based the common processes of combining coloured substances to obtain different coloured effects. Properties (c) and (d) together explain the varying degrees of strength, brightness or shade of colour of different materials. The three properties are illustrated collectively in the spectral reflection (spectrophotometric) curves shown with Chapter 6 on Colour Measurement, Plates 17–24.

All of these properties have an influence in one direction or another upon the choice or use of coloured materials for practical purposes. When matching a given pattern in the dyeing industry, for example, the dyer selects a suitable mixture of dyes to give the correct hue, he adjusts their strengths to control the saturation and lightness, and he may adjust the lightness independently by adding a dye of complementary colour (see p. 37) because this has a darkening effect. *Note.* In describing

these properties of coloured materials the single word 'reflects', which applies to opaque substances, has been most frequently used for the sake of simplicity. Strictly, the expression 'reflects or transmits' should have been used throughout because the properties described also apply to transparent substances. Where it is advisable to distinguish between the reflected and transmitted light this has been done, for instance, in describing property (d).

FADING

There is another effect produced by light on a large number of dyes and pigments which warrants mention, that of fading which means the loss of colour or bleaching. In the selection of dyes and pigments for certain uses, especially the production of curtain fabrics, posters and outdoor paints for example, their colour fastness to light, and sometimes to other conditions such as chemical action, may be quite as important as the hue, saturation and lightness. Fading as a subject, however, is outside the scope of this book.

INFLUENCE OF TYPE OF ILLUMINATION UPON APPARENT COLOUR OF MATERIAL

'Yes,' I answered you last night;
'No,' this morning, sir, I say.
Colours seen by candle-light
Will not look the same by day.

From 'The Lady's Yes' by Elizabeth Barrett Browning.

Throughout the preceding account of the colour properties of materials it is assumed that the materials are illuminated by daylight or white light. Colour, however, is not an inherent property of an object like its size and weight. The absolute property of a coloured object is its power of absorbing and reflecting or transmitting light rays of particular wavelengths, so that the observed colour of an object depends on the character of the incident illumination in the first place. For example, if a red material similar to vermilion (mercury sulphide) which absorbs more than 90% of green, blue and violet light is viewed in light of these colours only, it follows that practically no light is reflected and the material will appear well-nigh black. Similarly most blue or green substances appear almost black in red light. Materials that look white in daylight take the colour of the illumination if this differs from white.

Electric or gas lighting is usually deficient in violet and blue rays.

Consequently, blue substances such as ultramarine must reflect less violet and blue light in such artificial light than in daylight, and will, therefore, appear to be darker and of a somewhat different blueness in artificial light compared with the appearance in daylight.

The most glaring and common examples of the effect of the kind of illumination upon the colour of objects are provided by the widespread use of mercury vapour and sodium vapour street lighting. The type of mercury vapour lamp used for lighting main roads gives a general effect of bluish white, which leads to the mistaken impression that this lighting approximates to daylight; mistaken because, as shown in Plate 2, the light is in fact markedly deficient in blue, blue-green and red. As a result of the absence of red light, objects which are normally red in daylight appear almost black in mercury vapour light.

Some time after the introduction of mercury vapour street lighting, a large poster advertising a well-known brand of whisky was widely displayed in many areas, the message of which was changed disastrously by the lighting. The poster carried the legend:

<div style="text-align:center">

NOT A DROP IS SOLD
TILL ITS SEVEN
YEARS OLD

</div>

the first and third lines being in white and the middle line in red on a black background. At night under the light of mercury vapour lamps the red wording became indistinguishable from the black background so that the legend read:

<div style="text-align:center">

NOT A DROP IS SOLD

YEARS OLD

</div>

The bright yellow sodium vapour lighting is even worse in its effects on colours, because, as shown by Plate 2 (top), there are no violet, blue, green, orange or red rays in this lighting, and thus all objects lit by it must appear yellow, dull brown or black.

The principal colour changes produced by mercury vapour and sodium vapour illumination are indicated in the following table, reproduced by the courtesy of the Director of the Research Association for the Paper and Board, Printing and Packaging Industries (P.I.R.A.).

Dim viewing conditions may also cause upsetting changes of colour; thus a surface which appears a bright saturated red by daylight becomes a dark desaturated red at twilight and practically grey or black by moonlight. See p. 63.

It is evident from these facts that the colours for posters and other display material should be selected with considerable care by their designers to ensure that they are not unhappily changed by the forms of

Colour in daylight	As seen under sodium vapour	As seen under mercury vapour
Blue	Dark brown or black	Deep violet
White	Light yellow	Bluish white
Green	Brownish yellow	Deeper green
Yellow	Yellow	Greenish yellow
Black	Black	Black
Orange	Brown	Brown
Light red	Yellowish brown	Brown
Brown	Brown	Grey
Red	Brown	Dark brown or black

artificial or even natural lighting which differ appreciably from normal daylight. Because the spectral composition (spectral energy distribution) of artificial light usually differs from that of daylight, the colour rendering properties of the illumination are important in shops selling draperies, cosmetics, wallpapers and paints, meat and other foodstuffs, and, likewise, in cafeteria, to make the food look attractive. It is also obvious that for the judging and matching of colours the type of illumination employed is most important, good daylight being generally desirable.

COLOUR MATCHING

The human—especially the feminine—eye is outstandingly sensitive to small differences when direct comparisons are made between two or more coloured materials, but it is liable to surprisingly large errors when the materials cannot be brought together and reliance has to be placed on memory. It follows that whenever colours are to be carefully matched the materials or samples should be placed side by side and, for reasons connected with simultaneous contrast explained on p. 67, in direct contact with each other.

For the purpose of the examination and matching of coloured materials, the premises should be chosen with care so that generous window space is available and the room decorated preferably in light neutral tones. The windows behind which the actual matching is done should face north, because the diffused north light is more constant in character than direct sunlight, which may vary with the time of day and other conditions (see p. 46, Colours of the Sky). During periods of the year when deficiency of daylight makes it inadvisable to depend on it,

fluorescent Artificial Daylight lamps, BS 950, (see p. 50) are very satisfactory, or daylight glass or gelatin filters, for example, blue Chance glass OB8 or Corning 5900 or Wratten gelatin filter No. 78, may be used to correct the more common, yellowish, forms of artificial lighting. Note that these light filters, which are placed, of course, between the lamp and the materials to be illuminated, are bluish and function by restricting, through absorption, the red, orange and yellow rays from the light source, though they also reduce the overall intensity of the illumination. Dim lighting should be avoided for any form of colour examination. It is usually recommended that the illumination should meet the materials being inspected at an angle of 45°, the materials being viewed at right angles. In some cases, particularly with textured surfaces like cloth, however, it is helpful to view and illuminate the specimens at various angles.

It sometimes happens that two coloured materials, such as dyed fabrics or prints from apparently similar inks, will match under one form of lighting but not under another. Such materials are said to give a *metameric match*. Specific examples among materials are not common because they are usually undesirable with manufactured products, so a simple comparison between two lamps may serve to explain the phenomenon. An ordinary tungsten filament bulb can be painted with a yellow lacquer so that the light emitted appears to be a good visual match for a sodium vapour lamp. The yellow lacquer will, however, transmit red, orange, yellow and green light (p. 22) compared with the almost pure yellow radiated by the sodium vapour. The illuminations from the two lamps, that is, the two stimuli, are spectrally different and consequently have different colour rendering properties, yet they are visually identical. They constitute what is known as a *metameric pair*.

A textile coloured with one set of dyes may match in daylight another dyed with a different set of dyes but, due to different spectral reflections, the two fabrics may be a serious mismatch in artificial light. For example, some greenish dyes, while reflecting light mainly in the green region of the spectrum also reflect appreciably in the far red, yet they may give dyed fabrics which are metameric pairs in daylight with fabrics coloured with more normal green dyes. Under yellowish tungsten filament lighting, however, the colour of the first-mentioned fabrics will tend to change to brown while the others remain green. See Plate 17. The spectral reflections and absorptions of the pigments used on an artist's painting will, in general, differ from those of his subject, and such inherent metamerism in daylight may lead to some disappointment under certain forms of artificial lighting. Due to their different compositions, pigments matched against dyes are likely to be metameric, sometimes highly so, and consequently metamerism may be important when matching the colours of different materials such as plastics with cloth or

leather. There are degrees of metamerism and the greater it is the more susceptible the matching becomes to differences in colour vision between individuals.

When a metameric match is suspected between two substances, it is obviously advisable to compare them under various types of illumination and especially under lighting similar to that in which the substances are to be used if this differs from daylight. Colour matching cabinets fitted with both fluorescent and tungsten filament lamps, which may be used together and independently, are available and very useful for this purpose.

Another factor is important in the matching of materials like paints and printing inks which are normally used upon a base, such as an undercoating or paper, and that is the character of this base. Surface coatings are more or less transparent and consequently paints, printing inks, etc., function to some extent as filters—double filters really, because some light first passes through the coating to be reflected from the base, then passes a second time through the coating to reach the eye. It follows that the nature of the light reflected from the base will affect the apparent colour of the coating. The matching of such coatings should, therefore, always be done upon panels or paper stocks which are the same as, or correspond as closely as possible to, the actual materials to which the coatings will be applied in use. Patterns and test panels as large as practicable are recommended, to avoid variations which may easily be obtained when dealing with tabs of one inch square or smaller. It would seem that for good colour discrimination the light reflected from the sample should fill the eye as completely as possible.

Further factors involved in colour matching are mentioned on p. 58 (Colour Blindness), p. 65, (Colour Fatigue), and p. 67 (Simultaneous Contrast).

To summarize this chapter, the colour of an object depends on (i) the spectral energy distribution of the illumination, (ii) the spectral characteristics of the material as regards absorption, reflection, transmission. These are physical factors. The colour that is seen also depends, as explained more fully in following chapters, on (iii) the sensitivity of the observer's eyes, and (iv) the conditions under which the object is viewed. These involve physiological and psychological qualities.

SPECIAL CASES

COMPLEMENTARY COLOURS

THIS IS A CONVENIENT TERM often used, but often only vaguely understood, to express the relationship between two colours which are 'opposite', yet it has a precise meaning. Two colours are complementary, one to the other, when between them the whole spectrum of white light is completed or covered in one of two possible ways according to whether coloured lights or coloured materials are under consideration.

Two coloured beams of light are complementary when together, according to the meaning of the word, they complete the spectrum, that is, the two beams, when combined, will reform white light. For example, a compound and apparently red beam, which actually consisted of red and orange light, would be complementary to a compound greenish-blue beam composed of a mixture of yellow, green, blue and violet light. Clearly, white light is reconstituted if these two beams are blended with each other. Similarly, a purple or magenta beam, made up of red, orange, blue and violet lights, would be complementary to a green beam containing yellow and green light.

For reasons concerned with colour vision (Chapter 4) light that is visually white can be produced by mixing pairs of pure monochromatic beams of carefully selected wavelengths, and the members of these pairs are regarded as complementary. Yellow light of wavelength 570 nm mixed with blue of 436 nm gives white. This yellow is therefore complementary to the blue. Likewise, a cyan-blue light of wavelength 494 nm is complementary to a red ray of 700 nm because their mixture looks white. Such examples are rather academic, however, since monochromatic light does not occur naturally, but they may help to elucidate some of the features of colour vision.

The conception of complementary coloured *materials* is not quite so simple, because of the absorption of light by materials. The total light reflected (or transmitted) between two such substances will cover the

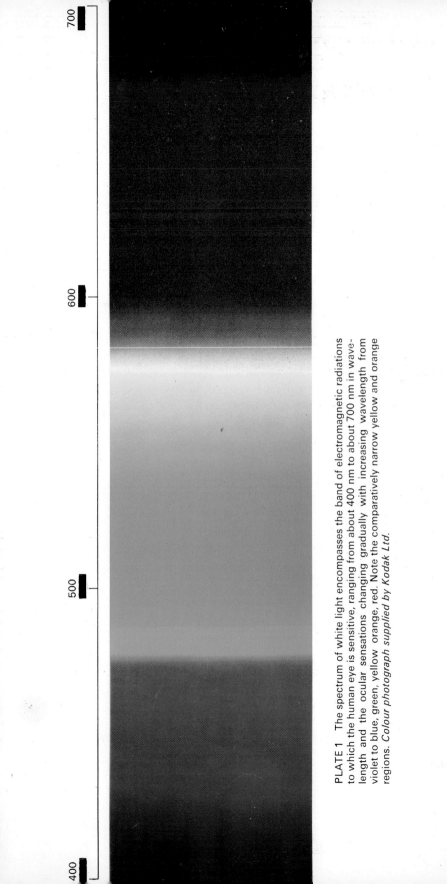

PLATE 1 The spectrum of white light encompasses the band of electromagnetic radiations to which the human eye is sensitive, ranging from about 400 nm to about 700 nm in wavelength and the ocular sensations changing gradually with increasing wavelength from violet to blue, green, yellow orange, red. Note the comparatively narrow yellow and orange regions. *Colour photograph supplied by Kodak Ltd.*

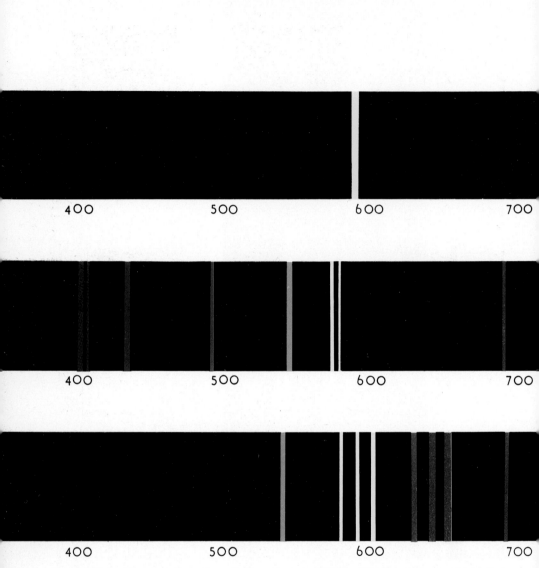

PLATE 2 **Line Spectra** *Top* Sodium Vapour. *Middle* Mercury Vapour, which also has many lines in the ultra-violet region of wavelengths below 400 nm. *Bottom* Neon, which has other prominent lines in the far red at wavelengths of 717 and 724 nm.

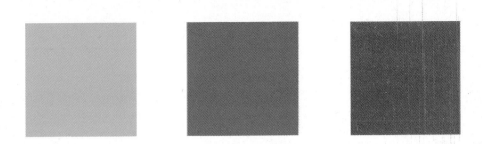

PLATE 3 **HUE** indicates the character or kind of a colour, that is, red, green, blue, yellow, orange, etc.

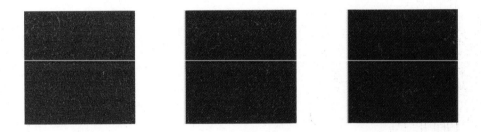

PLATE 4 **LIGHTNESS** indicates the brightness or, under the same conditions of comparative observation, the luminosity of a colour, as distinguished from dullness or darkness. The general terms 'shade' and sometimes 'tone' imply a colour of low lightness, often made so by the addition of grey or black.

PLATE 5 **SATURATION** indicates the strength, richness or purity of a colour. The general terms 'tint' and 'tone' usually imply a desaturated colour, often by the addition of white.

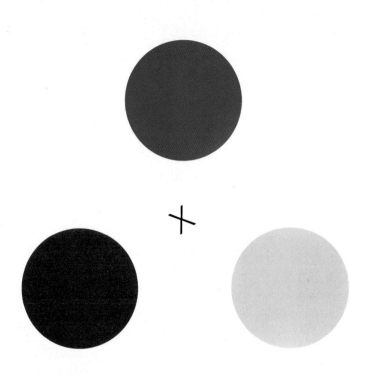

PLATE 6 **Colour fatigue or successive contrast.** After gazing steadily at the cross between the coloured discs for about two minutes and then viewing the white paper along-side, discs respectively complementary in colour to those printed will be seen, the complementary colours being tinted by the white of the paper.

PLATE 7 The contrast of complementary colours when viewed side by side is heightened by fatigue of the colour receptors in the eye. Due to the clash of the colours in this example, the edges of the letters may seem to vibrate. The high visibility of complementary colours against each other is increased if one of them is darkened.

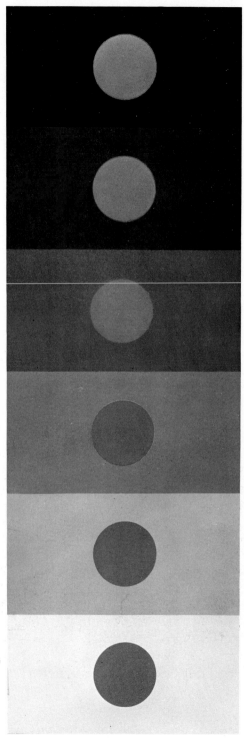

PLATE 8 **Simultaneous contrast of tone.** Note how the same grey spot appears lighter as the background becomes darker and vice versa. *Original prepared by Dr. G. L. Wakefield, MScTech, FRPS, FIIP.*

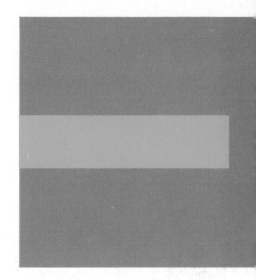

(a)

PLATE 9 **Tonal contrast in colour.** The panels are the same green in both (a) and (b) as may be confirmed by covering up the surrounds of the two panels.

(a)

PLATE 10 **Simultaneous contrast of hue.** As with Plate 9, the two panels are the same green. In (a) the panel tends to look yellowish-green and bluish-green in (b).

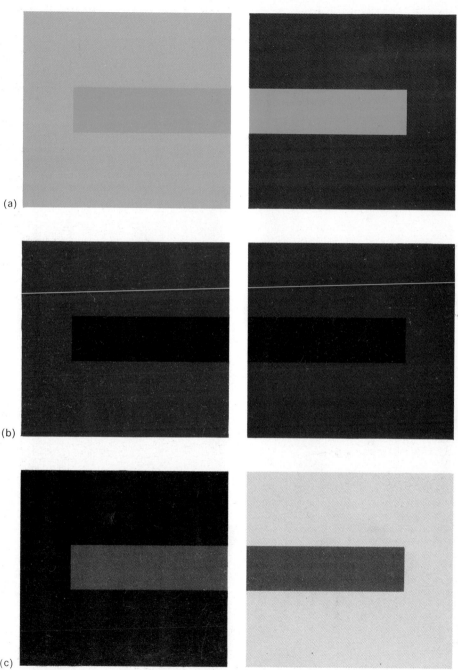

PLATE 11 Other examples of apparent colour or tonal change produced by juxtaposition. In (a) the same blue-green panel looks bluer against the green surround and greener against violet. In (b) the same purple appears bluer on the red ground and redder on the violet. The same orange on the panels of (c) looks lighter against the dark surround and deeper against the pale background.

PLATE 12. **The approach of colours in rather fine patterns.** If the illustration is viewed from a distance of 2 to 3 metres, or if the page is tilted so that the line of sight is across the stripes, the small coloured panels appear more like the nearest stripes. The effect is probably due to a combination of light spreading and scattering in the eye, of the chromatic aberration of the optic lens and of eye movements. (*Diagram*

spectrum, but one complementary substance will absorb the light which the other reflects. For instance, a yellow dye, transmitting red, orange, yellow and green light and absorbing blue and violet light, would be complementary to a bluish-violet dye which transmitted blue and violet light and absorbed green, yellow, orange and red light. If such pairs of materials are mixed or superimposed then all the components of white light are absorbed and the result, due to the complete removal of light, is blackness.

In practice, because of the incomplete reflection (or transmission) and the incomplete absorption of light by materials, it is extremely difficult to find two substances which are exactly complementary in colour to one another. In the example cited above it would be hard to find a bluish-violet dye which did not transmit an appreciable amount of green light in addition to the blue and violet, nor would the yellow and violet dyes be accurately balanced with regard to the relative proportions of coloured rays transmitted and absorbed, as the violet dye would not transmit all the blue and violet light and would not match the yellow dye for brightness, etc.

Nevertheless, the term is convenient if the reservation is borne in mind that it is commonly employed in a rather loose manner. The magenta coloured ink used in three- and four-colour printing is usually stated to be complementary to the green colour-separation filter by means of which the magenta printing plate is made, but, as reference to Plates 20 (Madder Lake) and 23 (Green Filter) will show, such materials are only approximately complementary. In fact, the general relationship between each of the three colour-separation filters and the respective dyes or pigments used to produce the final print in trichromatic colour reproduction processes, is conveniently expressed by briefly describing the dyes or pigments as being complementary to the filters (vide Subtractive Reproduction Methods, Chapter 8).

Because of the reference, particularly in colour physics, to complementary monochromatic radiations although, together, they by no means complete the spectrum, it is advisable to distinguish between (a) complementary colours (lights) as pairs which produce the sensation of white when mixed, and (b) complementary colourants (materials) as pairs that produce black when combined, in this case by the absorption of all the spectral radiations. So far as coloured substances are concerned, it may be considered that the light reflected or transmitted by a material is complementary to the light absorbed by it.

COLOUR CONTRAST

Since one complementary coloured substance reflects those spectrum

constituents which the other does not reflect, such substances usually possess maximum contrast for the colours concerned. The conception of complementary colours therefore supplies a useful working rule for the selection of colours when contrast is required. Hence a yellowish-green contrasts well against purple, or orange on blue, etc. In the extreme case, black is, of course, complementary to white. With colours, the contrast is greatest when the complements are of equal lightness (intensity) or 'tone value'; indeed, the contrast of two really bright, saturated, complementary colours is usually glaring, see Plate 7. Or, if it is desired to make a colour appear more intense, then contrast it with a complementary coloured background preferably on the dark side, as the artist often does. The difference between two colours placed together is enhanced by the effect of simultaneous contrast in colour vision (p. 67).

METALLIC REFLECTION

The bright reflection from polished metals is so characteristic that it is termed 'metallic lustre' and it has received special attention by a number of investigators. This lustre is often the means by which we recognize that an object consists of metal. It is not limited to metals however. Polished graphite, certain sulphides such as galena, several dyes in the solid state, for example, fuchsin, indigo and malachite green, the scales of beetles and the plumage of some birds exhibit a metallic shine or lustre.

It is generally accepted that metallic lustre is produced when all the light reflected from a substance comes from the surface with no appreciable reflection from beneath the surface. Probably such bright surface reflection is most readily obtained from metals because of their high opacities and high reflecting powers. Thin films of metal, for example, gold leaf and 'silver' (aluminium) foil are extremely opaque. Metallic lustre has been imitated by polishing the surfaces of sufficiently opaque materials. Non-metallic or vitreous lustre is the effect produced when part of the light is reflected from beneath the surface, as with mother-of-pearl and precious stones.

Moreover, the full effect of metallic lustre is obtained when the actual reflecting surface is easily seen. Hence a perfect mirror does not look metallic, but it does so if scratched so that one can see the reflecting surface. Likewise, a highly reflecting crystalline or hammered surface looks more metallic than one which is smooth. An air bubble in water can look metallic because of the total reflection of the light from the surface of it, the curvature of the bubble making it easy to see the surface.

Metallic lustre differs from the gloss or shine of most ordinary surfaces (p. 8) in that it is coloured, that is, the reflection from metals is tinted, if not strongly coloured as from gold and copper. For example,

aluminium, tin and zinc are bluish-white metals, aluminium being bluer than zinc. By comparison, the regularly or specularly reflected light from other shiny materials is quite white. This feature of metallic lustre is sufficiently characteristic to justify a rather more detailed explanation. It can be shown that most of the light falling on a polished metal surface is reflected directly according to the well-known and comparatively simple laws of reflection, and, as already stated, this light is coloured to some extent, that is, the high specular reflection is colour selective. With other glossy surfaces, however, which do not exhibit metallic lustre, the light *specularly* reflected is white (vide General Property of Materials (d), p. 24) and, if the surface is coloured, this is caused by the so-called *diffusely* reflected light, that is, the light which is scattered and diffused in all directions by the particles in the surface, a portion of this light becoming absorbed in the process and the remaining reflected portion being coloured as a consequence. The peculiarity of metallic lustre, which cannot be directly reproduced by oil or water colour paints, taxes the ingenuity of a competent artist to suggest the lustre in a painting and the same difficulty applies to some other methods of colour reproduction.

This subject of gloss and metallic reflection is discussed very fully and comprehensively by Dr. V. G. W. Harrison in 'Definition and Measurement of Gloss', 1945, (Printing and Allied Trades Research Association now Research Association for the Paper and Board, Printing and Packaging Industries).

BRONZING

The phenomenon termed 'bronzing' is shown by certain inks, paints and enamels. It is somewhat similar to the shot effect in textiles although this is produced deliberately and quite differently by weaving with warp threads of one colour and weft threads of another, so that the fabric changes colour when viewed from different angles. Bronzing is produced by a metallic lustre from the layer of pigment or dye in the film of ink or paint. It consists of the strong and direct *surface* reflection of a fairly narrow band of wavelengths giving rise to a characteristic coloured glare or metallic reflection at oblique angles, the principal colour of the material being produced, as usual, by the diffusely reflected light. Several blue pigments exhibit a reddish-purple or copper-like bronze, bronze blue being an example well-known to printers, and it seems that these materials have led to the name 'bronzing' for the general effect. Bronze blue in a printed ink film is dark blue when viewed at right angles but obliquely it has a pronounced reddish or bronze-like metallic sheen.

The pigment Chinese blue in an ink or paint film shows a green sheen. Some red pigments exhibit a yellowish bronze.

The colour of bronzing may be explained as follows. Matt surfaces are depicted on p. 10 and Fig. 1.3 as being due to the diffuse reflection of light from the surface irregularities, although these may be too small to be perceived by the unaided eye, and it has been mentioned that some matt surfaces exhibit sheen, due to specular reflection, when viewed at almost grazing angles. If the surface irregularities are small compared with the wavelength of the radiation falling on the surface, some regular specular reflection occurs which increases with the wavelength and the angle of incidence of the radiation. Consequently, a bronzing material shows a sheen colour which is different from that when viewed normally, the colour of the sheen being towards the longer wave end of the spectrum compared with the normal colour. Hence the most common bronzing colour is a golden yellow to orange-red shade. Bronzing is essentially a surface phenomenon since if the light penetrated as little as one wavelength into the material, the reflected ray would be destroyed by interference, as explained in the following section.

THE COLOURS OF THIN FILMS (INTERFERENCE COLOURS)

It is common experience that the thin films of soap bubbles and oil on water show bright colours, despite the fact that, in bulk, the soap, the water and the oil are not coloured materials.

Sir Isaac Newton observed that when a weak spectacle lens (that is, a convex lens of slight curvature and therefore low magnification) was laid on a flat glass plate there was a small black disc at the point of contact surrounded by coloured rings. These Newton's rings are caused by the very thin air film between the central areas of the lens and the glass plate. Where the air film thickness is of about the wavelength of light it produces interference between the light rays which are reflected from the lower surface of the lens and those which are reflected from the glass plate below the lens, whereby light rays of a certain wavelength reflected from the two surfaces reinforce each other whereas rays of another wavelength are thrown out of step with each other and are extinguished. This destruction of certain waves from the original white light causes the remaining reflected rays to be coloured, and the spherical surface of the lens produces concentric rings.

Likewise, two clean pieces of glass pressed firmly together will produce interference colours from the thin air layer between them and Newton's rings are a familiar nuisance when a colour photograph (transparency) is mounted between two sheets of glass (cover glasses) for projection. The

smoother the surfaces pressed together, the more regular the colour patterns become.

The colours of very thin oil and soap films are produced in the same way through interference between the light waves reflected from the two surfaces of the films. If a particular place on a soap bubble is of the right thickness to 'interfere' with, say, violet light this will be destroyed, but none of the other waves of ordinary white light will be extinguished, though some will be partially. Accordingly, the reflected light contains all the rays of the spectrum except violet and will appear greenish yellow. If in another part of the bubble the green rays are cancelled leaving the red and blue rays, the soap film at this point will have a purple colour. Since a soap bubble varies in thickness, every coloured ray will have some place where it is extinguished by interference and so every possible complementary colour appears somewhere on the bubble. The colours vary continuously because the thickness changes due to the effects of evaporation of the water from the film into the air and of gravity tending to draw the soap solution towards the lower parts of the bubble.

The colours of mother-of-pearl are produced by interference from very thin layers of calcium carbonate (marble) on the inside of the oyster shell. The brilliant colours of the peacock's tail, the dragon-fly's and other insects' wings and even of beetles are further examples of interference effects. No coloured materials are present: the peacock's tail breaks up white light to get its colours!

The principle of interference is best explained by reference to Figs. 3.1 (a), (b), (c) and (d). Light will be reflected from both surfaces, top and bottom, of a thin film, and, if it is thin enough, the troughs of certain light waves reflected from one surface will coincide with the crests of similar light waves reflected from the other surface. As light waves move across the direction in which the light is travelling, the waves under consideration will be moving in opposite directions, the wave motion from one surface being upwards or to the left when it is downwards or to the right from the other surface. Since these troughs and crests are really maxima and minima of electro-magnetic force, they cancel each other out, that is, the waves are extinguished. Those light waves which are reflected so that the crests of the waves from one surface of the film coincide with the crests of the waves from the other surface, thus continuing in step with one another, will not be interfered with. In fact, these rays will be reflected at increased strength or intensity, because the energy from the extinguished rays is transferred to those which do not suffer interference. The fundamental law of the conservation of energy tells us that energy cannot be destroyed, and when interference occurs none of the energy in the incident light beam is destroyed, it is merely redistributed in the interference pattern.

Figs. 3.1 (a) and (c) show in simplified form that when a film of

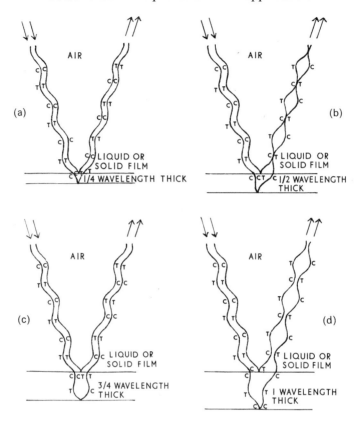

Fig. 3.1 **The principle of interference in a simple form.** Diagrams (a) and (c) illustrate how two light waves are reflected in phase, and are therefore reinforced by each other, from the outer and inner surfaces of films $\frac{1}{4}$ and $\frac{3}{4}$ wavelengths thick. Diagrams (b) and (d) show how two waves are reflected out of phase, and are thereby extinguished, from the surfaces of films $\frac{1}{2}$ and 1 wavelength thick. C indicates the crests and T the troughs of the waves.

transparent material is $\frac{1}{4}$ or $\frac{3}{4}$ or $1\frac{1}{4}$ wavelengths thick, the troughs and crests of the respective waves reflected from the two surfaces will reinforce one another, giving a bright reflection. If, as in Figs. 3.1 (b) and (d), the surfaces are $\frac{1}{2}$, 1, $1\frac{1}{2}$ or a whole number of wavelengths apart, the troughs of the light of this wavelength thrown back from one surface will oppose the crests of the similar light waves from the other surface, so that none of this light will be reflected. For film thicknesses of fractions of a wavelength, like $2\frac{3}{8}$ wavelengths, the light will be partly reflected and partly not. Note that when light is reflected as in most cases from a denser medium such as glass, water, oil, metal, etc., back into air, a

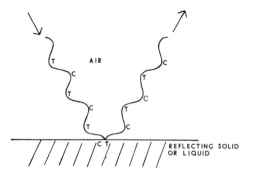

Fig. 3.2 Illustration of the change of phase, e.g. from trough to crest, that occurs when light waves travelling through a less dense medium, e.g. air, are reflected from the surface of a denser medium, e.g. water, oil, glass, metal. C indicates the crests and T the troughs of the wave.

change of phase occurs, whereby the troughs become crests and vice versa, as shown diagrammatically in Fig. 3.2.

Let us consider white light incident on a thin film the thickness of which is one quarter of the wavelength of red light that we will take to be 720 nm, so the film thickness is 180 nm. Light rays reflected from the lower surface pass twice, inwards and outwards, through the film, a distance of 360 nm assuming no refraction takes place, before meeting the rays reflected from the upper surface. As this distance is half the wavelength of red light the red rays in the white beam will be reflected from the two film surfaces in phase with, and therefore reinforcing, one another, since the rays reflected from the upper surface undergo a change of phase while those reflected from the lower surface do not because they are internally reflected. But for barely visible violet rays of wavelength 360 nm, the difference in the distance travelled between the rays reflected from the two surfaces will be equal to the whole wavelength and they will be in opposite phases thus neutralizing each other. Further calculation would show that the intensities of the reflections from the film vary with the wavelength of the light and hence the coloured effects produced from the white light, of which red would be the strongest in this example. We have ignored the refraction of the rays on passing in and out of the film, the extent of which depends upon the nature of the film (its refractive index) and of the materials (air, glass, water, etc.) in contact with the two surfaces of it, and upon the wavelength of each ray, refraction being a factor that has an influence on interference effects because it affects the length of the light path within the film.

Interference colours are different in character from those produced by selective absorption. A coloured ray produced by interference will

retain the full amount of light of the colour concerned that was present in the original white light, intensified by the transfer of energy from the extinction of rays of other colours. For example, a green will be obtained from the intensified amount of that green light which was present in the original illumination, whereas green materials absorb some green light as stated on p. 23, which is lost as heat. Interference colours are therefore brilliant.

APPLICATIONS OF INTERFERENCE EFFECTS

The phenomena of interference are useful for a variety of purposes. Because the thinnest film that causes interference is half a wavelength thick, Newton's rings, which are easily measured under a microscope, provide a way of measuring the wavelength of light. Conversely, by using light of known wavelength the thickness of thin transparent films may be measured, if the refractive index for a given film is also known. Interference effects are employed for gauging small distances and examining the smoothness or flatness of surfaces in many precision tool and optical workshops. Further, by observing the Newton's rings produced between two glass lenses their respective curvatures may be tested.

Dichroic mirrors that reflect certain coloured rays and transmit others with virtually no loss of light are examples of the interference principle, unlike the dichroism described in Chapter 2, p. 28, which is produced by varying the thickness or concentrations of a coloured material having different absorptivities around two different wavelengths. It has long been known that a very thin layer of gold transmits green light and reflects red and blue. Extremely thin films of silver or aluminium transmit blue and reflect red light. One of the first practical applications of metallic dichroic mirrors was in 'one-shot' cameras, p. 183, for colour photography, such mirrors being used to separate the light from the camera lens into two or more coloured beams. Colour television cameras, p. 156, are 'one-shot' electronic cameras, the requirements for which in the last twenty-five years have led to the production of dichroic mirrors having almost any desired transmission and reflection through inter-ference. The perfecting of techniques for the vacuum-deposition of very thin films of many different materials has made it possible to supply coatings of virtually any required thickness and with layers of different substances possessing different optical properties on top of one another. Zinc sulphide and cryolite are among the substances employed for the layers. Such films are finding increasing use as interference colour filters in instruments as they can be made to transmit quite narrow spectrum bands around any chosen wavelength.

The cancellation of light by interference is made use of in the production of lenses for cameras, binoculars and modern optical instruments by the process of surface coating known as '*blooming*'. Photographers will be aware that a camera lens has a purple-tinted 'bloom' which requires care in cleaning the lens. This is an extremely thin layer of transparent material, for example, calcium or magnesium fluoride, deposited on to the surface, the film generally being only a fraction of a wavelength in thickness. The purpose is to reduce the reflection of light from each air-glass surface in the camera lens system and from inside the lens barrel. These scattered reflections, called 'flare', are undesirable because they affect the image, sometimes causing serious difficulty, and they constitute a loss of light that should be transmitted. Since energy is indestructible, the decrease of the stray reflections carries with it a corresponding increase of transmitted light. The reason for the purplish hue of the lens coating, when viewed by reflected light, is that the wavelength usually chosen for interference is near the middle of the visible spectrum (green), thereby giving somewhat larger reflection of red and blue light.

A very useful arrangement based on interference is the *diffraction grating*, which is often substituted for the prism for the projection of spectra (see p. 11). The fine apertures between the numerous lines of the grating are not so narrow as to stop visible light waves, but they are narrow enough to deflect these waves out of their original direction of travel and interference occurs as the waves spread out after passing through the slits. Clearly, the shorter the wavelength the more easily the light waves pass through the narrow apertures, so that the shorter waves, that is, the violet and blue rays, are less deflected than the longer yellow and red waves. Due to the rays of different wavelengths being deflected through different angles they appear as a spectrum. This is a simplified description of the operation of a grating, the diffraction pattern being complex. When a bright source of light is viewed through a diffraction grating, a white central band or image is seen flanked on each side by a series of spectra, the length of the spectra increasing as one looks outward from the centre. Normally, one of the inner spectra is selected for use. A spectrum produced through a grating has certain advantages, mentioned on p. 11, compared with that obtained through a prism.

A particularly elegant and exact but, unfortunately, uncommercial *method of colour photography* founded on interference was devised by Professor Gabriel Lippmann, a French physicist, in 1891 and used by later workers. A specially prepared photographic emulsion of extremely fine grain backed with a layer of mercury was exposed in a camera. The mercury surface acted as a mirror so that the reflected and oncoming light waves travelling in opposite directions within the emulsion interfered

with one another. As a result, on development, fine parallel layers of silver were obtained, unlike an ordinary photographic film which contains silver particles distributed throughout the emulsion after development. The distance between the layers at any one part of the emulsion was a constant fraction of the wavelength of the light responsible for the exposure in that part, the layers therefore being more widely spaced for red light than green and for green more than blue, etc.

When the developed plate is viewed by reflected light a coloured positive image is seen, for the silver layers strongly reflect light whose wavelength relates appropriately to the distance between the layers and little or no light of other wavelengths. Thus colours are produced dependent on the spacing of the layers resulting from the original exposure and exact colour reproduction is obtained. The method cannot be widely used because the necessary extremely fine-grain silver emulsion is very slow, requiring an exposure of several minutes in bright sunlight, and the mercury layer is an inconvenience. Also, the angle of viewing by reflection is critical and duplicates cannot be made.

COLOURS OF THE SKY (LIGHT SCATTERING)

The sky gives out light because the sun's rays are scattered by minute particles of dust, water droplets, and even, to some extent, the air molecules. If there were no air, vapour or dust, we should see a black sky with the sun as a sharp circular disc of blinding light, for the light would all come from the sun and none from the sky. The sky is black on the moon, which has no atmosphere, as the astronauts have proved. Long waves may travel round comparatively small obstacles whereas shorter waves are more likely to collide with them. For this reason and because, as stated on p. 11, light of shorter wavelength (blue) is

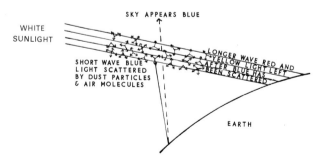

Fig. 3.3 Illustrating why the sky overhead is blue and dawn and sunset are red and yellow.

refracted more than the longer waves (red), it may be expected that fine particles will reflect and refract, that is, scatter blue light more than red. The scientific explanation of the scattering of light by extremely small particles is more complex, but it confirms that short waves are deflected by such scattering much more than long waves. Hence, from sunlight passing *across* the sky, the blue rays are scattered towards the Earth and give the sky its blue appearance, as indicated in Fig. 3.3. For a similar reason tobacco smoke has a bluish colour and water in which there is fine suspension, for example, of chalk particles, looks blue.

On the other hand, when sunlight which is travelling directly towards the Earth has to pass through a considerable thickness of air as at sunrise or sunset, or through air loaded with fine particles as in misty or smoky conditions, then the shorter rays are lost by scattering, so that only the yellow, orange, or merely the red rays actually penetrate to the Earth.

In addition to scattering, there may also be some absorption by clouds of different thicknesses composed of water vapour, water droplets and, perhaps, even ice crystals. Thin clouds may be lit by long rays from the setting sun and, if they are sufficiently transparent for the sky to be seen through them, their reddish colours may be modified to give beautiful crimsons and purples. Thus the beauty of the sunset has a relatively simple physical explanation.

Since the long red rays are least scattered, they should have the best fog-piercing powers—a theory which explains the purpose of orange or yellow fog-lamps on cars and of red neon lamps on aerodromes. Unfortunately, it is doubtful whether yellow fog lamps are of any real use to motorists, as the droplets of water in fog are mostly too large to produce selective scattering.

THE RAINBOW

The rainbow is not produced by quite the same scattering as that responsible for the colours of a sunset, but rather by refraction and reflection from the larger particles which constitute raindrops. A rainbow is only seen when the sun is fairly low in the sky and behind the observer. A brilliant 'artificial' rainbow can be seen in the spray of water from a garden sprinkler if the sun be shining behind the viewer.

When a ray of sunlight enters a drop of rain at a certain angle, it will be reflected by the back surface of the drop and emerge as shown in Fig. 3.4. The two refractions which occur when the ray enters and leaves the raindrop produce an appreciable separation of the red, blue and other coloured rays, the result being a spectrum. One of these rays will reach the eye of the observer, but not the other coloured rays since the separated

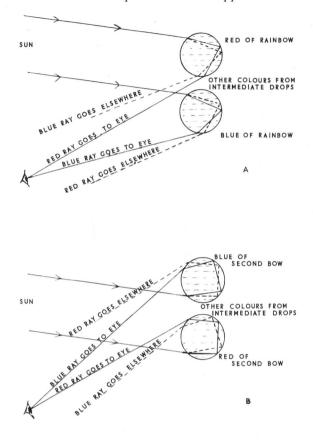

Fig. 3.4 How rainbows are produced by the refraction and reflection of sunlight within raindrops, each drop at a given instant contributing one particular colour to the bow seen by any one person. *Top* The main rainbow is produced by single reflections within raindrops, the higher drops contributing the red and the lower ones the blue and violet, with other colours from the drops between. *Bottom* The secondary rainbow is due to double reflections, which lead the colours to appear in the reverse order to an observer, red inside and violet outside. Loss of light from the two reflections causes the secondary bow to be less bright than (a).

rays are yards apart when they get as far as the ground. In fact, each drop contributes a particular colour to the rainbow seen by the observer according to the height of the drops, the lowest drops supplying the violet and blue and the highest drops the red, as shown in Fig. 3.4 (a). The diagram also indicates that if two observers at a distance from each other see a rainbow at the same time, they do not actually see the same arc.

The double rainbow often seen, in which the secondary bow is outside the first, is caused by double reflections within some raindrops,

as shown in Fig. 3.4 (b). Due to this double reflection, the secondary bow is not as bright as the first and the colours are in the opposite order, that is, red inside and violet outside, compared with the first bow having red outside and violet inside.

Why is the rainbow an arc? The colours will be seen only where the sun is at such an angle that the raindrops and the observer make the correct angle for the reflection of the sun's rays. It can be calculated from the laws of refraction and reflection that the angles between the incident sun's rays and the emergent reflected rays from the raindrops are about 42° for the principal rainbow and around 52° for the secondary bow. Considering the primary rainbow, *all* drops which make an angle of about 42° between the observer and the sun will give the coloured rays, and clearly these will lie in a circle which will be cut off at ground level. Completely circular rainbows may be seen from high cliffs or mountains. If the sun is higher than about 42° in the sky, no rainbow can be seen from the ground.

FLUORESCENCE AND APPLICATIONS

Whereas the light energy absorbed by most coloured materials reappears as heat, certain substances have the interesting property of absorbing ultra-violet 'light' and of giving out the energy in the form of visible light. Such materials are said to be fluorescent, since the mineral fluorspar was among the first materials observed to possess this property. The characteristic of *fluorescence* is the absorption by the material of short-wave rays of energy, particularly ultra-violet rays which are shorter than the visible violet rays of the spectrum, and the emission of this energy on a longer wavelength within the range of the visible spectrum. The short-wave 'light' supplies energy to the molecules of the material which they give out again as long-wave radiation. The effect is very striking when fluorescent substances are viewed in ultra-violet 'light', because this is invisible, while the light given out by the substances is coloured, usually blue-green, as with fluorspar, mineral oils, quinine, etc., but it may be red or violet, etc. with other materials. Fluorescence is readily demonstrated with a weak solution of red writing ink (eosin dye), which appears yellowish-pink by transmitted light, but which fluoresces in all directions so that, seen from the side, it appears bright green.

Fluorescence in ultra-violet 'light' finds a number of practical applications. For example, many things, between which it is otherwise difficult to differentiate, are easily distinguished in ultra-violet 'light' because they fluoresce differently. Mixtures such as margarine in butter, chicory in coffee, mineral oil in vegetable oil, or adulterants in wheat

flour can be readily detected in this way. Similarly, writing which has been erased usually leaves behind traces which will fluoresce, so that forgeries may be detected in ultra-violet rays; and blood stains also react in this way.

The modern *fluorescent lighting* uses the ultra-violet rays emitted by mercury vapour lamps to excite fluorescence in substances spread as a coating on the inner surface of the glass tube of the lamp. By the choice of suitable fluorescent substances, the blue-green light of the mercury vapour itself may be supplemented to give a total illumination which is a close approach to white daylight. A variety of such fluorescent powders, termed *phosphors* in this kind of application, has been specially developed and manufactured and these can be mixed to yield a wide range of colours. For fluorescent lamps the phosphor mixtures are selected according to the colour of the light required. Hence white, warm white, cool white and Artificial Daylight (BS 950) fluorescent lamps are available, the last-named giving a good imitation daylight.

Fluorescent lighting has various effects on the appearance of colours according to its difference from daylight, the so-called 'White' lamps tending to make dark blues and greens look brighter, cream colours yellower and reds darker than by daylight (see p. 14). The glass of the tubes for the lamps is opaque to ultra-violet so that these rays from the mercury vapour which cause the powders to fluoresce cannot escape. Fluorescent lamps have two major advantages. In the first place the colour of the light can be adjusted as explained and in the second place ultra-violet 'light' which would otherwise be wasted is converted into useful visible light thereby increasing the efficiency of the lamps. Their chief disadvantage lies in the distortions of the colours of illuminated objects which they may cause. The widespread use of fluorescent lighting has led to much study and investigation of the colour-rendering properties of light sources, a matter of considerable importance in many ways, and the Commission Internationale de l'Eclairage has recommended the adoption of a colour rendering index for the specification of these properties.

Phosphors have an essential role in *cathode ray and television tubes,* which must have a layer of suitable phosphor coated on the inside of the glass screen. In this case, however, it is the beam of electrons projected by the cathode which excites the fluorescent layer on the screen to produce light. Ordinary cathode ray and black-and-white television tubes have a uniform coating of phosphor which fluoresces white. For colour television the screen of the receiver is coated with three phosphors, one of which gives red, another green and the third blue fluorescence, these phosphors being arranged very ingeniously in the form of small dots placed in rows over the screen (see p. 162).

Everyone is now familiar with detergents which wash 'whiter than

white' and with the 'Day-Glo' colours of some advertisements. In the latter, specially manufactured *fluorescent pigments* are included in the printing inks and such pigments and dyes are being used with fabrics to intensify the colours, the ultra-violet in daylight producing the fluorescence to augment the normal reflection of coloured light.

Modern detergents incorporate colourless dye-like compounds termed *optical bleaches* which have a strong bluish-white fluorescence. Again the fairly high proportion of ultra-violet in daylight causes a garment carrying such a dye to appear distinctly whiter than it would normally and it may indeed emit slightly more white light than falls on it.

The same principle is applied in the manufacture of paper, especially photographic papers, to improve the whiteness, so that prints viewed in any light containing ultra-violet will show whiter whites and greater contrast than on old-type papers.

It has been common practice in papermaking to add a blue dye to the pulp to 'whiten' the finished paper, just as the old 'dolly-blue' was used in the washing of white clothing. But this corrects the natural yellowish colour of the material by absorbing light at the yellow and red end of the spectrum, so that the total reflection is reduced giving a degraded white, though probably the best that could previously be obtained. The application of fluorescence increases the total reflection and produces far better results.

Fluorescence has been applied to the subject of colour correction involved in the preparation of printing plates. The best pigments available for the inks employed in three- and four-colour printing processes fail to conform in certain respects to theoretical requirements. To compensate for the limitations of the inks various methods of colour correction are necessary in the preparation of the printing surfaces, in order to obtain good colour reproduction. The fluorescent method automatically reduces considerably the amount of special colour correction work normally required to be carried out on the photographic plates and/or the printing surfaces. The artist uses specially prepared fluorescent water-colour paints to produce the original copy for re-production. Put briefly, the principle of the method is that these water-colour paints fluoresce in direct proportion to the amount of colour correction otherwise required by each colour in a reproduction. For example, greens usually need the greatest amount of correction and so the green water-colour paints fluoresce most intensely. The fluorescence of the water-colours compensates for the colour correction and, there-fore, for the limitations of the printing inks. The original copy must, of course, be illuminated with ultra-violet as well as visible light during the photographic operations. The principles of colour printing processes and of colour correction are explained in Chapter 8.

In the 1939–1945 war, bombers' maps were printed with inks containing

luminescent pigments which were activated by 'black light', that is, ultra-violet, to make them visible in the dark. The maps were illuminated by invisible ultra-violet radiation.

PHOSPHORESCENCE

Phosphorescence differs from fluorescence in that the emission of light continues after the stimulating external radiation has been cut off, whereas fluorescence ceases when exposure to the beam of ultra-violet or other radiation ceases. Hence phosphorescent materials glow in the dark, the absorbed energy from previous exposure to light being stored, in a way not yet thoroughly understood, and gradually re-emitted afterwards on a longer wavelength.

Phosphorescence is shown by phosphorus (hence the name), some diamonds, calcium fluoride, and the impure sulphides of zinc, calcium, barium and strontium, these sulphides being used in luminous paints and printing inks. The impurities in most phosphorescent materials appear to play an important part in the phenomenon. Phosphorescence is often coloured, for example, white phosphorus emits a greenish glow and calcium sulphide a pale violet. With most materials the emission slowly dies out if they are kept in the dark, presumably as the stored energy is exhausted.

Fire-flies, glow-worms, fish and decaying wood are well known to shine in the dark, but this is not strictly phosphorescence; it is 'chemi-luminescence', light being emitted as the result of some chemical reaction.

COLOUR VISION

IT HAS BEEN STATED on p. 7 that colours are the sensations produced in the eye by light of particular wavelengths. For this reason, consideration must be given to the facts and theories of colour vision. An understanding of the whole subject of colour is particularly difficult mainly because of the complexities of colour vision, several of the facts of which still await an exact explanation.

THE EYE

The eye, the organ of sight, is capable of detecting at least three properties of light:

(a) the direction from which the light has come, whereby we distinguish shape or form, size and texture;
(b) the amount or intensity of light, which leads to the perception of contrast between, say, an object and its background;
(c) the quality or wavelength of light, that is, the perception of colour.

Fig. 4.1 shows a cross section of the eye from front to back, with the chief components indicated. The coloured part of the eye is the ring-shaped iris which expands or contracts involuntarily with the dimness or brightness of the illumination to expose more or less of the inner lens, that is, the dark central pupil. The back of the iris is black. There is very little pigment in the iris of a blue-eyed person whose eye colour is believed to be due partly to the black showing through and partly to light scattering in the iris. As more and more pigment is formed in the iris the eye tends to become hazel or brown.

The part of the eye most directly concerned with colour vision is the retina, a thin transparent membrane of nerve tissue lining the inner wall of the eyeball, in which the conversion of light energy into nervous

energy takes place resulting in impulses to the brain producing the sensation of sight. Within the retina is a complex arrangement of interconnected layers of nerve cells and nerve fibres, and in the hindmost layer are nerve cells terminating in thin rods or slightly conical-shaped bodies which are the actual light detectors. It is interesting to note that these rods and cones are on the side of the retina distant from the light, so that to reach them the light has first to pass through the other nerve layers; no human designer would have arranged it so. Actually the retina is quite thin and fairly transparent so that light reaches the back of it almost unaltered.

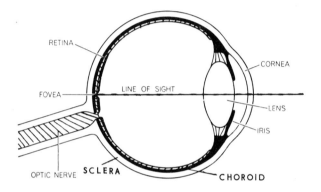

Fig. 4.1 **A horizontal section through the eye.** The regions in front of and behind the lens are filled with transparent media termed respectively the aqueous and vitreous humours. The retina contains the light receptors, the rods and cones, and is the site of the optical image focused by the lens. It has a fine complex layer structure of nerve fibres connecting the receptor cells to the optic nerve and the brain. In the choroid, a vascular membrane immediately behind the retina, there is normally a black pigment, epithelium, which absorbs unwanted light, thereby largely preventing glare. The dense packing and organisation of cones in the tiny retinal depression known as the fovea give this small central area high visual acuity and colour discrimination, the fovea being in the direct line of sight behind the lens.

It is generally believed that the first reaction in the retina is of a photo-chemical nature, that is, within the rods and cones are substances which are decomposed (bleached) by light, the decomposition products starting a train of electrical signals in the form of nerve impulses transmitted by the fibres and the optic nerve to the brain. This view is strongly supported by the fact that a light-sensitive, purple-coloured substance, 'visual purple', for which the chemical name is rhodopsin, has been extracted from the rods. These light-sensitive chemical substances within the rods and cones are continuously re-formed to make good those that have been broken down and so maintain the sensitivity

of the eye. It is assumed that the quantities of the decomposition products present in the retina at any one time are proportional to the intensity of the incident light. When the level of illumination is high, as in sunlight, very active decomposition takes place and considerable quantities of the breakdown products accumulate in spite of the process of synthesis which is proceeding all the time. As a consequence, when we go from bright lighting into a darkened room it takes a little time to get used to the lower level of illumination because this period is required for more of the light-sensitive compounds to be re-formed to enable our eyes to cope with the lower illumination.

The fovea centralis, or 'yellow spot' as it is sometimes called due to presence of a yellow pigment, is the most sensitive region of the retina and gives the best visual acuity, that is, the perception of fine detail. The highest concentration of cones is present in this region—no fewer than 100 000 it has been estimated. Beyond the central area of the fovea the cones are interspersed with rods and the proportion of rods to cones increases away from the fovea until at the edge of the retina only rods are present. It has been computed that in the retina there are about 100 million rods and 5 million cones, all of which function, of course, as an assemblage.

Where the retina is interrupted for the outlet of the optic nerve fibres there are no light receptor rods or cones, so that this is a blind spot. But we are not usually conscious of its existence because the eye is constantly on the move and so the light from any one part of an object does not fall continuously on this spot.

The rods and cones differ in function. The *rods* are the light detectors for low intensity vision; they are sensitive to faint light but do not give a distinct or sharp image nor do they perceive colour. It has been established that the colourless vision which occurs at very low levels of illumination, for instance, dim moonlight, depends on the bleaching of the visual purple contained in the rods. The *cones* only operate in good light, that is, at moderate or high intensities, but they are the organs of accurate sight and particularly of colour vision. At night, or under dim illumination, the cones do not function, being less sensitive and, over the retina as a whole, less numerous than the rods, the rods alone record the faint image so that everything is seen in a rather blurred monochrome. On the other hand, in conditions of good visibility, that is, of bright or fairly bright illumination, the rods seem to lose much of their activity, probably because their visual purple is almost bleached out, and therefore the cones play a much more important part in vision generally. There is an intermediate level of limited illumination in which both rods and cones operate simultaneously.

Exactly how the colour-sensitive cones distinguish one colour from another is difficult to determine and has been the subject of much

investigation. Ever since Thomas Young proposed the three-colour theory of vision early in the nineteenth century, it has been considered that the eye contains at least three different colour receptors. Although still uncertain, there is now reasonable evidence that in the cones are three photo-sensitive substances, one which absorbs mainly red light, another mainly green light and the third mainly blue light, and that these, like the visual purple in the rods, are decomposed or bleached by light to produce nerve signals to the brain. The sensation of colours other than red, green and blue arises from a combination of different degrees of bleaching of the three receptor substances. However, the retinal nerve fibres are so intricately interconnected as to make it unlikely that the colour information passed to the brain consists simply of three signals proportional to the absorptions of light by the three receptors. But colour vision probably depends *initially* on such absorptions of light in the red, green and blue parts of the spectrum and the probability is heightened by the success of modern methods of colour reproduction which are based on this theory.

THREE-COLOUR VISION

A well established fact of colour vision is that any given hue can be matched exactly by a mixture of three rays of light, each of about a single wavelength only, one red, another green, and the third blue. Thomas Young, an English physician who also originated the wave theory of light, put forward his well-known theory of colour vision, in 1807, to explain this phenomenon. His theory was modified about fifty years later by Helmholtz, a brilliant German physicist and physiologist, and has since been added to by other workers, but, although there are other hypotheses as to the nature of colour vision and no theory at present can completely explain all the observed facts, the Young–Helmoltz theory based on three-colour vision is the most generally accepted.

In order to distinguish between colours, the colour-sensitive cones of the retina must react differently according to the wavelength of the incident light. The three-colour theory assumes that the cones are essentially of three light-sensitive kinds, all of them sensitive to wide bands in the spectrum but most sensitive in three different regions, one kind being most sensitive to red light, the second to green light and the third to blue. When light strikes the eye each kind of cone reacts according to its sensitivity and the composition of the light, the three responses producing in the brain the complete colour sensation. For example, because the sensation of yellow can be obtained by means of a

mixture of pure red light, wavelength about 680 nm (containing no true yellow light), with pure green light, wavelength around 530 nm (likewise containing no yellow), it is reasonable to assume that the eye contains no actual yellow-sensitive cones, but that a beam of pure yellow light, wavelength about 590 nm (containing no red or green light), stimulates both the red- and green-sensitive cones thus producing a yellow sensation, there being, in this case, little or no response from the blue-sensitive cones.

The sensitivity of each kind of cone to light over broad bands of the spectrum is indicated in the first place by the fact that the wavelengths of the three coloured rays, which when combined give the sensation of white, can vary considerably; except that it is necessary to select the members of each trio as a set and individual members of one set cannot be interchanged with those of another to obtain white. The blue ray may have a wavelength of 436, 460 or even 480 nm, the corresponding green waves being of 546, 530 and 510 nm and the respective red wavelengths 700, 650 and 600 nm. There are many other combinations, the criterion by which the three beams are chosen being that no one of them is matchable by a mixture of the other two.

According to the work of Sir William Abney published as far back as 1901, the blue-sensitive cones react to light waves from 400 nm to about 560 nm, being most sensitive to waves around 460 nm; the green-sensitive cones react to wavelengths between about 460 and 650 nm, but mostly to waves around 560 nm; and the red-sensitive cones respond to light between approximately 450 and 700 nm, being most responsive to light waves of about 600 nm. Much more recent investigations have slightly lowered the wavelengths causing maximum response but have not effectively changed the figures for the bands of the spectrum to which the cones are sensitive. From these figures it will be seen that, except in the cases of the extreme violet and red, light of any particular wavelength stimulates two or all three of the colour-sensitive cones in varying degrees. See Fig. 4.2. As indicated in the previous section, p. 56, it is now confidently believed that the whole gamut of colour sensations depends upon variations in the vigour or magnitude of the responses of these red, green and blue sensitive cones (known as ρ, γ and β respectively) within the retina, the sensation of whiteness being produced when all three groups of cones are strongly activated. The nerve associations between the cones and also the rods preserve the retinal detail, or register, in the transmission of the visual image or signal to the brain.

Most systems of colour measurement are based on this belief and to a large extent it influences methods of colour reproduction, especially the so-called 'additive' processes. Three-colour vision and the conal sensitivities will be referred to again, therefore, in the following chapters which deal with the reproduction and measurement of colour. A detailed

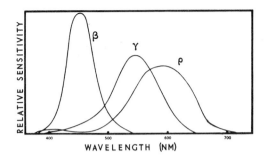

Fig. 4.2 The probable sensitivities to different parts of the spectrum of the three kinds of retinal cones or light receptors, β, γ and ρ, believed to be responsible for colour vision. As yet, the correctness of these curves remains to be established. The curves show that light of most colours stimulates more than one kind of cone, and the large amount of overlapping of the sensitivity curves accounts for fundamental difficulties in accurate colour reproduction by photography, television or printing.

yet precise account of the theory of trichromatic vision was given by J. Guild in his Traill Taylor Memorial Lecture, 1930, (The Photographic Journal, Vol. LIV, 1930, p. 22). The validity of the theory has been generally supported by more recent investigations.

DEFECTIVE COLOUR VISION (COLOUR BLINDNESS)

The exact judgement of colours, under the same conditions of illumination, depends very much upon the observer, a fact that is well known. It seems that the spectral sensitivity of the retinal cones and, perhaps, other factors, vary from individual to individual. In the majority of cases these variations are small and probably cause difficulty only in visual methods of colour matching and measurement. There is, however, a considerable proportion of individuals whose colour vision is grossly faulty. According to the 'Report on Defective Colour Vision' compiled by the Colour Group of the Physical Society, 1946, statistics show that 8% of the male population suffer from marked colour blindness while the proportion of colour-blind women is much smaller. Of the total population, between 4% and 5% possess more or less seriously abnormal colour vision. There is as yet no definite information about the cause and in the great majority of cases it is an hereditary characteristic.

There are several kinds and degrees of colour blindness, for which reason 'defective colour vision' is a far better term than 'colour blindness'. The most serious form, fortunately rare, is that in which a

person has no colour discrimination at all, his world consisting of a series of greys ranging from black to white. Those limited as much as this are called 'monochromats' and in most cases the defect seems to be due to inactivity of the retinal cones.

More commonly, to the extent of at least 30% of all colour blind persons, and still serious, an observer can distinguish between greens and blues but will confuse reds, greens and yellows. Such persons can make colour matches which are satisfactory to them by the use of two light waves only, one of short wavelength, that is, blue, and the other from some wavelength longer than the green, for example, yellow. They may be said to be 'red-green blind'. There are two main forms of this defect which are referred to as protonopia ('red blindness') and deuteranopia ('green blindness'). A few individuals, classified as tritanopes, have poor discrimination in the blue to green region and can 'match' all colours by mixtures of red and green lights, so that they are sometimes termed 'blue-yellow blind'. All these people possess dichromatic instead of the normal trichromatic vision and are therefore called 'dichromats'. Presumably the retina of the eye in these cases has only two forms of colour receptive cones or the cones may function in an abnormal way.

A somewhat less serious and less obvious abnormality is the colour vision of individuals classified as 'anomalous trichromats', who, although (like normal observers) they have trichromatic vision, that is, they require a mixture of three coloured light beams for colour matching, make 'matches' which are far from normal. The most characteristic defect with such persons is that they will match spectrum yellow with a different mixture of red and green lights (more red or more green) when compared with a normal observer.

In general, the total number of colours which colour-blind persons can recognize is always definitely smaller than the number recognizable by the normal observer, and commonly the most difficult colours to distinguish are red from yellow or yellow from green; blue-green, grey and purple also tend to be confused. There is not usually much difficulty in distinguishing green from blue, yellow from grey, or grey from blue. Monochromats, however, confuse green and blue but distinguish between red and yellow easily.

There are subsidiary aids to assist colour-blind persons to describe the colours of many objects correctly. We are taught as young children that grass is green, the sky blue, an orange is orange, a banana yellow, a tomato red, a brick reddish brown and so on, until eventually numerous objects and materials help us by association to link each colour sensation with its appropriate name. Many objects and their colours are distinguished by their lightness or luminosity and thus flowers, for instance, may be recognised by their lightness against the comparatively dark

green foliage. Such aids enable the colour-blind to distinguish the colours of well-known objects in ordinary life. They may lose something of the beauties of nature, but being unaware of the nature of the loss it is unlikely to trouble them except under unusual conditions. Surprising as it may seem, a few successful artists are colour blind! It is when the incidental aids to correct colour perception are missing that the person with defective colour vision becomes liable to make noticeable and possibly glaring errors. The colour-blind may succeed in distinguishing between red and green traffic lights when fairly close because of the positions of the lamps with the red at the top and similar clues, but when they are seen as pin-points of light in the distance, or through fog or rain, they are very liable to make a mistake.

Colour vision deficiency is an obvious handicap in any work in which colour matching is involved and, indeed, in colour work generally. In industry, the colour defective worker with coloured materials is very liable to produce unsatisfactory results, since his description of a sample may not tally with that of a normal person nor will he notice defects in colour quality so readily. Clearly, dyers, colour printers and sales-people in the drapery trades should have good colour vision. In certain industries, such as electrical engineering in which colour-coded wires are used, all branches of the transport services and in the Navy and the Air Force defective colour vision may be positively dangerous. Tests for colour vision are therefore necessary, though they are not yet as widely used as they might be.

The tests in use are, broadly speaking, either vocational in character, that is, they may be done to decide whether an individual is able to undertake certain kinds of work involving colours, or scientific for the purpose of finding the incidence and nature of the colour blindness. For vocational purposes, a trade test, in which the individual is asked to perform operations similar to those he would have to carry out in practice, is often sufficient, provided that the conditions of the test (illumination, state of specimens, etc.) are strictly similar to those of the works.

The complete diagnosis of colour blindness requires elaborate equipment, but, for most purposes, a simpler test is adequate. A common form of test makes use of confusion charts consisting of a series of cards on which a variegated pattern of coloured spots is printed, the sizes and colours of the spots being carefully chosen so as to form a figure or a letter of one colour against a background of a different colour. The normal observer can usually see the figure easily, while the colour defective may either fail to see a number or may see a different number. The well-known Ishihara Test for colour blindness published in Japan is of this kind. It consists of a set of cards and is obtainable from Kanchara Shuppan Co. Ltd., Tokyo, or H. K. Lewis & Co. Ltd. of

London. Similar examples are the Swedish Bostrom test and the American Optical HRR test. Where the recognition of coloured signal lights is important, lantern tests have been devised in which two or more apertures can be illuminated by light of different colours and brightness under laboratory-controlled conditions. These and other tests are described in the previously mentioned 'Report on Defective Colour Vision in Industry' by the Physical Society.

Fig. 4.3 **The D and H Color Rule.** It has the form of a slide rule and the ends of the two scales are shown, the scales, $14\frac{1}{2}$ in. $\times \frac{3}{4}$ in. (368 mm \times 19 mm), carrying differently numbered colour steps, each $\frac{5}{8}$ in. $\times \frac{3}{4}$ in. (16 mm \times 19 mm). The scales are adjusted until two steps appearing in the central window give the closest colour match. The similarity in colour vision of different observers may thus be tested and also the similarity in colour rendering of various kinds of illumination, the colours of the two scales being metameric.

The Davidson and Hemmendinger Color Rule, marketed by the Kollmorgen Corporation, provides a comparatively cheap and very simple means for testing the similarity of the colour vision of two or more observers or, for a single observer, the similarity of the colour rendering of various light sources. It consists of a slide rule with two colour scales of constant lightness, each scale having twenty-one differently numbered steps, one from blue to brown and the other from purple to green. See Fig. 4.3. For any observer and any light there is normally a pair of steps which approximately match. The two matching steps on the scale are strongly metameric (see p. 34) because they are coloured with very different pigments. In various phases of daylight most observers obtain a match within one or two steps of one another. Individuals with anomalous colour vision find matching steps on the two scales significantly different from those of normal observers and the match found by colour-blind persons may be four to six steps away from the average of other observers in the same light. In tungsten light the matching point is displaced fully six steps on both scales away from that in daylight.

LIGHTNESS (LUMINOSITY) AND WAVELENGTH

Since the eye is only sensitive to energy radiations between about 400 nm and 700 nm, it is, perhaps, to be expected that the eye would not be equally sensitive to all radiations within these limits. We are not considering here the colour, but the size or intensity of the visual sensation produced by a beam of light; that is, the apparent brightness of the light. It has been established that the magnitude, or intensity, of the response of the eye varies with the wavelength of the illumination. In other words, when the eye receives light waves of equal energies, or strengths, but of different wavelengths, the vigour or intensity of the sensations produced in the eye is not the same in all cases but depends upon the wavelength. Comparing light waves of equal energy, the eye is most sensitive to rays in the middle of the spectrum with a wavelength of about 550 nm, that is, green to yellow rays, and the sensitivity decreases fairly rapidly to rays in the blue-violet and red regions. Consequently, when viewing a true spectrum of white light the yellow and green bands appear to be the brightest, while the red and violet bands at the extremities fade away into darkness. If a colour television receiver tube is adjusted so that the screen appears white and the fluorescent emissions from the three phosphors (p. 50) are then viewed separately in turn, the green phosphor appears the brightest while the blue appears the least bright. Stated briefly, for a normal eye, green and yellow rays are more effective for a given energy than red and blue rays.

While this is a factor which might be expected, it introduces a complication into the study of colour which is of importance in colour measurement. This variation in the apparent brightness of light with wavelength causes the visibility of coloured materials to differ to some extent from what would be expected from a consideration of the general properties of coloured substances described in Chapter 2 and particularly the property of Lightness. For example, the comparatively low reflection of light from green materials is partially counter-balanced by the comparatively high sensitivity of the eye to green light, so that green substances may be said to look brighter than they actually are. The extent to which rays of light stimulate the eye depends partly on the energy and partly on the wavelength of the light entering the eye.

The variation of visual sensitivity with wavelength for the average eye is illustrated in Fig. 4.4. This refers to bright illumination when the maximum sensitivity, as previously stated, is approximately at a wavelength of 550 nm, presumably that of the retinal cones. A further, though less important complication is that as the intensity of illumination diminishes this maximum sensitivity shifts towards 510 nm. It appears that the retinal rods, while not being colour selective are most sensitive

to bluish-green light of the latter wavelength. The shift in the position of the brightest part of the spectrum with the level of illumination and the result it produces on vision is known as the Purkinje effect, discovered by a Czech physiologist of that name in 1825. The result is that under dim illumination the eye's sensitivity to blue as well as green light, as compared with its sensitivity to red light, is much greater than at normal levels of illumination, the most notable feature of which is the darkening of red and orange surfaces.

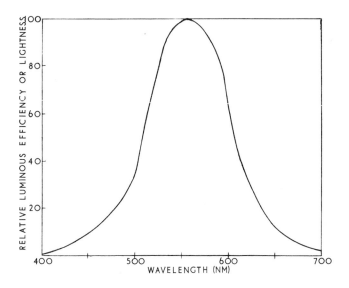

Fig. 4.4 The colour visibility or spectral sensitivity curve for the cone vision (good illumination) of a normal eye. The curve indicates the relative lightness or brightness of the various spectrum colours having equal energies at all wavelengths. The maximum sensitivity is at 555 nm. Under dim illumination the maximum, for rod vision, changes to 507 nm. The C.I.E. system (Chapter 6) is based in part on data obtained for average observers in matching an ideal white, for which the light energy is equal or constant throughout the spectrum, with a mixture of equal quantities of three primary monochromatic beams of light of wavelengths 700 nm (red) 546·1 nm (green) and 435·8 nm (blue). See p. 117. Taking the relative luminous efficiency or sensitivity for the red beam as 1·00, the green was found to be over four-and-a-half times brighter with a value of 4·59 and the blue beam had the small relative luminosity of 0·06 when measured in photometric units.

ADAPTATION OF THE EYE

The sensitivity of the eye is remarkably adaptable to the conditions of illumination with regard to both the intensity (brightness or luminance) and the colour of the illumination.

(a) Adaptation to Intensity of Illumination

In the first place, the eye accommodates itself to the brightness of the light falling on it through the automatic operation of the ring-shaped iris, the coloured part of the eye, which acts as a stop or buffer to protect the eye from intense illumination and to compensate for sudden changes in the intensity of the light. In bright light the iris contracts, the opening in it, which exposes a circle of the lens, the dark central pupil of the eye, becoming a pin-point. In dim illumination the iris expands widely. Thus the iris controls the amount of light entering the eye.

But the sensitivity of the eye is by no means always directly related to the amount of light received by it and we are not referring here to the influence of wavelength explained in the preceding section. Examples of variation of intensity of visual sensation with the brightness of the general lighting are common experiences. For instance, a searchlight or the beam from a car headlamp appears quite glaring at night when the eye is adapted to the general darkness; but does not look very bright by day when the eye is already adapted to the brightness of daylight. The explanation lies in the fact that, in the latter case, exposure of the eye to daylight has already decomposed a considerable proportion of the light-sensitive material in the retina, so that, by comparison with dark conditions, there is a reduced concentration of this light-sensitive material in the light-adapted eye to be affected by the searchlight beam, and consequently there is a less intense sensation.

On the other hand, the apparent brightness does not vary much for objects of which the actual or absolute brightness depends upon the general illumination, that is, objects seen only by the light reflected from them. The brightness or lightness of such non-luminous objects is judged by comparison with the surroundings. For example, paper which is white in a brightly lit room also looks white, not grey, in a dim room, just as an orange continues to appear orange and not brown. In this case, some mental as well as retinal adjustment appears to be involved; a mental adjustment similar to that by which a room, a few minutes after half the lights have been switched off, may look almost as bright as before. It is probably the influence of memory in association with the general level of lighting, for we know that ordinary paper is white and an orange is orange, just as we know what a room looks like before the lights are reduced and, following the adaptation of the iris to the modified illumination, our memory of the room is maintained provided the lighting is not reduced too much.

The foregoing examples indicate that the intensity of visual sensation is not necessarily proportional to the amount of light received by the eye, but depends upon the ratio between the amount of light received from the object under observation and the brightness or magnitude of the

general illumination, that is, the brightness of the surroundings. Of course, if two similar objects or two light sources are viewed side by side then that which gives off the more light will appear the brighter.

The adaptation of the eye to the general, overall, illumination can be demonstrated by a very interesting phenomenon. If a white material, such as a white paint, is mixed with a black so that the mixture reflects only 1/10th of the light reflected by the original white substance, then the mixture will appear to be a dark grey; if, however, the illumination on the original white material is reduced to 1/10th of its initial intensity, the material will still look white. Here we have the same amount of light entering the eye in the two cases, but, in the first, the light from the material is reduced in comparison with the general illumination, whereas, in the second, the light from the material is reduced to the same degree as the surrounding illumination. Similarly, a coloured substance on blackening becomes a dark colour, but it will retain most of its original colour under dim lighting; for example, an orange paint mixed with black becomes brown, yet an orange skin is orange under bright or dull illumination.

(b) Adaptation to Colour (Colour Fatigue)

Changes in the colour sensitivity of the eye are much less frequently experienced than changes of the intensity of visual sensation. Nevertheless, the effects of variations in colour sensitivity are sometimes important. If the eye gazes continuously at one distinctly coloured object for more than a few seconds, it seems to become fatigued to the coloured light received from the object. Consequently, if the fatigued eye now looks at a white surface, the surface will appear to be of a colour which is complementary to that of the coloured object. Plate 6 is intended to demonstrate this phenomenon. Stare at the cross between the three coloured discs for two minutes, then view the white paper, when discs of the respective complementary colours will be seen. The apparently coloured discs will usually be tinted to some extent by the white paper, so that they will not be exactly complementary to the printed discs.

The explanation here is that, having fatigued or adapted the eye to certain coloured light rays, on viewing a white surface, reflecting all the rays of the spectrum, the response of the eye to the coloured rays previously received is greatly reduced but not to the other rays of the spectrum, and these other spectral rays, therefore, produce a predominating sensation. Because the effect is obtained by viewing a colour followed by looking at a different surface, it is sometimes referred to as *successive contrast*.

As an example, yellow objects reflect red and green light, so that, by first adapting the eye to red light, a yellow material is made to look

green, because the red sensitivity of the eye has been reduced but not the sensitivity to green (or blue) light, and the green light from the yellow material consequently produces a greater response than the red light.

Similarly, due to fatigue, coloured haloes can be made to appear around coloured objects after prolonged viewing against a uniform background, the haloes being complementary in colour to the objects if the background is white.

The general effects produced by colour fatigue are in agreement with the theory of three-colour vision. Recovery of the eye after this fatigue is fairly rapid, although recovery from green fatigue may be slower than from red, and, in severe cases, full recovery from blue fatigue may take almost an hour.

It follows that colour fatigue may modify a person's judgement of colour considerably, and in the matching of colours it is important that one should not stare too long at the coloured specimens.

The effect of colour fatigue whereby the eye tends to generate complementaries of the colours it is viewing enhances the contrast produced when two complementary colours are used together (see p. 38). This is shown by Plate 7 in which the fatiguing of the red receptors of the eye by the strong red background heightens the brilliance of the blue-green letters and vice versa. Indeed, the clash of such strongly contrasting colours may cause the edges of the letters to appear to vibrate. This is an extreme example of simultaneous contrast described in a following section.

AFTER-IMAGES

The complementary colour seen as a result of colour fatigue is only part of the effect, though it is the part more frequently experienced because the circumstances required to produce it are more common and the eyes are usually moving to produce the successive colour contrast. If after a prolonged gaze at a colour one looks steadily at a black surface, instead of a white or bright one, or shuts the eyes so that they are not moved, then the after-image is of the same colour as the original subject. Such after-images are usually rather blurred and seem to be caused by the decomposed photo-chemical substance in the retina flooding into and stimulating surrounding regions. In certain instances, particularly if the eyes are kept as still as possible, this positive effect will overcome the complementary successive contrast and the simultaneous contrast (described in the following section). The wallpaper against which pictures are hung influences the pictures. If a green wallpaper be used, for instance, the pictures may be so flooded by green as to look quite wrong. The eyes in a portrait may be affected by the colour of the dress, eyes

painted as a neutral grey appearing to be blue if the dress of the figure is blue, or brown if the dress is brown.

SIMULTANEOUS CONTRAST OF TONE (LIGHTNESS) AND COLOUR

Adaptation of the eye to intensity of illumination and to colour produces important effects when different tones or shades (lightnesses) of grey or colour are placed side by side or when different colours (hues) are juxtaposed. The visual impression when two different greys are placed alongside each other is that their contrast is increased. Such simultaneous contrast of tone is demonstrated by the grey scale illusion of Plate 8. The circle of the same grey appears to become paler as the background varies from light to dark. A similar optical result is obtained when the same shade of a colour is viewed against different tones of that colour. Observe the apparent difference in tone of the mid-green panels in Plate 9, (a) and (b), which consist, in fact, of the same green against (a) light green and (b) dark green surrounds.

This kind of contrast may be called simultaneous tone, lightness, brightness or luminosity contrast, according to whichever term is best understood. Examples of its effect will readily come to mind, such as the influence on the appearance of an object produced by shadows over part of the background. It explains at least partially the disappointment that may be experienced when prints on paper are made from colour photographs (transparencies). The latter are projected and viewed in a dark room so that they have a dark surround whereas the prints usually have white borders. Consequently the projected pictures appear lighter in comparison with the prints which tend to be darkened by the border. Hence projected transparencies have an inherent advantage over reflection prints.

When different colours are placed together, side by side, a small, but noticeable change in the appearance of the colours usually occurs. This phenomenon is known as simultaneous contrast of colour or hue. The yellow of a primrose is deepened by contrast with the surrounding green leaves, and many other examples may be found. Even the green foliage of a tree will appear to change in hue if seen first against a blue sky and then against brown earth. Plate 10 (a) and (b), shows the same green as in Plate 9 against blue and yellow grounds. In each case the appearance of the green panel seems to change towards that end of the spectrum which is away from the colour of the surround; that is, the panel tends to become a yellowish-green in (a) and a bluish-green in (b). Similarly, if a grey patch is viewed against a bright red background the grey patch will appear bluish-green. Plate 11 shows other examples.

Lightly tinted, for example, pale cream or magnolia coloured paper or paint or other materials generally appear white when viewed alone, that is, without comparison, but when laid against a pure white surface they are seen to be definitely coloured. This indicates that our perception of colour is relative.

These usual effects of simultaneous contrast both of tone and colour may be summarized by the general statement sometimes called the law of juxtaposition that, 'when different colours, or tones of colour, are seen together, they appear as dissimilar as possible'. Such contrast phenomena are connected to the effects of colour fatigue and the continual movement of the eyes from one coloured area to the other, and there may be effects within the brain itself which enhance differences in tone and colour in much the same way that a thin man tends to look taller than a stout one though both may be of the same height.

This colour contrast is a common experience when fairly large areas of colour are seen together, the areas being at least large enough to be easily viewed singly. It is most marked where a smaller area of one colour is seen against a larger area of another. There may be other effects than that of colour contrast, as on the apparent size of a coloured area. Coloured lettering tends to look larger on a different coloured background than it does on a white background.

The phenomena can be used to advantage by the colour specialist, but the so-called 'law' of juxtaposition is not infallible. When both components are small in area and seen together or narrow striped patterns or fairly fine mosaics are being viewed, we may get the opposite effect, the colours seeming to become more like each other. In tweed textiles, for example, the different threads before weaving may be brilliant and contrasting in colour, yet when seen in the fabric they are much less so. Plate 12 shows this kind of effect which is believed to be due, at least in part, to the spreading and scattering of the various lights on the retina. These induced colour changes are developed as the viewing distance is increased and the angle subtended on the eye by the structure of the pattern is reduced. The reduction of colour difference in fine patterns is as important where it applies to the use of colour by designers as are the better-known contrast effects.

The opposing effects of simultaneous contrast are helpful in the matching of colours, since they will enhance any small differences in colour and lightness or brightness between the specimens under comparison. In order to make the greatest use of contrast effects in colour matching it is necessary to do two things. One is to place the colours concerned literally alongside each other, so that they abut one another. Any space or gap between the specimens will tend to diminish whatever colour contrast there may be. In addition, the comparison of the colours should be done against a black or dark grey surround because

this will heighten the apparent brightness of the colours and thereby accentuate any tonal contrast which may exist between them. Thus the matching of coloured materials is facilitated by covering them with a large black card out of which has been cut a rectangular 'window', say 6 in. × 4 in. (15 cm × 10 cm), the window being placed so as to expose approximately equal areas and shapes of the materials in close juxtaposition.

Although the enhanced effect produced by simultaneous contrast of tone and colour is illusory, it is well known to the artist and he takes advantage of it in his work. But attempts to heighten the intensity of a colour by colour contrast may have deleterious effects on other neighbouring colours, especially tints. A vivid contrasting background in a colour portrait may appear dramatic and accentuate the colour of the model's dress, but it is likely to destroy the subtlety of delicate flesh tones. Generally, the least objectionable and the simplest way to intensify a particular colour in a picture is to use a surround or background of a dark complementary colour or black.

On the other hand, in the measurement of colour it is essential that it is the quality of the light received by the eye (the stimulus) which is measured, and not the quality of the sensation, for the latter may be modified by fatigue or simultaneous contrast. In those colorimetric methods which are based upon visual observation it is necessary to know whether the measurements are affected by the conditions of observation. See Colour Measurement, Chapter 6.

CHROMATIC ABERRATION

A lens of the type in the eye, that is, a double convex lens may be considered as being approximately similar to two prisms placed base to base. Consequently, just as a prism separates the coloured rays that are present in white light so does a lens. This means that the convex lens of the eye does not bring rays of different wavelengths to the same focus on the retina, the greatest separation being between the short, violet waves and the long, red waves, as with a prism. The phenomenon is the well-known defect of single lenses termed chromatic aberration. Because the dispersion (refraction) of violet and blue light is greater than that of red light, violet and blue rays are brought to a focus slightly in front of the retina and red rays slightly behind it.

Fortunately, this chromatic aberration of the eye is not usually noticed in daily life because the sensitivity of the eye (see p. 62) is greatest to yellowish-green light near the middle of the spectrum and decreases rapidly on either side of this maximum, that is, towards violet and red light. The violet and red aberration fringes around the

image received from a white object are hardly perceived and the eye accommodates unconsciously in such a way that the greenish image is focused on the retina, the overall effect being interpreted by the brain as white. It may be that the visual mechanisms which bring about disappearing colour mixtures, such as the white sensation evoked by a mixture of blue and yellow lights, p. 36, and the sensation of yellow from a mixture of red and green lights, are also responsible for the usual elimination of the effects of the chromatic aberration fringes produced by the optic lens.

With bright lighting in certain circumstances the nonachromatism of the eye may be observed. For instance, if a purple light be looked at from a distance of about 20 yards or metres it will be seen as either a red disc surrounded by an area of blue-violet, or, if the blue-violet rays are focused, a blue-violet disc surrounded by red. Likewise, under certain conditions the chromatism of the eye may be troublesome; for example, it causes unpleasant fatigue in reading bright red letters on a blue background, and in a room illuminated only by blue or violet light a person with normal vision becomes myopic (short-sighted).

Attempts have been made recently to relate chromatic aberration to the still unsolved problems of colour perception and aesthetics of painting.

COLOUR HARMONY

In the artistic and aesthetic use of colour, it is usually desirable that various colours should appear to agree pleasantly together, that is, harmonize with one another. It is to be expected that similar colours will blend well, as in Plate 13, and, as a general rule, harmony will be obtained when light of at least one colour is present in the spectral radiations from both of the materials under consideration, just as contrast or discord is generally produced when there is no colour common to the reflected or transmitted rays from the two materials. For example, an orange-red tends to contrast or clash with a mid-blue, whereas a magenta, or purplish-red, will harmonize with the blue, or, vice versa, a purplish-blue will blend with the orange-red. Other perhaps more attractive combinations, termed 'analogous colours' by the designer, are orange and yellow, red or blue with purple, green with either yellow or blue, red or brown with orange or yellow. Some examples are shown in Plate 14. Shades, tints or tones of the same hue, which may be termed 'self-coloured harmonies', are extensively used by artists and designers in paintings, fabrics, carpets, wallpapers, ceramics, etc., with pleasant effects.

The artist's distinction between red, orange, yellow and yellowish-green as 'warm' colours and blue, bluish-green and purple as 'cold' colours is long-established and well-known. Yellow seems to have been regarded through the ages as the brightest colour, which is understandable when we know that most yellow materials highly reflect the light of about two-thirds of the spectrum. Whereas violet or purple and deep blue are looked upon as dark colours, no doubt largely due to the comparatively low reflectance of such coloured substances.

However, there are many aesthetic considerations of harmony and of contrast, concerning purpose, form and space, type of subject or pattern, shape, size, position, kind of material, surface texture, opacity or transparency, illumination, boundaries and backgrounds, light and shade, and mental effects more easily felt than described, which invariably enter into the use of colours and which belong to the realm of the artist.

All our estimations of colour are relative, formed in association with memory and the actual light which falls upon the eye, and there are occasions when more subtle factors seem to be at work. The eye is beautifully constructed, despite its optical errors, and the transformation processing of the physical input, the light that enters our eyes, by the visual system and the brain remains a matter of wonder as well as a complex subject for investigation.

COLOUR MIXING PROCESSES

IN THE PRECEDING CHAPTERS we have outlined the nature of colour—what colour is, how materials obtain their apparent colours, and the intricacies of colour vision. We are now in a position to consider the methods by which colour may be re-formed or reproduced, particularly for the purpose of making pictures of original scenes or designs that involve a range of colours. Fundamentally there are only two methods available, (a) by mixing or blending coloured lights and (b) by mixing or superimposing coloured materials. The former is termed additive mixing and the latter subtractive. In practice there is a variety of ways for achieving either kind of mixture and the two methods may well be combined to some extent. The applications and techniques of each method in the major industrial processes for producing pictures in colour and also in colour measurement are described in succeeding chapters. Here we are concerned with the principles involved.

ADDITIVE COLOUR MIXING

Having obtained a spectrum by passing a narrow beam of sunlight through a glass prism, Sir Isaac Newton confirmed the composite nature of white light by combining the rays of the spectrum through an inverted second prism (base uppermost) and thus reversing the dispersion of the coloured rays to re-form the white light. Without this confirmation it was possible that the spectrum produced by the first prism might have been due to some obscure reaction between the white light and the prism.

This experiment demonstrates that white light can be produced by mixing or adding together all the coloured lights of the spectrum. By using the initial letters to represent the six principal coloured

bands in the spectrum (see p. 12), this can be summarized as
$W = R + O + Y + G + B + V$.

Because of the seemingly triple nature of colour vision, however, the
sensation of whiteness can be obtained by combining only three mono-
chromatic light rays of selected wavelenghts, as stated on p. 57, one
in the red region of the spectrum, another in the green and the third in
the blue. Also as indicated on p. 57, there is some choice within each
of the three spectral regions of the exact wavelengths for the rays which
will give white on combination. So $W = R + G + B$. Indeed we can go
further and mix a blue ray of wavelength 436 nm with a pure yellow
light of 570 nm and again produce the sensation of white. In this case
$W = Y + B$ and the yellow ray may be said to be complementary to the
blue (see p. 36). But the sensation of yellowness is exceptional and, as
explained on p. 57, it is believed to be due to the simultaneous stimulation
of both the red- and green-sensitive cones in the retina. Hence in this
connotation, yellow is best regarded as a mixture of red and green,
that is, $Y = R + G$. So we are back to $W = R + G + B$.

The same effect is obtainable with other binary mixtures of so-called
complementary coloured lights. For instance, greenish-blue (cyan) light
of wavelength 493 nm with red of 650 nm gives white, and so does a
mixture of selected purple and green lights. Such other dual mixtures
like that of yellow and blue above are all in agreement with the theory
of three-colour vision, for which reason we have to return to the red,
green and blue triad.

In fact, the integration of red, green and blue beams of light, gives not
only the sensation of white, but, by making the appropriate variations
between one, two or all three beams and their intensities, the whole range
of colour sensations can be obtained, as stated previously on p. 56.
For this reason lights of these three colours provide the basis of all
additive methods of colour reproduction and are conveniently referred
to as the *light primary colours*, or the *additive primaries*, or, perhaps, the
physical primaries. Following our notation therefore: $W = R + G + B$,
so that $W - R = G + B$, signifying that white light minus or without
red light produces green-blue, such a colour being named cyan. Similarly,
$W - G = R + B$, meaning that white light minus green gives purple
or magenta; and $W - B = R + G$ which is, of course, yellow, so
yellow can be described as white light minus blue.

The description of colours as in the last paragraph by the nomenclature
of white light minus red, green or blue is often useful and in many cases it
accords well with the actual mixtures of lights reflected or transmitted
by coloured materials, particularly yellow materials which reflect large
proportions of red, orange, yellow and green light (see pp. 20–22),
that is, white light minus blue. Moreover, magenta or purple is not a
spectral colour but green is, so if we refer to the sensation of magenta as

white minus green, or just minus green, we are basing our terminology on the spectral colours. In the abbreviated form, yellow becomes minus blue and cyan is minus red.

Colours are produced additively by artificial means when two or more individual beams of coloured lights are brought together. The simplest way of doing this is to project beams of light on to the same screen by placing pieces of differently coloured glass or filters separately in front of each of a number of projection lanterns. However, we are now producing our beams of light through coloured materials (the filters) which, as explained in Chapter 2, do not transmit pure monochromatic light but mixtures. So our separate light beams are already composed of mixtures. Nevertheless, examples of this kind are in accordance with actual practice since the production of monochromatic light is more difficult and expensive and, for reasons that are explained on p. 84, monochromatic light beams would have no real advantage in colour reproduction processes over beams covering broad bands of the spectrum.

If a beam of light is projected through a piece of blue glass which absorbs red, orange and yellow the apparent blue beam will contain green, blue and violet and may be represented by G + B + V. Likewise, if a second beam is projected on to the same screen through yellow glass which absorbs only blue and violet light, the beam will look yellow but will contain red, orange, yellow and green and may be represented as R + O + Y + G. The resulting mixture on the screen is therefore the addition:

$$
\begin{aligned}
\text{Yellow Beam} &= R + O + Y + G \\
+ \\
\text{Blue beam} &= \qquad\qquad\quad G + B + V \\
\hline
\text{Mixture} &= R + O + Y + 2G + B + V \\
\hline
\end{aligned}
$$

This mixture contains all the ingredients of white light with excess green light and will appear to be bright, pale green to the eye.

As the blue glass suggested in this example is really a greenish blue, that is, cyan, the same result is indicated if we use the trichromatic notation, W = R + G + B, as follows:

$$
\begin{aligned}
\text{Cyan beam} &= \qquad G + B \\
+ \\
\text{Yellow beam} &= R + \ G \\
\hline
\text{Mixture} &= R + 2G + B \\
\hline
\end{aligned}
$$

which is white plus green. Perhaps it should be pointed out that although this result is greenish it is a very pale, bright green, being white light containing excess green, and it should not be confused with the dark green that is the familiar result of mixing yellow and greenish-blue *materials* (see Subtractive Colour Mixing, p.79).

Suppose that we have three projection lanterns, in front of one of which we place a red-orange filter, that would in fact look red, in front of a second we place a yellow-green filter that would look green, and in front of the third a blue-violet filter which would appear to be blue. Each of the projectors separately would supply a red, green or blue beam of light comprising one third of the spectrum and the chief results obtained by merging these beams together may be shown with our simple initial notation as follows:

(i) Red Beam = R + O
 +
 Green Beam = Y + G

 Mixture = R + O + Y + G, that is, yellow.

(ii) Red Beam = R + O
 +
 Blue Beam = B + V

 Mixture = R + O + B + V, that is, purple or magenta.

(iii) Green Beam = Y + G
 +
 Blue Beam = B + V

 Mixture = Y + G + B + V, that is, greenish-blue or cyan.

(iv) Red Beam = R + O
 +
 Green Beam = Y + G
 +
 Blue Beam = B + V

 Mixture = R + O + Y + G + B + V, that is, white.

Thus six colours and white are easily obtained and as the results are produced by adding beams of light to one another the colours are really bright or vivid. If the intensity of the light from each projector were

controlled and thereby varied, the range of colours would be greatly increased, to include orange, for example, and a wide gamut of tones of all the colours would be obtainable.

James Clerk Maxwell, a famous English physicist, in 1861 was the first to use triple projection in the above way to obtain a colour picture, though he did so for the purpose of demonstrating the triple nature of colour vision. Maxwell took three photographs each respectively through red, green and blue filters similar to those cited in the above example. Each negative therefore recorded the colours of the original subject and their amounts that were transmitted by the respective filter. From the three negatives, black-and-white positive lantern slides were made which, in turn, constituted the red, green or blue records of the subject. These three slides were then placed in separate projectors each behind the same colour filter that had been used for the photograph, the projectors being arranged to throw the red, green and blue images in register with one another on to a white screen. The colour rendering was surprisingly good in view of the quality of the early photographic materials that Maxwell had to use. These contained no colour-sensitizing dyes (see p. 149), which were not discovered until 1873. He had to give very long exposures through the red and green filters, and it has been found since that, by a fortunate coincidence, the red dye in his subject (a tartan bow) reflected ultra-violet as well as red light and the red filter he used transmitted ultra-violet, to which all photographic materials are sensitive. Thus the first additive colour photograph was produced, and Clerk Maxwell's experiment illustrates the fundamental principle of all modern processes of colour reproduction, especially the additive methods of colour photography (see Chapter 7).

The major effects of trichomatic additive mixing are shown diagrammatically in Plate 15. In a more general way, it will be obvious that the greater the number of coloured lights which are admixed the brighter and the nearer to white the result will be, so that as white is actually approached the resulting colours will become paler or tinted.

A straightforward example of the practical use of additive colour mixing is the stage lighting in a theatre where red, green and blue spot lights or floodlights are employed. The more involved applications in colour photography and television are explained in Chapter 7.

Instead of the cumbersome use of two or more light beam projectors, additive mixing demonstrations or experiments may be carried out with a *revolving colour disc,* sometimes known as a Maxwell disc. This may consist of a single cardboard disc with sectors painted in different colours, or, better, of three or more discs of the same size each painted with one colour and having a radial slit to enable the discs to be slotted or interlocked together so that different coloured sectors of varying areas can be exposed between the several discs. The discs are attached

to a spindle which can be spun rapidly either by hand or preferably by means of a small motor. On viewing the quickly rotating single or composite disc, the lights reflected by the individual coloured sectors fall on the same area of the retina of the eye in such fast succession that they are not seen separately at all, due to the persistence of vision, and the sensation of additive colour mixing is produced. If a single disc is divided into six sectors painted with six paints having the apparent colours of the spectrum, the spinning disc will look white. By using three interlocking red, green and blue discs the effects of varying the proportions of the three additive primaries may be studied by altering the angle of the sector occupied by each.

When using a colour disc it should be remembered, as with the projection of light beams through coloured glass filters (p. 74), that each paint on the disc will reflect light of more than its apparent colour, that is, a mixture. This factor may affect the expected results to some extent unless the actual colour values or reflections of each paint are known from measurements (tristrimulus values or C.I.E. specifications, see Chapter 6).

The principle of the revolving colour disc has been applied to cinematography and television in the successive frame method described on p. 144.

Another way by which additive colour mixing can be achieved without the use of projection lanterns is to construct a *mosaic of tiny areas or spots of different colours*. Provided the areas are too small to be seen separately, for instance by viewing the mosaic from a distance, the eye will confuse the various coloured light rays reflected or transmitted by the constituents of the mosaic, that is, they will be seen collectively or additively. This is the principle of the earlier, most successful and not long superseded commercial systems of colour photography and of the present-day colour television receiver, described in Chapter 7. A simple application is the weaving of grey cloth from black and white threads.

Because daylight and the light reflected or transmitted by everyday material substances are mixtures, they are widespread examples of natural additive effects.

SUBTRACTIVE COLOUR MIXING

Whereas additive processes are based on the projection and blending by suitable means of coloured *lights*, subtractive methods involve the mixing or superimposition of coloured *materials* usually in the form of paints, inks or dyes. The name 'subtractive' is used because the effects are obtained by combinations of material substances which always absorb or 'subtract' light in various ways as explained in Chapter 2.

In practice this method has been in use from time immemorial because if is comparatively easy to blend appropriate coloured substances and we are all familiar with it, if only in the mixing of water-colour paints when we were young. In contrast to white being the ultimate result of blending several coloured lights, it is common knowledge that if a sufficient number of coloured substances are well mixed the effect of black is obtained, which means the complete absorption of light.

Strictly subtractive mixture takes place only with transparent, non-scattering, media such as solutions of dyes and transparent printing inks. Paints and many printing inks contain opaque finely-divided insoluble pigment particles suspended in fluid vehicles, and these particles scatter the light by innumerable reflections, making the colour mixing situation more complicated. Similarly with dyed fabrics there is scattering from the multiple reflections and refractions between and within the fibres. Nevertheless, when scattering occurs the mixing is generally approximately subtractive and the qualitative discussion that follows is applicable, although the exact mathematical treatment is much more difficult.

Let us take a well-known example already mentioned in p. 22. If a yellow paint which reflects mainly red, orange, yellow and green light and absorbs mostly blue and violet light, is mixed with a blue, actually a cyan, paint which reflects mainly violet, blue and green light and absorbs mostly yellow, orange and red light, the result is green because this is the only light simultaneously reflected by both paints, all other coloured rays being absorbed. If a red paint which absorbs green light is added to this mixture, the final product is black because of the total subtraction of light.

Again, by using the simple notation of initial letters $W = R + O + Y + G + B + V$ we can put X in the proper position to indicate the absorption of light of a certain colour. So the yellow paint referred to above may be represented by $R + O + Y + G + X + X$, the cyan paint by $X + X + X + G + B + V$ and the red paint by $R + O + X + X + X + X$. On mixing, therefore,

Yellow paint	$= R + O + Y + G + X + X$
+	
Cyan paint	$= X + X + X + G + B + V$

Mixture	$= X + X + X + G + X + X$, that is, green
+	
Red paint	$= R + O + X + X + X + X$

| Triple mixture | $= X + X + X + X + X + X$, that is, black. |

Note that for the mixture of yellow and blue paints the two Gs have not been added as was done with the additive mixture of yellow and blue lights on p. 74. The reason is that green and blue materials do not reflect more than about 50 % of the incident light in these regions of the spectrum, as stated on p. 23, so this is the maximum of green light that can be reflected by the mixture. Hence the real result is a fairly dark green.

It will be appreciated that our initial notation is limited—it does not indicate the quantity or proportion of light, which in the case of materials means their lightness or brightness, although the notation could be amplified to show this by inserting a numeral or fraction alongside the respective initial letter. However, the initials alone do serve to show which portions of the spectrum are mainly reflected or absorbed by materials for the purpose of simplified explanation.

Referring back to our example, it will be realised that if the indicated red and cyan paints were mixed the result would appear black, not 'purple' as is commonly and erroneously expected when 'red' and blue materials are mixed, because the cyan paint absorbs the red, orange and yellow light and the red paint suppresses the green, blue and violet. To obtain a 'purple', actually a blue-violet effect, from a mixture involving a blue or cyan paint it is necessary to use a purplish-red or magenta paint, reflecting blue and violet as well as red and orange light, thus:

Cyan Paint $\quad = X + X + X + G + B + V$
$\quad +$
Magenta Paint $= R + O + X + X + B + V$

Mixture $\qquad = X + X + X + X + B + V$, that is, bluish-violet.

In this instance also the actual result would be a dark blue-violet because of the comparatively low reflectance of such light by material substances. See p. 23.

It is well-known, at least by artists, that the careful blending in various proportions of yellow, cyan and magenta paints, used alone and two and three together, will produce effects of all possible colours except white. Consequently, materials having these three colours are often referred to as the artist's primary colours. They are better termed the *subtractive* or *pigmentary primary colours*. They may sometimes be known as the 'downward working primaries' since, when mixed, the colour approaches black rather than white.

Many of us were brought up to believe that the primary colours in painting were red, yellow and blue, and in the printing industry the inks used in colour printing are still frequently referred to as red, yellow and blue. But, as shown above, the 'red' primary must be a purplish-red,

properly named magenta, and the 'blue' must be a greenish-blue, that is, cyan. Because white cannot be obtained from the subtractive primaries, they have to be placed on a white base such as paper, or, provided they are transparent, viewed against white light.

We have still to consider the third binary mixture from three primary coloured paints, that of yellow and magenta as follows:

Yellow Paint $= R + O + Y + G + X + X$
+
Magenta Paint $= R + O + X + X + B + V$

Mixture $= R + O + X + X + X + X$, that is, orange-red

So the mixing of yellow and magenta subtractive primaries gives red-orange or essentially red; the yellow and cyan primaries give green or yellow-green if the cyan reflects any yellow light; and the magenta with the cyan give blue-violet, essentially blue. The resulting red, green and blue are the *subtractive secondary colours* of the artist. In these terms the subtractive secondaries correspond to the additive primaries, and if we refer to the colours produced by the binary mixtures from the three additive primaries as *additive secondaries,* which are yellow, magenta and cyan (p. 75), they correspond to the subtractive primaries. Alternatively, the additive and subtractive primaries may be said to be complementary to one another, see p. 36.

These connections or relationships between the additive and subtractive primary colours are important. Processes of subtractive colour reproduction employ the yellow, magenta and cyan primaries which, on first impressions, seem to be quite different from the red, green and blue light primaries used in additive methods of colour reproduction. But the subtractive yellow primary removes blue and violet from white light, the magenta absorbs yellow and green and the cyan suppresses red and orange light. Virtually all colours, including white, can be produced by additive mixtures in various proportions of red-orange (red), yellow-green (green) and blue-violet (blue) lights. It follows that the subtractive primaries acting as absorbers of red, green and blue light may be regarded as controls for the red, green and blue parts or thirds of white light. By varying the amounts (concentrations, thicknesses or areas) of the subtractive primaries on a white surface, the intensities of the primary red, green and blue portions of the reflected white light are altered and, if this be done adequately, a very wide range of colours can be produced. It will be recognized, therefore, that both the subtractive and additive methods are actually based on the same principle and linked with the triple characteristics of colour vision, although the two methods differ in manner.

Now that we have connected the subtractive method with the additive, it may be helpful to revert to the nomenclature of white minus red, green or blue (p. 73) and to run through subtractive trichromatic reproduction in the notation of $W = R + G + B$ with the minus sign inserted respectively to show the absorbed third of the spectrum:

(i) Yellow Primary $= W - B$ $= R + G - B$
+
Cyan Primary $= W - R$ $= -R + G + B$

Mixture $= W - R - B$ $= G$, that is, green.

(ii) Yellow Primary $= W - B$ $= R + G - B$
+
Magenta Primary $= W - G$ $= R - G + B$

Mixture $\doteq W - G - B$ $= R$, that is, red.

(iii) Magenta Primary $= W - G$ $= R - G + B$
+
Cyan Primary $= W - R$ $= -R + G + B$

Mixture $= W - R - G$ $= B$, that is, blue.

(iv) Yellow Primary $= W - B$ $= R + G - B$
+
Magenta Primary $= W - G$ $= R - G + B$
+
Cyan Primary $= W - R$ $= -R + G + B$

Mixture $= W - R - G - B =$ complete absorption, that is, black.

It will be seen that we have obtained six major colours plus black, and white would be derived from the white base or background which is essential in the subtractive method. Further and as previously mentioned, by varying the amounts of the subtractive primaries on the white base various tints and shades (lightnesses and saturations) of these colours (hues) can be produced.

So far we have considered only coloured paints as familiar and suitable materials for subtractive mixing. Printing inks might equally have been referred to since both kinds of material normally contain fine insoluble

pigment particles as the coloured components. When such materials are mixed the pigment particles are too small to be distinguished individually and the net effect is due to the absorption of light by the two or more pigments. However, the particles in printing inks are appreciably smaller than those in paints. If an ink were mixed with a paint containing an equal volume of pigment, the finer ink particles would have a much larger surface area to reflect and scatter coloured light than the same volume of coarser paint particles, the light from the former therefore tending to outbalance that from the latter. Consequently, the colour of the mixture might be modified somewhat by the difference in the size of the particles and also, for similar reasons, by the shapes of the different pigment particles.

Paints are mostly opaque. Printing inks may be opaque or transparent, though for multi-colour printing work they must be transparent as explained in Chapter 8. The same qualitative considerations of subtractive colour mixing that we have been through apply whether the materials are opaque or transparent, provided we bear in mind that the coloured light is reflected if they are opaque and transmitted if transparent, and scattering of the light tends to affect the results in the case of opaque materials as mentioned on p. 78. Otherwise, the only difference is that transparent materials may be overlaid, or superimposed on one another instead of being actually mixed. If opaque materials are superimposed in layers thick enough to show their colours at full strength or maximum saturation, the uppermost substance will, of course, obliterate those underneath so that no mixed effect will be obtained.

If, therefore, three transparent glass filters having the yellow, magenta and cyan colours of the subtractive primaries are placed one behind the other in the path of a beam of white light, each will absorb one third of the components of the light so that none will penetrate the three filters and the end effect will be black.

If, on the other hand, we have three filters corresponding in colour to the red, green and blue additive primaries, we need to place them in pairs only in a beam of white light to absorb it completely. The reason will be obvious. Although each filter will transmit light of the respective additive primary colour, that is, one third of the spectrum, it is a material and will absorb the light of the other two thirds of the spectrum. In short, there is no part of the spectrum which is common to the transmissions of any two of such filters and so materials of these colours are not appropriate for subtractive colour mixing.

Because the subtractive method is, in general, easier to apply and has other advantages mentioned later, it is more widely used than the additive method. It is clear from the foregoing that the artist painter makes use of the subtractive method. On a much greater scale, however,

it is employed in modern colour photography, cinematography and in all branches of the printing industry (Chapter 8). The principle of the method using transparent materials is illustrated diagrammatically in Plate 16.

VISUAL LIMITATIONS OF TRICHROMATIC COLOUR REPRODUCTION

We have explained how both the fundamental methods of colour reproduction are based on the same principle—the physiological fact that visually the gamut of colours can be produced by mixing red, green and blue lights either directly by the additive method or indirectly by the subtractive process. It is fortunate that the eye views the comparatively complex spectral range of colours in this apparently simplified trichromatic way in terms of the three primary lights. Were it not so, none of the industrial methods of colour reproduction would work. Nevertheless, there are inherent difficulties in trichromatic reproduction.

In Chapter 4 on Colour Vision the approximate spectral sensitivities of the three colour-sensitive cones in the eye are stated (p. 57), and shown graphically in Fig. 4.2. It was pointed out and is readily seen from Fig. 4.2. that, except at the extreme ends of the spectrum, light of any particular colour (wavelength) stimulates two or all three of the cones to various extents. The sensitivity of the green responsive γ cones largely overlaps that of the red responsive ρ cones except to wavelengths longer than about 650 nm. The sensitivity of the blue responsive β cones overlaps those of both the green and red responsive cones at wavelengths around 500 nm. It is impossible, therefore, to find three primary monochromatic wavelengths that will stimulate the retinal cones separately, particularly in the green region of the spectrum.

The sensitivity of the eye to change in wavelength for spectrum colours is least at the extreme ends of the spectrum, where the change is more in apparent brightness or lightness than in hue, and greatest in the yellow and blue-green regions, where hue discrimination is normally highest. The latter are the regions in which the overlappings of the ρ and γ and the three conal sensitivities respectively are believed to be at a maximum. See Fig. 4.4.

This *overlapping of the conal sensitivities* introduces a basic complication into what would otherwise be relatively simple and exact trichromatic colour reproduction. For if the retinal cones were separately sensitive, one type to red light only, another to green light only and the third type to blue only, it would presumably be comparatively easy to arrange that the cones were activated by a colour reproduction to

precisely the same extent as by the colours of the original scene. As matters are, it will be seen from Fig. 4.2 that red light of wavelengths greater than about 650 nm stimulates only the red-sensitive ρ cones and blue light of about 450 nm wavelength greatly stimulates the blue-sensitive β cones and very little the red- and green-sensitive ρ and γ cones, but there is no part of the spectrum to which the green responsive γ cones alone are sensitive or even in which these cones are stimulated and the others only very slightly. If, therefore, three pure primary lights of about 650 nm (red), 500 nm (green) and 450 nm (blue) were used for colour reproduction, the amount of stimulation of the ρ and β retinal cones by the red and blue beams would be correct or nearly so. But the green beam, including all the colours in the reproduction that contain green light such as cyan, yellow and white, would produce unwanted responses by the ρ and β cones. These excessive responses of the red- and blue-sensitive cones would be greatest when the response of the green-sensitive γ cones was itself large, that is, with the green colours which would appear paler than they should. Whites would produce some excessive response of the red- and blue-sensitive cones giving them a tint of magenta, and so on, this effect becoming negligible only with the deeper red and blue colours.

Moreover, three monochromatic beams of light would have to be of high intensity to produce a bright picture and this factor brings in other difficulties, one of which would be cost. For these reasons there is no point in attempting to use monochromatic red, green and blue lights for practical colour reproduction, as already mentioned on p. 74. Beams covering relatively broad bands of the spectrum are easier and cheaper to obtain, for example, by means of simpler coloured filters in front of projectors or dyes on a white base, and are, therefore, always used in practice. Nevertheless, this results in additional inaccuracies of colour rendering as the broader coloured beams produce even more excessive conal responses than would monochromatic lights.

These visual limitations arising from the overlapping of the sensitivities of the retinal cones mean that exact colour reproduction by straightforward trichromatic methods is not possible. For this and further reasons to be mentioned in succeeding chapters, means have to be inserted in the technical colour reproduction processes to reduce such defects. Also, because of visual tolerances coupled with the adaptability of the eye and our inexact colour memory, together with the fact that in many cases no comparison is available or even possible between the reproduction and the original scene, the defects are often unnoticeable and colour reproductions, though they may be somewhat imperfect, are generally acceptable, frequently extremely pleasurable and can be reasonably faithful.

COLOUR MEASUREMENT

FROM THE PRECEDING EXPLANATIONS, particularly those of Chapter 2 on the General Properties of Coloured Materials, it will be clear that the names commonly given to colours in everyday life are vague and that the precise description of a colour is not a simple matter. For example, descriptive as it may sound, a name such as 'turquoise blue' means very little when an exact colour has to be matched or specified. It has been estimated that the human eye can distinguish differences among well over 2000000 colours and shades and upwards of 7000 of these have been tabulated in dictionaries of colours. But English language dictionaries list only some 3500 words for this vast range of colours.

INTRODUCTION

Measurement is the only logical way out of such confusion and colour measurements are now widely used in many industries and in the arts and even medicine as well as for scientific purposes. The unambiguous description of coloured samples is necessary to ensure that industrial products meet customers' requirements; colour is often a guide to the quality of raw materials and the measurement of colour may be used to control industrial processes and to grade the products; measurements of the original and reproduction colours are required in order to assess the performance of a system of colour photography, television or colour printing; standardization, for instance of coloured glasses for signals, calls for specifications that are precisely understood nationally or internationally; in the lighting industry colour measurement is important, as it has been in the study and development of the colour-rendering properties of fluorescent lamps; in the field of analytical chemistry, colour comparisons against standards and spectrophotometric measurements are prominent; and the examination of natural phenomena in

scientific research can be greatly assisted by means of colour measurements.

The visual quality of the colours of textiles and other fabrics, paper and boards, paints, lacquers and enamels, printing inks, cosmetics, plastics, tiles, porcelain, glass, wood, leather, etc., and of flowers, foliage, animals, birds, insects and of other colours occurring in nature is mostly important for its own sake. The colours are essentially decorative, about which opinions and requirements depend on a tremendously wide range of circumstances and tend to vary from individual to individual. One person may demand exact identity of colour between two materials or between an original design and its reproduction while another may accept an appreciable difference. The eye is very sensitive to slight differences in colour especially those for which a mental standard is firmly established so that, for example, the tolerance in flesh colours is always quite small. A firm engaged in the manufacture of a particular product is often chiefly concerned with small variations in colour but with many other products it is the absolute colour quality that matters.

There are numerous cases in which the colour of an object is an indication of other properties, a broad example being the colour of foodstuffs which we all use to judge the ripeness and quality of fruit, the freshness of meat, the quality of canned salmon and edible oils and the appetising appearance of our meals. Colour measurement is therefore important to the food manufacturer, and, since the colours of materials depend upon the illumination, attention has to be paid to the colour rendering properties of the lighting in restaurants and shops. Variations in the colour of a product can indicate variation in purity or composition, or deterioration. To retain the confidence of the purchaser in the uniformity of production, colour standards are maintained for many manufactured goods, among them being beer and spirits, cosmetics and pharmaceutical preparations. The colour of blood is related to its haemoglobin content. With other materials, colour may signify quality or purity, as with lubricating oils and sugar refining, tobacco, cotton, wool, rubber latex, varnishes, rosin, etc., or the strength of a solution, or the identity of a substance.

With such diverse applications, the requirements for colour measurement are varied. For some purposes a simple matching test or a specification on an arbitrary scale is sufficient while for others, measurement and specification of the highest accuracy on a standardized basis may be required. A knowledge of the integrated colour alone is often adequate but for several applications the spectral composition of the light constituting the colour has to be determined.

We have already made use of certain measurements, as with reference to the quantities or proportions of light reflected or transmitted by materials, and before we proceed to consider the practical processes of

colour reproduction some account of the principles of the measurement of colour is necessary. However, the complexities of colour, since it is a visual sensation, make colour measurement an involved subject and here little more than a descriptive outline will be attempted of the principal methods in use. For a detailed exposition on the subject the reader is well referred to the excellent book *The Measurement of Colour* by Professor W. D. Wright of London, which is listed in the Bibliography for Further Reading, p. 223.

TERMINOLOGY

Before we can measure we must define the terms or quantities to be measured. Colour terminology has been standardized, especially by the British Standards Institution (BS 1611:1953) and the Commission Internationale de l'Eclairage (C.I.E.), the latter body having undertaken the responsibility for defining an internationally accepted system of colour measurement (C.I.E. International Lighting Vocabulary, 1967).

It has been agreed internationally that colours have three main attributes—hue, saturation and lightness. These terms were introduced in Chapter 2 but it may be helpful to recapitulate:

Hue denotes the kind of colour, whether it appears red or green or blue, yellow or magenta, etc. It is the attribute by which the eye distinguishes different parts of the spectrum.

Saturation indicates how much of the colour there is, its richness or more precisely the extent to which the hue appears to be diluted or mixed with white. High saturation denotes little dilution, for example, a bright or deep red is highly saturated whereas a pale or dull pink has low saturation. Colours tend to appear paler, whiter or greyer as the saturation is reduced. Saturation is the attribute by which the proportion of colourfulness in the total sensation is judged.

Lightness denotes brightness, brilliance or intensity, that is, the extent to which a material appears to reflect or transmit light. It is the attribute by which one surface is judged to reflect a greater or smaller proportion of the incident light than another. A dark red and a bright red are of the same hue and may have the same saturation but the latter has greater lightness.

Note that lightness refers to surface colours, that is, the colours of material substances. *Luminosity* is the corresponding term generally used with reference to the apparent brightness or intensity of light sources such as lamps. Hue and saturation together indicate the quality of a colour sensation and lightness or luminosity the quantity of it.

The above are the accepted terms for the visual sensations of colours, denoting the appearance of colours to the eye, that is, *they are subjective terms* which cannot be directly measured on an instrument. Measuring instruments supply objective quantities which, unlike subjective ones, are not affected by changes in the adaptation of the observer. For example, wavelength and luminous intensity are measurable instead of hue and lightness. *The objective terms* that are correlated with the above subjective nomenclature are as follows:

Dominant Wavelength corresponds to hue.

Purity corresponds to saturation, being substantially the proportion of spectral coloured light which, when mixed with white, matches the colour sample.

Luminance Factor corresponds to lightness, being the proportion of the incident light reflected or transmitted by an object. This quantity may be named more specifically as the *reflection factor* (reflectance) or the *transmission factor* (transmittance).

The term *luminance* is used for the luminous intensity of a unit area of surface. Instruments for measuring luminous intensity are known as photometers, hence luminance was previously called photometric brightness. It is measured in photometric units about which the reader is referred to publications dealing with photometry. The word 'brightness' alone is ambiguous. It may mean luminance when referring to intensity of illumination, but to many people with regard to colour it denotes colourfulness (saturation and/or lightness). If the intensity of illumination on a surface is doubled, the luminance of that surface is doubled, but the brightness or colourfulness of the colour may remain unchanged.

Chromaticity is another objective term covering dominant wavelength and purity together that relates to hue and saturation combined, that is, to colour quality. It will be explained more technically as will dominant wavelength and purity in context with the measurement of colour.

METHODS OF COLOUR MEASUREMENT

Attempts to measure and record colour have followed two separate paths in the past, those based on the matching of colours which may be done in a variety of ways and those based on spectrophotometry which involves measurement of the spectral wavelengths and photometric brightness or luminance of colours. Subsequently, as will be explained, both kinds of measurement have been brought together through a

uniform system for expressing the results in the C.I.E. internationally accepted units.

Matching Methods

Matching in its simplest form employs colour cards or charts, as in the case of the familiar paint cards consisting of colour patches with names or numbers attached. But these are a means of colour assessment rather than measurement. In the scientific extensions of the matching method the matching may be done visually, or instrumentally by means of a photoelectric cell in place of the human eye. Visual methods of matching are by their nature subjective. The instruments designed to facilitate measurement by matching are known as colorimeters and they may use either additive or subtractive colour mixing principles. But before we consider these a description of two established scientific applications of the colour chart system to the specification of colours is relevant.

The Ostwald System

This scheme was devised about fifty years ago by Wilhelm Ostwald, a German scientist of international repute. Ostwald constructed a 'colour solid' made up of twelve double triangles or diamond-shaped charts, the solid forming a double cone, base to base, in which the axes of the twelve double triangles constituted the axis of the solid and each double triangle chart formed a section of the solid. Each chart, regarded as two triangles placed base to base, carries 64 slightly less than half-inch square colour patches, those at the apex of each triangle being of standardized highly saturated complementary colours, so that on any one chart the full-strength complementary colours lie at the extreme opposites to each other. See Fig. 6.1. If each sectional chart from the solid is viewed with the apexes of the double triangle, and therefore the full complementary colours, on the left and right, the colour patches show increasing tints of each full colour upwards towards the common axis or base of the two triangles, becoming white at the top of the axis, and increasing shades downwards, becoming black at the bottom of the axis. Consequently, the axes of all twelve charts show the same 'grey scale' consisting of eight patches having standardized gradings from white at the top to black at the bottom and this 'grey scale' forms the axis of the colour solid. This arrangement results in the twenty-four full-strength colours (twelve complementary pairs from the apexes of the double triangle charts) covering the range of the spectrum, with purple in place of violet, being located on a circle around the equator of the double cone with white at the upper apex and black at the lower.

The twenty-four full-colour standards, except the purples, were

related by Ostwald to wavelengths in the spectrum, though they were actually hand-painted with pigments of the maximum colourfulness obtainable. The intermediate tinted and shaded colours on the charts match those obtained by mixing the full colours with varying measured amounts of white and black, that is, they are made up in terms of 'colour content', 'white content' and 'black content'. The eight patches of the axial 'grey scale' are made up from tabulated percentages of white and black.

The patches on the double triangle charts are arranged in rows parallel to the three sides of the triangular halves in such a way that the rows parallel to the white-black axial side cover colours having equal amounts of full colour named isochromes, rows parallel to the white-full colour side cover colours comprising equal black named isotones, and rows parallel to the black-full colour side cover colours comprising equal white named isotints. The positions of the patches can therefore be referred to and easily located on a triangular key diagram from which, having found one of the total 680 patches over the twelve charts to

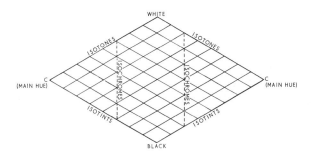

Fig. 6.1 **Section of the Ostwald Colour Solid. One of the 12 double triangular charts.** The 12 charts carry 28 colour patches in each triangular half and 8 white to black patches on the axial column. The coordinates of Isochromes (vertical shadow series each containing the same apparent amount of full colour), Isotones (downward sloping series each having the same apparent amount of black) and Isotints (upward sloping series each with the same apparent amount of white) are indicated. The two main hues at C are complementary.

match a specimen colour, that colour can be specified in terms of one of the numbered twenty-four full colours containing given percentages of white and black, these two figures plus the percentage of full colour totalling 100. These three quantities, colour content, white content and black content correspond to saturation and lightness, the hue being given by the number allocated to the respective full colour on the equatorial chromatic circle of the colour solid.

The complete set of twelve diamond-shaped charts that make up the colour solid is published in the form of an album or atlas. The limitation

of such a system is that the colour specifications are entirely determined by the full colours originally chosen and if brighter, more saturated pigments or dyes are subsequently developed, as some have been, they cannot be accommodated within the system.

The Munsell System

Another visual scheme providing an orderly arrangement of pigment or surface colours is the Munsell system which was evolved by A. H. Munsell in America about 1929 and is now published by the Munsell Colour Company. It is widely used, having been adopted by the American Standards Association for the specification of colours. Again it is based on a colour solid and the Munsell atlas contains some 960 colour patches. It has advantages over the Ostwald system in that it is more extensive and can be extended further if new, more saturated colours are produced, and the painted colour patches have all been measured and specified under the objective C.I.E. system (described later p. 116) thus making the Munsell system objective in character although it is scaled subjectively, because equal steps on its scales represent as closely as possible equal subjective differences of colour in terms of hue, saturation and lightness.

The Munsell colour solid is irregular in shape, being roughly like that of a bushy tree. The solid is made up of 40 charts, available separately, one for each hue, and the charts in the solid are arranged so that complementary colours are diametrically opposite to one another. As in the Ostwald solid, the most saturated colours lie on the periphery of a circle and a 'grey scale' forms the axis or 'trunk' of the Munsell solid, consisting in this case of nine steps or patches from white at the top to black at the bottom. Also, the intermediate colours become increasingly tinted towards the top white and darkened downwards to black.

The three Munsell properties are 'hue', indicated by the position on the hue circle; 'chroma', corresponding to saturation or purity; and 'value', corresponding to lightness or luminance factor. There are ten main hues equally spaced on the circumference of the circle, which are represented by initial letters, R for red, Y for yellow, YR for yellow-red (orange), etc., each of these main hues being prefixed with the number 5, and hues falling between each pair of main hues are prefixed with 2·5, 10 or 7·5 as illustrated in Fig. 6.2. Hence 5Y indicates the main yellow, 2·5Y a redder yellow and 7·5Y a greener yellow.

Chroma is actually the estimated colour content or the amount of colourfulness judged to be present without reference to the white or black content, in contrast to saturation which represents the proportion of colourfulness judged to be present in the total sensation. Consequently, the columns of patches representing constant chroma on a Munsell chart

tend to show increasing saturation with decreasing lightness. All colours of the same chroma contain the same amount of colourfulness whatever their value and hue. Chroma distinguishes colours by their colour content or strength in an even progression of equal steps outwards from the central axial grey scale towards maximum chroma on the perimeter. The maximum chroma obtainable depends on the hue and occurs at different levels of value for different hues, the maximum in the red

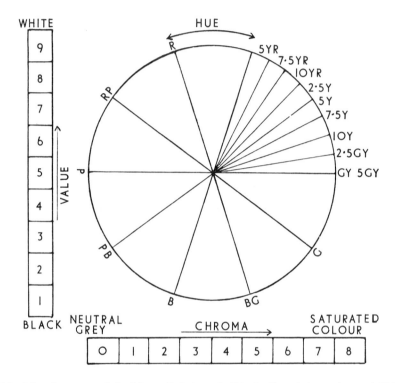

Fig. 6.2 **The elements of the Munsell Colour Solid**: the Hue circle, made up of 40 hue charts numbered as indicated, and the Value and Chroma scales. As with the Ostwald solid, the neutral grey patches, from white at the top to black at the bottom, form the axis of the solid at the centre of the hue circle. On each hue chart the colours are arranged vertically according to value and horizontally according to chroma. The maximum number of units on the chroma scale varies with the hue and value.

being taken as 14 whilst it is only 6 in the blue-green. It is because the maximum chroma varies with hue and value that the boundary or outline of the colour solid is irregular in shape.

Value distinguishes a lighter from a darker colour and is the estimated lightness of any colour on a scale of nine equal sensation intervals from

black, value 1, to white, value 9, this being the grey scale. The value of a colour patch on any of the 40 charts is indicated by its vertical position with reference to the grey scale. Thus the colour solid represents value vertically in the direction of the axis, chroma as the distance away from the axis (where chroma = 0) and hue in the different directions around the axis.

Having found a patch on one of the charts of the solid, or a page of the atlas, to match a given colour, the hue of that colour is specified by the letter with the appropriate prefix number. Two suffix numbers follow the letter, the first indicating value and the second, chroma. For example, a Munsell specification for a 'turquoise blue' might be 7·5BG 7/4, indicating a blue-green on the blue side, a fairly bright colour of value 7 and of fairly high chroma 4 or fairly saturated. As already mentioned, such a Munsell specification can be converted to C.I.E. units if required.

Glossy sample patches have been introduced recently for the Munsell system with an extension to higher chromas. This has necessitated a further subdivision of the hue charts from 40 into 80 hues which are used for all chromas above 12 and intermediate value spacings have also been provided.

A general disadvantage of any system involving charts or cards of pigment colours is the difficulty of preserving them from deterioration in use by soiling or fading. This may pass unnoticed and lead to errors. They are also limited by the number of colours it is possible to include of the several million surface colours that can be discriminated and by the kind of material and surface texture (glossy or matt, etc.) on which the colour patches are produced. But they provide easily portable physical standards that are simple to use. Because a colour atlas offers ready assistance in selecting, matching and describing colours, many have been prepared from time to time in various countries and they are still being developed. A more recent and enlarged form of the Ostwald atlas is the Colour Harmony Manual containing both glossy and matt surfaced patches produced by the Container Corporation of America. The fairly recent DIN-Farbenkarte with charts in transparent gelatine and in matt surface colours giving C.I.E., Munsell and Ostwald equivalent specifications is the official system of the German Standards Association. The British Colour Council produced a Dictionary of Colour Standards in 1934 which has been adopted by the British Standards Institution as a means of specifying colours. This dictionary is noteworthy for it includes 220 samples on both smooth and ribbed silk and it has been reproduced in wool yarn for use with rougher materials; also each colour has been specified in C.I.E. units and in terms of the red, yellow and blue scales of the Lovibond Tintometer (see p. 104). Among the most recent and extensive albums is the

Villalobos colour atlas developed in Argentina, which contains over 7000 patch samples, and Imperial Chemical Industries Limited in Britain have compiled an atlas that enables about 20000 colours to be matched.

Colorimetry

The systems previously described based on charts are essentially only a means of comparing and classifying colours. Colorimetry is a fundamental method of measuring colour and it depends on two basic principles. First, that any colour can be matched (with a few exceptions mentioned on p. 121) by a suitable mixture of three selected beams of light (radiations), normally red, green and blue which give the greatest possible range of colours, as explained in Chapter 5. Second, that two colours when matched in turn by such mixtures will, on mixing them together additively by appropriate optical means, be matched by the sum of their separate matching combinations similarly mixed. It should be appreciated that this process, which is in accord with the trichromatic theory of colour vision (Chapter 4), expresses an equivalence between the sensation produced by the colour and the sensation produced by the admixture of the selected light rays, termed the radiation stimuli. In other words, the colorimetric specification of a colour is a physical specification in terms of the light rays, the three stimuli, and not a specification of the physiological colour sensation on the retina of the eye which, as yet, is beyond the reach of existing physiological techniques, though progress is being made in the latter direction. Colorimetry is most intensely applied in the dyeing industry and the field of colour television.

ADDITIVE COLORIMETERS

As indicated, *additive colorimeters* produce a match between the colour being measured and a known mixture of three primary lights and the measure obtained is, therefore, in terms of the amounts of the three primary lights that are found to match the specimen colour. The red, green and blue primary lights may vary somewhat in exact colour or wavelength except that they must be selected in sets or groups of three members to produce white collectively, and so that no two of them can be combined to match the third, as mentioned on p. 57.

The general principle of trichromatic matching colorimeters is illustrated in Fig. 6.3. One half of the white screen is illuminated only by the mixed red, green and blue lights from three lamps or a single lamp fitted with three colour filters to give three separate beams. An opaque

specimen illuminated by white light is placed against the other half of the screen. or if the specimen is transparent it is placed in the path of the white light and the transmitted coloured light is reflected by this half of the screen. The two halves of the screen are viewed side by side through the narrow angle subtended by the aperture to the eye. By using suitable means to adjust the relative and absolute amounts of the red, green and blue lights. their mixture as reflected by the screen is made to match the colour of the reflected light from the specimen. According to the means

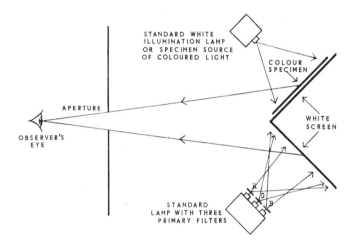

Fig. 6.3 **The principle of trichromatic matching colorimeters.** The light reflected from the upper screen is solely that of the specimen and from the lower screen only the mixture of red, green and blue light. By adjusting the amounts of red, green and blue light, for example, by varying the operative areas of the primary filters, the mixture in the lower half of the field of view can be made identical in appearance to the colour of the specimen in the upper half of the field of view.

employed to adjust the three primary light beams, the controls of the colorimeter give the amounts of these lights. which may be termed tristimulus values, required to produce the colour match, these, as already stated, being the measure of the specimen colour as supplied by the instrument. Such instrumental readings may suffice among users familiar with the colorimeter concerned. For more general purposes, from technical information based on the calibration of the particular colorimeter including the colour characteristics of the filters used with the lamps, this instrumental measurement can be transformed to a corresponding specification in terms of the standardized C.I.E. system (p.136).

Several types of such colorimeters have been devised which differ chiefly in the means adopted to achieve the additive mixing of the three primary coloured lights. This may be done in one of three ways: (i) The light beams may be projected on to the same area of a white reflecting screen as illustrated in Fig. 6.3. (ii) The beams of the different lights may enter the eye together and are, therefore, perceived as a mixture. (iii) The beams may be projected to the eye in rapid succession so that there is no sense of flicker, as in the case of revolving colour discs described in Chapter 5, p. 76.

Visual Colorimeters

The Donaldson colorimeter, a visual matching instrument contrived by R. Donaldson about 1935, has been most widely used in industry. In this instrument, as in a well-known earlier one developed by J. Guild, light from a powerful lamp is passed through three separate primary red, green and blue filters, the amount of light in the three transmitted beams being controlled by varying the exposed area of each filter using three separately adjustable shutters until the specimen colour has been matched. In the Guild colorimeter, however, the light from each filter is swept in rapid succession into the line of the observer's view by means of a rapidly rotating prism in front of the filter-shutter assembly, whereas in the Donaldson instrument the three beams from the filters pass through a small window into an 'integrating sphere'. This is an interesting device consisting of a sphere having a matt white-coated interior surface which acts like a spherical screen so that the three beams undergo repeated diffuse reflections and hence uniform colour mixing within the sphere. A second window at a right angle to that by which the beams enter the sphere allows the mixture of the beams reflected from the opposite wall of the sphere to emerge into the aperture of the colorimeter where it is viewed alongside the light from the specimen.

The primary light filters mostly used in tristimulus colorimeters for obtaining the three coloured light beams are generally highly saturated red, green, and blue, and they have to be chosen for uniformity and permanence. It is the usual, though not exclusive practice to illuminate an opaque specimen at an angle of 45° and to view in a direction perpendicular to the surface, or vice versa, so that the measurement is made essentially on the light that is diffusely reflected by the specimen.

A colorimetric match, whether additive or subtractive, is valid for general use, or reference to other instruments, only when the character of the illumination of the matched specimen is specified. For this reason the C.I.E. system has standardized three selected illuminants, labelled S_A, S_B, and S_C, and more recently three others, which are described on pp. 117–118.

Visual colorimeters, being subjective in operation, have the limitation that the results obtained tend to vary from observer to observer and even a reliable observer will tend to work more accurately while fresh at the beginning of the day than when fatigued towards the end of the day or after a heavy meal when it is well known that visual efficiency goes down. Consequently visual additive colorimeters have given way to photoelectric tricolorimeters, although it is not easy to make a photoelectric colorimeter that can compete with the sensitivity of the eye for colour discrimination.

Photoelectric Colorimeters

Many *photoelectric colorimeters* have been developed and marketed in recent years. In principle they are simple. Either the coloured specimen is illuminated in succession by the three primary lights obtained through standard filters and the reflected light in each case is picked up and measured by a single photoelectric cell, or the light from the white-illuminated specimen is reflected to three photocells each having one of the primary filters in front of it. The former is the method adopted in present-day commercial instruments, presumably because the optical system is simpler and the cost lower compared with the provision of three cells with balanced sensitivities (see below). The small electric current generated by the action of the light on the photocell is amplified and measured on a galvanometer, the scale of which usually supplies readings (tristimulus values) related to or convertible into the international C.I.E. units (see p. 116). Prior to making measurements it is generally necessary to calibrate or balance the photoelectric cell or cells against the light reflected by a good white reference surface, which may be composed of freshly prepared magnesium oxide as giving the best approach to an ideal white, or is often a calibrated secondary standard of opaque white glass.

The spectral colour sensitivities of the photocells are important. It is extremely difficult to make cells having the correct sensitivity but, fortunately, most of the differences in relative response between a photocell and the human eye can be corrected by the choice of supplementary filters for use with the cell as a unit. For the same reason, the exact requirements in the three primary colour filters depend upon the sensitivity of the photoelectric cell or cells in the particular type of instrument. Colorimeters can be designed to give direct readings in C.I.E. units, but a large number of coloured filters is required to modify the spectral response of the photoelectric detector to achieve precise agreement with the colour vision (colour matching functions, p. 137) of the average human eye or standard C.I.E. observer (p. 117), and the use of so many filters presents practical problems. With the several

photoelectric colorimeters currently available commercially, the number of filters is restricted to give a reasonable approximation to the C.I.E. functions, so that they are useful, essentially, only for differential colorimetry, that is, the measurement of colour differences between materials of nearly the same colour, rather than for highly accurate absolute colour measurements.

Two widely used and typical photoelectric colorimeters are the Colormaster, made by Manufacturers Engineering and Equipment Corporation, Pennsylvania, and the Color Eye, made by Instrument Development Laboratories, Massachusetts, a division of the Kollmorgen Corporation. The Colormaster, a differential colorimeter, is well-known in the textile, paintmaking and other industries. In this instrument, see Fig. 6.4, light from a suitable standard source is split into two beams,

Fig. 6.4 **The Colormaster, Model 5**, photoelectric colorimeter, made by Manufacturers Engineering and Equipment Corporation, Warrington, Pennsylvania. In the top centre of the control panel is the microammeter which shows the balance between the two photo-currents obtained from the sample and the reference surface. The balance is determined by a variable aperture for the illumination of the reference surface, the control for which can be seen on the left side of the panel, with the displayed measurement above it. The switch for operating the red, green and blue tristimulus filters is on the right-hand centre of the panel. The standard illuminant can be changed to detect and measure metamerism (p. 34). *Photograph by Dr G. L. Wakefield, MScTech, FRPS, FIIP, through courtesy of Dr L. C. Spark, AInstP.*

one of which illuminates the test specimen and the other a white reference surface. The light reflected from each is collected respectively by two matched photoelectric cells. A variable aperture adjusts the amount of light falling on the reference surface and the two photo-currents from the cells are balanced or equated in a sensitive electrical circuit, the control of the variable aperture to give the balance providing the measurement, which is displayed on the control panel of the instrument.

Measurements are made in turn with the red, green and blue filters to obtain the tristimulus values, the filters being carried on a rotatable disc controlled by a switch.

The Color Eye, which has also won acceptance in many industries, is both a tristimulus colorimeter and an abridged spectrophotometer

Fig. 6.5 **The Color-Eye Model LS (Large Sphere)** photoelectric colorimeter and abridged spectrophotometer, made by Instrument Development Laboratories, Attleboro, Massachusetts. The large integrating sphere, 18 in. in diameter, by which the specimen and standard are illuminated, enables measurements to be made on samples of almost 3 in. (75 mm) diameter. This model is designed particularly for textiles and other materials with irregular surfaces. The sample holder can be seen on the right of the sphere, the holder for the reference standard being on the far side of it. On the top of the sphere is the external illuminator which minimises heating of the sample and is convenient for changing the illuminant. The dial for selecting the tristimulus filters or the 16 spectral filters is located on the left centre of the control panel. The digital dial, which shows direct readings, is on the upper right side of the panel and the meter on the top left. Transparent samples are introduced into the light path by inserting a sliding sample holder to the right of the control panel, when a matched white standard has been placed in the reflection sample holder behind the sphere. An additional unit, named the AutoMATE, is now available which automatically operates the filter wheel and digital display dial and prints out (teletypes) the measurements, providing a punched tape for use on a computer.

(see p. 111). The simple rotation of a dial selects the tristimulus filters for colorimetric readings or sixteen narrow-band interference filters for spectrophotometric measurements. The test specimen and the reference standard are diffusely illuminated from each half of an integrating sphere (p. 96) which is itself illuminated by an appropriate illuminant.

Fig. 6.6 **The Colormate 2000, Model 602,** photoelectric colorimeter, made by Neotec Corporation, Rockville, Maryland. This colorimeter uses a single beam of light to illuminate both sample and standard, instead of two beams as in most other instruments. The light beam, after passing through the automatically cycled tristimulus filters in turn, is projected by a lens system on to a rotating white standard shaped like the figure 8 with two lobes and two spaces. When the beam misses the revolving lobes it continues a short distance to the sample, placed over a viewing port. The light reflected alternately by the standard and sample is sensed by a photoelectric cell mounted inside a vertically moving chamber. The opening or 'window' to this chamber is split by the edge of the rotating standard into an upper part exposed to the sample and a lower part exposed to the standard. The photocell chamber is moved automechanically up or down until the light received by the cell no longer fluctuates, that is, the quantities of light entering through the two areas of the 'split-window' are equal. For a bright sample this occurs when the chamber is low, so that the lower part of the opening, facing the standard, is large compared with the position for a dark sample. The equilibrium position determines the results that are displayed, in sequence with the filters, at the left-hand side of the front panel. The push-buttons for operating the filters are on the right side of the panel. With the most popular model, the numerical results are related, by reference to a chart supplied with the instrument, to the units of the Munsell system (p. 91), although models giving readings in C.I.E. units are available. The handle visible at the right-hand end in the picture confirms the portability of the instrument. The colorimeter can be directly connected to a print-out accessory or a computer.

The converging light beams from the specimen and the standard are 'chopped' by a rotating flicker mirror and alternately focused on to a photoelectric photomultiplier tube (a type of photocell which amplifies the initial photoelectric current) after passing through the selected filter. The flicker photometer system produces an electrical signal representing the difference in brightness between specimen and standard which is

PLATE 13 An example of colour harmony, red against reddish-brown. Such similar colours look pleasant together because they blend well, but their visibility, one against the other, is low and the lettering in this example becomes almost invisible at a distance.

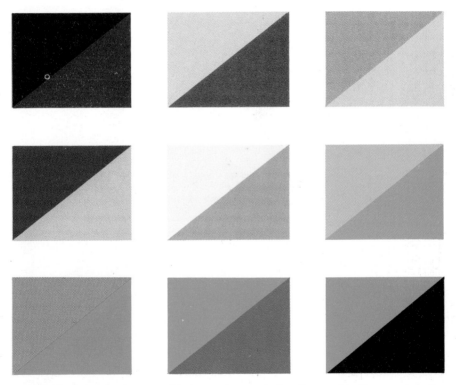

PLATE 14 Related colours provide harmonious and attractive combinations, such as the examples shown above, and are termed analogous colours by the artist.

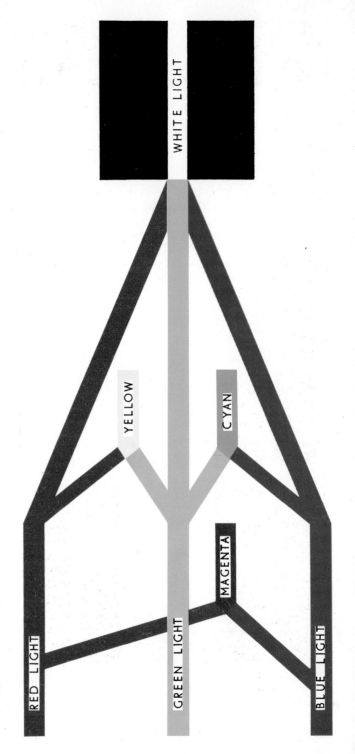

PLATE 15 **ADDITIVE** colour processes are based on the projection by suitable means of separate beams of coloured lights which are mixed or blended to produce other colours, including white, to the eye.

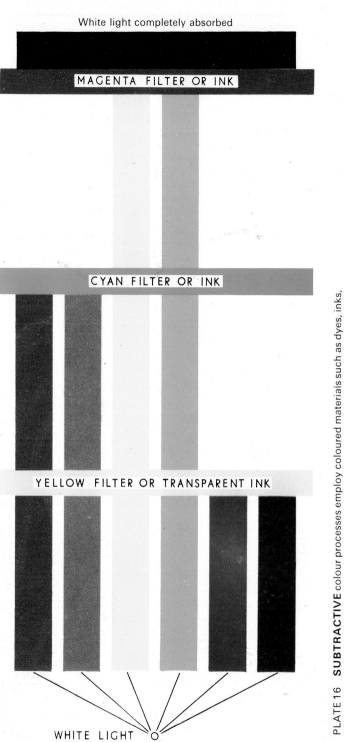

White light completely absorbed

MAGENTA FILTER OR INK

CYAN FILTER OR INK

YELLOW FILTER OR TRANSPARENT INK

WHITE LIGHT

PLATE 16 **SUBTRACTIVE** colour processes employ coloured materials such as dyes, inks, paints, etc., which are mixed or superimposed to obtain other colours and black.

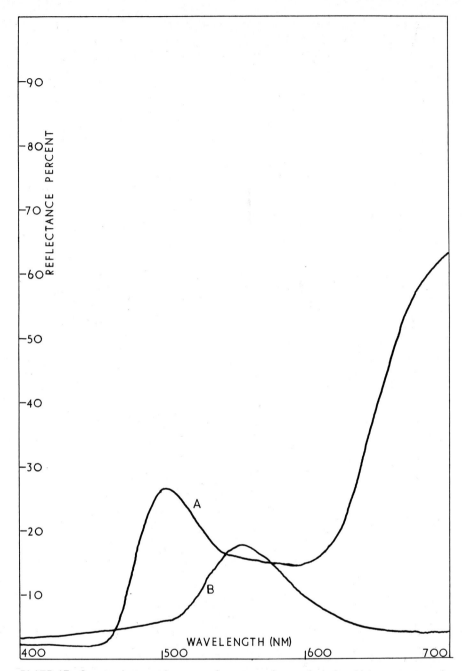

PLATE 17 Spectrophotometric curves from two pieces of cloth which are metameric. They appear to be a closely similar yellowish green in daylight, but the cloth represented by curve A becomes a reddish brown in tungsten lighting. Note the three crossing points of the two curves and that, in this example, the peak of curve B, which is typical for a normal yellowish green material, falls between the two peaks of curve A for the cloth that is yellowish green in daylight and markedly reddish in most artificial light.

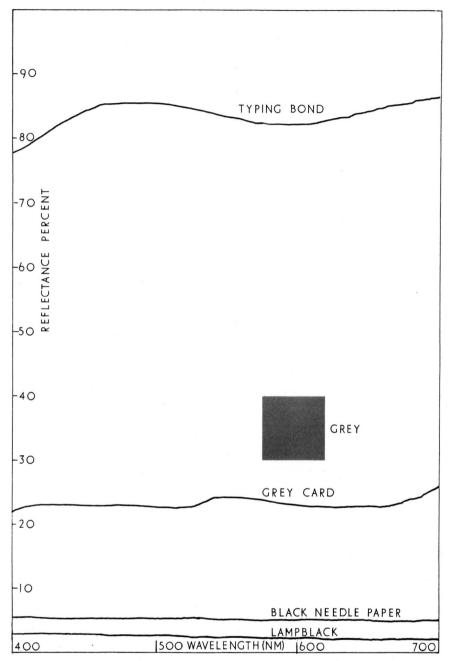

PLATE 18 Spectral reflectance curves for a white paper, a mid-grey card and two familiar black materials.

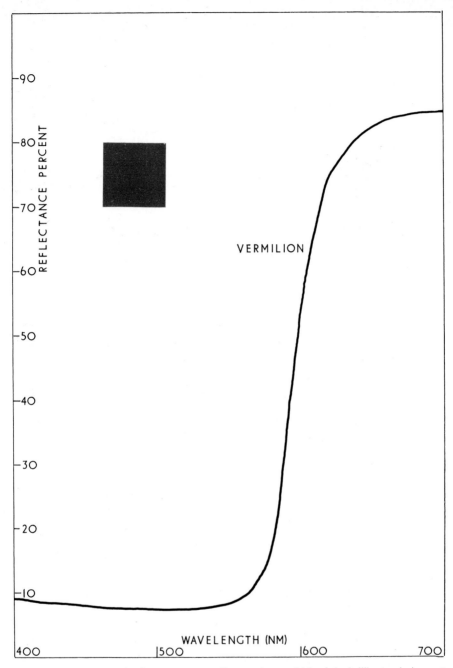

PLATE 19 The spectral reflectance curve, discussed on p. 115, of the brilliant red pigment known as vermilion. The curve is typical of those obtained from several 'pure' red and scarlet materials which, as the curve shows, are actually orange-reds.

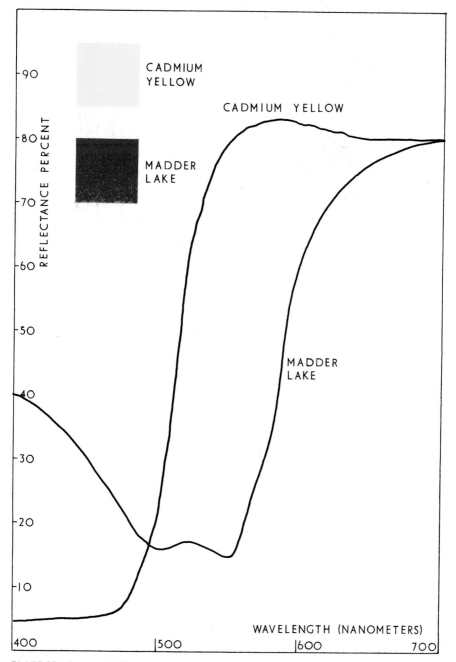

PLATE 20 Spectral reflectance curves for well-known bright yellow and magenta pigments. The cadmium yellow reflects around 80% of the incident light over almost two-thirds of the spectrum and absorbs nearly all the blue and violet. In a dense film the madder lake approaches crimson but in thin films it becomes bluer, that is, more purple.

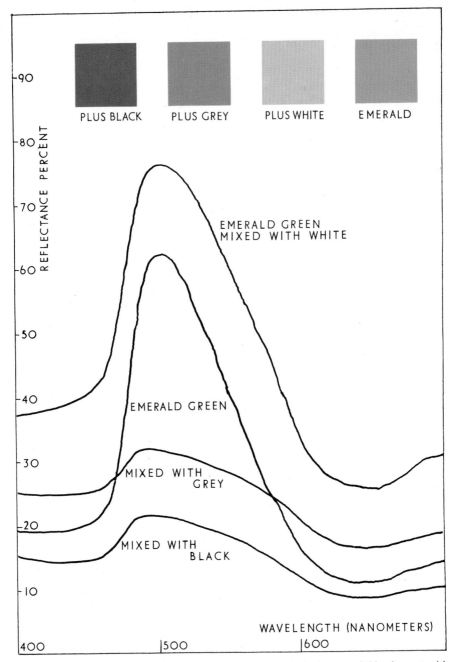

PLATE 21 Spectral reflectance curves of emerald green and mixtures of this pigment with white, grey and black. Note the desaturation produced by all the mixtures, that is, the increased proportion of reflection at other wavelengths compared with the green reflectance; and the large decrease in the green reflectance (lightness) of the two shades.

fed to the indicating meter. The instrument therefore measures the light from the specimen relative to that from the standard for each of the filters. See Fig. 6·5, p. 99, and the addendum, p. 142.

A portable electronic colorimeter which incorporates a novel method for equating the light from the standard to that from the specimen, the Colormate 2000, has been marketed lately by the Neotec Corporation of Maryland, U.S.A., and is described with Fig. 6.6.

A new photoelectric colorimeter that makes use of fibre optics and has potentialities for development into an instrument for the direct and accurate measurement of C.I.E. values has been designed very recently by the Paint Research Association. While it was devised primarily as a differential colorimeter for remote colour control in paint manufacture, the use of fibre optics overcomes the practical difficulties presented by the inclusion of a large number of filters in the more traditional optical systems for exact duplication of the C.I.E. functions. The instrument has been patented and is expected to be marketed very shortly.

Fibre Optics

Fibre optics have been developed over the past two decades, chiefly to provide flexible light guides or conductors made from glass fibres for a range of important optical applications. The fundamental principle is that of total internal reflection. Because the angle of refraction is greater than the angle of incidence when light passes from a denser to a rarer medium, say from glass to air, rays travelling in the denser medium which strike the surface between the two media obliquely, at angles greater than the so-called critical angle at which the refracted ray skims along the surface, are completely reflected back into the denser material. If light is passed into the end of a transparent rod or fibre some of it will emerge through the side, but the rays striking the surface at more oblique angles will be totally reflected within the rod or fibre and therefore transmitted along its length, until some part of the surface is encountered which allows refraction outwards. This part of the surface could be vitiated by a film of grease, oil, water or dust, or just a scratch. By surrounding the rod or fibre with a protective and optically insulating sheath of material having a lower refractive index than the rod or fibre, such loss of light is prevented and the light in transmission is held within the fibre. The sheath is an essential addition to the transparent light-carrying core which has made fibre optics practically possible. See Fig. 6.7.

A sheathed glass or plastic fibre that is fine enough to be flexible acts as a light pipe which can be arranged in any course its flexibility and length allow. Fibre optic elements have been made with glass fibres as fine as 0·005 mm in diameter, the core of relatively high refractive index

E

being some 0·004 mm in diameter, which is the optical limit. Plastic fibre elements have not been made so far of diameters less than about 0·05 mm.

To be sufficiently robust and to transmit adequate light in use, a fibre optics component consists of many fine fibres arranged alongside each other, the ends being fixed together and the fibres in between left free so that the whole assembly is highly flexible. For such flexible fibre

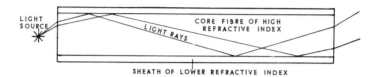

Fig. 6.7 **The principle of sheathed fibres in fibre optics.** The sheath protects the surface of the fibre from contamination and damage so that the internal reflection of light within the fibre is maintained throughout its length and the fibre functions as a light guide.

bundles, fibres of approximately 0·05 mm in diameter are generally used. Alternatively, the parallel fibres may be fastened up into a rigid, solid bundle and the end shaped to give a plane or curved image, or a solid bundle of fused glass fibres that have been tapered in diameter will enlarge an image presented to the small end to the size of the large end. These alternatives extend the applications of fibre optics considerably.

The main components of the *fibre optics colorimeter* developed by the Paint Research Association are shown in Fig. 6.8. A sensing head consisting of a hemispherical shell with seven radial holes in it is placed against the sample to be measured. One flexible fibre optic element connects the standard light source (C.I.E. illuminant S_A) to the central hole of the sensing head, thus illuminating the sample perpendicularly or normally. Six other fibre optic elements are attached to the other six holes which are symmetrically arranged at angles of 45°, so that the light diffusely reflected from the sample is efficiently collected by these elements at 45° in six different directions around the perpendicular. Coloured correction filters can be positioned at one or both ends of some or all of the seven fibre optic elements. The light collected by the six elements is transmitted by them to the detector head, which is composed of two coaxial cylinders, the inner one being rotatable relative to the outer cylinder to which the ends of the six collecting fibre elements are symmetrically connected. The inner cylinder carries several more filters for correcting the colour sensitivity of the instrument to obtain close correspondence with the C.I.E. colour matching functions. If

higher accuracy is required, more than six collecting fibre elements with filters can be used.

Light from the detector head passes into a light-tight unit and through the usual tristimulus filters, in turn, to a photoelectric photomultiplier, the output voltage from which is measured by a voltmeter. Another particular advantage of the flexible fibre optics light guides in this new colorimeter is that the sensing head can be brought to the specimen for

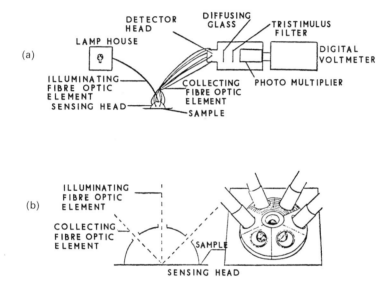

Fig. 6.8 The fibre optics photoelectric colorimeter developed by the Paint Research Association, Teddington, Middlesex. (a) is a schematic diagram showing the different parts of the colorimeter. In (b) the sample to be measured is shown against the sensing head. *Reproduced from Optica Acta, 1970, Vol. 17, No. 10, by courtesy of the Paint Research Association and Optica Acta.*

measurement, instead of bringing the sample to the instrument as in existing additive photoelectric colorimeters. This makes the instrument useful for remote measurements and, therefore, for control of colour at a reasonable distance, so that it should be a very suitable tool for automatic production control in many colour-based industrial processes. In the prototype instrument constructed at the Paint Research Station, the fibre optic elements are about 1·2 m in length.

SUBTRACTIVE COLORIMETERS

Subtractive colorimeters operate on the subtractive principle which is closely parallel to the additive principle, as explained in Chapter 5, p. 80. Quite the most widely-used instrument of this kind is the *Lovibond Tintometer* developed by The Tintometer Limited, Salisbury, England. The specimen sample is placed in the instrument and illuminated alongside a standard white surface in front of which subtractive primary coloured glass filters are inserted until a match is obtained, the sample and the matching filters each occupying one half of a narrow field of view, as seen through the eye-piece of the instrument. It is worth interpolating here that the purpose of the narrow angle of viewing adopted in all visual colorimeters is to concentrate the light from the colours being matched on to the highly colour sensitive fovea in the centre of the retina of the eye.

The Tintometer filters are very carefully prepared and standardized and supplied in three graduated sets corresponding to the subtractive primaries, each set ranging from slightly tinted glasses to deeply coloured slides. Each filter is numbered according to its depth of colour on a scale of two properties. First, the scale units are so chosen that each filter set is additive, that is, a filter of a given value is equivalent to two or more in the same series having the same total value; for example, a filter designated as 3 units of yellow will match a combination of a 2 unit yellow and a 1 unit yellow. Second, the units for the three sets are related in such a way that when three filters of equal value from the three series are superposed and viewed against the white background, their subtractive colour combination gives a neutral grey. In the nomenclature of the Tintometer system, the filter sets are referred to as red, yellow and blue, although they are actually the magenta, yellow and cyan subtractive primaries described in Chapter 5. The filters are mounted in racks so that they can be readily traversed in turn across the field of view.

The colour matching precision of the instrument is limited by the discrete steps that separate one filter from the next in the series. Nevertheless, the total number of steps in each primary series is 220, so the number of different colour combinations obtainable is almost 9 000 000. For many purposes when no more than arbitrary colour measurements are required, specifications in terms of the Lovibond units are fully adequate.

The instrument has been modified in the Lovibond–Schofield Tintometer, Fig. 6.9, to give the units in a form easily converted to the equivalent C.I.E. specification. The same three filter series are employed but not more than two of the sets are used when making a measurement,

for example, only the yellow and blue series are used for matching green samples, or only the red and yellow sets for orange samples, etc. This enables specimens to be matched in hue and saturation while lightness is matched by manipulating a vane which controls the relative illumination of the two halves of the field of view. There is provision for the use of the C.I.E. standard illuminants S_A, S_B or S_C. A conversion graph (a nomo-

Fig. 6.9 **The Lovibond Schofield Tintometer,** made by The Tintometer Limited, Salisbury, Wiltshire. The viewing tube is prominent. The racks of glass colour filters are situated immediately behind and to the right of the base of the viewing tube. On the left and right of the instrument casing are the circular covers with vents to the housings of the paired lamps which illuminate the sample and the white reference standard. Between the lamp houses is the compartment for accommodating liquid samples. Solid samples are held centrally to the back of the casing by means of magnetic spring clamps. The control knob for operating the photometric or brightness vane unit is visible on the left side of the instrument, and above it is an illuminated dial for recording brightness levels. The separate unit on the right is a stabilized power pack to control the illumination system accurately to illuminant S_A. Provision is made within the viewing tube for a two-compartment glass cell holding the standard colour filter solutions to transform the illumination to either S_B or S_C (see p.117).

gram) and tables are available from which the corresponding C.I.E. specification can be read off directly from the Tintometer readings. The nomogram, being a conversion graph, enables the procedure to be reversed. That is, known numerical C.I.E. values of a colour can be converted into the respective combinations of Lovibond filters which

can then be viewed in the Tintometer, so that the specified colour can actually be seen. This is a unique advantage of the Tintometer system.

The Lovibond Flexible Optic Tintometer is now available which uses flexible glass fibre optic leads to connect a viewing head to the instrument, as with the photoelectric colorimeter recently developed by the Paint Research Association. The viewing head has two leads, one for illumination and the other for observation of the sample to be measured, the observation lead transmitting the light from the sample to half the viewing field in the eye piece of the instrument. Colour correction filters are fixed at the ends of the fibre optic leads to eliminate, in this instrument, any inherent colour of the glass fibres. Various viewing heads are provided that, with the flexible leads, make the colorimeter especially suitable for very large, very small, or irregularly shaped samples, for specimens difficult of access or which have to be measured under controlled ambient conditions. Printed nomograms are supplied for converting the measurements to C.I.E. values.

Where measurements are confined to a small colour range, as with many industrial products, this can be covered with a small number of filters. Hence a simple colour comparator has been developed that is extensively used in the testing of oils, food, agricultural, pharmaceutical and manufactured products and in medical work.

SPECTROPHOTOMETRY

The spectrophotometer is another fundamental instrument for colour measurement that is widely and increasingly being used. The measurement is in the form of a graph, the curve of which shows how the proportion of incident light reflected or transmitted by a specimen varies throughout the spectrum. Such comprehensive information about the spectral composition of the light from materials, when illuminated by some specified illuminant, is essential for the solution of many colour problems and from it the international standard C.I.E. specification for a colour can be derived.

Photoelectric Spectrophotometers

Visual spectrophotometers were originally developed but the observations are lengthy, fatiguing and generally less accurate than with photoelectric instruments which have now replaced them. Several *photoelectric spectrophotometers* are available that differ in technical details such as the means of obtaining a spectrum and the methods of illuminating and collecting the light from the specimen, but they are similar in general principle. See Fig. 6.10.

A spectrum is produced by passing the beam of light from a suitable lamp through either a prism or a diffraction grating (see p. 11), usually the former. From this spectrum a narrow wavelength band is isolated by means, say, of a movable and adjustable slit. This narrow colour beam may then be projected to illuminate the specimen and a standard white surface, magnesium oxide, in succession, or it may be split into two beams to illuminate the sample and the white surface simultaneously.

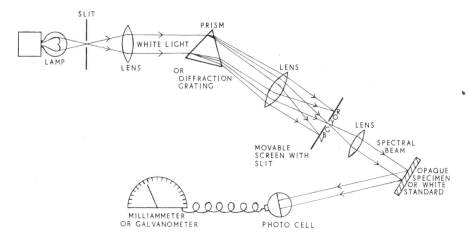

Fig. 6.10 **The principle of a full spectrophotometer,** arranged primarily for measurements on opaque reflecting surfaces.

With a single-beam instrument, as shown, measurements are made alternately on the specimen and a white standard at each very narrow waveband passed through the movable slit, to obtain the reflection factor of the specimen at almost each wavelength of the spectrum. Some spectrophotometers, particularly those which provide an automatic record, employ a double-beam arrangement in which the isolated spectral rays are split into two beams, and the specimen and the white standard are illuminated simultaneously alongside each other. Using the arrangement shown, transparent materials may be introduced into the path of the spectral waveband, on the right of the diagram, while keeping the white standard in the place of the opaque specimen throughout the measurements.

The light reflected from the two surfaces is received by a photoelectric cell, the current from which, in the former case, is used as a measure of the amount of light entering it from each surface, or, in the latter case, the photocell is used to test for equality between the two beams when their relative intensities are adjusted with a calibrated optical device. By these means the amount of the almost monochromatic light reflected from the specimen is measured as a percentage of that reflected from the white surface, which is the reflection factor of the specimen at the particular waveband selected. By moving the slit or rotating the prism this narrow waveband can be made to traverse the complete spectrum and thus measurements are taken almost wavelength by wavelength

in turn. Finally, these measurements are plotted on a graph to show the percentage reflection, usually on the vertical axis, against wavelength, on the horizontal axis. If the specimen is transparent, the spectral beam is projected through it and from it to the photoelectric cell.

It will be appreciated that the more thoroughly the spectrum is covered, waveband by waveband, the more time is consumed in making the measurements and plotting the spectrophotometric curve; and that a full spectrophotometer is a relatively complicated, large and expensive instrument. These factors have resulted in opposite consequences as follows.

Recording Spectrophotometers

Automatic recording spectrophotometers have been devised in which, through ingenious electrical and mechanical linkages with the optical system, a pen is made to move according to the reflection factor of the specimen over a cylindrical drum carrying a sheet of graph paper which rotates in accordance with the wavelength of the light. Thus a spectrophotometric curve is produced automatically and, comparatively, very quickly. Probably the best known of the number of recording instruments

(a)

Fig. 6.11 **The Hardy recording spectrophotometer,** now made by the Diano Corporation, Foxboro, Massachusetts. (a) The complete instrument with tristimulus integrator. (b) The spectrophotometer with cover, access doors and panels removed, showing the main details. The clamps for holding opaque specimens and the white reference standard are shown at the right-hand end of the instrument, these being at the back of an integrating sphere which collects the reflected light. The handle on the top right, in photograph (a), is for opening the compartment into which transparent samples are inserted in the light beam as it enters the sphere, when a matched white standard is placed in the reflection sample holder. The lamp is situated at the near centre under the ventilation grid visible on top of the casing. A spectrum is produced by means of a prism to the left of the lamp, from which narrow regions are successively separated by a slit and reflected to the right from a mirror towards the rear side of the apparatus. Further slits and prisms continuously isolate narrow wavelength bands of about 10 nm and split these into two beams that illuminate the sample and standard simul-taneously. The reflected light collected by the integrating sphere passes to a phototube and photometer unit under the sphere. The rotation of a special prism, at the rear centre in picture (b), balances the light reflected from the sample and standard. A sensitively controlled cam is connected to this prism with a measurement mechanism, which translates the position of the prism into percentage reflectance that is displayed on a digital indicator and recorded by a moving pen on the graph-paper covered drum seen in photograph (a). Another cam with gearing, situated in the middle of the apparatus, connects the mirror unit to the recording drum to give an evenly-spaced wavelength scale on the graph. The whole instrument is controlled automatically. A tristimulus integrator is installed beneath the actual spectrophotometer and the control panel for this is visible on the lower left-hand side of picture (a). Computer automation of the instrument has now been developed.

now on the market is the Hardy spectrophotometer, first developed by A. C. Hardy in the 1930s in America and manufactured, including subsequent redesigning, by the American General Electric Company

until very recently and now by the Diano Corporation, Massachusetts. See Fig. 6.11. This apparatus will supply a complete spectrophotometric curve in about two minutes. The calculation required to convert such a curve into the equivalent international C.I.E. units is tedious and so a very useful addition, named an Automatic Tristimulus Integrator, has been made available in recent years which gives the corresponding C.I.E. quantities automatically as the curve is being recorded.

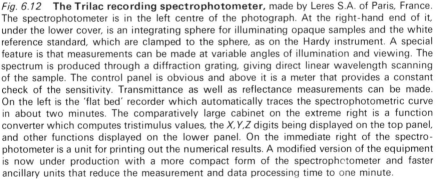

Fig. 6.12 **The Trilac recording spectrophotometer,** made by Leres S.A. of Paris, France. The spectrophotometer is in the left centre of the photograph. At the right-hand end of it, under the lower cover, is an integrating sphere for illuminating opaque samples and the white reference standard, which are clamped to the sphere, as on the Hardy instrument. A special feature is that measurements can be made at variable angles of illumination and viewing. The spectrum is produced through a diffraction grating, giving direct linear wavelength scanning of the sample. The control panel is obvious and above it is a meter that provides a constant check of the sensitivity. Transmittance as well as reflectance measurements can be made. On the left is the 'flat bed' recorder which automatically traces the spectrophotometric curve in about two minutes. The comparatively large cabinet on the extreme right is a function converter which computes tristimulus values, the *X,Y,Z* digits being displayed on the top panel, and other functions displayed on the lower panel. On the immediate right of the spectro- photometer is a unit for printing out the numerical results. A modified version of the equipment is now under production with a more compact form of the spectrophotometer and faster ancillary units that reduce the measurement and data processing time to one minute.

More recently a Japanese automatic spectrophotometer which incorporates certain novel features and includes a tristimulus integrator has been marketed. There are several other recording instruments such as Leres' Trilac (Fig. 6.12), which is linked with a tristimulus integrator,

the Pye Unicam (Fig. 6.13), Beckman, Bausch & Lomb, Cary, and Zeiss spectrophotometers. Such more elaborate instruments are, obviously, still more expensive and complicated to operate, yet their industrial use is growing with the expanding applications of electronics and computers.

Fig. 6.13 **The Unicam SP700 recording spectrophotometer,** made by Pye Unicam Ltd., Cambridge, England. This instrument is intended primarily for analytical and chemical research spectrophotometry on transparent solutions and vapours, which are placed in a compartment shown under the operator's right hand. For reflectance measurements, this compartment is replaced with a special accessory into which the opaque sample and white reference surface are inserted. A pure silica prism provides a wide spectral range from 190 nm, in the ultraviolet, through and beyond the visible region, and a diffraction grating is used to extend the range for transmittance measurements to 3570 nm in the infra-red. The narrow waveband isolated by means of slits is split into two beams to illuminate or irradiate the sample and standard, and the radiation transmitted or reflected by them is focused by mirrors on to a photomultiplier up to 700 nm and at longer wavelengths on to a lead sulphide photo-electric cell. The signals from the detector are amplified and automatically switched between sample and reference standard, the reference signal being maintained approximately constant. The output signals are fed through a precisely adjusted electrical system, situated between the controls on the front operating panel, to the chart recorder above the panel which plots the ratio of the sample transmission or reflection to that of the standard.

Abridged Spectrophotometers

In the opposite direction, simpler and therefore cheaper '*abridged*' *spectrophotometers* are much used where the requirements are more

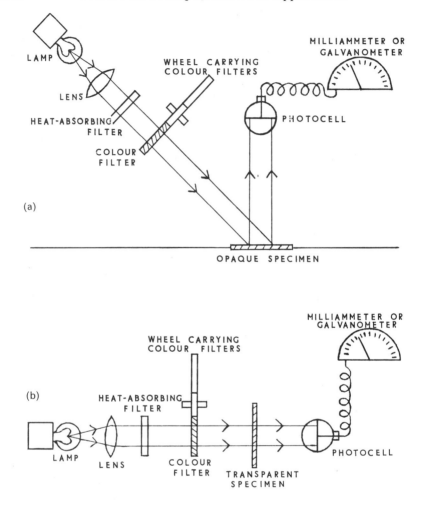

Fig. 6.14 **The principle of abridged spectrophotometers** for (a) reflection and (b) transmission measurements. The filter wheel carries a range of filters to cover the spectrum, each filter transmitting a known wavelength band. Measurements are made in turn through each filter. In the simpler instruments, a standard white surface is first introduced in place of the specimen and the galvanometer reading adjusted to 100 for the respective filter, so that a percentage colour reflection or transmission reading is obtained for each measurement on the specimen. The results are then plotted graphically in accordance, on the wavelength axis, with the peak of the transmission band for every filter.

limited and an approximate spectrophotometric curve will suffice. The sample specimen is illuminated through a series, one at a time, of eight to sixteen narrow band colour filters and the reflected or transmitted light is measured, again in comparison with that reflected from a

standard white surface representing 100%, with a photoelectric cell connected to a galvanometer. See Fig. 6.14. The filters are selected so that the series usually covers the spectrum in a succession of narrow zones or intervals, each filter transmitting the light over one zone of, perhaps, 30 nm between 400 and 700 nm. In this way eight or ten or more

Fig. 6.15 **The Pretema FS-3A Spectromat** filter spectrophotometer, made by Pretema AG, Zurich, Switzerland. The base of the large integrating sphere for illuminating the sample and standard can be seen on the right. The supported stage or platform below the sphere holds the sample and the white reference standard against an aperture in the base of the sphere which can be varied from 5 to 50 mm in diameter. On the upper left-hand side of the operating panel, the paper roll on which the results are printed-out is shown emerging, visual readings being displayed on the right-hand side. Along the lower part of the panel are two rows of controls for the 33 narrow-band filters. The instrument is fully automatic in operation after selecting by push buttons the reflectance or appropriate C.I.E. *X, Y* or *Z* function and the required standard illuminant and pressing a starting button. *Photograph supplied by Instrumental Colour Systems Ltd., Reading, England.*

reflection or transmission factor measurements are obtained which can be plotted on a graph to give a curve approximating to that obtained with a full spectrophotometer. A well designed instrument will enable any appreciable differences to be shown between specimens having the

same general shape of reflectance curves for example, metameric pairs (see p. 34). But the small number of measured points on the curve may make it difficult to determine the exact positions of the peaks of the curve, and if the curve is complex interpretation tends to be difficult.

The growing use of automatic recording spectrophotometers with their speed and convenience has led to a considerable increase over the last few years in the number of such instruments that are marketed from America, Britain, France, Germany and other countries. Among them is the Swiss Pretema Spectromat, Fig. 6.15, a more elaborate form of abridged spectrophotometer in that measurements, with the latest model FS-3A, are made over 33 narrow wavebands at intervals of 10 nm from 390 to 710 nm by means of 33 interference filters. Also, the instrument has a built-in automatic tristimulus computer or integrator which calculates C.I.E. tristimulus values (see p. 127) electronically for the standard illuminants S_A, S_C and D_{6500} (p. 117). The light source is a xenon lamp by which the specimen samples are diffusely illuminated from the walls of a large integrating sphere, 13 in. (330 mm) in diameter. The Spectromat both displays and prints-out the reflectance and tristimulus values. In line with the modern trend, it can be linked with a computer for the purpose of storing reflection and transmission measurements and solving problems concerning colour matching formulations, corrections and colour differences.

Although *a spectrophotometric curve* may be considered to be a complex measure of a colour, it is a completely objective measurement being totally independent of the characteristics of colour vision. It gives more detail about the specimen than does colorimetry since it shows the amount of reflection and absorption at every part of the spectrum in the form of a pictorial record. Specimens that have identical curves throughout the spectrum will match one another under every type of illumination and in all circumstances their colours will look alike even to colour-defective persons and animals, since they are physically identical. Spectral reflection or transmission curves will show why specimens which are a visual match under one kind of illumination are not so under different illumination (metameric matches, p. 34). An interesting and characteristic feature of the differing spectral reflection curves of metameric pairs is that the two curves cross each other at least three times, the wavelengths of the crossing positions tending to be near to those of the maxima of the three retinal colour sensitivities, Fig. 4.2, a feature which is a prerequisite of the three-colour vision theory as regards metameric matching. See Plate 17. The colour of a specimen under any illuminant, the character of which is known in terms of its energy distribution over the spectrum, can be calculated from spectrophotometric measurements. See p. 137.

TYPICAL SPECTROPHOTOMETRIC CURVES

As already stated it is the accepted convention to plot a spectrophotometric graph to show the percentage reflection/transmission or the reflection/transmission factor on the vertical axis and wavelengths on the horizontal axis. A perfect white or transparent material would give a straight line graph parallel with the wavelength axis at maximum reflection/transmission of 100% and a perfectly black material is indicated by the wavelength axis itself showing no reflection at all. Other straight line graphs parallel to the wavelength axis indicate actual whites and neutral greys, the line being at a higher percentage reflection level for a light grey than a dark grey. See Plate 18.

For coloured substances all the physical colour properties explained in Chapter 2 are accurately expressed in spectrophotometric curves. Plates 19 to 23 show typical curves for red, yellow, green, blue and magenta materials, measured from well-known artists' pigments such as are used in paints and printing inks.

Plate 19 illustrates that English vermilion (mercury sulphide) reflects about 85% of the red and around 70% of the orange light out of the incident white light, and absorbs about 80% of the yellow light and more than 90% of the green, blue and violet light. The small quantities of violet, blue, green and yellow lights which are reflected (around 10%) considered together with corresponding small quantities of the orange and red lights will constitute a small proportion of white light. Approximately, therefore, this red pigment may be said to reflect around 80% of the red and orange light together with about 10% of white light from the incident illumination. Such a small proportion of white light is almost negligible for practical purposes, so that, roughly speaking, this pigment may be said to reflect mainly red and orange light. It is clearly of a red hue with high lightness and saturation and of dominant wavelength about 670 nm. However, if this pigment is considered for use in any careful process of reproduction, then, from the scientific point of view, its accurate behaviour with regard to the light of all the colours of the spectrum, as shown by the curve, must be taken into account.

Plate 22 shows in the same way the exact properties of ultramarine blue (sodium aluminium silicate plus sulphur). This substance reflects no more than about 45% of the violet and blue light, less than 10% of the green and only 3% of the yellow out of the incident light; nor is its absorption of orange and red light complete. Because the total quantity of light reflected by this pigment is appreciably less than the quantity reflected by the vermilion, this blue pigment is bound to be less brilliant, that is, of lower lightness or luminance factor, than the vermilion under conditions of equal illumination with white light.

Plate 20 illustrates likewise the properties of light cadmium yellow

(cadmium sulphide plus barium sulphate) and madder lake (organic dye on inert inorganic base) respectively. Plate 21 shows the spectral reflection curves for emerald green (copper aceto-arsenite) together with a tint and two shades of it; and Plate 23 the reflection curves for chrome green (lead chromate plus prussian blue) and an olive green, with the transmission curve for a highly transparent green filter (dyed gelatin) of the kind used in photography for colour separation. Note (a) the high reflection of red, orange, yellow and green light and the high absorption of blue and violet by the cadmium yellow, indicating high lightness and saturation as with the vermilion; (b) the reflection of light from both ends of the spectrum by madder lake, though mainly at the red end giving the pigment a reddish purple (magenta) appearance or hue; (c) the comparatively low reflections and, therefore, low lightness even in the green region of the emerald green and particularly the chrome green pigments with dominant wavelengths of about 505 and 520 nm; and (d) the complete absorption of violet and red light and nearly all blue and orange light by the yellow-green filter, showing it to be of high saturation or purity and having a dominant wavelength of 530 nm. Plate 23 also shows the curve produced by a cabbage leaf and Plate 24 those obtained from specimens of fruit and a flesh tone.

THE C.I.E. SYSTEM

For a diversity of reasons indicated at the beginning of this chapter, all the different methods previously described for the measurement of colour are in widespread use and will continue to be. A major step to bring uniformity into the various established methods of colour measurement was taken in 1931, when an international conference of the *Commission Internationale de l'Eclairage* (C.I.E.) agreed upon a system for the numerical specification of colours. This system provides a common basis for all colour measuring methods which is independent of the colour vision of any particular individual, so that results may be interchangeable between different methods and between different instruments using any one method. It is a convenient numerical code that is not difficult to interpret and it gives an unambiguous definition of a colour, representing the sensation that colour would produce on an average observer. Moreover, it provides a means for calculating and predicting the results of colour mixtures and so on. Because of its advantages as a precise kind of universal language for colour, though a numerical one, its usage is steadily spreading and there has been a general rationalization of the design of colour measuring instruments following its introduction. A notable example of both national and international use of the C.I.E. system is provided by the standardized

specifications of coloured signal glasses for the various forms of transport, and as a consequence of studies now proceeding it is probable that the colours of road signs will be internationally agreed and defined within the system before long.

Standard Observer

The purpose of the internationally accepted C.I.E. system is to give an accurate description of what a colour looks like. But as mentioned in Chapter 4 on Colour Vision, p. 58, there are some differences in the reactions of individual observers, excluding those with defective colour vision, so that one of the features of the C.I.E. system is a definition of an imaginary *Standard Observer*. In fact, this definition is based on the average results obtained by a number of non-colour-defective observers in matching colours additively under standardized conditions by means of three selected primary lights or stimuli as the latter are called, of wavelengths 700·0, 546·1 and 435·8 nm. Hence the definition of the standard observer involves the colour-matching data related to the theoretical primary stimuli of the C.I.E. system (p. 123), in the form of a series of reference tables of figures, for a good average or normal observer and C.I.E. specifications always give results that are acceptable to ordinary observers. See also the captions to Figs. 4.4 and 6.20.

Standard Illuminants

Another factor, explained on p. 31, that affects the apparent colour of objects is the character of the illumination. For colour measurement, therefore, a standardized kind of illumination or illuminant is essential. Three *Standard Illuminants* were adopted by the C.I.E. in 1931 to provide a choice depending on which is the most representative of the conditions under which materials for measurement will normally be used and seen. One of these, illuminant A or S_A, is a gas-filled tungsten filament lamp operated at a colour temperature of 2854°K (see p. 14), giving a standard illuminant typical of average artificial tungsten-lamp lighting. The other two sources of illumination, standard illuminants B and C, or S_B and S_C, are intended to be representative of sunlight and light from an overcast sky (average daylight) respectively, and are obtained by using illuminant A together with liquid colour filters consisting of two chemical solutions made up to specified compositions each in a thickness of 1 cm contained in colourless optical glass cells, to give colour temperatures of approximately 4900°K and 6700°K. For the mathematical purposes of the C.I.E. system, the energy distributions over the whole of the spectrum for each of these illuminants are specified in the form of tables showing their energy values at each wavelength,

since the spectral energy distributions of the illuminants, particularly S_B and S_C, differ significantly from those of a perfect black body at the temperatures quoted.

Although illuminants B and C represent sunlight and daylight fairly well, they are seriously deficient at wavelenghts below 400 nm, that is, in ultra-violet rays. The increasing use of fluorescent dyes and pigments (see p. 51) has led recently to the definition of additional standard illuminants representing daylight at all wavelengths between 300 and 830 nm. These are known as D_{6500}, D_{5500} and D_{7500}, the figures indicating correlated colour temperatures. For general use the spectral energy distribution of D_{6500} is typical of that for average daylight, D_{5500} represents a yellower daylight (sunlight plus skylight) and D_{7500} a bluer daylight (north skylight). It is expected that S_C will be replaced by the better D_{6500} as the standard daylight illuminant when a suitable form of lamp becomes available. As yet there are no standard illuminants representative of the various types of fluorescent lighting in use, but appropriate standards may be set up eventually. In a colorimeter intended for standard measurements, the specimen to be measured is illuminated by the most suitable of the illuminants, S_A, S_B or S_C, etc. A precise knowledge of the characters of illuminants within the C.I.E. system, in terms of their energy distribution over the spectrum, enables a spectrophotometric colour measurement related to one illuminant to be transposed to that under another, as is explained later.

The Chromaticity Triangle

It has been indicated above, with reference to the standard observer, that the additive mixture of three primary coloured lights is the basis of the C.I.E. system. These three lights may be supposed to occupy the corners of an equilateral triangle and the concept of a colour triangle may be familiar because it is often used to demonstrate additive colour mixing principles. For that purpose a flat triangular board is fitted with a housed lamp at each corner, each lamphouse carrying one of three red, green and blue filters facing the board. The additive mixing effects explained in Chapter 5 are produced very simply with this apparatus, approaching white in the centre of the triangle, yellow half-way along the side between the red and green lights, purple (magenta) between the red and blue, and greenish-blue (cyan) half-way along the side of the green and blue lights. A triangle is often drawn to represent such an arrangement and it can be applied to colour measurement.

Let us consider an equilateral triangle as in Fig. 6.16 on which the apexes, marked R, G and B, represent three spectral primary lights isolated from the spectrum. These will be fully saturated colours of maximum intensity or luminance of 100%. We will assume the lights

are so adjusted that as they progress across the triangle away from the corners they become uniformly weaker and diminish to zero intensity, that is, they disappear, when each reaches any point on the side opposite to it. At the centre of the triangle, equidistant from the corners, the three lights will be present in equal amounts to give white. Along the side between the red and green primaries will be all those hues through orange, yellow and yellow-green obtained by mixing these two lights in varying proportions. Likewise, on the side between the green and blue lights will lie all the greenish-blues, cyan and bluish-greens, and along the third side the hues resulting from mixtures of primary blue and red lights, namely bluish-purples, magenta and reddish-purples. The pure yellow (red + green) which is the exact complement of the primary blue will fall directly opposite the blue corner, that is, half-way along the red-green side, and, similarly, the cyan (green + blue) which is exactly complementary to the red primary will be just mid-way on the green-blue side, and the complementary magenta (red + blue) exactly opposite the green corner. These hues which actually lie on the sides of the triangle are the most fully saturated hues that can be obtained from the respective pairs of the primaries, because the third primary is not present at all in the mixtures; for example, none of the green-blue colours represented on the left-hand side of the triangle contain any red as this is of zero amount along the side furthest from the red source.

If a line is drawn across the triangle, for instance, from the blue corner to the complementary yellow at the centre of the green-red side, at positions inwards along this line the saturated hues of the green-red side become increasingly diluted with blue light and, therefore, less saturated, passing from yellow to buff, cream, etc., until white is reached in the middle of the triangle. Continuing along the line from the white point towards the blue, the colours contain more and more blue in the mixtures, becoming increasingly saturated from pale blue to full blue at the corner. The same holds good for all other positions in the triangle. Thus, from the cyan on the left-hand side and moving towards the centre, the green-blue effects are increasingly diluted with red through pale blue-green to white and from the white through pink to saturated red. Therefore, all the colours that can possibly be produced with the three primary lights are represented within the triangle and its three sides, and any colour corresponding to a point within the triangle can be matched by some combination of the three primaries. In short, the triangle provides a kind of colour map in which all colours are represented systematically by points in or on the triangle.

Chromaticity Coordinates

The exact and the simplest way to define the position of a point in a

triangle is by means of lines drawn perpendicularly from the sides to the point, as shown for the point *P* in Fig. 6.16. The lengths of these perpendiculars, indicated by *r*, *g* and *b* in the diagram, fix the position of the point. The lengths of such perpendiculars are termed the *co-ordinates* of the point. In the colour triangle, therefore, *r*, being opposite the red primary, is a measure of the amount of red light in the mixed

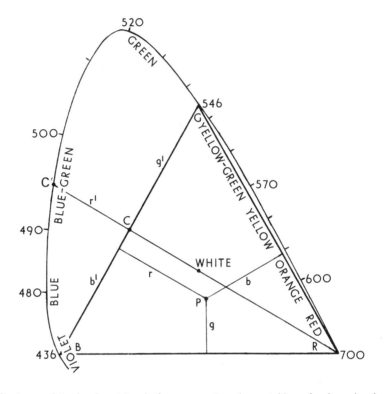

Fig. 6.16 An equilateral colour triangle for representing the matching of colours by three monochromatic primary lights (stimuli) of the wavelengths indicated at the apexes, R, G and B. The curve round the triangle is the locus of spectral colours. If three other matching primary stimuli are chosen, the curve of the spectral locus will be different, though of the same general shape. A mixture of equal quantities of the three stimuli matches white, represented at the exact centre of the triangle equidistant from the three corners. The significance of the other points and lines in the diagram is explained in the text, point P with reference to chromaticity coordinates *r*, *g*, *b*, and C, C¹, r¹, g¹, and b¹ illustrating how the spectral locus is plotted.

colour represented by *P*, *g*, opposite the green primary, is a measure of the amount of green light and *b* is a measure of the blue light in the mixture. So the colour at $P = r + g + b$, and, as *r*, *g* and *b* are co-ordinates of colour, they are appropriately called *chromaticity co-ordinates*.

Within an equilateral triangle, it is a geometrical fact that the sum of the lengths of the three perpendiculars from any point to the sides is equal to the length of a perpendicular from a corner of the triangle to the opposite side, and it is a convention to regard this perpendicular as having a length of unity. Hence $r + g + b = 1$, and the three co-ordinates of any point within the triangle will always add up to the same total. Consequently, if any two coordinates are known, then the third is also known, being the difference obtained by subtracting the sum of the two from unity. Moreover, it will be obvious that if the values of any two perpendiculars or coordinates are known, these alone will determine the position of a point within the triangle, because the third perpendicular must pass through their point of intersection.

THE SPECTRAL LOCUS

Unfortunately, no matter what pure monochromatic wavelengths or bands of wavelengths are chosen for the red, green and blue primary lights, it has been found in practical additive colour matching (colorimetry) that there are some colours which cannot be represented within an equilateral triangle. These are particularly the colours of an actual spectrum, the spectral colours, with the exception of the three chosen spectral primary lights themselves which lie at the apexes of the triangle. The spectral colours are more saturated than any of the saturated mixtures from any two of the primaries that are represented by the sides of the triangle. For example, spectral cyan of wavelength 495 nm appears much richer and is much more saturated than any cyan that can be produced by mixing primary green and blue lights. Such spectral colours can only be matched by first mixing some of the third primary with the spectral colour itself, to reduce its saturation, and then matching this mixture against the other two primaries. The spectral cyan light just mentioned can only be matched by green and blue primary lights if some red light is mixed with the spectral cyan.

This means that all the highly saturated spectral colours except the three primaries must be located outside the equilateral colour triangle, and they are found to lie along a curve as shown round the triangle in Fig. 6.16 passing through the three apexes, this curve being known as the *spectral locus*.

To explain how the spectral locus curve is plotted with reference to the colour triangle, let us take the example of spectral cyan. The perpendicular line from the red corner of the triangle to the opposite side represents all the primary red light diminishing to nil at the mid-point opposite which indicates the complementary additive cyan obtained with an equal mixture of the green and blue primaries. But to enable this

mixture of the green and blue primaries to be matched against spectral cyan, when using a matching colorimeter, it is necessary to add some of the red primary light to the spectral cyan. The mid-point on the green-blue side of the triangle, marked C in Fig. 6.16, indicates nil of red light and positions along the perpendicular from it within the triangle signify the addition of red to the green and blue primaries. Hence, to show the addition of red to the spectral cyan, this perpendicular is extended beyond the triangle by a length proportional to the measure of the primary red light that has to be added, to arrive at point C^1. The positions of all the other points on the spectral locus are plotted in the same way from practical colour measurements. Note that there is no curve round the base of the triangle because this line represents the pure purples or magentas consisting of mixtures of red and blue light which do not occur in the spectrum and are, therefore, non-spectral colours.

The extended portion of the perpendicular may be regarded theoretically as a negative amount of primary red to be 'added' to the mixed green and blue primary lights to give the match with the spectral cyan, and this is in accord with the simplest rules of algebra. Using coordinates as in the case of point P, with g^1 and b^1 representing the lengths, and correspondingly the amounts of light, from G and B to point C of Fig. 6.16 (ignoring the fact that g^1 and b^1 are equal in this example), r^1 represents the length of the extension of the perpendicular from R outside the triangle and corresponds to the amount of primary red required to be added to the spectral cyan or, theoretically, the negative amount to be 'added' to the green-blue mixture. So the position of spectral cyan is defined as $g^1 + b^1 - r^1$. Similarly, with reference to the triangle, other points on the spectral locus, except those of the three primary lights themselves, can be specified only by using negative coordinates for the amount of the third primary light needed with the spectral colours in order to match them.

It will be appreciated from the foregoing that it is quite impossible to match any of the spectral colours represented by the curve with straightforward mixtures of whatever three primary lights are chosen. One of these primaries has to be added to the specimen spectral light, not to the mixture of the primaries. This fact largely explains why it is not possible to reproduce fully the brilliance (saturation) of spectral colours by the usual additive or subtractive methods of colour reproduction such as photography, television or colour printing. Let us look again at the spectral locus on Fig. 6.16. The locus for spectral orange, yellow and yellow-green lies close to the red-green side of the triangle which means that additive mixtures of red and green lights closely approach the saturation or brilliance of these spectral colours. For this reason together with the high reflection or transmission of light of the longer wavelengths by yellow, orange and red dyes and pigments, well saturated

colours corresponding to this part of the spectrum are generally reproduced best. On the other part, however, spectral green-blues including cyan fall widely away from the green-blue side of the triangle, which explains why the most saturated green-blue light mixtures that can be obtained are comparatively dark, and such colours are still darker in reproductions due to the relatively low reflection or transmission by green and blue materials. If a cyan of high lightness or luminance factor is required, some red light must be included with it which will lower its saturation. Otherwise, increased saturation with green-blue materials can be obtained only at the sacrifice of some reduction in light reflection or transmission. Remember, however, that our visual assessment of lightness is modified somewhat by the high sensitivity of the eye to green light (p. 62).

THE C.I.E. CHROMATICITY CHART

Apart from the meaning of negative amounts of colour being difficult to understand, it is inconvenient, particularly for mathematical purposes, to use negative coordinates for the specification of colours, being mathematically and practically much easier to have them all represented by positions within a triangle. But this requires all colours to be matchable by positive mixtures of the primaries without any negative quantities. Yet, if *real* primary lights are used, this is unattainable.

The Commission Internationale de l'Eclairage overcame this difficulty in 1931 by postulating three theoretical and 'unreal' primaries having greater saturation than the spectral colours so that their positions, with reference to the triangle we have been considering, lie right outside the spectral locus. In colorimetry some choice of groups of the three matching primary lights is available, as mentioned on p. 94, and values or specifications on one set of primaries can be transposed into another if the relationship of the two sets of primaries is known. In this respect the relationship of the imaginary C.I.E. primaries to the spectral primaries is precisely defined mathematically (see p. 135) and consequently the specification of colours is facilitated. This is the foundation of the C.I.E. system. Because these theoretical primaries cannot actually be produced nor appreciated by the eye if they could be produced, they are always referred to as 'stimuli' rather than as primary colours and they are denoted by capital letters X, Y and Z.

Fig. 6.17(a) illustrates how the supersaturated theoretical X, Y, Z stimuli can be chosen so as to enclose the entire spectral locus and all other real colours within a triangle. Thus these stimuli avoid the use of negative values in colour specifications and the calculations involved when measurements by one instrument or method are referred to

another. The locations of X and Y were chosen and defined by the C.I.E. so that the line XY, as shown in Fig. 6.17(a), lies close to the spectral locus between R and G of the original triangle and, indeed,

Fig. 6.17 (*a*) Oblique triangle showing how the theoretical reference stimuli X, Y and Z may be selected to enclose the spectral locus and all other real colours. The C.I.E. chose X and Y so that the line XY lies along the spectral locus at the red end of the spectrum, that is, XY lies on or close to the locus between R and G. Consequently the blue coordinates (for Z) could be made zero for a considerable range of wavelengths in the red region. The position of the line XZ was also chosen so as to represent colours having zero luminance, and thus all the luminance of a colour is given by its Y value.

Fig. 6.17 (*b*) Transformation of the X, Y, Z triangle into a right-angled triangle to simplify the graphical plotting of chromaticity coordinates and related mathematics.

coincides with the locus towards the red end of the spectrum. Consequently, the blue coordinates (for Z) are zero for a considerable range of wavelengths in the red region, a factor that reduces some of the calculations.

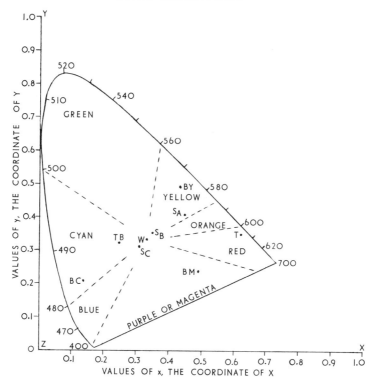

Fig. 6.18 **The C. I. E. Chromaticity Chart** plotted in terms of the reference stimuli *X*, *Y* and *Z*. The curved 'flat-iron' outline is the spectral locus, the figures round it indicating wavelengths, and the straight-line base is the locus of the most saturated or purest non-spectral purples. The area of the chart encloses all possible physical colours, the dotted lines demarcating the approximate zones of the main colours. *W* is the position of the ideal white at the centre with both coordinates *x* and *y* = 0·333. The locations are shown for the standard illuminants S_A, S_B and S_C; for a tomato, *T*, and a turquoise blue pigment, *TB*, under illuminant S_B; and for British Standard, BS 3020, trichromatic printing inks under illuminant S_C, marked BY, BC and BM. The spectral locus from the red end to green at a wavelength of about 540 nm lies mostly along the *XY* line, so the *Z* (blue) coordinates are zero over much of this wavelength range. The green and cyan wavelengths are spread over a relatively long curved stretch of the locus, the blue and violet wavelengths and those of the red region being compressed into the ends. This variation of the wavelength scale is largely due to the spectral sensitivity of the eye (Fig. 4.4), but the differing colour areas of the chart make it difficult to assess visible colour differences on it, see p. 132.

However, the *X*, *Y*, *Z* triangle of Fig. 6.17(a) is not equilateral and an advantage already mentioned with an equilateral triangle is that the sum of the three coordinate values is always unity. Having defined the stimuli *X*, *Y* and *Z* in relation to the real primaries R, G, B, to which they are respectively analogous, it is simple and perfectly legitimate to redraw and reposition the spectral locus and the original colour triangle

within an equilateral *XYZ* triangle. The three coordinates for any colour plotted on such a triangle will add up to unity and so it is only necessary to know the values of two, from which the third can be deduced. This allows a further logical simplication to be made, to arrange the *X*, *Y*, *Z* stimuli at the corners of a right-angled (rectilinear) triangle, enclosing the spectral locus and the other colour triangle within it, and then two coordinates can be plotted on ordinary rectilinear (Cartesian) graph paper. It should, perhaps, be observed that the *X,Y,Z* triangle, like the R,G,B triangle also, may be of any desired shape, but a right-angled triangle is the most convenient mathematically.

Such a right-angled triangle is shown in Fig. 6.17(b), and in Fig. 6.18, a graph of the spectral locus and the base of the original triangle representing the non-spectral purples. It is unnecessary to draw in the other two sides of the R,G,B triangle representing other colours because these lie inside the area of the graph. Any two coordinates for *X*, *Y* and *Z* may be plotted graphically in this way, as the sum of the three is always the same total, but it is the accepted practice to use *X* and *Y*. It is the coordinates for the theoretical reference stimuli *X*, *Y* and *Z* that are plotted, that is, the proportions of those stimuli which are found to be required to match a given colour, the three proportions adding up to unity. The proportions, or coefficients as they are sometimes called, are termed chromaticity coordinates in accordance with the earlier explanation of this term, and they are symbolized by lower-case *x*, *y* and *z*. The curved triangular-shaped graph of Fig. 6.18 is known as the *C.I.E. Chromaticity Chart*. This chart has been determined for the standard observer and on it all real colours, including those of the spectrum, can be placed and their positions specified exactly by entirely positive chromaticity coordinates, which have international significance.

For instance, the colour quality of the tungsten lamp, standard illuminant S_A, is matched, as found by calculation from its energy distribution over the spectrum, by the following proportions of the theoretical stimuli: 0·448 (44·8 %) of the *X* stimulus, 0·407 (40·7 %) of the *Y* stimulus and 0·145 (14·5 %) of the *Z* stimulus. Therefore

$$S_A = 0·448X + 0·407Y + 0·145Z$$

and the chromaticity coordinates, *x*, *y* and *z*, are 0·448, 0·407 and 0·145 respectively, the first two coordinates being used to plot the position of the colour on the chart. Since the three coordinates add up to unity the above equation is known as a unit trichromatic equation.

We have emphasized that these coordinates for colour quality or chromaticity are the proportions of the stimuli required to match a colour. In trichromatic colorimetry the proportions of the three real primary stimuli are sufficient to determine the quality of a colour, and, because they are proportions, it is only necessary to quote two of them.

Thus, a statement that a colour is matched by 20% of the red primary and 50% of the green is adequate for its chromaticity, because it goes without saying that the blue primary accounts for the remaining 30%. On this basis, chromaticities may be plotted on a two-dimensional diagram.

TRISTIMULUS VALUES

An additive trichromatic colorimeter will have three real primary lights (stimuli), R, G and B, usually produced from a single lamp or illuminant by means of filters, and matched so that equal quantities combine to produce white, the white often being that of the illuminant itself. We have mentioned earlier, p. 95, that the amounts of the three primary lights which are found to match a given colour may be termed tristimulus values. But such numerical quantities apply essentially to the primaries chosen for the particular colorimeter, and in the previous reference it is also stated that technical information about the instrument enables the measurement to be transformed to a corresponding specification in terms of the universal C.I.E. system. This means that if the values of each of the real red, green and blue stimuli of a colorimeter are known in terms of the theoretical C.I.E. X, Y and Z reference stimuli, as they are with modern instruments, the measured instrumental tristimulus values for the colours of specimens can be readily converted by calculation into the amounts of X, Y and Z. These are the figures more commonly referred to as tristimulus values, because of their general significance. They are, of course, *C.I.E. tristimulus values* and they indicate the amounts of the three theoretical primary stimuli that would be required for a colour match if the standard observer were to use a colorimeter employing the primary stimuli. Any two colours which have the same tristimulus values, in terms of the same primaries, will match each other.

In fact, the known X, Y, Z values of the real R, G, B primaries make it unnecessary to determine the quantities of R, G and B, that is, the amounts of light, required to match colours. Their relative proportions are sufficient since, as explained in a following section, the Y tristimulus value for a colour gives the luminance factor for quantity. When a specimen colour is matched by certain proportions of the primary R, G and B lights, as measured on the colorimeter, these proportions can be converted arithmetically, using the known X, Y, Z values of the primaries, into the C.I.E. tristimulus values for the colour, as shown in a later section, p. 136. Indeed, as mentioned earlier, p. 97, colorimeters have been devised to give these tristimulus readings directly, though not as yet to a high degree of accuracy in commercial instruments. Spectro-

photometric measurements which cover the visible spectrum always enable tristimulus values to be calculated in relation to any standard illuminant, in the way also shown in the later section.

The chromaticity coordinates, x, y and z, for a colour are derived from its C.I.E. X, Y and Z tristimulus values by dividing each of these values by their sum total, so that the resulting coordinates add up to unity as required for the chromaticity chart (p. 126). The procedure is manifest from the following simple equations:

$$x = \frac{X}{X + Y + Z}, \qquad y = \frac{Y}{X + Y + Z}, \qquad z = \frac{Z}{X + Y + Z}$$

Clearly $x + y + z = 1$ and the coordinates are the proportions of X, Y and Z that constitute a particular colour. The numerical chromaticity coordinates define the hue and saturation of the specimen by fixing its position on the chromaticity chart, for which only x and y are actually required. The chromaticity coordinates for the standard illuminant S_A have been quoted above and these correspond to tristimulus values of $X = 109.9$, $Y = 100.0$ and $Z = 35.6$, with Y adjusted to 100.0 so as to give the percentage luminance directly, in accordance with the usual practice mentioned in the section after the next. Calculation from these tristimulus values, using the given equations, will confirm the figures for the chromaticity coordinates.

DOMINANT WAVELENGTH AND PURITY

If a straight line is drawn from white located at the centre of the chromaticity chart through the position of a specimen colour to intercept the spectral locus, the wavelength value on the locus will indicate the hue and indeed the dominant wavelength of the specimen, and the distance of the specimen point along the line from white is a measure of its saturation or purity. Such a line is shown on Fig. 6.19 for a yellowish-green specimen, C^1. The values for the dominant wavelength and the distance from it of the colour along the line to white, which also fix the position of the specimen on the chart, are known as *polar*, or geometrical, *coordinates*.

For purples in the bottom segment of the chart, which have no real wavelength being non-spectral colours, the convention is to extend the line from white to the position of a particular purple backwards to the spectral locus and to take the complementary wavelength where the line intercepts the locus as defining the dominant wavelength of the purple. The purity of any colour is precisely defined by the ratio between the distance from white to the colour and the total length of the line

from white through the colour point to the perimeter of the chart; which for colours that lie on the perimeter becomes unity, indicating full saturation. Furthermore, this ratio, for colours other than purples,

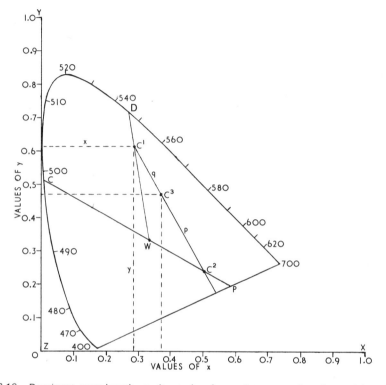

Fig. 6.19 Dominant wavelength, purity and colour mixture on the chromaticity chart. By plotting on the chart the known coordinates (x, y) for a colour, for example C^1 (a yellowish green), and drawing a line from W, the white point, through C^1 to the spectral locus, C^1 can then be specified by the value of D, its dominant wavelength, which gives an idea of the hue of C^1, and by the distance of C^1 along W to D, that is, WC^1, which gives an indication of its saturation. The purity is the ratio of WC^1 to WD, that is, WC^1/WD, so the purity of colours may vary from zero at W to unity on the spectral locus. For a colour, C^2, in the purple or magenta segment, the dominant wavelength is defined by its complementary wavelength C, obtained by drawing a line from C^2 through W to the spectral locus, in this case is the ratio WC^2/WP, P being the point of intersection of the extended line WC^2 on the base line of the chart. Colour mixture (p. 133): If p units of colour C^1 are mixed additively with q units of colour C^2, $p + q$ units of a new colour C^3 will be produced, and the position of C^3 on the chart is given on the line joining C^1 and C^2 by $C^1C^3/C^3C^2 = q/p$. From this position, the coordinates of C^3 can be directly evaluated on the x and y axes.

gives the proportion of spectral light having the dominant wavelength required to be mixed with white light to match a specimen colour. The specification of colour in terms of dominant wavelength and purity (polar coordinates) rather than chromaticity coordinates may be

preferable in some industries, dyeing and colour reproduction for example, because these values are more directly related to the techniques and to the subjectively perceived attributes of colour. Colours of the same dominant wavelength, though differing in purity or saturation, are generally more acceptable to the eye as similar colours than those having different dominant wavelengths. See Fig. 6.19.

LUMINANCE FACTOR
(REFLECTANCE OR TRANSMITTANCE)

So far as we have gone, the place a colour occupies on the chart defines its hue and saturation, its chromaticity or quality, but a third property, lightness or luminance factor for quantity, is needed to specify the colour completely. A point on the chromaticity chart represents all colours of that quality whether they be bright or dark, that is, irrespective of their intensities or luminance factors. For example, a cherry red and a dark red may be represented by the same point because they have the same colour quality, but the cherry red has greater luminance or lightness than the dark red. Even the central white point of the chart indicates the whole range of neutral greys as well as white, as they are all of the same neutral quality and differ only in luminance or reflection factor.

The luminance of a colour can be measured independently with a photometer but it is hardly convenient to make a separate determination as part of colour measurement. The luminous intensity of coloured light is determined by the sum of the luminances of its component colours, that is, in trichromatic colorimetry, by the additive intensities of the three primary stimuli required to match a colour. In this respect the C.I.E. system includes another important simplification in that the theoretical X, Y, Z stimuli have been so chosen, from a number of alternatives, that the *Y value gives the luminance factor*. This means that the locations on the triangular chromaticity chart of the theoretical reference stimuli relative to the spectral locus for the standard observer were deliberately selected by the C.I.E. so as to give the X and Z stimuli zero luminance, again in a theoretical way. Consequently, all the photometric content of colour measurement is referred to the third stimulus, Y. The clever allocation of colour values but no liminosity to X and Z fixes the position of the line XZ in Fig. 6.17(a). Any other set of stimuli would require the inclusion of luminance quotas with the values of all three stimuli (tristimulus values), resulting in more involved calculations. It is clearly an immense advantage to have a system of colour specification based on only three units, in which one of them defines the amount of light in a colour. The luminance factor is a third dimension

for colour and may be regarded as being represented on a third axis added vertically to the chromaticity chart.

The Y tristimulus value is always proportional to the luminance factor and is usually made equal to it as a percentage figure by adjusting the calculations to derive the tristimulus values from colour measurements so that the Y value is 100 % for a perfect white surface (magnesium oxide), that is, by calculating the percentage ratio between the Y value of the measured colour and that of the standard white. Some colorimeters give a direct reading of the percentage Y value.

Thus, *a C.I.E. specification* consists of a set of three numerical quantities. These may be the X, Y and Z tristimulus values or the x and y chromaticity coordinates with the Y tristimulus value. In the former case, the chromaticity coordinates can be easily obtained from the tristimulus values as shown on p. 128. In the latter case, the two coordinates, x and y, are customarily placed first as they give the quality of the colour from its position on the chromaticity chart, that is, its hue and saturation or its dominant wavelength and purity, and the third quantity is the Y tristimulus value which gives the luminance factor (reflection or transmission factor). The latter form of specification is more immediately informative as colour differences are not readily evident from tristimulus values. In either form, a C.I.E. specification supplies a complete and unique definition of a colour, including the luminance factor often as a percentage.

TYPICAL C.I.E. VALUES

For example, the C.I.E. values for the turquoise blue specimen shown in Fig. 6.18 and measured under Standard Illuminant B (sunlight) might be 0·251 and 0·326 for the chromaticity x and y coordinates respectively and 22·5 for the $Y\%$ reflection factor. The colour of a tomato might give 0·623 for x, 0·350 for y and 12·2% for Y. C.I.E. values for the standardized trichromatic inks used in colour printing (BS 3020:1959) under Illuminant C (daylight) are tabulated below.

	x	y	$Y\%$
Yellow ink	0·434	0·492	69·2
Magenta ink	0·490	0·238	11·9
Cyan ink	0·139	0·208	13·9

How such values are derived mathematically from colour measurements is indicated in the final section of this chapter.

COLOUR DISCRIMINATION AND THE C.I.E. CHART

It will be noticed that the segments of the chart on Fig. 6.18 which are marked by dotted lines to indicate the main colours or hues represented by these areas are not of equal size. That is, colours are not uniformly distributed over the chart so that equal distances within different areas do not represent equal differences of hue as seen by the eye. This is unfortunate and it is the only serious disadvantage of the *XYZ* system. The green zone is comparatively the largest and, therefore, a large distance or length of line in this area represents quite a small perceivable change of hue, whereas a very short distance or line in the blue or orange to red zones corresponds to a considerable difference in hue to the eye. Allowance must be made for the unequal distribution of colours on the chart when considering the distance apart of two or more colours as plotted on the chart. Unless such allowance is made, this distance can give a very misleading impression of the magnitude of the difference in the visual sensations produced by the colours concerned. Two greens could be well apart on the chart yet be an acceptable match to the eye, while two blues would have to be very close together to give a tolerable visual match. It is difficult, therefore, to assess what variations or divergencies in a C.I.E. specification can be accepted to give a reasonably close match to a stated colour. Slight differences in luminance or luminance factor, the *Y* value that is not recorded on the chromaticity chart itself, are usually less serious than small errors in colour matching quality.

Measurements have shown that a normal observer can detect colour changes in the orange to greenish-blue regions of the spectrum equivalent to less than 1 nm in wavelength. The just noticeable or least perceptible difference in colour which on the chart is the shortest distance in any area corresponding to an observable change in hue or saturation is often important and is called a 'j.n.d.' or 'l.p.d.' step. When specifying the colour of a paint, dye or other material, the question frequently arises as to what amount of departure from the standard can be permitted; in other words, within what limits must the specification be adhered to? The colour of an industrial product may have to be maintained virtually the same over periods of months or years. A similar problem applies to the latitude or tolerable inaccuracy of colour reproductions. Probably the largest commercial usage of colorimeters concerns the measurement of colour differences rather than the absolute measurement of colour. Permissible limits of colour variation are easier to understand if stated in 'number of j.n.d. steps', because if the tolerance is stated in the conventional C.I.E. values this gives little indication of the allowance without working out actual examples.

For the above reasons *uniform or equal chromaticity charts* have been

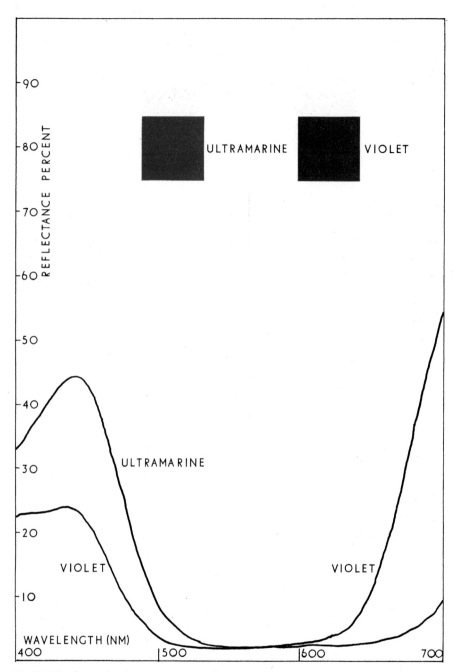

PLATE 22 Spectral reflectance curves of the blue pigment known as ultramarine and a violet pigment. Note the lower reflectances and therefore lower lightness of both these pigments compared with those represented by the previous spectrophotometric curves. The violet pigment, like the madder lake of Plate 20, reflects light at both ends of the spectrum but much less than the madder in the orange and red.

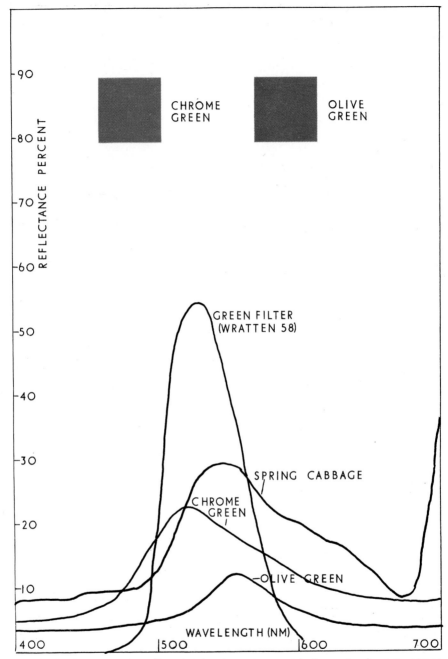

PLATE 23 Spectrophotometric curves for chrome green and olive green pigments, a transparent green dyed filter and a spring cabbage leaf. The reflectances (lightness) of the three opaque green materials are low and also their saturations, because of their widespread reflections, whereas the filter is a highly saturated green with some yellow, due to its absorption of light over more than two-thirds of the spectrum. The curve for the olive green confirms that this is a dark degraded green, sometimes called a tertiary colour along with citrine and russet, which are largely degraded yellow and red respectively.

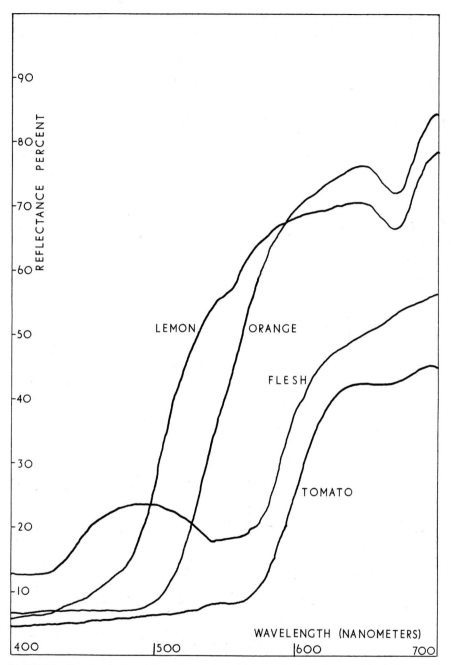

PLATE 24 Spectrophotometric curves measured from typical specimens of the fruits named
and flesh (an upper arm). The red reflection of the flesh tone is desaturated towards pink
mainly by the peak in the blue region, which also helps to explain why we are sometimes
said to turn blue !

PLATE 25 **Enlargement of the printed and dyed reseau or mosaic of Dufaycolor film.** In this very successful additive process of colour photography the mosaic had about a million colour elements to the square inch and was much too fine to be seen by the unaided eye.

Original subject

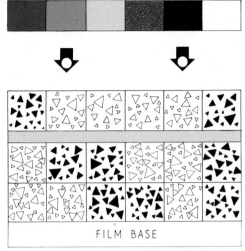

FILM BASE

After camera exposure and ordinary development

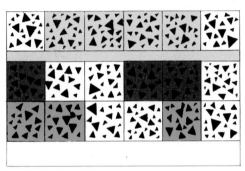

After reversal exposure and colour development

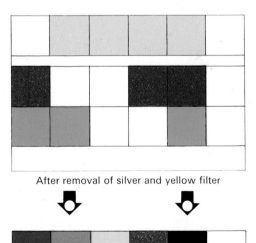

After removal of silver and yellow filter

Reproduction as seen by transmitted light

PLATE 26 Steps and results in processing integral tripack reversal photographic colour film. See pp. 188-189.

Original subject	Colour negative

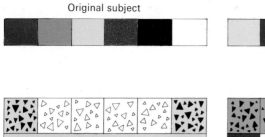

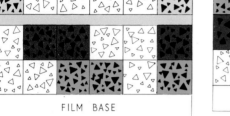

FILM BASE PAPER BASE

After camera exposure and colour development

Developed dye and silver image after exposure through negative

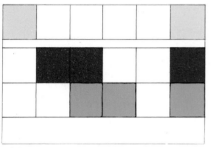

After removal of silver, silver halide and yellow filter

Positive dye image after removal of silver and silver halide

Colour negative	Colour print

PLATE 27 Sequence of operations and results in processing photographic integral tripack negative film and positive print (see p. 189). In Kodacolor negative film a mask layer was originally included but has been superseded by coloured couplers.

(a) Cyan impression.

(b) Magenta impression.

(c) Yellow impression.

(d) Black impression.

(e) Cyan and magenta superimposed.

(f) Three colours superimposed.

PLATE 28 The separate images from each respective printing plate for the four-colour half-tone reproduction of an original colour photograph, and the progressive images obtained during printing. *Courtesy: H. M. Ricketts.*

(*g*) *The complete four-colour print.*

(a) *Letterpress four-colour half-tone print.*

(b) *Offset-lithographic four-colour half-tone print.*

(c) *Three-colour conventional photogravure print.*

PLATE 29 Photomicrographs taken necessarily from small areas of colour prints. Magnification x20 diameters. In the cases of both letterpress and lithographic prints, (a) and (b), the smaller half-tone dots lie in juxtaposition, due to the different screen angles used for each primary coloured image, and only the larger dots and coloured areas are superimposed. The colour effects, when a print is viewed without magnification, are, therefore, partly additive and partly subtractive. The varying half-tone dot sizes are essential, however, for the reproduction of tonal effects. In conventional photogravure, (c), the coverage of the paper by each ink and thus their superimposition is much greater, so that the colour effects are largely subtractive; tonal effects and some colour variations are obtained by the differing ink film thicknesses. In addition to illustrating the structures of colour prints and the number of printings, the photomicrographs show other characteristic features that enable the process by which a particular print has been produced to be identified. *Colour photomicrographs by Dr. G. L. Wakefield, MScTech, FRPS, FIIP.*

proposed in which the C.I.E. chart is transformed or distorted to foreshorten the green corner and expand and elongate the blue and red corners, so that the latter areas are selectively enlarged. One of these modified charts, proposed by D. L. MacAdam, was approved provisionally by the C.I.E. in 1959. It is an approximately uniform chromaticity triangle based on transfigured stimuli, labelled *U*, *V* and *W*, which are related to the *XYZ* system. In 1963 the C.I.E. developed this triangle into a uniform colour solid to accommodate lightness (luminance factor) as well as chromaticity and this solid approximates to that of the Munsell system. Although no projection of the C.I.E. diagram can show exact equality of the j.n.d. steps, a uniform chromaticity chart assists the stipulation of tolerances for colour matches in different areas, in terms of the space or steps between the points on the chart representing the required colours and those actually attained. With such distances, however, there may still remain the question of the relative importance, say to the manufacturer and customer, of the matching with respect to differences of hue versus saturation, both of which properties are covered, as explained, by the chromaticity chart. Even so, uniform chromaticity charts are much used, and when a large number of samples have to be compared with a single standard it is logical to prepare a uniform diagram for only the small portion of the overall chart that is involved. Many such 'rectified local colour maps' have been produced.

To facilitate the conversion or transfer of specifications or data from a uniform chromaticity chart to the standard C.I.E. system and vice versa, as, for instance, between the *XYZ* and *UVW* charts, a diagramatic device called a *nomogram* may be used. A nomogram is available and convenient for converting readings on the subtractive Lovibond–Schofield Tintometer directly to the corresponding C.I.E. values, as mentioned on p. 105. Other nomograms can be worked out for converting the results from various instrumental methods of colour measurement to the C.I.E. system of colour definition.

COLOUR MIXTURE ON THE CHROMATICITY CHART

A colour triangle and particularly the C.I.E. chart is easily applied to the solution of colour mixture problems and this is a further important primary use for it. The results of mixing two or more colours additively can be readily evaluated on the chromaticity chart. In a simple case, if equal amounts or intensities of two colours are mixed, it can be shown mathematically that the new colour obtained lies half-way on the straight line joining the points on the chart which represent the original colours. The chromaticity (hue and saturation) of this mid-point is,

therefore, easily assessed and specified. Because the mixture is additive, the resulting intensity or luminance is twice that of the components.

Likewise, if five units of one colour are mixed with three units of a second, the new colour will be situated on the chart line joining the positions of the constituent colours at a distance of three-eighths of the length of the line from the first colour and five-eighths of the line from the second. That is, the distances of the mixed colour from the ends of the straight line between the original colours are in the inverse ratio of the intensities or quantities of these colours. The same principle applies to additive mixtures of three or more colours. The total amount of light or luminance of the new colour formed from such mixtures is the simple arithmetic sum of the individual amounts or luminances of the contributing colours. Thus, in the example just given, there would be eight units of the new colour. See Fig. 6.19.

By plotting on the C.I.E. chart the chromaticities of the three primary stimuli colours used in a system of additive trichromatic colour reproduction and drawing a triangle between the three points, this triangle will indicate from the chart the overall range or gamut of colours which can be reproduced by that system. Similarly, for an ideal subtractive system the chromaticities of the three effective primary stimuli (see p. 80) may be plotted as a triangle to denote the reproducible gamut of colours. For an actual substractive system, however, the colour coverage shown by such a triangle will be far from exact because of limitations imposed by colour imperfections of the subtractive coloured materials. It will be even more inexact if the materials scatter the light, and the optical properties of the support or substrate on which they are used may introduce further inaccuracies. To show the colour range correctly in this way for a real subtractive system, it is necessary to plot numerous chromaticities derived from the particular set of primary materials and their practicable mixtures under a known illumination, when the overall area on the chart is likely to be no more than approximately triangular.

In the case of subtractive colour mixtures the calculations to obtain the results are laborious due to complications introduced by the light absorptions of the dyes or pigments to be mixed, the effects, such as light scattering, of the material on which the mixture is to be placed (the substrate), and so on. A C.I.E. specification, being numerical, lends itself to computerization, along with numerical information from spectrophotometric curves of the individual dyes or pigments on the particular substrate, and computer programmes are being used increasingly for tristimulus calculations. Consequently, computers are now being applied in the dyeing, paint and pigment industries to the speedy derivation of the recipes (colorant formulations) required for mixtures of three or more colouring substances to match a specified colour on a given substrate. This procedure establishes the merits of trichromatic

colorimetry with the C.I.E. system of colour measurement as an industrial tool.

DEFINITIONS OF THE PRIMARY STIMULI

The qualitative chromaticities of the C.I.E. theoretical reference stimuli X, Y and Z are defined by the following unit trichromatic equations. These are based on colour matching data of the standard observer obtained for foveal vision (field of view subtending a narrow angle of $2°$ to $4°$) using the real red, green and blue primary stimuli of wavelengths 700 nm, 546·1 nm and 435·8 nm respectively, with units such that equal quantities of these real stimuli are needed to match the ideal white, the light energy of which is the same throughout the spectrum.

$$\text{Red primary,} \quad R_{700} = 0·7347X + 0·2653Y + 0·0000Z$$
$$\text{Green primary,} \quad G_{546} = 0·2738X + 0·7174Y + 0·0088Z$$
$$\text{Blue primary,} \quad B_{436} = 0·1666X + 0·0089Y + 0·8245Z$$

The coordinates are rounded-off to four decimal places. Note that in the case of the red stimulus the coordinate for Z is zero, because, as mentioned on p. 124, the XY side of the chromaticity triangle lies along the red end of the spectral locus.

Quantitatively, the mathematical definition of X, Y and Z in terms of R_{700}, G_{546} and B_{436} for the standard observer data is:

$$1·0X = \quad 2·3646R - 0·5151G + 0·0052B$$
$$1·0Y = -0·8965R + 1·4264G - 0·0144B$$
$$1·0Z = -0·4681R + 0·0887G + 1·0092B$$

$$\text{Sum} = \quad 1·0000R \quad 1·0000G \quad 1·0000B$$

The summations show that unit quantities of the three stimuli in both sets match the ideal white. Note the negative quantities of the real primaries required to match the theoretical stimuli, the significance of which has been explained on p. 122, but, because X, Y and Z lie outside the spectral locus, these negative amounts are greater than those required in matching any spectral colours.

The reciprocal equations for R_{700}, G_{546} and B_{436} in terms of X, Y and Z are:

$$1·0R = 0·4900X + 0·1770Y + 0·0000Z$$
$$1·0G = 0·3102X + 0·8124Y + 0·0100Z$$
$$1·0B = 0·1998X + 0·0106Y + 0·9900Z$$

$$\text{Sum} = 1·0000X \quad 1·0000Y \quad 1·0000Z$$

The luminosity (relative luminous efficiency) of X and Z is zero, as mentioned earlier, the whole of the luminosity being given by the unit of Y. Hence the luminous intensities of unit amounts of each of the real primaries are in the proportions of 1·0, 4·59 and 0·06 respectively, obtained by dividing each of the above Y values by 0·177, these proportions being their accepted relative luminosities or visual efficiencies. See the caption to Fig. 4.4. These transformation equations from which the trichromatic coordinates for the theoretical stimuli X, Y and Z are derived from the real 700, 546·1 and 435·8 nm primaries, as in the unit equations above, will serve a corresponding transformation for the \bar{x}, \bar{y}, \bar{z} colour-matching functions referred to in the following section.

CALCULATION OF C.I.E. VALUES FROM COLOUR MEASUREMENTS

We have described earlier in this chapter the fundamental methods of colorimetry and spectrophotometry for colour measurement. It may be helpful to show the typical kinds of calculation that are involved to convert such measurements into the units of the universal C.I.E. system.

(i) Let us first consider the simpler case as regards calculation of measurements made on a trichromatic colorimeter. Suppose it is established with a particular instrument and illuminant that the X, Y, Z equivalents, or transformation equations as they are called, for equal units of the instrumental R, G, B stimuli required to match a standard real white are as follows:

$$1 \cdot 0R = 0 \cdot 7479X + 0 \cdot 2841Y + 0 \cdot 0000Z$$
$$1 \cdot 0G = 0 \cdot 1501X + 0 \cdot 7218Y + 0 \cdot 0751Z$$
$$1 \cdot 0B = 0 \cdot 1470X + 0 \cdot 0491Y + 0 \cdot 8249Z$$

Note that the sum total of these X, Y and Z values from the three equations is 3·0, equal to the three unit quantities of R, G and B.

If the proportions of R, G and B to match a colour specimen are found to be 20% of R, 50% of G and 30% of B, the conversion to the X, Y, Z tristimulus values for the colour is:

For X: $0 \cdot 2 \times 0 \cdot 7479 + 0 \cdot 5 \times 0 \cdot 1501 + 0 \cdot 3 \times 0 \cdot 1470 = 0 \cdot 2687X$
For Y: $0 \cdot 2 \times 0 \cdot 2841 + 0 \cdot 5 \times 0 \cdot 7218 + 0 \cdot 3 \times 0 \cdot 0491 = 0 \cdot 4325Y$
For Z: $0 \cdot 2 \times 0 \cdot 0000 + 0 \cdot 5 \times 0 \cdot 0751 + 0 \cdot 3 \times 0 \cdot 8249 = 0 \cdot 2850Z$

Total $= 0 \cdot 9862$

Acting upon the equations given on p. 128, the chromaticity coordinates for the colour are calculated by dividing each tristimulus value by the sum of the three. Hence

$$x = \frac{0 \cdot 2687}{0 \cdot 9862} = 0 \cdot 2725; \quad y = \frac{0 \cdot 4325}{0 \cdot 9862} = 0 \cdot 4385; \quad z = \frac{0 \cdot 2850}{0 \cdot 9862} = 0 \cdot 2890$$

As previously explained, it is not actually necessary to calculate the z coordinate, since the figures for x and y enable the position of the colour on the chromaticity chart to be determined and $z = 1 - (x + y)$.

The luminance (reflection or transmission) factor is obtained as a percentage from the ratio of the Y tristimulus value for the colour and the sum of the Y values of the transformation equations, that is, 1·0550, as the figure representing 100% luminance for the standard white under the specified illumination of the colorimeter.

So
$$Y\% = \frac{0 \cdot 4325}{1 \cdot 0550} \times 100 = 41 \cdot 0\%.$$

Taking Y as the percentage figure of 41·0, X becomes

$$\frac{0 \cdot 2687}{1 \cdot 0550} \times 100 = 25 \cdot 5 \text{ and } Z \text{ is } \frac{0 \cdot 2850}{1 \cdot 0550} \times 100 = 27 \cdot 0.$$

The Commission Internationale de l'Eclairage recommends the quotation of tristimulus values on this basis.

Therefore, the colour specimen is specified by the tristimulus values of $X = 25 \cdot 5$, $Y = 41 \cdot 0$ and $Z = 27 \cdot 0$, or by the chromaticity coordinates of $x = 0 \cdot 2725$, $y = 0 \cdot 4585$ and the Y luminance factor $= 41 \cdot 0\%$, under the standardized illuminant of the colorimeter.

(ii) As stated earlier, a spectrophotometric curve always enables the C.I.E. values to be derived in relation to any standard illuminant and this is often done. But the calculations are tedious because they involve measurements over many wavelengths.

The colour to the standard observer corresponding to each wavelength in the visible spectrum can be precisely represented as the sum of the amounts of X, Y and Z, tristimulus values, required to match it. Moreover, it can be proved that the tristimulus values for the colour of a stimulus (light) are given by the arithmetic sum of the tristimulus values for all of the individual wavelengths of which the light is composed. The tristimulus values for the spectral wavelengths are designated by the symbols \bar{x}_λ, \bar{y}_λ and \bar{z}_λ (λ being the accepted symbol for wavelength) and are called 'colour-matching functions' since they are based on the colour vision of the standard observer. These symbols are also termed 'distribution coefficients', their values being determined for the equal-energy spectrum, that is, the spectrum of an ideal white light having the same energy level or distribution at all wavelengths. Stated definitively, these three distribution coefficients indicate respectively the amounts of each of the X, Y and Z primary stimuli required by the standard observer to colour match equal amounts of energy at each wavelength and they are,

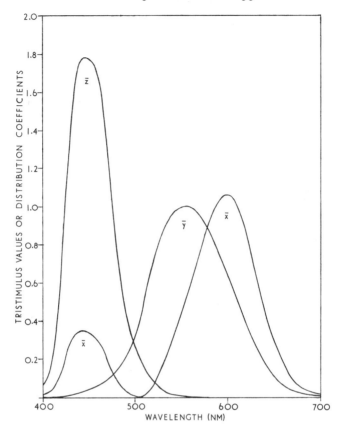

Fig. 6.20 C.I.E. tristimulus values, \bar{x}_λ, \bar{y}_λ, and \bar{z}_λ, for the various spectrum colours. Also termed distribution coefficients or colour-matching functions. They represent the colour vision of normal observers and give the amounts of the primary C.I.E. stimuli, X, Y and Z, analogous to red, green and blue, required to match the colour at each wavelength in the spectrum. The small secondary \bar{x} curve is largely due to the apparent 'redness' in the violet region. Notice the identical correspondence of the \bar{y} curve to that of Fig. 4.4 for the sensitivity of the eye to spectral luminosity, because the Y tristimulus values for colours supply all the luminance information. Numerical tables for \bar{x}_λ, \bar{y}_λ and \bar{z}_λ are available, the sum totals of each being equal since equal units of X, Y and Z match the ideal (equal-energy) white, so that the areas under the \bar{x}, \bar{y} and \bar{z} curves are also equal.

therefore, the tristimulus values for the various colours of an ideal spectrum. Graphs of the colour-matching functions are shown in Fig. 6.20 with some further explanation in the caption.

No real sources of light give an equal-energy spectrum (see Fig. 1.6), but, as stated on p. 117, the spectral energies of the standard illuminants at each wavelength, their energy distributions, are accurately known. Tables giving \bar{x}_λ, \bar{y}_λ and \bar{z}_λ values over the whole spectrum, usually at

wavelength intervals of 5 or 10 nm and chosen so that \bar{y}_λ is proportional to the luminosity of the various spectral wavelengths, are available in reference books on colorimetry. These tables are most directly useful for evaluating the colours of light sources. The much more general requirement, however, is the evaluation of the colours of materials under specified illumination. To this end, it is convenient, in that it reduces the amount of calculation, to use tables which take into account the unequal or non-uniform energy distributions of the standard illuminants.

For the purpose of calculating C.I.E. values from spectrophotometric measurements, it is necessary to multiply the \bar{x}_λ, \bar{y}_λ, \bar{z}_λ values, which correspond to 100 % of light energy at each wavelength, by the relative energy, E, of the particular illuminant at the same wavelength, that is, the products of $E \times \bar{x}_\lambda$, $E \times \bar{y}_\lambda$ and $E \times \bar{z}_\lambda$ are required. These products are the tristimulus values at the respective wavelengths for this illuminant and the summations of the $E\bar{x}_\lambda$, $E\bar{y}_\lambda$ and $E\bar{z}_\lambda$ products over the spectrum give the complete tristimulus values for the illuminant concerned. Tables of these products for each of the standard illuminants, S_A, S_B, S_C and, since 1967, for D_{6500}, D_{5500} and D_{7500}, as well as the \bar{x}_λ, \bar{y}_λ, \bar{z}_λ tables, are provided in reference works on colorimetry. In most of these tables, the products are all multiplied by a factor chosen to make the total obtained by adding together all the products for $E \times \bar{y}_\lambda$, that is, the Y tristimulus value and, therefore, the luminance of the illuminant, come to 100·0. Consequently, the Y values of the tristimulus specifications for colours calculated from such tables give the percentage reflection or transmission factors directly. The $E\bar{x}_\lambda$ and $E\bar{z}_\lambda$ totals are different, of course, because these must give the tristimulus values and coordinates for the white reference surface under the particular illuminant.

To calculate from a spectrophotometric curve the C.I.E. values for a coloured material under a specified illuminant, the $E\bar{x}_\lambda$, $E\bar{y}_\lambda$ and $E\bar{z}_\lambda$ products at regular narrow wavelength intervals (generally 5 or 10 nm) for the illuminant involved, which are the colour values of this illuminant according to the wavelength, have each to be multiplied by the reflection or transmission factor of the material at the respective wavelength, as obtained from the curve. These three groups of second products must then be added up, separately, to obtain the values for X, Y and Z respectively.

As a simplified example, let us take a red filter or signal glass for which a colour specification is required when used in front of a lamp having the quality of illuminant S_A. Suppose that, according to spectrophotometric measurements, the transmittances of the glass are nil at wavelengths below 500 nm, 1 % at a wavelength of 550 nm, 50 % at 600 nm, 80 % at 650 nm and 90 % at 700 nm. These wavelength intervals of 50 nm are too widely separated to yield more than a roughly approximate specification but they will serve to show the mode of calculation. For

highly accurate results, tables giving the distribution coefficients at 1 or 5 nm wavelength intervals throughout the spectrum and arithmetic multiplications at each interval are necessary.

Reference to condensed tables for the distribution coefficients weighted by the energy values of illuminant S_A at wavelength intervals of 10 nm supplies the following products at the quoted wavelengths:

Wavelength	Weighted distribution coefficients	
550 nm	$E_A\bar{x}$	3·7329
	$E_A\bar{y}$	8·5707
	$E_A\bar{z}$	0·0749
600 nm	$E_A\bar{x}$	12·7103
	$E_A\bar{y}$	7·5460
	$E_A\bar{z}$	0·0096
650 nm	$E_A\bar{x}$	4·3447
	$E_A\bar{y}$	1·6389
	$E_A\bar{z}$	0·0000
700 nm	$E_A\bar{x}$	0·2067
	$E_A\bar{y}$	0·0744
	$E_A\bar{z}$	0·0000

Hence the calculation to obtain the tristimulus values for the colour of the light transmitted by the red glass is:

For X:	For Y:	For Z:
0·01 × 3·7329	0·01 × 8·5707	0·01 × 0·0749
+ 0·5 × 12·7103	+ 0·5 × 7·5460	+ 0·5 × 0·0096
+ 0·8 × 4·3447	+ 0·8 × 1·6389	+ 0·8 × 0·0000
+ 0·9 × 0·2067	+ 0·9 × 0·0744	+ 0·9 × 0·0000
Sum = $10\cdot39023\,X$	Sum = $6\cdot00815\,Y$	Sum = $0\cdot01229\,Z$

The summation of the numerous multiplication products, that have to be worked out at short regular wavelength intervals throughout the entire visible spectrum in order to compute the tristimulus values accurately, is expressed mathematically as:

$$X = \sum (t_\lambda \cdot E\bar{x}_\lambda); \quad Y = \sum (t_\lambda \cdot E\bar{y}_\lambda); \quad Z = \sum (t_\lambda \cdot E\bar{z}_\lambda);$$

where t_λ represents, according to the wavelength, the transmission or reflection factor measured on the spectrophotometric curve of the material. Wavelength intervals of 1, 5, 10 or 20 nm may be used depending on the precision sought in the result.

To convert the above tristimulus values to the chromaticity coordinates of the unit equation, each is divided by the sum of the three. Thus:

$$X + Y + Z = 10.39023 + 6.00815 + 0.01229 = 16.41067,$$

and

$$x = \frac{10.39023}{16.41067} = 0.6331; \quad y = \frac{6.00815}{16.41067} = 0.3661; \quad z = \frac{0.01229}{16.41067} = 0.0008$$

If the computations to obtain X, Y and Z had been made at wavelength intervals of 10 nm over the spectrum range, in accordance with the tables from which the listed distribution coefficients have been extracted, the sum of all the $E_A \bar{y}_\lambda$ values of the tables for illuminant S_A totals 100·0 and, therefore, the Y tristimulus value above would have been the percentage luminance (transmission) factor of the red glass. Since, in the interests of simplicity and brevity, we have included calculations at only four wavelengths, a rough approximation for the overall transmission factor may be derived from the ratio of the above Y value for the glass filter to the representation of that for the white of the illuminant obtained by adding together the four abstracted $E_A \bar{y}_\lambda$ values in the above list, that is,

$$8.5707 + 7.5460 + 1.6389 + 0.0744 = 17.8300.$$

So the percentage transmission factor of the filter or signal glass,

$$\simeq \frac{6.008}{17.830} \times 100 = 34\%.$$

It will be realized that considerable time and labour is involved in fully computing C.I.E. specifications from spectrophotometric measurements at wavelength intervals of 1, 5, 10 or even 20 nm and the shorter the intervals the longer the calculation. Hence the advantage of a recording spectrophotometer with an automatic tristimulus integrator that supplies the results directly in C.I.E. units very quickly. We have stated earlier that spectrophotometric measurements related to one illuminant can be transposed to another and it will be evident from the above explanation that a spectrophotometric curve enables C.I.E. values related to any one of the standard illuminants to be computed.

If two or more beams of coloured light are additively mixed and the tristimulus values of each beam are known, the respective summations of their X, Y and Z quantities give the tristimulus values of the mixture, as indicated on p. 137. In the case of a simple subtractive mixture like that of two or more pieces of clear coloured glass placed in series in a beam of white light, the transmission factor of the combination at each wavelength is the product of their individual transmission factors, ignoring possible inter-surface reflections. If, therefore, the spectro-

phototometric curve for each glass is measured, calculations such as those above can be extended to obtain the tristimulus values and chromaticity coordinates of the combination. Similarly, for transparent dye solutions, which do not scatter the light or introduce other optical complications, the C.I.E. values of their subtractive mixtures in given concentrations can be calculated from spectrophotometric measurements on the individual solutions.

Detailed and more scientific expositions of the procedures for evaluating C.I.E. quantities from colour measurements on colorimeters and spectrophotometers, as well as the necessary numerical reference tables, are available in specialized textbooks, such as *The Measurement of Colour* by W. D. Wright and *Colour Science* by G. Wyszecki and W. S. Stiles, listed in the Bibliography for Further Reading, p. 223.

It will be seen from this and the preceding section that there are four entities involved in the calculations to derive the C.I.E. specification for a colour, which are as follows:

(a) The spectral energy distribution of the chosen illuminant.

(b) The amounts of the colour-matching functions (distribution coefficients), \bar{x}, \bar{y}, \bar{z}, for the standard observer.

(c) The relative luminous efficiencies at each wavelength in the spectrum, that is, the relative sensitivities of the eye of the standard observer to light of the same energy at each wavelength, which are incorporated in the \bar{y} values of the colour-matching functions as indicated in the caption to Fig. 6.20.

As previously mentioned, the published tables usually give figures for \bar{x}, \bar{y} and \bar{z} already weighted by the energy values for each standard illuminant. Therefore, these tables for weighted distribution coefficients combine the quantities of (a), (b) and (c).

(d) The spectral reflection or transmission characteristics of the measured specimen, which, for the greatest accuracy, are best obtained from detailed measurements in a spectrophotometer, that is, from a full spectrophotometric curve.

Addendum to p. 101

Since this text was written the Kollmorgen Corporation has introduced in 1971 an entirely new Automatic Color-Eye, the KCS-18, which offers rapid measurements that can be linked directly to a computer. This high precision colorimeter/abridged spectrophotometer uses an eight inch diameter integrating sphere and, as well as the tristimulus colorimetric filters, nineteen narrow-band interference filters having transmission ranging from 380 to 740 nm to provide the spectrophotometric data which can include fluorescence measurements.

ADDITIVE REPRODUCTION METHODS

IN THIS AND THE FOLLOWING CHAPTER we shall describe the more important industrial methods that have been developed for the production of copies of an original scene or design. These methods are based in principle upon either the additive or the subtractive colour mixing processes explained in Chapter 5. As will be related in the next chapter, the two methods are combined to some extent in photographic and photomechanical (printing) processes in that colour filters similar to those used to produce the three primary coloured light beams for additive methods are employed in these subtractive processes to separate the primary coloured constituents of the original scene to be reproduced, as a first step in the production of the final subtractive colour picture. Such usage confirms the common principle of additive and subtractive methods explained on p. 80.

Additive methods employing beams of red, green and blue light to produce all the colours can give excellent and, if separate lantern projectors are used, brilliant results relative to subtractive methods, because the beams of coloured lights are merely added to and thereby reinforce one another. But the coloured beams must be projected separately by suitable means, either simultaneously or in rapid succession, which is not so easy to contrive as superimposing coloured materials in subtractive methods, and further difficulties may be involved by the necessity to blend the beams in such a way that the separately projected primary coloured images register with each other to yield a sufficiently sharp single image in the ultimate visual picture. Such difficulties limit the commercial application of the additive process except in television.

Nevertheless, the earlier industrial processes of colour photography and cinematography were additive and very ingenious. It will be

appreciated that Clerk Maxwell's original method described on p. 76, using three separate projectors, is commercially both expensive and cumbersome, although it has been used experimentally and additive viewing instruments called chromoscopes were devised in which images seen through red, green and blue filters were superimposed by means of mirrors. Among numerous experiments and inventions by creative workers in several European countries and in the U.S.A. aimed at circumventing in various ways the use of separate projectors, attempts were made with some success to apply the principle of the revolving colour disc explained on p. 76.

THE SUCCESSIVE FRAME METHOD

The projection of primary-coloured, red, green and blue, moving pictures in rapid succession by a single projecting machine, resulting in the images being blended by the persistence of vision to give the appearance of a picture in full colour, was suggested very early in the history of cinematography. It was the first colour cinematograph process to be launched publicly in 1908, under the name of 'Kinema-color'.

A disc containing segments of the primary-coloured filters, arranged in succession to one another, was rotated in front of the lens of the cine-camera in synchronisation with the camera shutter and the film transport so that successive frames (pictures) were exposed through each primary filter in turn. The film was processed by the well-known photographic chemical reversal method to give black-and-white positive images. This film was then shown with a projector equipped with another disc carrying filters identical to those used in exposing the film, the disc being rotated in front of the projector lens again in synchronisation with the shutter and the film. In this way each frame or image on the film was projected through the primary filter by which it was photographed; thus, whenever a positive black-and-white image taken through the red filter was in position behind the projector lens, a red filter was in front of the lens, followed next by green and then blue similarly.

More recently the same system has been applied to *colour television* with a red, green and blue filter wheel rotating before the lens of the television camera and a similar wheel rotating in synchronisation in front of the tube of the television receiver.

In spite of initial successes, however, the successive frame or rotating filter method has failed to establish itself. It has several inherent defects. High-speed cameras and projectors are necessary but even at high speeds the pictures of quickly moving objects show objectionable colour

fringes because the images change their positions between the three successive colour frames. The blue filter is darker than the red and green filters, which results in a brightness flicker that causes eyestrain on prolonged viewing. For colour television the rotating discs on the camera and receiver are liable to mechanical breakdown—a serious disadvantage for domestic television receivers. Also, a colour television system of this kind could not be received as black-and-white pictures on existing black-and-white television sets, such a system being said to be 'incompatible'. However, this type of colour television system, known as the '*field sequential system*', is the simplest and it has found some applications in closed circuit television (see p. 156).

A very recent, specialised application of the field sequential system has been made in the Kodak video colour negative analyser for the purpose of evaluating colour negatives quickly to produce high quality colour prints. Light from a flying-spot scanner cathode-ray tube (see pp. 153 and 159) passes through the colour negative on to a photomultiplier tube which is enclosed in a rotating drum carrying red, green and blue filters in sectors. Signals are thus generated in the photomultiplier tube that correspond to the red, green and blue components of the light transmitted by the negative. These signals are treated electronically and presented as positive black-and-white images on a display cathode-ray tube which is also mounted within a rotating drum having sectors of the three filters, so that the images are viewed sequentially through these filters. The rapidity of the sequence is such that the eye integrates the individual red, green and blue images to give the impression of a full-colour picture. A mechanical link between the filter drums enclosing the photomultiplier tube and the display cathode-ray tube ensures that the colour filter signals synchronize respectively with the three primary display images. The visual brightness and colour balance of the complete display image can be adjusted by manipulating calibrated dials on the control panel of the analyser until the image compares favourably with a reference or standard print. The control settings then provide photographic information for producing colour prints from the negative to match the displayed image.

THE LENTICULAR SCREEN METHOD

An elegant method of additive colour photography was invented in 1909 which had a successful commercial life from about 1925 to 1935, the best-known example being Kodacolor 16 mm ciné film marketed in 1928 (should not be confused with the present Kodacolor process, which is subtractive).

The back of the film support or base was moulded or embossed

during manufacture into very fine parallel furrows or lenticulations, forming minute semicylindrical lenses with axes running along the length of the film. The photographic emulsion was coated on the plane other side of the film support and exposed in the camera behind the lenticulations, that is, with the lenticulated back of the film towards the lens. Thus, each of the minute semicylindrical lenses formed a tiny image in the emulsion, the curvature of the lenticulations being made so that they focused tiny images of the camera lens on the emulsion layer. The camera lens was covered with a triple filter in which red, green and blue strips were fixed side by side and parallel to the direction of the lenticular mouldings on the film. Therefore images of these three filters were formed in strips on the emulsion along the entire length of each lenticulation. This meant that the picture on the exposed film was divided up into triads of fine strips along each furrow or lenticulation, the three strips of each triad recording the red, green and blue constituents of the view.

The film was processed by chemical reversal, as in the successive frame method, to give a positive and apparently black-and-white picture. It was then projected through a lens having a triple filter identical with that used for the exposure, so that the optical path followed during exposure and shown in Fig. 7.1 was precisely reversed in projection. The result was that the fine strip records of the red, green and blue constituents of the picture were focused by the individual lenticulations of the film on to the respective filters on the projector lens, which in turn focused the consequent red, green and blue light on to the same point on the screen. Hence the primary colours were mixed additively to reproduce the full colour picture as effectively as by triple projection.

The early Kodacolor film that has been mentioned carried 22 lenticulations per millimetre. The colour reproduction of the process is good and a great deal of investigation was made into its improvement especially in the U.S.A. and Germany, but as a photographic process it has been supplanted by subtractive systems. It is difficult to produce duplicates satisfactorily but the major disadvantage, as with all additive photographic methods which must use colour filters, is the inevitable loss of light through the filters resulting in a dimmer picture as compared with black-and-white, see p. 151. The lenticulations also cause some loss of definition or sharpness.

The principle of this method has been applied in recent years to *colour television* in the Lawrence television receiver tube or 'Chromatron'. The inside of the face of the tube is coated with red, green and blue fluorescing powders (phosphors, see p. 50) arranged in fine strips either vertically or horizontally, the strips being fine enough to give adequate definition in the picture. The strips of phosphors are activated

selectively either by three electron beams, one for each phosphor, inside the one tube or by deflecting a single electron beam to the respective phosphors. In both cases the electron beam is guided to the required phosphor strips by means of wires in a grid-like structure running parallel to the strips at a little distance from them. These electrified wires create electrostatic attracting or repelling forces between them which focus the electron beam or beams on to the appropriate phosphors, that is, they act as cylindrical electrostatic lenses in place of the lenticulations on the photographic film. If the strips are arranged vertically, the electron beam is actually deflected either to the left or right or allowed to travel straight on, so that it strikes the correct phosphor strip, by varying the voltage on and between the wires. Thus, as the electron beam scans the phosphors it produces red, or green or blue light in coincidence with the broadcast signals generated by the red, green and blue television camera tubes, and additive colour pictures are obtained on the face of the receiver tube.

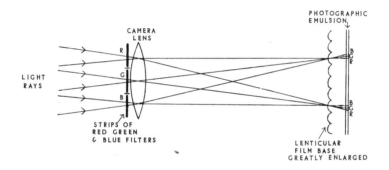

Fig. 7.1 Diagrammatic representation of the lenticular method for additive colour photography.

A receiver tube of this kind with a single electron gun producing one electron beam is simpler to make and operate, and hence cheaper, than a tube having three guns and three beams requiring registration and balancing of the three images. As yet the triads of phosphor strips can only be aligned accurately enough for small tubes and quite recently a Japanese 13-inch colour television set has been marketed which contains a single-gun tube of the kind described, named the 'Trinitron' tube. All other colour receivers for domestic use up to now employ the so-called shadow mask tube, described on pp. 161–164, which is much more expensive. There may be further developments, therefore, of the 'lenticular screen' type of television tube.

THE MOSAIC SCREEN METHOD

In 1869, only eight years after Clerk Maxwell's original demonstration of the additive process, a remarkable Frenchman, Louis Ducos du Hauron, published several suggested methods for reproducing colours photographically which anticipated most of the methods that have subsequently been employed, and all of them aimed at dispensing with the use of three projector lanterns. One of his inventive proposals was an adaptation of a principle that had been used by a school of French painters, known as 'pointillistes', who placed tiny dots of colour side by side to give the effect of continuous areas and tones of colour when viewed from a sufficient distance. Du Hauron proposed that a photograph should be taken through a fine mesh or mosaic of minute red, green and blue filters, too small to be seen individually, these filters to be applied on top of a photographic plate. In this way the records of the three primary colours would be obtained on the same plate which, if developed by chemical reversal (discovered in 1868), would give a positive image in colour. This is the coloured mosaic method mentioned on p. 77. It remains the simplest and has been the most successful additive process of colour photography.

During exposure in the camera the tiny filters of the mosaic determine which colours of the scene are recorded in the photographic emulsion behind them. Similarly, when the positive image has been chemically developed and is viewed, the same filters determine the colour of the light transmitted by the respective areas of the photograph, while the black-and-white continuous tone image in the emulsion controls the amount of light transmitted, that is, the tones or light and shade of the picture.

If a red object is photographed, the red light is recorded through the tiny red filters but is absorbed by the green and blue filters. After the usual first chemical development, therefore, an opaque silver deposit is formed exactly underneath each red filter whereas the emulsion under the green and blue filters is unaffected. For chemical reversal, the developed plate is placed in a solution which dissolves out the developed silver image and still leaves the unexposed emulsion unaffected, so the plate is rendered transparent under the red filters. The unaffected emulsion under the green and blue filters is then blackened and made opaque by a second development. Thus, when the plate is viewed, only the red filters transmit light and an image of the red object is reproduced. In general, of course, a photographed scene is more complex than this and various intensities of light of the constituent colours will be recorded behind all three filters, producing, after the reversal process, different degrees of transparency in the emulsion. Corresponding proportions of light of each of the three primary colours are then transmitted by the

tiny filters and, because the filters are too small to be resolved by the eye, the coloured rays are seen collectively and additively blended.

Up to the 1890s du Hauron's ideas could not be thoroughly put into practice until fully colour sensitive (panchromatic) photographic emulsions had been developed and also fully colour-corrected lenses, that is, lenses which bring all the rays of the spectrum to the same focus and do not produce colour fringes by unequal refraction (see Chromatic Aberration p. 69). Such lenses resulted from the discovery of new varieties of optical glass in 1880.

Ordinary, black-and-white, photographic emulsions are sensitive only to violet, blue and blue-green light. It was first discovered in 1873 that the addition of dyes to an ordinary photographic emulsion extended its colour sensitivity. Emulsions sensitive into the green and yellow regions of the spectrum are known as *orthochromatic* and have now been used for many years for improved black-and-white photography, by which, for example, a yellow flower photographs as nearly white compared with very dark grey on an ordinary emulsion. *Panchromatic* emulsions are sensitive to the whole spectrum and films, or the now obsolete glass plates, coated with such emulsions are essential for colour photography. Since the discovery of dye sensitization there has been continuous progress, through intensive chemical research for better dye sensitizers, in the production of photographic emulsions having high sensitivity to any desired part of the visible spectrum and also to the longer infra-red rays. Nevertheless, panchromatic and other emulsions dye-sensitized to radiations of longer wavelengths are still most sensitive to blue and ultra-violet rays, like ordinary emulsions. This unequal colour sensitivity can be easily corrected to give better overall colour rendering in black-and-white on panchromatic film by using a pale yellow filter (blue and ultra-violet absorbing) in front of the camera lens. Or better still, a pale yellow-green filter to subdue at the same time the slightly higher sensitivity to red than that of the eye.

By the early 1890s, therefore, these related and essential discoveries enabled several inventors to explore the mosaic screen method of additive colour photography and three important variations of it were ultimately marketed, as follows.

The Separate Colour Screen Process

Around 1895, Professor Joly of Dublin successfully produced colour pictures by mechanically ruling adjacent fine lines of red, green and blue dyes, about 200 to the inch or 8 per millimetre, with a set of fine pens across a sheet of glass. This ruled colour screen was placed in contact with a photographic plate which was exposed in the camera behind the screen. From the resulting negative a positive image on glass was made

by the usual straightforward photographic process. The colour screen was then registered in contact with the glass positive so that the lines of the red, green and blue record in the black-and-white positive coincided with the red, green and blue lines of the screen. On viewing the combined glass screen and glass positive in front of white light, the original photographed view was rendered in its colours.

This method was introduced commercially by Finlay from 1906 onwards, who printed the fine primary coloured lines on to glass. The screen was relatively coarse but the method had the advantage that any number of positives could be made from one negative. It was revived after the 1939–45 war as the Johnson Colour Screen Process with an improved screen of 350 lines per inch and survived until the mid-1950s.

Random Mosaic Processes

The Lumière brothers in France produced the first commercially manufactured irregular or random mosaic screen in the Autochrome plate in 1907. Mixed red, green and blue dyed starch grains, which are minute and of fairly uniform size, were dusted over glass plates previously coated with a tacky varnish. The single layer of grains adhering after removing unattached grains was rolled under pressure so that the grains were pressed into thin discs, and the plate was then dusted with finely powdered carbon black. The latter adhered only to the remaining exposed varnish, thereby filling in the interstices between the starch grains to avoid dilution of the colours with white light. After covering the mosaic screen of starch grains with a protective varnish layer, a panchromatic emulsion was coated directly on to the screen plate.

After exposure in the camera with the mosaic towards the lens, the plate was processed by the chemical reversal method to give a positive image (transparency) in colour for viewing by transmitted light. The fineness of the irregular pattern of tiny primary-coloured filter elements was probably of the order of 400 or 500 starch grains per inch (15 to 20 per millimetre) and the Autochrome plate enjoyed popularity for a quarter of a century.

The first Agfacolor plate, which appeared after the 1914–18 war, was similar in principle but droplets or particles of dyed resin were used for the mosaic instead of starch grains, giving a rather more transparent result.

Random mosaic-screen processes gave rise to problems due to clumping together of dyed grains of the same colour which caused an increase in apparent mottle. Regular mosaics became finer and subsequently more successful.

Regular Mosaic Processes

Louis Dufay in France had introduced the 'Dioptochrome' plate in 1908 in which the screen had printed lines of colour. This was steadily improved and later applied to film rather than glass. It was perfected on roll film by mass-production methods in England about 1934 as *Dufaycolor*, which became the best known of the regular screen additive processes.

The film base was first coated with primary blue-dyed collodion and on this fine parallel lines of greasy ink, 500 to the inch or 20 per millimetre, were printed from an engraved cylinder, the lines running diagonally across the film. The printed film was passed through a bleaching bath to remove the blue dye from the unprotected spaces between the printed lines, and then into a green dye solution which dyed these spaces green. The greasy ink was next removed in a bath of solvent, revealing a pattern of alternate blue and green lines, 40 per millimetre in all. Another series of greasy ink lines was printed at right angles to the first, again the unprotected interspaces were bleached and this time dyed primary red. After removing the greasy ink, a geometrical mosaic or reseau was obtained consisting of alternate blue and green squares separated by thin red lines (see Plate 25), giving 1 600 primary-coloured filter elements per square millimetre or one million per square inch. It was a triumph of mechanical printing and precision processing. A protective varnish was applied to the reseau and finally the film was coated with panchromatic emulsion.

As in the Autochrome process, the emulsion was exposed through the mosaic and processed by chemical reversal to give a positive image. Dufaycolor had a higher light transmission than any other mosaic-screen plate or film, the colour rendering was good and the exceedingly fine pattern of the reseau made it suitable for projection without the pattern being perceptible at reasonable viewing distances from the screen, so that it was adapted as a negative–positive process for cinematography.

Notwithstanding that mosaic-screen processes were the most successful for additive colour photography, they have fallen out of use as subtractive methods were progressively developed, because they suffer from *two serious limitations*. Each primary-coloured filter element in the mosaic should in theory transmit only one third of the spectrum, the light of the other two thirds being absorbed. The white areas of an image are rendered by all three filters in the mosaic with no opaque silver deposit in the underlying photographic emulsion, but the filters transmit no more than one-third of the illuminating white light. In practice they absorb some light of their own colours and transmit considerably less than a third, only 20–25 % of the illumination. Strong illumination is necessary, therefore, for both projection and direct

viewing by transmitted light. Wherever additive primary filters are used there is inevitably much loss of light and this makes the additive process useless for paper prints viewed by reflected light. Additive colour filter elements on white paper absorb at least 75 % of the incident light, some of which is also absorbed by the paper after the light has first penetrated the filter elements, and the filters then remove a further 75 % or more of the remaining reflected light, so that the whites of the picture become dark grey.

The second disadvantage is that the separate or discontinuous filter elements cause some loss of definition of fine detail in the image and the pattern of the mosaic becomes obtrusive on limited enlargement by projection. The subtractive method, explained in Chapter 8, largely avoids these inherent restrictions of the additive process in photography. In *television*, however, these disadvantages are much less serious, partly because the phosphors by emitting light do not waste it as absorptive filters must.

COLOUR TELEVISION

The current success of the additive method for colour reproduction, and particularly the mosaic-screen principle, is in television. Essentially, the television camera separates the colours of the picture through primary red, green and blue light filters to derive the electrical signals that are broadcast and the television receiver converts the signals back into three primary beams of light which are additively mixed, usually by the eye.

Many formidable problems have had to be overcome not only to reproduce the scene as a colour picture of good quality, but also because colour television requires the transmission by electromagnetic radio waves of three pictures compared with one for black-and-white (monochrome) television. The 'spectrum' of radio waves between wavelengths of well over 2000 metres to much less than one metre is a lot wider than the spectrum of light and, therefore, it may be thought that the transmission of three pictures should not be difficult. But for fundamental technical reasons a television system can only be transmitted on much shorter wavelengths than ordinary sound radio, around half a metre corresponding to frequencies around 600000000 cycles (waves) or 600 megacycles per second, and it has to be fitted in to the demands of many other short-wave radio communication systems such as VHF radio, police, military, shipping and aircraft radio and radar. Due to the relatively short ultra high frequency (UHF) wavelengths of television signals, they are not refracted or reflected back to the Earth's surface, as are longer-wave radio signals, by the so-called ionosphere in the higher atmosphere, and this loss into space limits the range of a television

transmitting station to less than 100 miles (160 kilometres) at ground level. However, advantages of such short-wave transmission are that a comparatively small aerial can be used to pick up the radiations and there is less interference.

In radio and television studies it is the practice because it is more convenient to refer to the frequency (see p. 6) rather than the wavelength of the electromagnetic waves. A radio or television transmitter continuously emits what is termed a carrier wave of definite frequency or wavelength to which the radio or television receiver is tuned. The electrical impulses generated by a microphone for sound or a television camera are superimposed on the carrier wave which is thereby 'modulated', that is, modified in intensity (amplitude) and within limits in frequency. These modulations of the carrier wave produce identical impulses in the tuned receiver which amplifies the electrical impulses to activate a loudspeaker or the electron beam emitter (electron gun) of a television tube.

Because of the frequency variations of the carrier wave caused by the signal modulations, the transmitter must have adequate frequency space or bandwidth as it is called to accommodate the range of variations, and the multiple images for colour television, if transmitted separately, require more bandwidth than monochrome television and this in turn more than sound radio. Hence the difficulty of fitting colour television frequencies in between those of other systems of radio communication, all of which must be adequately separated to avoid interference. Moreover, the more detail required in a television picture (number of screen lines and number of pictures per second), the greater is the bandwidth of the transmitted signals. A great deal of highly ingenious investigation has been applied to reducing the transmission bandwidth for colour television as much as possible while maintaining sufficient detail in the picture, and in European systems the bandwidth is now limited to 8 megacycles per second for any one transmission 'channel', which is no wider than that hitherto needed for black-and-white transmission. The sound signal of a television programme is also transmitted in the UHF range alongside the vision signals though on a much narrower bandwidth of lower power.

For television, the two-dimensional image of a scene, as formed by a camera lens, has to be converted into a one-dimensional electrical signal for transmission and at the receiver the one-dimensional signal has to be reconverted into a two-dimensional copy of the image. These conversions are achieved by the process of scanning or 'reading' the original camera image in narrow lines one after the other at extremely high speeds with a fine beam or pencil of electrons, and at the receiver by the reverse process of reforming the picture line by line through the fluorescence produced on the face of the television tube by a similar high speed

scanning beam of electrons, the energy or intensity of which varies with time in accordance with the transmitted signal.

The speed of scanning is such that the whole image is traced by the electron beam or spot traversing 625 horizontal lines in 1/25 second in the European systems or 525 lines in 1/30 second in the system adopted in the U.S.A. The total cycle, therefore, takes 1/25 or 1/30 second to build up the whole picture, which is shown one part at a time but all within that small fraction of a second. Because at this speed the first part of the image has not faded from the retina before the last part makes its impression, that is, due to the persistence of vision, the eye sees the complete picture. The general effect is similar to that of the successive frame projection in cinematography. Flicker is minimized in television by using 'interlacing', by which the electron beam first scans all the odd, first, third, fifth, etc., lines of the picture in 1/50 or 1/60 second and then re-scans along the intermediate, even lines in the second half of the picture interval.

Television Cameras

It will be appreciated that a television camera is very different from a photographic camera. Its function is to produce electrical signals, not a visual image. It is similar only in that it carries a lens, a colour-corrected lens for colour work, to focus the light reflected from the scene on to a light-sensitive surface, but the latter is not a photographic emulsion. The image formed by the lens is focused on to a photosensitive layer having electrical properties which vary with the intensity of the light to which it is exposed, in the same way that a photoelectric cell reacts to light. This electrical image is scanned by an electron beam in the way already mentioned.

In one of the somewhat simpler types of electronic scanning devices used in colour cameras, called a *vidicon* tube, the photosensitive layer consists of a thin film of photo-conductive material such as selenium or antimony sulphide. This material becomes electrically conductive on exposure to light, the conductivity increasing with the light intensity. On the outer side of this photo-conductive layer, that is, on the surface facing the lens, there is a transparent conducting film. Behind the photo-conductive layer is an electron gun producing a beam of electrons which scans the layer, the whole arrangement, as with all television camera scanning units, being housed in an evacuated (vacuum) glass tube. See Fig. 7.2. Where there is no light in the image formed by the lens on the photo-conductive film, the latter acts as an insulator and prevents electrons, that is, current, flowing from the gun to the transparent conducting film. Where light does fall on the photo-conductive layer the

electron beam, and therefore current, is conducted through to the transparent conducting film and this current, which generates the required television signal, increases with the brightness or luminance of the image.

A smaller but otherwise very similar device, the *plumbicon* tube, uses lead oxide (litharge) as the photo-conductive material, hence the name of the tube. Another, more sensitive and larger tube than the vidicon, the *image-orthicon tube,* that is widely used, employs a photo-emissive metallic material for the photosensitive layer instead of a photo-conductive substance. A photo-emissive metal, for example, caesium,

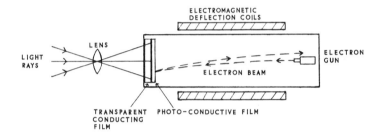

Fig. 7.2 Diagrammatic illustration of the main features of the vidicon television camera tube.

emits electrons from its surface when illuminated by light and the amount of the emission is proportional to the intensity of the illumination, although it varies with the wavelength of the light. In the image-orthicon tube, the optical lens image falls on a very thin, semitransparent photo-emissive layer and the electrons released from the inner surface of this are focused by means of electronic controls on to a 'target'. The target is an extremely thin glass membrane and the electrons emitted from the photo-sensitive layer produce an electronic-charge pattern or image on both sides of it. This pattern causes changes, proportional to the original image luminance, in the current of the electron beam scanning the target, which are amplified and the sensitivity thereby increased through an electron-multiplier to provide the signals.

Obviously the photo-sensitive layer in these tubes for colour cameras must be sensitive to the whole of the visible spectrum, as with panchromatic photographic emulsions. The materials used tend to have greater sensitivity in the blue than in the red regions of the spectrum, but this can be corrected adequately by means of filters and electrical circuitry. The electronic procedure for correcting the spectral sensitivities of camera tubes is termed matrixing.

In the case of closed circuit television, in which the signals are carried by cable from the camera to the receiver, the comparatively simple 'field-sequential' television version of the successive frame colour reproduction system, explained on p. 144, may be employed. For this a filter wheel rotates in front of a camera which requires only a single camera tube as does a camera for black-and-white television, since the colour signals or 'frames', like the colours at the receiver, are produced by the rotating filter disc. Unfortunately, such a system is not suitable for a public colour television network for reasons given on p.145.

For the broadcast transmission of colour television it is necessary to transmit red, green and blue signals simultaneously. These signals must represent the same scene viewed from the same position and this requires cameras containing three identical camera tubes of the kind described above, one tube for each colour signal, with all three tubes obtaining their images from one viewing lens. The usual colour television camera, therefore, is similar in principle to the 'one-shot' camera used in colour photography (see p. 183). Behind the viewing lens and as close as possible to it there is an assemblage of partially reflecting and partially transmitting mirrors or prisms, mostly colour selective (dichroic—p. 44), that splits the light from the lens into three separate beams, each of which is focused on to a camera electron tube. Each light beam passes through a primary colour filter (red, green or blue) so that the colour components of identical images are received simultaneously by the electron tubes. Thus, red, green and blue images are continuously passing to the camera tubes and the resulting electrical colour signals are conveyed by cable from the camera to encoding units and the transmitter.

The three identical electron tubes in the camera may all be of the image-orthicon, vidicon or plumbicon type, each type allowing a different arrangement of the semi-reflecting mirrors or prisms, which affects the overall size of the whole camera; though, because the light is filtered, the actual colour responses of the three tubes need not be identical. The choice of tube is determined by relative differences in factors such as sensitivity, spectral response and size. Focusing is carried out, as usual, by adjusting the position of the viewing lens, which is often either a zoom lens or one in a turret carrying three or more lenses on the front of the camera. Clearly, the images formed on the three tubes must be geometrically identical and in exact registration with one another, otherwise poor definition and colour fringing will occur. It follows that a colour television camera demands very precise optical and electronic assemblies which must be mounted rigidly. For a description of a two-tube colour camera see p. 184.

In practice, the most widely used colour cameras contain four tubes, the fourth to provide a black-and-white (luminance) signal, for reasons explained in the following section, although the available light has to be

shared among four tubes instead of three. The signals produced by the electron tubes are weak so they are first pre-amplified within the camera and then passed to further amplifiers, which also enable any necessary corrections of the camera signals to be made, prior to transmission. Likewise, the broadcast signals from the transmitter that are picked up by any one receiver at a distance are feeble and have to be amplified again in the receiving set.

Colour Transmission

The importance of limiting the bandwidth of the frequencies used for television transmission has been mentioned on p. 153. The principles of colorimetry and of electronics have been applied with great ingenuity to this problem as they have to the whole field of colour television. Some of the ways by which reductions in the bandwidth have been accomplished, involving the concepts of band-sharing and carrier-sharing, are outside the scope of this book. But one remarkable procedure that has resulted in considerable savings in bandwidth is quite relevant and must be mentioned.

The visibility of fine detail in a view depends on differences in the luminance over the detailed scene much more than on colour differences or contrasts. For instance, coloured lettering on a dark background of a complementary colour is hardly more visible from a distance than the same lettering in white on a dark grey background. From this premise, it has been found possible electrically to separate the luminance content from the colour information supplied by the television camera, that is, to transform the three electrical colour intensity signals from the camera into a luminance signal and two colour difference or chrominance signals.

The three signals actually transmitted, therefore, consist of a luminance signal for definition of the image and two colour-difference (difference from white) signals that transmit the colour information rather than the detailed image definition. Such a procedure is parallel with the C.I.E. system in that the luminance signal is analogous to the Y luminance factor of a C.I.E. specification and the two colour signals to the x and y chromaticity coordinates. This device provides not only decisive economy in the frequency bandwidth for transmission but several additional advantages in the colour system itself including reductions in interference, compared with the transmission of three actual colour signals. It also enables the luminance signal to be used by monochrome receivers to give black-and-white pictures, the colour signals being ignored by such receivers. This is an important contribution to compatibility between colour and monochrome reception of television programmes.

The luminance signal, which we may call Y, is derived from all the tubes of a three-tube red, green and blue camera, but mainly from the green tube in accord with the colour-luminosity sensitivity of the eye (p. 62). The output signals from the three primary-colour tubes are adjusted to be equal when the scene is white, thus relating to the tristimulus values of the C.I.E. system (p. 127). The colour-difference signals are obtained by electrically subtracting the luminance signal from each of the primary R, G, B signals, to give $R - Y$, $G - Y$ and $B - Y$. Each camera tube picks up information on the luminance (lightness), hue and saturation of any part of a scene so that, having subtracted the luminance, the colour-difference signals represent the hue and saturation, that is, the chrominance. When all the colour-difference signals are zero, white or a neutral grey is produced according to the intensity of the luminance signal.

Because there is a constant relationship between the colour-difference signals for the three primary colours, it is only necessary to specify two of them, from which the third can be derived as with C.I.E. chromaticity coordinates, and in fact the third colour-difference signal is easily reconstructed electrically in the receiving set. Hence two colour-difference signals are sufficient to transmit the chrominance information. It can be shown that the red and blue colour-difference signals, $R - Y$ and $B - Y$, with the green colour-difference derived from them, give better results than either of the two alternatives; and these are therefore the two chrominance signals that are transmitted. As the eye does not notice colour in the very fine detail of a picture but only the luminance, the chrominance signals may be omitted or reduced in such areas, which allows some further electrical simplification and band-width reduction of the transmitted signals. The phase of the chrominance signal waves conveys hue, and the amplitude, which is the height or strength of the waves, corresponds to the saturation of that hue. Ligtness, as indicated, is transmitted by the luminance signal.

Some contrast correction of the signals is normally necessary because the light output from the phosphors of receiver tubes (see the next section) is not exactly proportional to the energy of the electrical signals. It is relatively difficult to produce a truly corrected luminance signal when this is obtained entirely from the primary-colour tubes as it has to be from a three-tube camera. Such problems are simplified by using a four-tube camera, the fourth tube without a colour filter to supply a separate luminance (black-and-white) signal that can be fully contrast corrected. The two colour-difference signals are, of course, wholly derived from the red, green and blue tubes. As with three-tube cameras, the light from the viewing lens is split by means of semi-reflecting mirrors and prisms, in this case into four separate beams focused on to the four tubes. The separate high definition luminance signal makes

registration of the colour-difference signals less critical and deficiencies or errors in saturation and to some extent in hue of the colour reproduction from a four-tube camera are less than those from a three-tube camera, while somewhat better black-and-white, monochrome reception is supplied.

Colour Receivers (Display Devices)

So far all the systems that have been brought into use for the reproduction of colour pictures by television involve the additive mixture of primary red, green and blue lights (stimuli). Television receivers based on the subtractive method have been suggested but, as yet, unsuccessfully.

All television receivers make use of *cathode-ray tubes*, the picture being reproduced by fluorescing phosphors (see p. 50) on the face of the tube. Although these units are hardly tubular in shape in the large modern sets, the early cathode-ray tubes really were glass tubes. The essential features are indicated in Fig. 7.3. Cathode rays consist of a stream or beam of electrons emitted from a negatively charged electrode, termed a cathode, when it is heated or an electric discharge takes place between it and the positively charged electrode, the anode, in a vacuum. Hence the cathode and anode must be enclosed in an evacuated glass envelope, from which virtually all air and other gases have been pumped out. In the type of tube used for television, the cathode in the form of a small nickel cylinder is coated with a material such as an oxide that readily emits electrons when heated, this being done by an adjacent electric heater—the warming-up process after switching on. The electrons supplied by the hot cathode are rapidly accelerated through attraction towards the oppositely charged anode by keeping the anode at a high electrical potential relative to the cathode, commonly some tens of thousands of volts higher. The intensity or power of the stream of electrons from the cathode is altered by changes in the difference in voltage, amounting to teens of volts, between the cathode and the surrounding cylindrical control-grid, this difference being determined by the incoming amplified signals, although it can be adjusted somewhat by means of the 'brightness' and/or 'contrast' controls on a domestic receiver.

When the control-grid voltage is at its lowest below that of the cathode, the electrons fail to reach the phosphors on the face of the tube and the effect is black. When the grid voltage is at its highest above that of the cathode, the electron beam has maximum power and produces peak white from the phosphors. The stream of electrons is focused into a fine beam or pencil and projected down the axis of the tube, to produce a tiny spot on the phosphor screen, by means of electromagnetic or electrostatic focusing devices in the neck of the glass envelope. The

beam or electron spot is deflected and made to move at high speed across the phosphor screen, so as to scan the screen line by line in the way described earlier, by electromagnetic deflection coils. The electrons strike the phosphor screen coated on the face of the tube and excite the phosphor to emit light by fluorescing in proportion to the intensity of the electron beam, that is, to the amount of current flowing in the beam, as determined by the incoming signal. Thus the picture is obtained by the variations in the amount and position of the fluorescent light produced according to the changes in the power of the 'spot' beam as it traverses the screen during scanning.

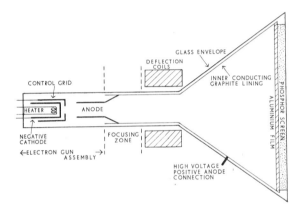

Fig. 7.3 Diagram, not to scale, showing the essential features of a cathode-ray tube for television.

The accuracy of the scanning beam is aided by lining most of the inside of the tube with a conducting layer, as shown, connected to the anode. On the face of the tube, that is, on the inner surface of the phosphor screen, this conducting layer consists of a very thin film of aluminium which, in addition to assisting the scanning, reflects forwards the light emitted backwards by the fluorescing phosphor screen that would otherwise be wasted. Real cathode-ray tubes actually used in television are more complex than the foregoing description indicates, but the elaborations, which are chiefly on the electrical side, need not concern us here.

It will be realized that three different *phosphors* are required for colour television, one that provides a suitable red fluorescence, another green and the third, blue. Over the last twenty years much work has gone into the development of improved phosphors having C.I.E. chromaticities

for their fluorescence that enable a wider range of colours to be re-produced than in the early days of colour television and with higher efficiency or luminance. Some of the phosphors are specially manu-factured forms of zinc and cadmium sulphides, others are more complex metallic compounds.

The field-sequential colour television system has been mentioned on pp. 145 and 156. The receiving cathode-ray tube in this method requires only a white fluorescing phosphor since the colours are produced by the rotating filters in front of the screen. But, as previously stated, this system has very serious disadvantages for public broadcasting.

Perhaps, in principle, the least complicated broadcast colour reception arrangement is that in which three cathode-ray tubes are used, one for each of the three primary colours. By means of semi-reflecting dichroic mirrors (reflecting one colour and transmitting another, p. 44), the images on two of the tubes are combined in register with the third, and a truly additive colour picture is obtained. The so-called 'Trinoscope' is such an arrangement. The separate cathode-ray tubes allow special, high efficiency phosphors to be used in each tube, to give images of greater luminance than in other contrivancies. A three tube display system has the further advantages that the whole of a tube face is available for each primary colour and the tubes do not require a shadow mask (see below) to stop electrons from the scanning beams, so a comparatively bright display can be provided. Better resolution of picture detail is also obtainable as there is only one continuous phosphor on each tube face instead of the pattern of three phosphors (see below) on a single colour-receiver tube. But the constructional problems to achieve the necessary precision in registering and matching the three images are similar to those of a three-tube colour camera. Not only is such a system too bulky but also much too costly for domestic receivers. Its chief use is for colour tele-recording on film, where the high luminance image is an advantage.

For projection purposes in cinemas and the like, the additive triple projection method can be used. Three separate, high intensity cathode-ray tubes fitted with wide aperture lenses and mirror systems are arranged to throw red, green and blue images, superimposed in register, on to a single screen. Again, however, there are the considerable difficulties of accurate registration to be overcome.

Shadow Mask Tube

Out of numerous alternatives that have been proposed from time to time for domestic colour television receivers, the only one to have been proved suitable for mass production is *the shadow mask tube,* until the very recent advent on the market of the Trinitron tube described on p. 147

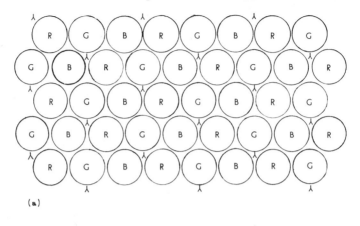

(a)

(b)

SCREEN OF PHOSPHOR DOTS

METAL 'SHADOW-MASK'
PLATE WITH HOLES

ELECTRON BEAMS

ELECTRON
GUNS

Fig. 7.4 (*a*) The regular mosaic arrangement of the red, green and blue fluorescent phosphor dots, greatly enlarged, on the screen of a shadow-mask colour television tube. λ marks the positions of the holes in the shadow mask behind the screen, each hole being opposite the centre of a triad of phosphor dots.
 (*b*) Representation of the function of the shadow mask. As each hole in the mask is centred on a triad of phosphor dots, the beams from the three triangularly positioned electron guns, each activated by a red, green or blue signal, can scan only the respective phosphors. The solid portions of the mask stop electrons from reaching the wrong phosphor dots. The dots are too small to be individually visible on the screen of the television receiver and their red, green and blue fluorescence is mixed additively by the eye.

which uses the lenticular screen principle. So far, however, it has been found possible to employ the latter only for the smaller and less popular sizes of television sets.

The shadow mask tube is based on the colour mosaic principle. This enables three electron guns, each controlled by a primary colour signal, to be incorporated in one cathode-ray tube. The face of the

tube is coated with a regular mosaic of tiny dots of the red, green and blue fluorescing phosphors arranged in rows roughly parallel to, though not necessarily coinciding with, the scanning lines of the picture, also arranged in sequence in each row and in such a way that the same sequence is repeated in alternate rows, as indicated in Fig. 7.4(a). Thus the screen is covered with small triads or triangles of the three phosphor dots, which are less than 0·4 mm in diameter and 0·7 mm apart and too fine for the eye to resolve either the individual dots or the triads at normal viewing distances. There are, generally, $1\frac{1}{4}$ to $1\frac{1}{2}$ million phosphor dots on the screen, each of which is scanned in turn.

The obvious problem is how to ensure that each phosphor dot is bombarded or irradiated only by the electron gun controlled by the respective colour signal, that is, the red phosphor dots by the red signal gun, the green phosphor dots by the green signal gun and the blue phosphor dots by the blue signal gun. This is the function of the shadow mask. It consists of a thin metal plate with about 400 000 separate holes in it, fixed rather less than $\frac{3}{4}$ inch (19 millimetres) from the phosphors. The pattern of the holes is so arranged that each hole lies exactly opposite the centre of each separate triangle of phosphor dots as indicated by the λs in Fig. 7.4(a), so that there is one hole in the mask for every triad. The most compact disposition for the three electron guns in the tube is triangular and, therefore, the three electron beams are projected at different angles to one another towards the mask and screen dots. Hence the layout of the holes in the mask in relation to the phosphor dots allows each electron beam to strike only its respective phosphor. The solid areas of the mask stop the electron beams that would otherwise reach the wrong phosphors. The paths of the electron beams to the mask and through the holes to the phosphor dots are illustrated in a simplified cross-sectional form in Fig. 7.4(b).

With three electron guns in the same tube, the same electro-magnetic focusing and deflection devices can be used to register all three electronic images to form the picture, although special electrical provision has to be made to modify the magnetic fields so as to make the three beams converge correctly over the whole of the picture area.

The shadow mask tube yields pictures of high colour quality, but it requires great care in manufacture because of the essential precise geometrical alignment of the electron guns and especially of the shadow mask holes with the phosphor dot pattern. To secure the required accuracy, the holes in the shadow mask are etched by photoengraving (p. 193) from a master negative and the phosphor dots for each colour are affixed separately on the face of the tube by a photomechanical procedure (p. 199), repeated three times behind the exactly re-positioned metal mask, using a light-sensitive material as a coating to bind the phosphors in the correct dot pattern. These constructional difficulties

make the tube more expensive than is desirable but at present it is quite the most widely used type of colour television receiver.

The transmitted luminance and two colour-difference (chrominance) signals representing the brightness and colour of the picture are separated and decoded at the receiver by appropriate electrical circuits or electronic devices connected to the cathode-ray tube, so that the signals fed to the electron guns correspond to those initially generated by the colour camera tubes. After recovering the green colour-difference signal in the receiving set, it is usual to apply the contrast-corrected luminance signal to the cathodes of all three electron guns of the shadow mask tube and the relevant corrected colour-difference signal is applied to the control-grid of each gun (see Fig. 7.3). This means that the luminance signal, which we have labelled Y, is added to each colour-difference signal $(R - Y, G - Y$ and $B - Y)$, thereby producing from the electron guns the three correct colour signals, R, G and B, to activate the phosphors to the required extent to give the copy of the original scene displayed on the screen of the tube. The process, though performed electrically, is akin to the transformation of a colour specification from the C.I.E. XYZ system to a normal, red, green, blue additive three-colour system. Thus, the original camera signals which may be regarded as coded for transmission are re-converted by the receiver, and the coloured fluorescent lights emitted from the screen of the cathode-ray tube are proportional to the three primary colour contents of the televised scene, giving an additive reproduction of it to the observer.

Standard Colour Television Systems

The U.S.A. was the first country officially to adopt a system of colour television for general use with Japan following some years later. Initially, the system accepted in the U.S.A., though only from 1950 to 1951, was a version of the 'field sequential' or rotating filter colour method (p. 144) developed by the Columbia Broadcasting System. In 1953 the quite different scheme recommended by the National Television System Committee (N.T.S.C.) in 1951 was put into practice, this being a 'simultaneous' system with its important advantages. Modified versions of the N.T.S.C. system were developed in France, the S.E.C.A.M. (Sequence and Memory) system which has also been adopted by the Soviet Union, and in Germany, the P.A.L. (Phase Alternation by Line) system, the latter being that subsequently adopted in Great Britain and most other West European countries. All are based on C.I.E. specifications for the chromaticities of the receiver colours, the fluorescencies of the phosphors, to provide as wide a range of reproduced colours as feasible. From these specifications the required relationships between the luminance and the two chrominance transmission signals and other

factors can be evaluated mathematically with reference to the chromaticity chart. Essentially, they are systems for the transmission of the signals. All three systems have been well proved in practice and they produce very similar pictures, so similar that differences are not easily detected.

They differ in technical details, especially in the way each system uses to transmit the two chrominance signals. The fundamental difference between the N.T.S.C. and P.A.L. systems on the one hand and the S.E.C.A.M. system on the other is that the former transmit and receive the two chrominance signals simultaneously, whereas the 'sequence and memory' S.E.C.A.M. system sends the signals sequentially one after the other with one scanning line difference in time (sixty-four millionths of a second), which is simpler and less liable to interference but a one-line delay unit acting as a store or memory is required in the receiver to bring the chrominance signals to the same scanning line. The feature distinguishing the P.A.L. system from the N.T.S.C. system is a phase difference in the chrominance subcarrier wave transmitted. Both these systems involve amplitude modulation of the carrier waves while the S.E.C.A.M. system uses mainly frequency modulation (see p. 153) and, as mentioned earlier, the American system scans the picture at the rate of 525 lines per 1/30 second (30 pictures per second) compared with those now employed in Europe of 625 lines in 1/25 second (25 pictures per second). Of the two European modifications of the preceding N.T.S.C. system, the P.A.L. system has greater similarity to the N.T.S.C. scheme than does the S.E.C.A.M. system. For a detailed consideration of these systems, with particular reference to colour, the excellent book on *The Reproduction of Colour* by Dr. R. W. G. Hunt, listed in the Bibliography for Further Reading, should be consulted.

The transmitted signals in television systems are balanced so that equal red, green and blue emissions at the receiver reproduce white, and they are usually colour standardized as though the illumination under which the scene is taken corresponded to the C.I.E. standard illuminant C (daylight), no matter what the actual illumination may be. This means that when the reproduced picture is viewed in artificial (tungsten-lamp) lighting, as is often the case, the picture may tend to appear bluish because tungsten lighting is deficient in blue compared with daylight. But if the reproduced white (and greys) were made to correspond to the colour temperature of tungsten lighting, the picture would be objectionably yellowish when viewed in daylight. Also, if the luminance of the picture is greater than that of the surrounding illumination, which is usually relatively low or dim, the eye adapts itself to the character of the lighting of the picture rather than that of the ambient lighting, and the bluing effect of artificial room lighting is not noticeable. Largely for this reason, the white light emitted by most domestic receivers cor-

responds to a colour temperature of about 6 500°K to 9 300°K (see p. 14, Colour Temperature).

The colour television cameraman is confronted with some difficulty when a scene is partly lit artificially and partly naturally, such as a setting against a window, and he has to use special filters to balance the illumination. It will be realized that transient signals produced by electrical interference from a variety of possible sources may momentarily cause large colour distortions in a television picture.

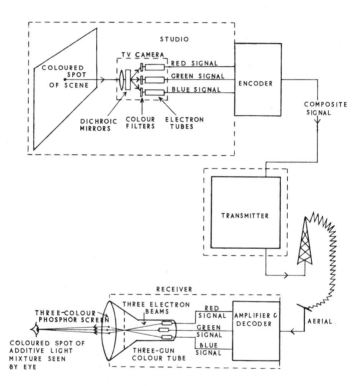

Fig. 7.5 Schematic diagram of basic broadcast colour television system.

A diagrammatic representation of a complete basic colour television system is given in Fig. 7.5.

TWO-COLOUR REPRODUCTION

Depending very much on the subject and its illumination, remarkably good colour imitations can sometimes be obtained by blending two colours only. The possibility of a two-colour additive process for colour reproduction with the concurrent simplifications of the requirements and equipment stimulated a great deal of earlier work in this direction. The near-complementary colours cyan and orange (blue-green and orange-red) were found to be the best 'two-colour primaries' and have been used in commercial cinematography employing two-colour projection. Properly chosen, the cyan and orange together give a reasonable approach to white, flesh tints can be satisfactorily reproduced, but violets, real blues and deep reds are absent from the results. The effects on the eye are often better than might be expected, probably due to colour contrast and after-image effects (see pp. 65 and 67) and partly, perhaps, because the imagination supplies qualities of colour which are not actually present.

Much interest was aroused little more than ten years ago by demonstrations of two-colour projection made by Dr. E. H. Land, which showed that under suitable circumstances colours appear to be seen that are not physically present. For this purpose, a colour scene is photographed twice, through red and green filters, and two transparent black-and-white positives, lantern slides, are prepared. These are then projected separately but in register on to a screen, the positive from the red filter being projected through a similar filter while the other positive is projected without any filter, that is, with the white light of the lantern. Surprisingly, the additive red and white image shows a wide range of mixture colours, including green or cyan, and appears to be an acceptable reproduction of the original scene.

This demonstration has a simpler parallel in the coloured shadows first described by Goethe one hundred and seventy years ago. If in a dark room a table top covered with a white cloth is illuminated with red and white lanterns at right angles to each other and an object is placed on the centre of the cloth, it will cast shadows from the two beams of light. The general illumination is pink (red plus white) and the shadow from the red lantern is illuminated by the white beam while the other shadow is lit by the red beam. Actually, the general illumination appears to be near white and, by colour contrast, the shadow illuminated by the white lantern looks cyan.

A striking feature of the additive red and white Land projections is that reasonable colour reproduction is obtained only if the two images are in register with each other or very nearly so. If the registration is badly out, only reds, pinks and whites are seen. This implies that more than colour contrast effects and adaptation of the eye to the pink

colour of the general illumination are involved, for these would not depend upon the registration. It seems that, if the two images are close enough to produce a recognizable picture, the eye discounts the overall pink illumination and, presumably, in part from colour memory or association, sees the scene as though it were lit by white light.

Whether a two-colour reproduction, either from the commoner cyan and orange mixtures or the red plus white, is acceptable depends on the nature of the scene. Indoor subjects generally give better results than outdoor scenes, due probably to the yellowish character of indoor lighting, particularly from blue-deficient tungsten filament lamps. A considerable limitation is the inability to show much, if any, colour difference between blues and greens, such as blue sky and green foliage.

DEFICIENCIES IN ADDITIVE METHODS

In Chapter 5, p. 83, we have explained how the overlapping of the colour sensitivities of the red, green and blue responsive ρ, γ and β retinal cones in the eye imposes unavoidable inaccuracies in colour rendering by straightforward trichromatic reproduction, whether it be additive or subtractive. Because the use of colour filters, essential in photographic processes, to obtain the additive primary light beams involves loss of light by absorption from white illumination, and also there is the cost factor to be considered, it is the practice to use filters transmitting broad bands of the spectrum, usually about one third each, rather than monochromatic or near-monochromatic primary beams. This increases the optical colour rendering inaccuracies, as already mentioned on p. 84. The general effect of the overlaps in the colour sensitivities of the retinal cones is to make colours appear to be less pure, that is, less saturated, than they are, and this desaturation is increased by broadening the spectral composition of the primary light beams. One result of this is a tendency for very pale colours to appear white or grey. For this reason, in the mosaic methods of colour photography filter elements having narrower spectral transmissions were used to obtain improved colour reproduction, though at the expense of fractional loss of light. Likewise, for special purposes, such as when a more than generally correct record is required or for the reproduction of scenes covering a small range of fairly pure, saturated colours, it may be advantageous to employ narrow-transmission filters in additive processes.

As can be shown on the chromaticity chart, the use of broader primary light beams (stimuli) for additive methods, instead of mono-chromatic primary stimuli, restricts somewhat the gamut of colours that can be reproduced, chiefly as regards saturation in the green, green-blue

and magenta (purple) areas. Also, as the spectral locus of green-blues lies widely away from the colour triangle, it has been pointed out on p. 123 that it is not possible to match the saturation of real spectral green-blues, and that highly, though not fully, saturated green-blues can be obtained only at the sacrifice of reduced light transmission or reflection. Such factors enforce a compromise between the narrowness or saturation of the transmissions of the red, green and blue filters selected and the overall amount of light, that is, the brightness or luminance of the picture obtained in additive colour reproductions.

Fortunately, real fully saturated spectral colours, especially blue-greens, are uncommon in everyday life, the colours of material objects are so generally desaturated by the reflection of some white light, as emphasized on p. 26, and colour saturation is often further reduced by conditions such as atmospheric haze, dust, a film of water, or artificial illumination (due to its low blue content), so that the deficiencies mentioned above, particularly in saturation, are rarely serious in practice. Moreover, for reasons given in the concluding section, p. 221, exactly correct or true colour reproduction is by no means always necessary. Defects of hue and saturation are relatively much greater in the basic subtractive reproduction methods, which suffer from their own deficiencies as well as those inherent in additive methods, and in which, therefore, corrective steps have virtually always to be inserted.

More important limitations of additive reproduction methods are those already explained on p. 152 concerning their unsuitability for the production of reflection copies or prints on paper and some loss of definition in fine detail by the mosaic and lenticular screen methods, which have resulted in these becoming obsolete industrially, except in colour television.

SUBTRACTIVE REPRODUCTION METHODS

THE SUBTRACTIVE COLOUR MIXING PROCESS, that is, the mixing of coloured materials, has been used by painters and other artists over the ages, but the trichromatic subtractive principle explained in Chapter 5 was first described by that outstanding Frenchman, du Hauron, in 1862. The incentive behind the industrial development of the subtractive method is the tremendous market and demand for colour reproductions on paper particularly in books, periodicals and nowadays in newspapers, for which, as they are viewed by reflected light from the paper, the additive process is not suitable for the reasons explained on p. 152. This is entirely true of the printing industry and in photography, despite the success of additive mosaic screen transparencies, there has always been a need for colour prints on paper as well as for improved definition of detail in transparencies.

The light reflected by subtractive colour prints on white paper, unlike that from additive prints, is adequate to give bright pictures because the the subtractive primary coloured materials transmit approximately twice as much as the additive primary filters (approaching two thirds compared with one third of the spectrum) and white is provided by the paper itself without the primary coloured materials; also, in subtractive colour photography there is no need for any screen. Progress in the general use of subtractive trichromatic colour reproduction has been hampered, however, by complications and deficiencies arising from the superimposition of layers of imperfect yellow, magenta and cyan dyes or printing inks, which make an exact theoretical analysis in terms of three-colour mixture much more difficult than in the case of additive processes. There were also earlier practical difficulties to be overcome in devising ways for superimposing the layers easily so as to give a

sharply defined image and in the varying amounts necessary to give correct tonal effects.

DEFICIENCIES OF PRACTICAL SUBTRACTIVE PRIMARIES

The inherent inaccuracies of colour rendering due to the overlapping colour sensitivities of the retinal cones apply to the subtractive as well as the additive reproduction process, as previously explained on pages 83 and 84. We have also mentioned at the end of the preceding chapter, p. 169, that the basic subtractive methods suffer from additional deficiencies. These arise fundamentally from the general properties of coloured materials described in Chapter 2.

It has been explained in Chapter 5, p. 80, how by varying the amounts of the yellow, magenta and cyan subtractive primaries on a white surface, they may be regarded as controlling through absorption the intensities of the additive primary stimuli, the red, green and blue thirds of the reflected white light. In both colour photography and printing, the subtractive materials are overlaid on one another (not mixed), in ways that are described later, and so they must be transparent. Ideally, therefore, each subtractive primary coloured dye or printing ink should completely transmit the light of two thirds of the spectrum and completely absorb the light of the other one third of the spectrum. Hence, as indicated on p. 81, the yellow primary should be completely blue (and violet) absorbing (minus blue), the magenta completely green (and yellow) absorbing (minus green), and the cyan completely red (and orange) absorbing (minus red). Consequently, at every wavelength of the spectrum two of the primaries will transmit 100 % of the light reflected from the white base, for example, 100 % of green light by the yellow and cyan primaries, while the third primary, in this example the magenta, absorbs all the light of that wavelength, and thus the three primaries together produce black. In fact, however, coloured materials that exactly fulfil these requirements do not exist.

There are several yellow dyes and pigments that approximate fairly well to the requirements but the best available magenta and cyan materials have considerably imperfections. Fig. 8.1. (a) and (b) shows spectral transmission curves for the ideal subtractive primaries and for a typical set of real ones. It will be seen that the curve for the real yellow primary, although showing a little unwanted absorption in the green region, is reasonably close to that of the ideal, whereas the real magenta and cyan curves are not. The real magenta is fairly satisfactory in the red region but it does not transmit sufficient blue light, in other words there is unwanted absorption in the blue region, so that it looks redder

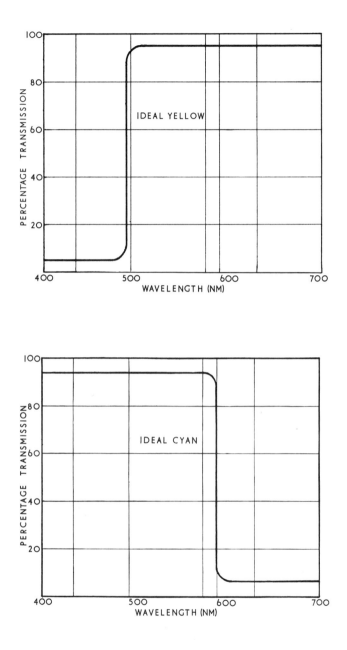

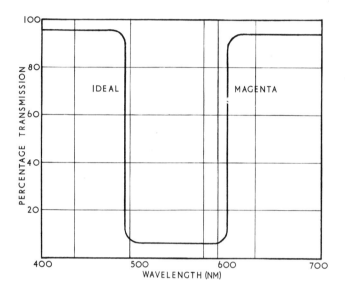

Fig. 8.1(a) Spectral transmission curves for ideal subtractive primaries, with allowance for negligible absorptions and transmissions of up to 5%. The colours essentially controlled by the primaries are red, green and blue, so that each should absorb the light over one of these three wavebands covering a third of the spectrum, the divisions being at about 500 and 600 nm. The best values for the divisions are not exactly determined and most estimates suggest wavelengths around 490 and 580 nm. Each primary coloured material should, therefore, fully transmit two thirds of the spectrum from its respective division. The above curves or closely similar ones are generally regarded as 'ideal' for the subtractive primaries but realistic considerations have led some investigators to propose modifications.

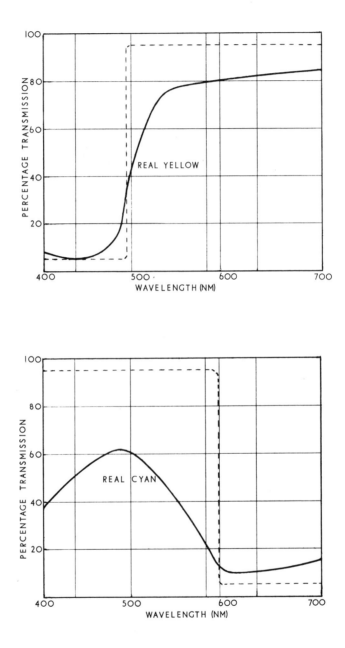

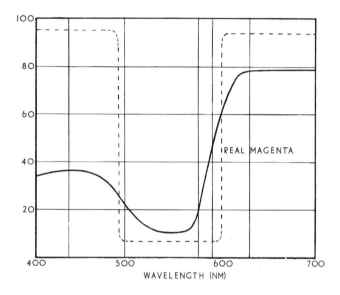

Fig. 8.1(b) Typical spectral tránsmission curves for real primary coloured materials used in actual subtractive colour reproduction processes. It will be seen by comparison with the ideal curves (dotted lines) that the real magenta is seriously deficient in the blue region and the cyan has a quite generally low transmission. These unwanted absorptions cause many colours, especially blues and greens, to be reproduced too dark and, along with other defects such as incomplete absorption where totality is required, they are the chief reason for the inclusion of various methods of colour correction in subtractive processes.

than it might, and it transmits some green light which should be completely absorbed. The real cyan is unsatisfactory in that it absorbs too much light, or does not transmit enough, in both the blue and green regions, while its absorption of red is not quite complete. Its high absorption of yellow light (in the green region) causes it to look bluer than it might.

While yellow, magenta and cyan coloured primary materials enable the widest gamut of chromaticities to be obtained subtractively, these defects reduce the overall range of colours that can be reproduced compared with the range theoretically possible with the ideal primaries. The incomplete absorption of green light by the magenta primary and of red by the cyan primary means that the three primaries together do not produce a jet black, though this fault is more serious in printing than in photography. Of greater importance is the unwanted absorption of the magenta material in the blue region and of the cyan in the blue and green regions, which results in all blue, green and purple colours being reproduced appreciably darker than they should be. The degraded blues and greens which are reproduced also adversely affect the colour rendering or balance in that the reds and oranges produced by the high red and orange transmissions of the yellow and magenta primaries are so much brighter by comparison. Purples and pinks lose some blueness because of the unwanted absorption of blue by both the magenta and cyan materials, and greens tend to appear brownish due to the incomplete red absorption by the cyan.

The general effect of the unwanted absorptions is to make the reproductions duller than they might be with many colours desaturated and distortions of hue in some cases. On the other hand, the imperfect absorptions of the primary coloured materials, by giving more than the theoretically required overlapping of their transmissions, allow just a few other colours, mainly purplish-reds, to be reproduced than would the ideal primaries.

In practice, therefore, the faults in the actual subtractive primary dyes and pigments have to be balanced against each other and corrected as far as possible to secure what amounts to the best compromise. The deficiencies as described are perceptibly worse in the best available pigments for printing inks than in the dyes available for colour photography. For this and certain other technical reasons (see pp. 206–210), the gamut of reproducible colours by printing is significantly smaller than by photography, especially as regards saturation. Various effective means have been developed in printing and photography to minimise the shortcomings of the primary materials and thereby improve colour quality, of which the principal techniques will be mentioned in the following pages. The most important and generally applicable modern means of colour correction is that known as 'masking'.

CORRECTION BY COLOUR MASKING

A subtractive trichomatic photograph or print is essentially made up of three superimposed primary coloured positive images among which ideally, the cyan (minus red) image absorbs the correct amount of red light, the magenta (minus green) image absorbs the correct amount of green light and the yellow (minus blue) image the correct amount of blue light from the incident white light. To produce the photograph or print it is necessary to obtain first three photographic negatives which are separate records in black-and-white of the red (minus cyan), green (minus magenta) and blue (minus yellow) constituents respectively of the original scene. These colour separation negatives are obtained by taking three photographs through red, green and blue filters in turn or simultaneously on panchromatic film. The photographic positives (or printing plates) then made from the negatives are printed in the respective complementary colours, that is, the positive image from the red separation negative is printed in cyan (red absorbing), that from the green separation negative in magenta (green absorbing) and the positive from the blue negative record is printed in yellow (blue absorbing). The three coloured positive images must, of course, be printed to coincide in register with one another to give the complete subtractive picture.

In present-day subtractive colour photography the production of separate colour separation negatives and a procedure for superimposing the coloured positive images in register are avoided, the former by including three colour-sensitive layers in the same photographic film linked with chemical reversal processing of the exposed film and the latter by incorporating 'colour couplers' in the film or developers which form the three primary coloured dye images *in situ* during development. This elegant process greatly simplifies and reduces the operations involved and it is described later, but it is based intrinsically on the whole process outlined above.

In reality, the positive images, particularly the magenta and cyan, that comprise the final subtractive picture are defective as explained in the previous section. The real magenta image, having unwanted blue absorption, may be considered as equivalent to the ideal magenta combined with a thin or weak yellow image which would supply the unwanted blue absorption. Similarly, the real cyan image, having unwanted blue and green absorption, may be regarded as equivalent to the ideal cyan combined with weak yellow and magenta images, the yellow giving the unwanted blue absorption and the magenta the unwanted green absorption.

In most areas of a subtractive picture which are not white all three primary colours are present to some extent, that is, there are three

positive primary images differing in intensity over most areas. If, therefore, a low contrast, weak positive image (transparency on black-and-white film) is made from the green separation negative and this positive transparency is bound up in register with the blue separation negative to make the final yellow positive image, the density of the yellow positive will be reduced to an extent corresponding more or less with the unwanted yellow in the real magenta image. The low contrast positive combined in this way with the blue separation negative acts as a mask, hence the name for the technique.

We must bear in mind that the densities of the primary coloured images will vary according to the intensities and tones of colour over the picture. Thus, the positive yellow image produced from the masked blue separation negative will have less density, that is, less yellow, in areas where the magenta image is dense or strong, but full or maximum yellow where the magenta image is absent. The positive mask from the green separation negative (magenta printing positive) adds a low contrast copy of what the magenta image will be to the making through the blue separation negative of the final yellow image and this, by reducing the yellow (blue absorbing), corrects for the unwanted blue absorption of the real magenta image. The fundamental point is that as the unwanted absorption of the magenta dye or pigment is blue it can only be corrected by an appropriate reduction of the blue absorbing, yellow image where it coincides with the magenta image.

To correct for the unwanted green and blue absorptions of the cyan dye or pigment, weak, low contrast masking positive transparencies prepared from the red separation negative (cyan printing positive) may be combined with both the green and blue separation negatives for making the magenta and yellow positive images, so that the densities of colour in these images are reduced where they coincide with the cyan image in the complete picture.

Likewise, a mask may be used, if required, to compensate for the incomplete absorption or unwanted reflection of red by the real cyan primary material through a little reduction of the density of the magenta image where it corresponds with the cyan image. For this purpose, a low contrast positive transparency is made from the red separation negative (cyan printing positive) and bound up as a mask in register with the green separation negative (magenta printing positive), thus effecting the required diminution of the magenta image.

In principle, to provide overall correction six masks would be required for masking each of the three separation negatives with positive masks made from the other two. But it is the yellow and magenta images which mostly need modification and it is unusual to go further. Colour correction by masking which means colour reduction of the cyan image does not generally help subtractive reproduction because of the inade-

quacies of the three primary dyes and pigments in the blue-green region of the spectrum and particularly of cyan materials.

In practice colour masking can largely overcome the departures of the real subtractive primaries from the ideal, but it is difficult. The masks must be made to carefully measured densities or contrast ranges for the determination of which trial and error may have to be used to secure the best results, and there are several alternative masking procedures. The problems are complex and simplified theory can do little more than point the way to their solution, just as this explanatory outline can only provide a basic understanding of the subject. See also p. 190 on masking by coloured couplers in colour photography.

COLOUR PHOTOGRAPHY

Popular subtractive systems of colour photography followed additive methods historically because of the practical complications involved in producing three primary coloured images superimposed in register, and their development as a mass medium was delayed until processes for generating suitable subtractive dyes in the photographic emulsion itself by colour development and 'colour coupling', were discovered. Prior to the comparatively recent introduction of so-called 'monopack' materials, subtractive colour photographs on film or paper could be made only by transferring three separate transparent images into registered superimposition.

Du Hauron had patented as early as 1897 a 'tripack' arrangement consisting of three red, green and blue sensitised plates or films interleaved with appropriate colour filters which was exposed in the camera, after which the tripack was taken apart for individual processing and subtractive colouring of the plates or films that subsequently had to be re-registered. Such tripacks were marketed but had no commercial success, chiefly because the difference in the positions of the three photographic emulsions in the bulky arrangement gave unsharp pictures.

Gelatin Relief Methods

Much more successful so that they became well known were the Carbro, Vivex, Duxochrome and similar processes for producing colour prints on paper. These are based on the preparation of relief images in dyed or pigmented gelatin, the relief images being finally superimposed.

The *Carbro process* was popular among advanced amateur and professional photographers for a long time and will be described briefly as typifying these methods. Three colour separation negatives are taken

through the usual red, green and blue filters and from the negatives three ordinary black-and-white positive prints on photographic paper are made. These photographs are then pressed with a squeegee against sensitized Carbro tissue which consists of paper coated with gelatin containing a yellow or magenta or cyan pigment and is sensitised by soaking in an acidified solution of potassium dichromate, potassium ferricyanide and potassium bromide. The colour of the tissue selected for each black-and-white photographic print is, of course, complementary to that of the taking filter. A complex interaction takes place between the print and the tissue whereby the gelatin is tanned, that is, rendered insoluble, in contact with the photographic silver image to an extent proportional to the amount or density of the silver and, therefore, to the tones of the print.

After separation from the print, the tissue is squeegeed face down on to a sheet of wax-polished celluloid or Perspex and treated with warm water. The paper backing floats off and the gelatin that has not been made insoluble dissolves away, leaving a relief image in hardened pigmented gelatin, the density of colour of which is clearly proportional to the varying thickness of the gelatin. This image is finally squeegeed on to a permanent support of gelatin-coated paper and the celluloid or Perspex sheet carefully removed. All three cyan, magenta and yellow relief images are produced in this way and transferred in register to the same paper support.

Gelatin Dye Imbibition Methods

Other rather similar processes that are still in use are based on dye imbibition, that is, the ready absorption of dyes by gelatin, two examples being the *Dye Transfer process* for paper prints and the *Technicolor process* for cinematograph films. In the former, having obtained three colour separation negatives these are each photo-printed on Dye Transfer Matrix film which consists of an ordinary photographic gelatin emulsion (sensitive only to blue light) that is dyed yellow and supported, as usual, on a film base. This matrix film is exposed under the negative through the base so that the positive image is first formed in the emulsion layer in contact with the base. The purpose of the yellow dye is to absorb the blue light to which the emulsion is sensitive, for the light must penetrate increasingly thicker yellow layers to reach the emulsion further away from the base and be increasingly stronger to do so. By retarding the penetration of the actinic blue light, the yellow dye helps to form a good relief image and limit the contrast. Thus, due to the varying densities according to the tones of the separation negative,

Fig. 8.2 Diagrammatic illustration of the sequence of operations for (a) producing a gelatin relief image from a colour separation negative, and (b) transferring a dye-image to paper from the relief image (the Dye Transfer process).

the emulsion is exposed to varying intensities of light over the area of the picture and the image is formed in variations of depth in the emulsion. Under the most transparent parts of the negative, corresponding to the darkest or most dense colour tones of the original subject the image is

formed throughout almost the whole emulsion layer, but under denser areas of the negative (less dense in the subject) a shallower image is formed in the emulsion. To produce the relief positive image formed in this way, the matrix film is processed with a tanning developer (gelatin insolubilizing) that develops both the silver and hardened gelatin image, followed by washing in warm water to remove the unhardened, still soluble, gelatin and the soluble yellow dye. The process is illustrated in Fig. 8.2.

The three relief images are then soaked separately in solutions of the respective subtractive yellow, magenta and cyan dyes and finally squeegeed successively, in register, on to paper coated with mordanted gelatin, when the dyes in the hardened gelatin reliefs are imbibed by the fresh film of gelatin and fixed in it by the mordant. The thicker areas of the relief images, corresponding to the denser coloured areas of the picture, will, obviously, hold more dye than the thinner parts and so varying amounts of the three subtractive dyes are transferred to the gelatin coated paper to give the colour print.

An advantage of imbibition methods is that the process of dye absorption by the gelatin relief matrices and the transfer of the dyes to a suitable support can be repeated many times, so as to obtain a large number of copies (prints) from the same matrices. This is a great economy, for instance, in the Technicolor motion-picture method for producing numerous duplicate colour films from a single original set of colour separation negatives without the expense of using photographic silver emulsion film for the copies. In the Technicolor process, the colour separation negatives are taken on 35 mm cinematograph film. From these, positive gelatin relief images are made on the lines described, from which, in turn, dye imbibition prints on clear gelatin coated film instead of paper are prepared as in the Dye Transfer method. A weak black positive is usually combined with the final Technicolor print to give better blacks and deep shadows, as is commonly done in colour printing, see p. 216. To have solved the problems of accurately registering the small 35mm film images and of operating such an intricate process on the required mass-production scale for world-wide cinema display was a considerable achievement.

The advent of integral tripack negative films (p. 185) suitable for cinematography has obviated the need to obtain three individual colour separation negatives by means of the one-shot camera (p. 184), but otherwise the duplicating process remains the same. Nowadays a monopack (integral tripack) colour negative, incorporating the red, green and blue records in one film, is obtained from an ordinary cinematograph camera and is then printed separately through red, green and blue filters on to panchromatic gelatin matrix film to make the positive copies.

Colour Derivations

The Dye Transfer method linked with other photographic artifices has been used to produce very pleasing and interesting colour reproductions that closely resemble paintings and are known as *Colour Derivations*. A black-and-white negative made from a colour photograph (positive transparency) will show the inverse of the light and shade of the photograph. If the negative is bound as a mask in register with the colour transparency and the combination is used to produce a Dye Transfer print, the colours will be retained but the tones of light and shade will be reduced or even eliminated. By inserting a thin transparent sheet between the negative and the colour transparency to separate them slightly and by using a swinging light when making the prints, the pictures can be made with the colour areas edged by a thin black line, an effect often shown in modern paintings. A negative used as a mask reduces the contrast of light and shade, yet, if it is separated from the transparency, it functions unsharply and does not reproduce fine detail; hence the unsharp mask reduces the contrast of large areas but not of the fine detail reproduced by the transparency. The technique of unsharp masking is sometimes employed to enhance fine detail in colour printing (pp. 192 to 218).

ONE-SHOT CAMERAS

The processes described so far for producing colour photographs require colour separation negatives. The simplest way of obtaining these is to expose three panchromatic plates or films successively in an ordinary camera with red, green and blue filters in front of the lens in turn. But this method is feasible only with still-life subjects, of course, owing to the time involved in changing the films and filters. Repeating back cameras, incorporating filters with three films in a sliding panel or dark-slide at the back of the camera, were devised to reduce the time factor and were much used for colour portraits and the like. However, for taking simultaneous, snapshot, photographs many types of one-shot cameras were invented in which all three films were exposed together. Indeed, du Hauron's original suggestions included a description of one. The operating principle of all one-shot cameras, as of current television cameras (p. 156), depends upon the light from the lens being divided or split inside the camera into three beams by an arrangement of semi-transparent, half-silvered or dichroic, mirrors or prisms, that diverts the beams along separate paths to form identical images on three photographic plates or films in front of each of which is a primary colour filter. Fig. 8.3 depicts such a system. Much ingenuity was expended on minimizing the size and weight of these cameras.

The Technicolor cinematograph camera, which was widely used until suitable integral tripack films were introduced not many years ago, was a cleverly designed one-shot camera. The beam-splitting device was a cube-shaped prism block divided diagonally at 45° by a thin film of gold between the prismatic halves of the block, and placed immediately behind the camera lens. A sufficiently thin film of gold acts as a dichroic mirror (p. 44), freely transmitting green light and strongly reflecting red and blue. In the Technicolor camera, the green beam or waveband was transmitted by the prism block and gold film directly to a green-sensitized photographic film, while the red and blue wavebands were reflected in focus on to a sandwich of ordinary, blue-sensitive, film and a red-sensitized film with a layer of red or yellow dye as a filter between them. Thus the three essential colour separation motion-picture records were obtained simultaneously. The camera was an apparatus of high

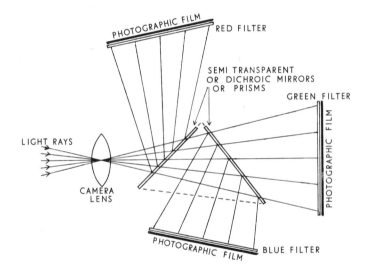

Fig. 8.3 Principle of the one-shot colour camera.

precision, though very bulky and heavy. Weighing about 300 lb (136 kilograms), it needed a special tripod to support it and a small crane for moving it about.

The principle of the beam-splitting device in the Technicolor camera, whereby only two images are formed, one in green light and the other in red and blue light, is applied in a type of colour television camera (Marconi) containing two electron-tubes instead of the usual three for

the primary colours. In this camera a dichroic mirror transmitting green light and reflecting red and blue is situated behind the lens. The primary green image is transmitted directly to one electron-tube while the reflected red and blue images are focused with the aid of an auxiliary lens on to the second tube. To distinguish between the latter two images, a grid of alternate yellow and transparent lines is interposed in the path of the red and blue beam. This grid transmits the red light freely but the blue light is absorbed by the yellow lines and passed through the transparent lines. The effect of the resulting line pattern imposed on the blue image when both the red and blue images are scanned by the electron-tube is to produce a high-frequency oscillation of the electrical signals for the blue image and the oscillations enable the signals for the blue image to be separated electronically from those for the red image. This causes some loss of definition in the blue and red images but the two electron-tube arrangement avoids the problem of registering these two images as is necessary in a three-tube camera and, of course, permits a smaller camera.

It may be noted with both the Technicolor and Marconi cameras that the beam-splitting devices allow the green waveband to pass straight from the lens to the light-sensitive surfaces, whereas the red and blue wavebands are reflected along a different path. This is also the practice in three- and four-tube television cameras. The reason is connected with the greater sensitivity of the eye to green light, that is, the visual acuity of fine detail in the image depends more upon the green waveband image than on the red and blue images, actually in that order of priority. Hence the green image should be most sharply focused in systems of this kind, avoiding, so far as possible, any loss of definition through reflection.

In colour photography, one-shot cameras have now gone out of use with the steady improvement of monopack or, as they are more commonly called, integral tripack materials in which the three coloured images are produced in one film.

INTEGRAL TRIPACKS AND COLOUR DEVELOPMENT

Modern methods of colour photography are based fundamentally on du Hauron's original, though bulky, tripack arrangement (p. 179), except that very considerable simplification has been achieved by coating all the layers in superposition on one film support to give a sharp image and by surmounting the difficulty of processing the three adjacent layers separately, so as to produce a different primary coloured image in each without parting them for the purpose. Such an integral tripack òr monopack arrangement was first proposed in 1905 but could

not be put into practice because at that time no means were known for converting the photographic silver images of the three layers into images of the correct colours. This has become possible through progress in the chemistry of colour development and colour sensitisation.

It was noticed early in the present century that coloured compounds are formed when some developing agents are used to develop ordinary black-and-white photographs and before the 1914–18 war a German worker, Rudolf Fischer, demonstrated the formation of dye images produced by adding colour-coupling compounds to the photographic emulsions before coating on the base, so that in a single development each layer appeared in its appropriate colour. It was not possible, however, to ensure that the coupling compounds remained in their own layers without wandering into adjacent layers, nor were suitable colour sensitising dyes (p. 149) known for the emulsion layers. The outbreak of the first World War stopped further advance in this promising direction and the major problems were not overcome for about twenty years.

Colour-couplers are substances which combine with the new products (oxidized compounds) formed when certain developing agents have reacted with the silver compounds in a photographic emulsion to develop the silver image, the combination of the coupler with the oxidized product from the developing agent producing an insoluble dye or pigment. The developing agents and colour-couplers are mostly colourless and the colour of the dye produced during development depends upon the nature of the coupler and the developer used. The amount of dye formed is determined by the quantity of oxidized product produced from the developer which depends upon the amount of silver that has been developed and this in turn depends upon the exposure the emulsion has received in the camera or during photographic printing. Thus more insoluble dye is produced in those localities of the emulsion layer that have received more light and the quantity of dye is directly proportional to the amount of exposure over the area of the emulsion, so that a coloured image results.

Colour-couplers may be used in two ways, either added to the developing solutions, in which case three developers with couplers are required (one for each emulsion layer and primary coloured dye), or incorporated in the emulsion layers during the manufacture of the integral tripack film in which the couplers must not wander from one layer to another. The former was the method first introduced commercially in 1935 with Kodachrome film. This film was subsequently modified to reduce the complications involved in its processing and the following is a description of the present-day system as a typical example of this kind of integral tripack reversal process.

Processes Using Couplers in Developers

The film has four very thin coatings on a transparent base, only one of which is a filter layer, other filters being obviated by appropriate colour sensitization of the photographic layers. The top layer is an ordinary photographic emulsion, sensitive only to blue light and therefore giving the blue record of the scene. Below this is a yellow filter layer that prevents blue light from penetrating to the layers underneath it. The third layer consists of an orthochromatic emulsion (p. 149) which, in the absence of blue light, records only the green image. Finally, the bottom emulsion is sensitized with a special dye so that it records the red colour constituents of the scene.

After exposure in the camera, the film has to be processed to convert or reverse the photographically negative red, green and blue colour separation records into respectively complementary coloured positive images. The processing is complex, hence it is necessary to return the exposed film to the makers or to specially equipped processing firms. In outline, the film is first developed as usual to give a black-and-white negative image in all three layers, which means that the undeveloped portions of each layer form the positive images. Then the film is exposed through the base to red light, which renders the previously undeveloped portions of the red-sensitive bottom layer developable, and is developed with a colour developer containing a cyan dye-forming coupler. This treatment produces a cyan positive image in the bottom layer together with developed silver throughout that layer. The film is next exposed from the top to blue light, which, because of the yellow filter, affects only the top layer and this is developed with a yellow dye-forming coupler in the developer, so that an insoluble yellow positive image plus the whole of the silver is developed in the top layer.

There remain only the undeveloped positive image portions of the middle, green sensitive, layer to be treated. Being sandwiched between two completely blackened silver layers, the middle layer cannot easily be exposed to light. It is colour developed, therefore, with a magenta dye-forming coupler in a strong, 'fogging', developer that reacts with the previously undeveloped silver compounds in this layer even though they have not been activated by exposure to light. The film now holds insoluble subtractive primary coloured images with all the silver blackened by development in the three photographic layers and the yellow filter between the top yellow image and the middle magenta image. The last stage is to remove the silver completely and at the same time the yellow colour from the filter by means of photographic 'bleaching' and fixing solutions. This leaves the requisite three positive images in the subtractive primaries or minus colours automatically registered with each other to form a colour transparency.

Although the processing is complicated, the results are very good and remarkably so for the definition of fine detail which makes it suitable for the small picture frames (5 mm × 3·7 mm) of 8mm ciné film. There are now several makes of this type of integral tripack film on the market.

Note that in a subtractive colour photograph the usual silver image of a black-and-white photograph is replaced by transparent dyes in superimposition, whereas in additive colour photographs the additive colour filters are superposed over the silver positive image. If the silver image were retained in a subtractive photograph it would greatly darken the picture.

Processes Using Couplers in the Film

By including the appropriate colour couplers in each of the three photographic emulsions of an integral tripack film the processing operations are simplified, but there is the serious difficulty of preventing the couplers from wandering by diffusion into other emulsion layers where they would produce the wrong colours. This problem was first resolved by the Agfa company in Germany in 1936 by combining the coupler molecule with a large inactive molecule in the form of a long molecular chain that serves to anchor the coupler. The Eastman Kodak company in the U.S.A. followed in 1942 with a process in which the coupler is dissolved in an oily liquid and dispersed throughout the emulsion in microscopic droplets or globules.

Tripack films incorporating the couplers, like those for which the couplers are supplied from the developers, usually comprise three thin layers of red-sensitive, green-sensitive and blue-sensitive emulsions from bottom to top with a yellow filter layer between the blue- and green-sensitive emulsions. Processing, however, is sufficiently simple to be carried out by the photographer himself and, furthermore, instead of process reversing the film to a positive transparency, it can be straightway developed to a colour negative from which positive prints in colour can be made as required.

To obtain a positive transparency from this kind of integral tripack, the film from the camera is developed normally to a black-and-white negative image throughout. The oxidized product from an ordinary black-and-white developing agent does not react with the couplers. The undeveloped, positive image, portions of each emulsion layer are then made developable by exposing the film from both sides to white light, and the film is developed again, this time with a developer yielding an oxidised compound that combines with each of the different couplers in the emulsion layers to form the requisite primary coloured insoluble dye in each layer. Or, these two steps may be substituted by using a

'fogging' colour developer. Lastly, the silver and the yellow filter are removed by immersing the film in a photographic 'reducing' (bleaching and fixing) solution, to leave the coloured positive. The sequence of operations is illustrated diagramatically in Plate 26.

If the film, after exposure in the camera, is first developed with a colour developer, the result is a colour negative from which it is only necessary to remove both the exposed and unexposed silver with the yellow filter and this is done with a photographic reducer. Being a colour negative the light and dark tones of the picture are reversed as in a black-and-white negative and also the colours to their complementaries, for example, red becomes cyan, green becomes magenta, blue becomes yellow, and vice versa. The advantage of a negative is, of course, that any number of positive prints, including enlargements, can be made from it. To produce a colour positive print from a colour negative, all that is necessary, as in black-and-white photography, is to expose to white light underneath the negative a fresh piece of similar integral tripack coated film or paper. On straightforward colour development followed by chemical removal of the silver and filter, as used to obtain the negative, the tones and colours of the picture are again reversed to give a photographic copy of the scene in its correct colours, and this print may be based on opaque white paper or on transparent film. Moreover, it may be an enlargement from a small colour negative. The process is summarised in Plate 27.

The commercial introduction of integral tripack materials was an instant success, so much so that the several brands of reversal film for colour transparencies and of negative–positive versions for colour prints and enlargements are all now very widely used by amateur photographers.

In fact, the first systems offered to the general public in the early 1940s for subtractive colour prints and enlargements on paper used positive colour transparencies, not negatives, the transparency being printed directly on to photographic reversal colour papers to give positive copies, and some specialized processes on this basis are still available. In colour copying, however, there is some loss of quality, especially when the copying is done on an incompletely reflecting material such as white paper (see p. 207), and this loss is partly due to the deficiencies of the primary coloured dyes or pigments. By copying from one set of primary coloured dyes to a second, the effects of their deficiencies, particularly their unwanted absorptions, are 'doubled-up' and become more noticeable. A negative–positive process has several photographic advantages over a positive–positive process and in colour work a negative can provide better colour correction by means of masking (p. 177), so colour negative films are mostly used in the camera when reflection prints are required.

Masking by Coloured Couplers

The earliest popular negative–positive processes for colour prints to be marketed were Agfacolor in Germany and Kodacolor (the name originally used for the obsolete lenticular additive film, p. 145) in America, both about 1942. In the case of Kodacolor film the colour masking device has been modified and improved since it was introduced, the current method ingeniously using the colour couplers for the two-fold purposes of colour masking and dye formation, a method now employed extensively in colour negative films. In reversal films for positive colour transparencies the couplers are colourless until they combine with the oxidation product from the developer, but in Kodak negative films the couplers themselves are coloured compounds in order to serve as masks to reduce the unwanted colour absorptions of the subtractive dyes developed in the final positive picture. The colour of the coupler is destroyed where it combines with the primary dye-forming product from the developer during the preparation of the negative. The principle involved is closely similar to that explained on pp. 177–179 and is as follows.

Cyan dyes absorb, undesirably, some green and blue light. Suppose the coupler to form the cyan dye in the bottom emulsion layer of a colour-negative film is itself pink (pale orange-red) so that it absorbs the same amount of green and blue light as does the cyan dye. After the film has been exposed and developed there will be cyan dye, partially green and blue absorbing, in the image areas where the coupler has been converted into dye, and unchanged pink coupler, also partially green and blue absorbing, in the non-image areas. Thus the developed layer will have the same absorption for green and blue all over, so that it may be regarded as being made up of an ideal cyan dye having no green and blue absorption with a filter over it which absorbs green and blue uniformly over the whole picture area.

Since the yellow dye is in itself satisfactory, only a second coloured coupler is needed, that is, a pale yellow coupler absorbing some blue light, for the magenta-forming dye which has unwanted blue absorption. A colour negative is obtained after development, therefore, which is equivalent to one made with perfect dyes, but with a uniform orange tint all over it from the pink and pale yellow couplers. This overall tint does not matter in a negative because it is easily compensated when printing the positive by suitably adjusting the colour of the light used for printing which means making it somewhat greenish-blue. In fact, by using couplers of deeper colours, not only can the unwanted absorptions of the cyan and magenta dyes in the negative be counterbalanced, but also, to some extent, those of the dyes used in the print made on tripack material containing colourless couplers.

It will be appreciated that the above is a simplified account of how coloured couplers can be used to bring about colour correction. Their use has been developed so as to correct considerably for the unwanted absorptions of the cyan and magenta dyes in both the negative and the print. The introduction of coloured couplers in 1948, like that of couplers themselves, is one of the major milestones in the progress of colour photography.

Because of the very noticeable orange tint in the lighter areas produced by coloured couplers, they cannot be used in film intended for reversal processing to give direct positive transparencies. The brilliance of colour obtainable in these is believed to be due to inter-image effects during exposure, that is, effects of the three layers on each other, giving advantageous results not unlike those derived from coloured couplers.

It might be thought that a simple way of obtaining positive colour prints on paper would be to expose a sheet of triple emulsion coated paper in the camera, followed by photographic reversal processing. But there is at least one serious difficulty in this procedure. The image formed in a camera is laterally reversed from left to right and vice versa—it is a mirror image. This creates no difficulty with a positive colour trans-parency produced on reversal film because it is viewed through the back, that is, through the film base. But if opaque reversal colour paper were used in the camera it would require a reflecting prism or mirror in front of the lens with the camera back at a right angle to the scene to overcome the lateral reversal, and this would generally be highly in-convenient. A prism is used in this way in photomechanical operations for making printing plates (p. 203) but the circumstances are very different.

The specially designed *Polaroid-Land camera,* which supplies a positive paper print from the camera sixty seconds after exposure, is becoming increasingly popular. However, in this remarkable process, for both black-and-white or colour prints, a special sensitized paper and a receiving paper are used in the camera. The laterally-reversed image is formed on the sensitized paper and the receiving paper is pressed face to face in contact with it so that the transferred image is again laterally reversed, as in a negative–positive process, to give a picture which is correct with respect to the actual scene. The special developers employed in the process are contained in small plastic pods attached to the receiving paper, thus enabling the development and transference of the image to take place within the camera.

Because artificial tungsten-lamp lighting is deficient in blue compared with daylight (p. 15), two main varieties of reversal film for positive colour transparencies are manufactured, one of which contains a more sensitive, faster blue receptive layer for tunsten light and the other a slower, less sensitive blue layer for daylight. The former should be used

for colour photography in artificial light or with clear flash bulbs, the latter is balanced for daylight and blue flash bulbs or electronic flash. Either type may be used in the illumination for which it is unsuitable provided an appropriate colour filter is placed over the camera lens, but, as the filter absorbs some light, a longer exposure is necessary. In negative–positive processes for colour prints compensation for the colour or character of the illumination of the photographed scene can be made during the printing operations.

COLOUR PRINTING

For the production of numerous multiple copies of colour pictures and the like on opaque materials such as paper, board, cloth, tin-plate, etc., the only practicable method of colour reproduction is essentially subtractive, as explained earlier. Colour illustrations in magazines, books, journals, newspapers, catalogues, greetings cards, posters, wrappings and packagings, all products of the printing industry, are part of our everyday lives. Mechanized processes similar in principle are employed for colour printing on textiles (excepting the weaving of patterns into fabrics), metals particularly tin-plate, plastics and ceramics as well as paper, but paper printing methods have attained the highest stage of refinement as regards colour reproduction. To facilitate our consideration of colour printing on paper it may be helpful to outline first the main features of printing methods.

There are three principal processes available for the mass production of printed matter, namely letterpress, lithography and photogravure. The essential distinction between them lies in the nature of the printing surface employed, that for letterpress being raised in relief from the non-printing areas, whereas lithographic methods use a planographic plate on which printing and non-printing surfaces are practically on the same plane, and photogravure involves a recessed or intaglio image that is lower than the non-printing surface. See Fig. 8.4.

Letterpress

Historically, the relief method of printing is much the oldest, originating, it is believed, in China in or before the ninth century with the hand carving of wooden blocks from which the non-printing areas were gouged out of the surface. The remaining uncarved relief surface was inked by wiping an inked pad over it and the inked pattern transferred by pressing it into contact with paper, which had also been invented in China some seven centuries earlier. Such a relief surface lent itself readily to the printing of letters, copied at first from written characters,

and this led to the name of the process. The invention of movable metal type about 1450 A.D. for the printing of books is generally attributed to Johann Gutenberg of Mainz, Germany, and the basic principles of the process have remained virtually unaltered since. This process is therefore the best known, especially for the production of text matter for which it is most suitable, the relief letter surfaces giving a clean, sharp impression. Nowadays, letterpress type matter is almost always produced and composed mechanically, from alloys of lead, antimony and tin, on line composing machines (Linotype or Intertype) in the form of solid metal lines of text, or on Monotype machines which automatically cast the type one letter at a time.

(a)

(b)

(c)

Fig. 8.4 Representations showing the differences, cross-sectionally, between letterpress, lithographic and photogravure printing surfaces after inking. The relief surface of (a), the planographic surface of (b) and the intaglio surface of (c) distinguish each of the three major processes of printing.

Diagrams and the simpler forms of illustrations are reproduced from various kinds of line blocks, which may include stipples for shading effects, the original diagram being copied in the form of a relief surface by photographic and etching techniques, known as photoengraving, in zinc or sometimes magnesium. See p. 199. Photographic illustrations involving an appreciable range of tones, either in monochrome or colour, require so-called half-tone blocks, mostly made in copper, and these are described in a following section.

The composed type matter with any blocks required are firmly secured, 'locked-up', in their correct positions within a rectangular steel frame, called a chase, to produce a letterpress forme ready for printing. For book or magazine work the forme usually comprises 4, 8,

16 or 32 pages imposed, that is, planned in their correct positions to give the required sequence after folding and cutting of the printed sheets. The finished forme may be used directly on a press.

An advantage of the letterpress method is that duplicate plates of an original forme, or of individual blocks, for printing on several presses at the same or at different places can be made comparatively quickly and economically by the processes of either stereotyping in metal (lead, antimony, tin alloy), plastic or rubber, or copper electrotyping, and such duplicates may be nickel or chromium plated for long life. A further important advantage of these processes, particularly stereotyping, is that, as the moulds taken from the original formes or blocks are flexible, they can supply curved plates that are essential for rotary cylinder presses.

Letterpress printing machines can be classified in four main groups. (i) Comparatively small platen presses on which the whole of the flat inked forme or plate is impressed at the same instant on to the paper sheet, which may be fed into the press by hand or automatically at speeds from about 800 to 4500 an hour. Platen machines are most suitable for small sheet, short run work such as business cards, letter headings, notices, programmes and handbills. (ii) Flat-bed cylinder machines which hold the forme on a robust flat bed that reciprocates to and fro under the inking mechanism and the impression cylinder carrying the paper. Such presses vary considerably in size and are usually fitted with automatic sheet feeders running at 2000 to 5000 impressions per hour. These machines are used for a wide variety of work and are very suitable for high quality reproduction on larger sheets. (iii) Sheet-fed rotary machines operating at 6000 to 10000 impressions per hour on which thin photoengraved or electrotype metal plates or plates photoengraved in light-sensitive plastic or rubber or plastic stereoplates are curved round one cylinder while a second cylinder running in virtual contact with the other conveys the paper. They are intended for the competitive production of large quantities of work of good quality, for example, illustrated catalogues and magazines. (iv) Reel-fed rotary presses producing up to 40000 copies per hour and obviously applicable to work of long runs. The continuous web of paper is carried round one cylinder in contact with the inked printing plate cylinder and the press is usually made up of multiple printing units even for monochrome work. The gigantic newspaper presses, using heavy curved metal stereoplates, are the best-known example, with four or five or more reels of paper fed in at one end and slitting or cutting, folding and counting units following the several printing units so that the finished newspapers are delivered at the other end. Magazine rotaries will also include a stitching unit. But there are also reel-fed *'flexographic'* machines for printing cheap editions of books, packaging materials

and continuous-commercial stationery from rubber stereoplates, some of which for small wrappings and tickets may be quite modest in size, though fast.

Lithography

By drawing with a greasy ink on slabs of Bavarian limestone available near his home town, Munich, Alois Senefelder, after much experimenting, invented lithography in 1798. The name of the process is due to the earlier use of flat limestone slabs as the printing surface but litho stone has been superseded by zinc or aluminium plates which can be clamped round the cylinder of a rotary press. The principle of this planographic process requires the image to be maintained with a fatty ink while the non-image areas are kept free from ink by covering them with a thin film of water. Metal plates have to be finely roughened, 'grained', to enable them to hold a continuous film of water. The image may be drawn directly on the plate by an artist (autolithography) or imparted from a transfer or put down by photomechanical methods as in the case of half-tone illustrations, and there are automatic precision 'step-and-repeat' machines for the photolithographic preparation of plates carrying accurately positioned multiple images of, for instance, labels or repeat patterns. The latest step-and-repeat machines are controlled by means of programmed cassettes.

Except for a very few specialized purposes, all lithographic printing today is produced on offset machines. On these the plate is fitted round one cylinder and has to be damped as well as inked, the inked image is printed on to a rubber blanket around a second cylinder and offset from this to the paper carried by a third cylinder. There are technical advantages in offset lithography, particularly concerning the kind of surfaces that can be printed upon, compared with printing direct from the plate. Rotary offset machines range from small sheet-fed offset duplicators, often used in offices and capable of good quality production in moderate quantities of business literature, calendars in colour, etc., to large multi-unit reel-fed (web offset) presses, normal speeds for automatically sheet-fed machines being 3000 to 7000 impressions per hour and around 16000 i.p.h. for bookwork on web-offset presses.

The necessary 'grain' or matt surface of the lithographic plate causes a slight loss of sharpness in the print, yielding a somewhat softer overall effect than letterpress which is advantageous for certain kinds of work, for example, the reproduction of pencil sketches and water-colour paintings. The printed ink film from offset lithography tends to be thinner than that obtainable by other processes and, to get greater density of colour and sharper definition, this has led to the wide use of so-called 'deep etch' plates having a very slightly recessed image, and

multi-metal plates having the image etched out of a top thinly electro-plated layer. The more recent introduction of pre-sensitised plates, coated with a photosensitive layer by the manufacturer, and similar coatings that are simply wiped on the plates has reduced the photo-lithographic processing operations and provided still better image definition.

For many of the more usual categories of work the letterpress and lithographic processes are keenly competitive and it has become hard to claim superiority for either. It is more difficult to print well by letter-press on hard or non-absorbent rough materials, that is, to ensure that all the small relief printing areas contact an uneven surface, and for half-tone illustrations the smoother the paper surface the better, as indicated later. Whereas, offsetting the image from a rubber blanket enables almost any material from tin-plate and glass to rough cartridge paper to be well printed by lithography provided the surface is not loose or fluffy. Large posters involving considerable areas of art work and colour are most economically and suitably printed by offset lithography. Lithographic plates can now be used on letterpress newspaper presses fitted with special dampening systems, and planographic plates are being developed to print without water or any fluid other than ink.

Photogravure

Although hand engraved copper cylinders were in use much earlier, for wallpaper and calico printing, photogravure had to await the development of photography. Hence the early history of the process is linked with such names as Fox Talbot, famous for his pioneering work in photography, and Karl Klič in the second half of the nineteenth century. The preparation of the intaglio surface in copper is entirely photo-mechanical (see p. 200) and printing is on fast-running rotary presses for which reason the process is more precisely termed rotary photo-gravure.

To suit high printing speeds from a recessed image the ink has to be of a very fluid, milky, consistency compared with the usual stiff, buttery, letterpress and lithographic inks. In order to hold such an ink in a rapidly rotating intaglio surface, the whole of the image, text as well as illustrations, has to be divided into tiny cells separated by thin walls of copper, many of these small cells etched to the maximum depth of about 0·03 mm forming each letter of text matter and in the case of illustrations the cells vary in depth according to the tones. The division of the image into this cellular formation is done during the photo-mechanical operations by means of a fine screen, which for conventional photogravure consists of narrow transparent lines, 6 or 7 to the milli-metre (150 or 175 to the inch), at right angles with opaque squares

between, the squares being normally three times as wide as the lines. See Fig. 8.5(b). The opaque squares give the cells in the printing surface so that these are all of the same area but vary in depth in an illustration as stated. For illustrations that do not require the highest quality, the preparation of the printing surface is facilitated by combining the half-tone principle of differing areas (see p. 201) with the characteristic photo-gravure variation in depth by what is called an 'invert half-tone' method.

On the press the cells are flooded with ink and a thin steel 'doctor' blade held against the cylinder cleanly scrapes all surplus ink from the non-image surface. The paper carried round a second cylinder is pressed against the printing cylinder and 'lifts' the ink from the cells. 'Gravure is the only process in which tonal illustrations are reproduced by different thicknesses of ink. This imparts a comparatively richer quality that makes the method particularly suitable for photographic illustra-tions. On the other hand, the breaking up of lettering by the essential screening limits its typographic use.

Printing is done for moderate quantities from plates clamped round a cylinder on smaller sheet-fed machines at about 1 500 impressions per hour hand fed and up to 4 000 i.p.h. for automatic feeding, or on a large scale from copper electroplated cylinders, which may be further chromium faced for very long runs, on reel-fed multi-unit presses at a speed of 200 or more feet (60 metres) per minute up to magazine work approaching the speed (and size) of a newspaper machine.

The process work of preparing rotary gravure plates and cylinders is more involved and therefore more expensive than for corresponding letterpress blocks and photolithographic plates, so that this method becomes an economic proposition mainly for long run work such as popular illustrated magazines or where the high photographic quality of reproduction justifies the cost in the case of sheet-fed machines, for example, for greetings cards, pictorial brochures and art reproductions. Gravure can be successfully printed on almost any kind of paper, though the best results are obtained on those which are not too hard or rough. Excellent pictorial effects are achieved on transparent packaging materials like 'Cellophane'. British postage stamps are printed by rotary gravure.

Screen Printing

A different printing method known as screen or silk screen printing is finding increasing use. The image is in the form of a stencil prepared by hand or photographically which is affixed to silk or other fine mesh material tightly stretched across a frame. A fluid ink is squeegeed through the stencil and mesh on to the paper underneath. Printing, although now mechanized, is slower than other methods mainly due to

H

the time required to dry the thicker ink film. The process is much used for show-cards and medium size posters in moderate quantities, as the printing surface is less robust than metal, and the thicker printed ink film is particularly suitable for fluorescent inks (see p. 51). It is also used very effectively on textile fabrics, ceramics, glass and plastic containers, etc. Tonal illustrations are reproduced by the half-tone method (p. 201).

Collotype

An account of colour printing would be incomplete without reference to the method named collotype, practised by a very few specialist firms largely for the high-class reproduction of artists' drawings and paintings and of photographs, from which the process can yield facsimiles. The method is related to the photographic processes based on light-hardened gelatin images (p. 179) and to lithography in that the printing surface is almost planographic and non-image areas are maintained free from ink by moistening them.

A thick glass plate or, more recently, an aluminium or zinc plate or may be a celluloid sheet is coated with dichromated gelatin as in the photomechanical processes described in the next section. The sensitised gelatin is exposed to light under an ordinary black-and-white con-continuous-tone negative from, for example, a wash drawing, or a similar colour separation negative for colour work. The exposure is long enough to insolubilise the gelatin over the whole of the image area, but in the process the surface of the gelatin reticulates or wrinkles very finely and the more so the greater the exposure, that is, under the denser image areas. Surplus dichromate is washed out with water, the plate dried and then treated with a solution of glycerin. The glycerin swells the non-printing parts and moisturizes them, while the hardened reticulations accept fatty ink and give the printing surface. The reticulations, which are narrower and sparser in the lighter, less dense areas, provide the necessary breaking up of the image according to the tones but to an appreciably finer and less regular extent than the usual half-tone screens in lithography (see the next section), so that the finest detail can be reproduced. The resulting pattern produced in prints can be seen under a low-power or pocket microscope and is most obvious in the middle tones as a network composed of three lines meeting at a point, being roughly similar to that of a very fine honeycomb.

Printing is done directly from the gelatin surface which usually limits the run to about 5000 impressions. Collotype from the more usual glass plates is printed on flat-bed cylinder presses adapted from the kind once used with litho stones. By dint of careful retouching and correction of the negatives and the gelatin image itself, coupled with printing in six or

seven or even up to eleven colours to counter the deficiencies of the inks, beautiful and exact colour reproductions of fine art subjects are obtained. The process is also used for picture postcards and illustrations in scientific publications where detail is important.

PHOTOMECHANICAL PROCESSES

The term 'photomechanical processes' covers the various photographic and etching techniques that are applied to the making of printing plates. These processes are all based on the insolubilization and hardening of light-sensitized colloidal substances such as egg albumen, fish glue, shellac, gum arabic, gelatin, polyvinyl alcohol and certain synthetic resins, to form either the actual printing image on the plate or a resist to protect the plate completely or partially during etching. When any of such substances is mixed in solution with ammonium or potassium dichromate and then spread into a thin layer on an inert support and dried, it becomes light sensitive, though much slower than the silver compounds used in photographic emulsions. Exposure to strong short-wave light or ultra-violet radiation from, for example, an arc lamp, mercury vapour or xenon lamp, renders the colloid insoluble in water.

To make a *letterpress* line block, the metal plate is coated with a suitable dichromated colloid and the coating is exposed in close contact under a negative of the original line drawing, the negative, of course, comprising transparent lines with a black surround. The light in-solubilises the colloid under the transparent lines, following which the image is 'developed' with water that dissolves away the unaffected colloid surrounding the lines. Thus the insoluble lines of colloid remaining on the surface of the plate, after further hardening by heat, protect the metal during the etching operation which removes metal from the bare non-image areas but leaves the lines standing in relief. Zinc and magnesium are etched with nitric acid but copper, for both letterpress and photogravure, is always etched with solutions of ferric chloride which is easier to control. During the past ten years or so, plastic relief plates have come into use which consist of special forms of light-sensitized nylon or similar substances on an aluminium or steel backing and are readily curved round the cylinder of a rotary press. After exposure under a negative and development with an alcoholic solution or a very dilute alkali solution, the remaining insolubilised material gives the relief printing surface and so no acid and no etching are required.

The preparation of a *photolithographic* surface plate follows similar lines except that no etching as such is carried out, the layer of light-hardened colloid that remains on the plate after development consti-

tuting the printing image when covered with a fatty ink. For making a 'deep-etch' plate the light-sensitive coating is exposed under a transparent positive instead of a negative, so that the light-hardened layer is formed over the non-image areas on the plate as a kind of stencil overlay to protect these parts when, after development, the bare image areas are weakly etched to a much shallower depth than are the non-image areas of a letterpress plate. A protective lacquer followed by a stiff ink are applied to the slightly recessed image and the stencil is then removed from the surface of the plate. With the recent presensitized plates and wipe-on coatings, specially prepared light-sensitive resinous compounds of the kind chemically known as diazonium salts, which are either rendered insoluble on exposure or decomposed and solubilized by light, the former intended for use with negatives and the latter for positives, have replaced the conventional dichromated colloids and have some technical advantages.

For making *photogravure* plates and cylinders, the light-sensitive material is exclusively dichromated gelatin, used as an etching resist. The gelatin coated on paper or polyester plastic film and coloured with a pigment to make it easily visible during processing is known in the industry as 'carbon tissue' or 'pigment paper'. A sheet of this is sensitised by immersion in a dichromate solution and then exposed under a continuous tone black-and-white positive transparency, which for the larger cylinders will consist of a number of separate transparencies imposed in page formation on a large sheet of glass or transparent foil. The exposure renders the gelatin insoluble to different depths depending on the amount of light action in accord with the tones of the transparency.

A second exposure is given behind the photogravure screen mentioned earlier, which completely insolubilizes the gelatin under the thin transparent lines of the screen. The carbon tissue is then pressed face down into intimate contact with the copper plate or cylinder and developed with warm water. The paper or film backing washes off with the soluble gelatin to leave a negative relief image in gelatin on the copper, the shadow tones corresponding to an almost imperceptibly thin layer, highlights to a relatively thick layer and intermediate tones to different thicknesses between these limits, while the network of screen lines stands everywhere at the highest level. Etching then takes place through the gelatin relief image, resulting in the image produced on the plate or cylinder being formed of very small square recesses or cells of varying depth down to about 0·03 mm. Text matter, taken from a letterpress print on transparent film or from photographic film on which it has been set directly by a photocomposing machine, is uniformly etched to the full depth but is, of course, cut across by the screen lines.

Text matter composed automatically on photographic film in a

photocomposing, often called a filmsetting, machine is also directly applicable to photolithographic platemaking, avoiding the necessity, otherwise, for a letterpress proof from metal type.

The Half-Tone Principle

In both the letterpress and lithographic methods all the units of the printing surfaces are one level plane, the relief elements of letterpress all being 'type high', and as the surfaces are inked from rollers it is not possible to apply different thicknesses of ink to various parts of these surfaces for the purpose of obtaining tonal reproductions. It is a matter of full inking or no inking. The only alternative is to divide up the image into separate units too small for the eye to detect at normal viewing distances, these units varying in area according to the tones of an illustration in order to apply different areas of ink to paper to produce the effect of tonal range. This is the function of the half-tone process. Greys in black-and-white letterpress and lithographic prints comprise mosaics of blank ink dots and white paper dots. Just as the eye fails to resolve the coloured dots on a colour television screen or on an additive mosaic colour photograph, by the same physiological property the eye blends the black and white dots of these prints into greys.

To break up the image into tiny varying areas, which in fact range from separate pin-point dots in the highlights through squarish dots joined at the corners in the middle tones to well-joined areas broken by white paper dots in the dark tones, in short, dots of different sizes, a glass screen ruled with fine opaque lines at right angles leaving transparent square interstices is used in the photomechanical processes by which half-tone letterpress blocks and photolithographic plates are prepared. The opaque lines and transparent squares are normally of the same width, as illustrated on an enlarged scale in Fig. 8.5(a).

Half-tone screens of different cross-line rulings are employed according to the purpose of the illustration and particularly the surface of the paper or other material on which the plate is to be printed. Because of the comparative difficulty in achieving contact between all the relief units of a letterpress plate and rougher paper surfaces, screen rulings for letterpress printing range from 65 lines per inch (25 per cm) for newspaper to 120 or 133 lines per inch (47 to 52 per cm) for most commercial work of good quality on smooth coated 'art' papers and up to 175 or more lines per inch on the smoothest papers when the reproduction of detail is important. Offset lithography does not need such a wide range and 120-, 133- and 150-line screens are generally used.

For poster work half-tone negatives taken through such finer screens may be 'blown up' on an enlarger camera to produce prints corresponding to a half-tone screen of about 50 lines per inch (20 per cm).

(a)

(b)

Fig. 8.5　Small areas, highly magnified, of (a) a half-tone screen used for the reproduction of tonal illustrations by the letterpress and lithographic printing methods, and (b) a conventional screen used for the reproduction of all subject matter (lettering, lines and illustrations) by the rotary photogravure process. Half-tone screen rulings range from 65 to 300 lines per in., those most commonly used for good quality reproduction being 100, 120, 133 and 150. Photogravure screens usually have 150 or 175 lines per in.

The half-tone stencil images for reproducing illustrations by the screen printing method cannot be very fine on the mesh that supports the stencil and screens of 50 to 75 lines per inch are usual, often obtained by enlargement from fine screen negatives.

Half-tone screens are used in *process cameras* which in general must be large enough to take photographic film sheets of the same sizes as the required printed images. The original photograph or tonal illustration for reproduction is photographed in front of a process camera, fitted if required with a right-angled prism or plane mirror to give the lateral reversal essential for making letterpress blocks (see p. 191), and a suitable half-tone screen is placed in the camera a fraction of an inch or a few millimetres in front of the photographic film. The short distance between screen and film is critical because on it depends the resulting dot structure of the negative image produced on the film to give the best tonal gradation and contrast. The light from the original tonal subject passes through the grid of the screen, the separated 'pinhole' beams of varying intensities converging or diverging therefore, due to shadow and diffraction effects, so that over the gap between screen and film these small beams are recorded as dots of different sizes on the film. The exact separation of the screen from the film is determined by the screen ruling, the aperture of the camera lens and the camera extension (distance from lens to film), the last factor depending upon the required enlargement or reduction in the size of the original picture.

The half-tone method of producing grey tones by means of varying mosaics of black and white dots imposes some limitations on the definition of detail and the tonal range, with slight errors of tonal values in reproduction. To counteract these limitations, correction, often done by hand, of the half-tone negatives and, for letterpress, the printing plates is usually required.

Within the last thirty years *contact screens* have been developed, originally for photolithography but now applied to letterpress and invert half-tone photogravure also. These have a vignetted chessboard pattern similar to that obtained at the proper distance behind a ruled half-tone screen with uniformly even illumination, and which, as the name implies, are used in contact with the photographic film. Because a contact screen gives about the same light distribution on the film as does a half-tone screen out of contact, it breaks up the image into a similar dot pattern, but being used in contact it gives better definition of fine detail and somewhat improved contrast and gradation which can benefit the quality of colour reproduction. Contact screens are made photographically so that they are much cheaper, though less durable, than a ruled half-tone screen and their introduction has facilitated the employment of enlargers and copying cameras, and, for same-size reproduction, contact-printing frames in photomechanical

work. More recently, photographic film that incorporates a screen pattern in the emulsion (Kodak Autoscreen film) has come into use chiefly for monochrome reproduction by screen printing and offset-lithography.

Screen Angles

Although half-tone dots are normally too small to be seen individually, the regularity of the dot pattern can become obtrusive and to minimise this in black-and-white reproductions the screen is always used with the lines at 45° to the horizontal or vertical sides of the illustration. In colour printing the three half-tone patterns of the primary colours are superimposed and if this were done with the lines of dots all parallel objectionable moiré or check-like coloured patterns would be produced. To avoid these undesirable moiré patterns, the three half-tone images are printed with the lines of dots at different angles, as widely apart as possible, viz., cyan, being the darkest colour, at 45° like the black in monochrome reproduction, magenta at 75° to the horizontal and 30° to one side of the cyan, and the yellow at 15° to the horizontal, that is, 30° to the other side of the cyan. Largely for reasons connected with the deficiencies of the inks and explained later, a fourth printing in black half-tone is often included in colour work, in which case the usual arrangement is for the screen angle of the black to be 45°, the magenta 75°, cyan 15° and the yellow 90° or parallel to the horizontal. The necessarily different angles and dot sizes of the half-tone images result in only partial superimposition of the coloured inks on a print and this affects the colour rendering as referred to later.

Colour Printing Plates

For colour printing, half-tone colour separation negatives on panchromatic film (or positives for 'deep-etch' lithography) are taken through the usual red, green and blue filters. If a fourth printing in black is required, the half-tone negative may be taken by photographing the original subject through a yellow filter to counterbalance the high blue-sensitivity of the photographic film in the camera, or there are other methods for preparing the black printing plate.

Having obtained the half-tone negatives, the operations for making both letterpress and lithographic printing plates are closely similar to those already described on pp. 199 to 200. Photogravure requires continuous-tone colour separation positive transparencies in black-and-white for the conventional process, which are prepared from continuous-tone separation negatives, and the necessary three or four colour printing plates or cylinders are made from the positives in the

way described on p. 200. A fine screen half-tone letterpress block cannot be etched to a depth exceeding about 0·03 mm without weakening the small relief dots, which means, in general terms, that the relief of the printing units from the non-printing areas in a letterpress surface may be only 0·02 mm or 0·001 inch, though, of course, it is often much more than this, for example, with type. The etching may be done by hand or, more commonly, in etching machines, or letterpress plates may now be produced directly on *electronic engraving machines.*

The latter machines dispense with the conventional photomechanical camera, half-tone screen, printing on to metal and etching procedures, but they are expensive. The original illustration is scanned by a thin pencil of light, the reflections are picked up by photoelectric cells from which the electrical impulses pass through amplifiers and electronic gear to a cutting stylus that removes material from a metal or plastic sheet to leave a relief printing plate. Electronic engraving machines are available that can enlarge or reduce from the size of the original, produce line or half-tone blocks, these in a selection of screen rulings and at rates up to 1 000 dots per second. There are also electronic colour scanners, described later, working on similar principles, two of which produce three- and four-colour letterpress plates directly that are automatically colour corrected. For photogravure, electronic engraving machines are coming into use, operating from an original or a colour separation positive, which cut out tiny cells in this case to form the recessed image in the copper surface of a press cylinder.

COLOUR PRINTING PRESSES

Actual colour printing in all three major methods, letterpress, offset lithography and rotary photogravure, is done on single- or multi-colour machines. On single-colour presses, printing takes place one colour at a time, as the name implies, and the plates have to be changed for each colour. Multi-colour machines combine two, three or four printing units with the primary colour plates on each unit and therefore print two, three or four colours in rapid succession. In addition to speed of production, multi-colour presses have an advantage over single-colour machines as regards registration of the coloured images in that paper and most other materials on which printing is required are not dimensionally stable under varying atmospheric humidity. On the other hand, there are problems concerning the printing of the inks 'wet-on-wet' which necessitates careful adjustment of the viscosities and drying properties of the inks and the thickness of the printed ink films.

COLOUR RENDERING IN PRINTING METHODS

The colour materials in printing inks, like those in paints, must normally be pigments insoluble in oils, water and other solvents, resistant to fading on exposure to light especially for posters and displayed matter, and often resistant also to waxes, greases, fats, detergents, acids and alkalis and the lacquers or varnishes that are applied to give a high gloss for the purpose of enhancing the colours of prints. These requirements limit the choice of the colouring agents for printing inks compared with the dyes for colour photography. As a consequence, the overall range of colours that can be reproduced by printing is less than the range obtainable by photography, the main differences being in saturation rather than hue. This means that if the gamut of colours reproducible from trichromatic printing inks is plotted on the C.I.E. chromaticity chart, the area covered lies within the approximately triangular region representing the various colours that can be produced from the dyes used in integral tripack photographic films. Indeed, the best dyes now available for subtractive colour photography have somewhat greater colour coverage, again in saturation, than the additively operating phosphors used on a television screen. Because these dyes can produce colours that are more highly saturated than those attainable with printing ink pigments, a present-day colour photograph, particularly a transparency, may appear to be more vividly or strongly coloured than a print of the same or a similar subject in a publication. Fortunately for colour printing, small losses in saturation are hardly noticeable and, in general, the desaturation of colours is less serious than inaccuracies of hue. This is an aspect of colour reproduction that is discussed in the concluding section.

The more limited colour range of trichromatic inks is due to the pigments being more deficient compared with the ideal, in the ways explained early in this chapter, than are the dyes in colour photography. Furthermore, there are other complications. The distortions in tone reproduction induced by the half-tone process of letterpress and lithography that tend to make some greys too dark and others too light, for which corrections of the half-tone negatives or positives or of letterpress plates are often necessary, have been mentioned on p. 203. In colour printing, the superimposition of the three- or four-colour half-tone images at different screen angles and having different dot sizes gives only partial superimposition of the inks as indicated on p. 204. Where the ink dots are small, as they are in the light tones or pale colours of a half-tone print, they fall in juxtaposition more or less side by side. In the middle tones the squarish ink dots may be almost equal in size but, because of the different screen angles, they do not completely cover one another, and it is only in the denser coloured areas that the

ink layers approach full superimposition. The appearance of letterpress and offset lithographic half-tone colour prints when magnified is shown in Plate 29 (a) and (b). It will be seen that half-tone colour reproduction is a cross between a subtractive and an additive mosaic process, though it is treated as being essentially subtractive.

As previously explained in Chapter 5, p. 81, the subtractive primaries provide six major colours, yellow, magenta and cyan, green from the yellow and cyan, red from the yellow and magenta and blue from the magenta and cyan, plus black from the three primaries together and white from the paper. These eight colours, including white, are all that can be produced subtractively by the letterpress and lithographic half-tone colour methods, since the inks are either fully printed or not at all, effective different ink thicknesses being impossible. Hence other colours and tones of colour are largely produced by additive effects where the ink dots are not superimposed. In 1937 H. E. J. Neugebauer, using the units of the C.I.E. system in conjunction with the probable areas of the eight colours, derived mathematical equations for a scheme of colour reproduction based on eight-colour mosaics. Such equations provide a theoretical analysis of the half-tone colour method and although complex they have led to improved procedures for colour correction by masking and especially by colour scanners (p. 214).

In conventional photogravure, however, tonal variations are reproduced by different ink film thicknesses so that distortions in tone rendering are less than by the half-tone method and, as the primary colour images are not broken into dots of different sizes (although different screen angles for the images are also used in this process), the ink films largely cover one another and the process is more truly subtractive. See Plate 29 (c).

The deficiencies of the printing ink pigments demand attention in all colour printing methods and a great deal of consideration and skill is devoted to the production of the best possible results from the inks available. Evidence of their success is to be seen in almost any illustrated publication, including this book. In the letterpress and lithographic half-tone methods both tone correction and colour correction are normally necessary and, as no printing or even photographic method gives entirely satisfactory tonal reproduction automatically, some tone as well as colour correction is also required in photogravure. It is usual, in practice, to combine the two forms of corrections, the techniques being similar.

THE INFLUENCE

Paper and similar opaque materials on which colour reproductions are

based, whether by printing or photography, cause additional losses of colour saturation and tonal range. There are three main effects of the substrate on a reflection print.

Since the effectiveness of a subtractive colour picture on a reflecting base depends upon the absorptions from white light by the dye or pigment layers before and after its reflection from the base, one would expect the *colour* of the base to be important. It is generally true that the whiter the paper or other substrate the better the result. Yet a small degree of 'off whiteness' may not be at all serious, mainly because of the adaptation of the eye which tends to accept the brightest part of a picture as 'white' even though it may in fact have a definite tinge of colour. For this reason the whiteness of the paper is not as important in photogravure, in which process ink is transferred over the entire paper surface including the highlights, as it is in the half-tone methods where the clear spaces of paper between the ink dots are critical.

The wide use of fluorescing artificial whiteners in papers (p. 51) can cause some unexpected results in colour printing. Most printing inks absorb ultra-violet, so that the artificial whitener in the paper under the ink becomes ineffective and the visible light which penetrates the ink film may be reflected from a paper surface that, without the action of whitener, is far from white, the colour of the ink being degraded as a consequence. With half-tone printing there may be a further greying effect in the lighter tones where the ink dots are surrounded by fluorescing white paper. This is most noticeable in pale yellow tones, the ink being blue absorbing. The fluorescing paper surface in the spaces between the ink dots reflects excess blue which counteracts the blue absorption of the yellow ink and a greyed result is produced.

The *smoothness* of the paper surface is another important factor, in three respects. Firstly, it is easier to obtain uniformly thin ink films when printing on a smooth surface. On a rough surface more ink has to be applied to ensure that the depressions in the surface are covered or 'bottomed' and this may cause sufficiently non-uniform ink films as to give a mottled appearance. Secondly, a rough surface tends to break up the outline of printed units and in the half-tone methods of letterpress and lithography it is essential to retain the dot areas faithfully for good tone and colour reproduction. Here again photogravure has some advantage, because the square cell screen has no image-producing function so that it is of little consequence if the cell outlines are lost, as they often are, by the ink spreading, and the much more fluid photogravure inks enable a moderately rough surface to be well covered. Hence the photogravure method is quite suitable for papers of only medium smoothness. If the surface is too rough or pitted, however, some of the inked cells of the photogravure image will fail to contact the paper, resulting in a noticeable mottle in the print. As indicated

earlier, surface smoothness is often less important in offset lithography than in letterpress.

The third influence of paper smoothness is general to all reflection prints. No paper surface is perfectly smooth—if it were, it would be mirror-like. Papers are white because a considerable proportion of the light is reflected diffusely rather than specularly (see p. 8). Papers reflect light in all directions, some light penetrating the surface and being scattered and the rougher the paper surface the more light is scattered and lost by internal reflections. Obviously, the more the light is scattered within the paper surface, the less is reflected in any direction to the eye. Considering that printing inks and dyes or other materials are never completely transparent, that the light has to traverse the coloured layers twice, before and after reflection from the paper, and that a little scattering will occur within the coloured layers themselves, particularly from the particles of pigmentary ink layers, the significant effect of loss of light by scattering in the paper surface will be appreciated. It reduces the lightness of the coloured layers and also tends to reduce their saturation.

In addition to scattering losses on entering a paper surface, there is the effect of light reflected from the top-most surface of a reflection print, particularly from the top of the image layer. As emphasized in Chapter 2, p. 25, all surfaces reflect some unchanged white light, that is, in our present case, light that does not traverse the image layer. This white light desaturates the colours of the image, its most apparent effect being in strongly coloured and dark areas. Even more important is the restriction this top-surface reflection has on the range of tones or luminances that can be obtained. The white reflection lightens or 'desaturates' the blacker tones, causing detail or contrast to be lost in these dark tones. The luminance of the lightest tones is limited by the reflection of the paper itself which often amounts to no more than 80% of the incident light. Hence a reflection print should not be expected to show as wide a separation of tones, particularly in shadows and high-lights, as a projected transparency. The increased reflection of un-changed white light produced by roughening a coloured surface has been explained on p. 25. It follows that the smoother and more glossy a paper surface on which a colour picture is printed, provided it is not viewed at the mirror-reflecton angle, the less the colours will be de-saturated by surface reflections and the greater will be the reproducible range of tones.

Lower light scattering and surface reflection are the chief reasons why colour prints always look better and brighter on smooth papers. They also explain the practice of coating prints with a gloss varnish or similar smooth film, and such coatings have the additional advantage of giving colour prints a more durable surface.

The *absorbency* of paper is a third property that can affect colour reproduction by printing, though it is not generally so important as smoothness and colour. It is a common experience that when paper is soaked with oil or even water it becomes less opaque and yellowish, the effect usually being greater with oil and some papers becoming translucent. This is because the liquid displaces the air between the paper fibres and, as the reflectivity of paper depends largely on these air spaces, for example, blotting paper compared with greaseproof paper, the reflection of light is reduced and its penetration increased, the shorter blue waves tending to be absorbed in the process to give the noticeable yellowing. The same effect takes place when a coloured ink is printed, though it may be less evident. The absorption of blue light responsible for the yellowing of the paper may be advantageous with a yellow ink but it is detrimental to cyan and magenta inks which have their own unwanted blue absorptions. The effectiveness of gloss varnishes, mentioned above, may be lost in a similar way on papers that have a high absorbency. Unexpectedly different results can occur when coloured inks are printed on papers of similar whiteness and smoothness if they differ in absorbency. As a rule, therefore, paper for high quality colour printing should not be very absorbent.

COLOUR CORRECTION IN PRINTING METHODS

The considerable deficiencies in printing ink pigments, as described at the beginning of this chapter, coupled with the tonal and colour distortions of the half-tone process and smaller distortions introduced photographically in the photomechanical operations for making the plates, make some form of correction an essential part of all colour printing methods whenever correct colour rendering, or nearly so, of original multi-coloured subjects is required. The colour separation filters used in the initial photomechanical stages normally have transmission spectra of the kind shown in Fig. 8.6, which have been found generally to give the best results. Slight faults may arise, depending upon the subject, from the overlapping transmissions, whereby certain blue-green and yellow-orange colours are each recorded to some extent on two separation negatives, which tend to produce some loss of saturation in the reproduction. A choice of filter sets having sharper 'cut-offs', though somewhat narrower transmission bands, is available however, such filters often being more suitable for making separations from colour transparencies that have relatively high saturation. The blue filter is always the darkest being the least transparent, but this does not matter since it only means a longer time of exposure in the camera. Even photographic panchromatic films are not perfect, their sensitivities

to different colours varying slightly as mentioned on p. 149. But the faults in the filters and panchromatic emulsions are almost negligible compared with those of the primary ink pigments.

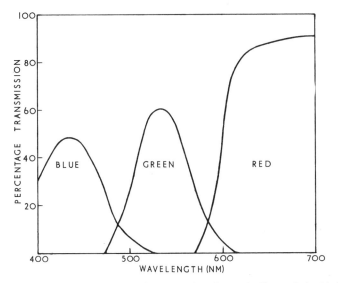

Fig. 8.6 Spectral transmission curves for a set of trichromatic filters of the kind generally used for colour separation in the photomechanical processes of making colour printing plates. Each filter transmits light over approximately a third of the visible spectrum. Like coloured materials in general (p. 23), the blue and green filters have considerably lower transmissions than the red. This is only a minor disadvantage, however, because it is easily compensated by adjustment of the time of the camera exposure through each filter.

Before the invention and establishment of the trichromatic half-tone process it was a common practice to use six or more coloured inks, for instance, two 'magentas' (a magenta and a pink), two 'cyans' (a cyan and pale blue), yellow and black, thus more or less counterbalancing the limitations of only three inks. Prior to the introduction of the half-tone process, the most used commercial method for producing multi-coloured illustrations was chromo lithography. Skilled lithographic artists drew on stones or plates as many as ten to fifteen or sixteen 'separations' which were printed in appropriate colours and tints to build up the desired result. The practice of using six to eight colours persisted, particularly in lithography, until better trichromatic pigments were discovered and improved methods of colour correction and control of printing processes were developed. Even today, and again mainly in lithography, where the reproduction of brighter secondary colours, for

example, violets in the reproduction of a painting, are involved or other special requirements, additional printings in such special tones of colour can be worthwhile.

A number of near-magenta, yellow and near-cyan pigments have been available for a long time, the 'magentas' ranging from scarlet to purple, the 'cyans' from almost violet to almost green, and there are yellows varying from greenish-yellow to lemon, thus providing a choice of sets of near-trichromatic inks. Many firms are engaged solely in the photo-mechanical production of plates, chiefly letterpress, for supply to printers and publishers. Up to less than twenty years ago, therefore, it was by no means uncommon for a printer to be called upon to print side by side in the same forme plates made by different supply firms each to give acceptable results with different sets of inks, yet no single set would suit them all.

This troublesome situation ultimately led to the *standardization of ink sets* for colour printing. In Great Britain letterpress inks were the first to be standardized in 1949 under BS 1480 which provided specifications for both three- and four-colour sets, the fourth being a black the inclusion of which is explained later. As better, mainly brighter, pigments have been produced improved standards have been accepted, and so BS 3020 for four-colour letterpress inks followed in 1959, and BS 4160 in 1967, the latter also being accepted to some extent in Europe. For offset lithography a larger plate usually carries several images but, as these are prepared on the plate at one and the same time, the lithographic printer is not faced with the problem of printing various half-tone surfaces from different sources. Even so, there are advantages in the general use of standard colours and BS 2650 for five lithographic inks was issued in 1955 covering magenta, cyan, black and a choice of opaque or transparent yellows. All these British Standard inks standardize the properties of hue, strength (lightness) and light-resistance.

In Europe, trichromatic inks conforming to the German standards DIN 16508 (letterpress) and DIN 16509 (lithography) have been widely adopted. In the U.S.A., balanced sets of inks recommended by the Graphic Arts Technical Foundation are popular. These inks are designed to minimize colour correction particularly by masking (see p. 177), the blue deficiencies of the magenta and cyan being 'balanced' to enable a single mask to control the yellow image correctly for both. If the blue deficiencies of the magenta and cyan inks differ to any great extent, the effect of a single correction mask on the yellow image would be to over-correct for one and under-correct for the other, that is, two masks are really required.

Photogravure inks have not yet been standardized, partly because of the smaller number of firms employing this more involved method, partly because the operating techniques, especially those of preparing

the printing surface, are more difficult to control precisely, and partly because the colour reproduction process is more completely subtractive and some adjustment of the density of the fluid inks by dilution can be made on the press to give the best colour rendering.

Having emphasized earlier that materials which are superimposed in a subtractive colour reproduction process must be transparent, an opaque standardized yellow ink has been quoted above. With an opaque substrate like paper, it is obvious that the *first* coloured material laid on it can, if necessary be opaque. Chrome yellow (lead chromate), which is a relatively cheap but very opaque pigment, has been much used in colour printing and this determined the sequence of the colours, yellow first, usually followed by magenta and then cyan. However, it is not easy to judge accurately the amount or film weight of a yellow ink on white paper. Good transparent yellow pigments are available and have been included in the standard ink sets since 1955, so that the colours can be printed in any desired sequence.

The half-tone colour reproduction process was applied at first in letterpress printing because corrections are comparatively easy to make on the relief plates and the procedure of chromo lithography employing many lithographic artists was traditional in the planographic method. It will be appreciated that in these earlier years all colour correction work had to be done by hand. A half-tone letterpress block has to be etched into relief in the first place and it is an advantage of the relief printing method that the block can then be further treated in local areas by what is called *fine etching* for the purpose of making both tonal and colour corrections. Fine etching, as the term implies, reduces the size of the relief dots on those parts of the plate from which a reduction of the amount of ink printed is required.

Treatment of half-tone negatives and positives by hand *retouching* and photographic chemical *dot reduction* methods is also carried out, these being the only means of increasing or reducing the printing surface areas locally on a photolithographic plate. In photogravure most of the corrections are made on selected areas of the continuous-tone photographic negatives and positives, though some limited hand engraving and further etching to increase the depth of the recessed cells in the printing surface are also done. The excellent colour reproductions printed by the three major processes before the 1939–45 war were very largely due to the skill and patience of the fine etchers, retouchers and hand engravers. But all forms of hand correction are time-consuming and therefore expensive, and they tend to obscure fine detail. Correction by more automatic methods is now the common practice, yet some additional hand retouching is often still necessary, particularly for high-quality reproduction, and this will certainly be the case for some time to come.

The principle of colour correction by *masking* has been explained on p. 177. Masking is widely used in preparing the composite colour separation negatives and positives from which printing plates are made photomechanically, the procedure of masking being readily applicable to the separate red, green and blue photographic records that are involved. Each of the three separate records can be masked if required so that, at least in theory, full colour correction is possible. In practice, however, it is most usual to mask only the blue and green filter negatives in the way described on p. 178 for making the yellow and magenta positive printing plates. Even this frequently calls for three masks; two (prepared from the red and green filter negatives) for the yellow printer to correct for the unwanted blue absorptions of the cyan and magenta inks, and one (prepared from the red filter negative) for the magenta printer to compensate for the low transmission or unwanted absorption of green by the cyan ink. If a fourth printing in black is required, a four-mask system has been recommended in which the fourth mask is bound up with the negative from which the black printing plate (see p. 204) is made. Masking, therefore, can consume appreciable quantities of photographic materials and time in preparing the masks and registering them accurately with the respective colour separation negatives.

Within the last five or six years, in order to simplify masking procedure, special multiple-layer colour films containing dye-couplers have been marketed which produce three or more mask-images in a single film. These are known as Multimask or Tri-Mask film. They are intended primarily for use with photographic colour transparencies, very many of which are reproduced by colour printing, but can be easily adapted to the reproduction of original reflection pictures as well. When such a multi-layer film is exposed to white light under a colour transparency, weak, low contrast cyan, magenta and yellow dye-images are produced. The special form of colour negative thus obtained is bound up as a mask in register with the transparency, and colour separation negatives can then be made directly from the combined transparency and mask with the usual red, green and blue filters. A very high degree of colour correction is provided, yet only one mask has to be made and registered with the transparency, and all three separation negatives plus a fourth for black are taken from the same transparency-mask combination.

Electronic Colour Scanners

The established advances in electronics by which mathematical equations can be converted into electric signals, as in computers, has led to the development of electronic *colour scanners* which produce highly colour

corrected separation negatives or positives automatically, and the evolution of such computerised machines is continuing. Several of these elaborate devices having different features are available, most of which supply continuous-tone separations, others half-tone separations and two of these go further and produce finished letterpress printing plates directly by combining colour scanning with electronic engraving (p. 205). Depending on the type of scanner, the original illustration for reproduction may be a colour transparency or a reflection picture, in some cases it may be only a transparency, while a few work from a set of uncorrected colour separation negatives. Means for making changes in size between the original and the corrected separations or printing surfaces are usually provided.

As the name implies, the general principle of scanners is that the original or the set of separation negatives from it is scanned as in television, but the scanning is done with a fine pencil or spot of light instead of a beam of electrons and not at the same extremely high speed. Better definition is required than in television and so the scanning is much finer, usually 250, 500, 1 000 or even 2 000 lines per inch (100 to 800 lines per cm). Scanning times from a few minutes to about an hour are usual, depending on the size of the picture and the fineness of scanning.

Using suitable arrangements that vary considerably with the type of scanner, the scanning light is converted into electrical energy by passing it to photoelectric cells, mostly with red, green or blue filters in front of them and the electrical signals are fed to a computer unit. This unit, having been supplied with the appropriate colorimetric information, compares the signals with what is required to give the correct colour and the computer controls the intensity of another fine beam of light which is focused on to a sheet of unexposed photographic film, or the corrected output signals from the computer control an engraving tool in the case of scanners producing finished printing plates. With some appliances the original to be scanned and the film or films to be exposed are mounted side by side on a rotating cylinder, these being termed drum scanners, for which the originals must, obviously, be flexible. Others, called flat-bed scanners, carry the materials on a flat base that normally oscillates sideways and slowly moves forwards under the scanning and exposing light-beams.

In one of the first scanners invented (1948) the colour corrections were evaluated by the electronic computer unit in terms of the equations derived by H. E. J. Neugebauer for the eight-colour half-tone mosaic referred to on p. 207. The correcting functions of later scanners tend to depend on colour masking theory. In this case the electrical circuits of the computer may be linked so that any one of the primary colour signals is modified appropriately by the magnitudes of the other two

signals at the same point on the picture. That is, the intensity of the exposing light-beam is determined by signals obtained not only from its main primary light filter, for example, the blue, but also from the other two filters, the red and green. Thus a corrected blue filter separation negative or yellow positive printing plate may be produced with the image reduced commensurately in areas where magenta and cyan will be printed, to compensate for the low blue transmissions of the magenta and cyan inks, and so forth as in masking methods. As already indicated, the majority of colour scanners produce corrected separation negatives or positives, and from these printing surfaces are made by the orthodox methods. Although scanners are comparatively complicated, electronic computerization offers wide flexibility for both colour and tonal corrections, including a very efficient means of 'under-colour removal' for printing which is explained in the following paragraphs.

Four-Colour Printing

The use of a black ink for colour printing in addition to the normal yellow, magenta and cyan inks has been mentioned several times in preceding pages. In practice, *four-colour printing* is much more generally used than three colours only. The unwanted transmissions of all three trichromatic ink pigments, in the spectral regions where they should absorb completely, result in some light still being reflected when the three inks are superimposed. This makes it very difficult to produce a dense black in three-colour work. An acceptable black is possible, but unless great care is exercised, for instance, if the amounts of ink in the three layers are allowed to vary slightly, the 'black' becomes a dark brown or a deep purple and a colour cast will also tend to be shown by greys and neutral tints. If, however, the subject for reproduction does not include black and dark tones, satisfactory prints are often obtainable in three colours.

But there are other advantages in the use of a black, or may be a grey, as a fourth printing. It allows better control of detail or definition in shadow areas and adds sharpness or crispness to a colour print, giving it 'modelling' or 'life'. One of the reasons given on p. 157 for transmitting a separate luminance signal in colour television is that the visibility of detail and the impression of sharpness in a picture depend far more on differences in luminance than on colour differences and, in this respect, there is an interesting connection with colour printing. The black printer controls to a large extent the variations in luminance or lightness over the print. Moreover, the use of a black ink to deal with the darker tones and detail enables greater attention to be given to the quality of colour reproduction, especially the subtractive second-

ary colours, red, green and blue-violet, from the three primary coloured inks. In short, the primary inks determine the chromaticity and the black the luminance of a four-colour print.

The black printing plate is made by photographing the original through a yellow filter or similar technique when using the conventional photomechanical procedure. Theoretically, on the basis of complementary colours, the filter should be white, that is, no filter would seem to be necessary. But, as mentioned already on p. 204, the yellow filter is required to counteract the excessive blue-sensitivity of photographic emulsions. Otherwise, the black plate, or the separation negative or positive from which to make it, may be obtained from a colour scanner.

Plate 28 (a) to (d) shows separate prints in their respective colours taken from each plate of a four-colour half-tone set and (e), (f) and (g) are the progressive results of superimposing two, three and all four images, the black last.

Occasionally, particularly in half-tone reproductions where cost is important, the colours may appear duller than expected and examination with a magnifier will reveal very small black half-tone dots in the brightest areas of colour. It may seem illogical to dull down coloured inks that are themselves defective by printing black on them. But the reason for the black dots over the brighter coloured areas is usually an economic one. It is simpler and therefore cheaper, especially with letterpress blocks, not to remove the fine black dots from these areas.

A fourth printing in black is generally beneficial but it can cause difficulties during printing and it is wasteful of relatively expensive coloured inks to superimpose all three primary colours plus black in the darkest tones. The printing difficulties are concerned with inks covering adequately and drying properly when printed on top of one another, problems that become more acute as the number of ink layers increases and particularly on multi-unit presses when the inks are superimposed while still wet (see p. 205), these difficulties being greatest in the letterpress method. When a black printer is used, it is unnecessary to print the coloured inks in the black areas, the darkening of secondary colours can be done with the black instead of a third colour and neutral greys can be better rendered by the black alone than by the primary inks. This requires the removal or reduction of the primary coloured images in the grey and dark-toned areas of the picture, a procedure known as *under-colour removal* since the black is normally printed last.

Correction of this kind is carried out on the colour separation negatives and positives from which the printing plates are made, but it is not easily done by orthodox techniques. The appropriate clear areas on the negatives may be opaquely painted out or the density of corresponding areas on the positives reduced by laborious handwork, and masking methods are difficult to adapt fully to under-colour removal.

On the other hand, it can be very well done on certain types of colour scanners. As the original is scanned through the three primary light filters simultaneously, electrical signals being generated for correction through the computer unit and transmission to the preparation of the separation negatives, the computer can be regulated to reduce or suppress colour signals in grey and dark areas that are to be overprinted in black.

In this section some account has been given of the variety of ways and means employed in the printing industry that are aimed principally at overcoming the deficiencies in the best subtractive primary inks available for colour reproduction. Essentially, they are five in number:

 (i) The adoption of standardized inks, except for special require-
 ments such as subjects involving one or two predominating
 secondary colours.
 (ii) Corrections carried out by hand on the colour separation
 negatives and/or positives and, in letterpress and to some extent
 in photogravure, on the printing surfaces.
 (iii) Photographic masking corrections made on the final separation
 negatives or positives from which the printing surfaces are
 prepared.
 (iv) Corrections made electronically on colour scanners.
 (v) The addition of a fourth printing in black, which, of course, is
 decided upon before work on a reproduction is commenced.

When we consider that there are additional faults to be circumvented arising from the necessity to break up printing images with screens, especially the half-tone screen, that other variables are involved as well, such as the influence of the paper and dichroic effects from the magenta in particular if the ink film thickness varies, it will be appreciated that the printed reproduction of tonal colour pictures is more a matter of compromise than is the production of colour photographs. It is sur-prising, therefore, that arresting printed colour reproductions, frequently having high fidelity to the original, are achieved so regularly and credit is due to many people, both past and present, whose labours have made and continue to make such admirable results possible. Further improve-ments, for instance, the production of better primary coloured pigments, may be expected, but, in view of the comparatively weaker transmission of light in the shorter wavelength half of the spectrum by coloured materials generally, it is doubtful whether ideal magenta and cyan pigments will ever become available.

VISUAL APPRAISAL OF A COLOUR PICTURE

Despite all that has been written about the limitations of the materials and systems used for colour reproduction, aesthetically satisfying pictures are commonly produced by photography, by the various printing methods and by additive colour television as well as by art painters. There are a number of reasons for this several of which have been mentioned already in relevant sections of the text, but, as a suitable conclusion to this book, it may be helpful to recapitulate and to add some final points.

In Chapter 6 when explaining the spectral locus with reference to the C.I.E. chromaticity chart, we have seen that no practical system of colour reproduction can match the full saturation of the colours of an actual spectrum, particularly in the green-blue region. But real spectral colours, green-blues especially, are rare. The natural spectral rainbow is desaturated by atmospheric haze and the scattering of light. It has been explained that, due to the deficiencies of the primary coloured materials and surface reflections, subtractively produced colours tend to be less saturated than those derived additively, and colour prints less saturated than subtractive photographic transparencies. Yet the saturation of colours in everyday life varies so much with variations of illumination and conditions of viewing, the nature or texture of the surfaces of coloured objects, dust and water films, changes in the concentrations or thickness of colouring matter present, etc., that reduced saturation in a reproduction often passes unnoticed or is accepted as agreeable.

The blueness of the sky is a good example, ranging, even in clear weather relatively free from haze, from near-white close to the sun to deep blue away from the sun. Leaf and grass greens are other examples. Blue sky and green foliage are frequently components of colour pictures and their colours are in the region where a very high degree of saturation cannot be reproduced, but, if it were, they would look unnatural. Indeed, subtractive photographic transparencies are sometimes criticized that the sky is too blue and the grass too green (usually blue-green) and this may be true in comparison with other colours if no ultra-violet filter has been used over the camera lens. The ultra-violet in addition to the high blue sensitivity of photographic emulsions will render the blue of the sky and to a less extent blue-greens more saturated than the other colours. The colours in ordinary life that are normally most saturated, red, orange and yellow, are those that can be reproduced at near-similar saturations, as previously explained on p. 122. Many of the pigmentary colours commonly used by artists have low saturation, yet we are rarely conscious of any lack of truthfulness from this cause in

paintings. From such considerations we can understand that reproductions are acceptable if the desaturation of colours conforms to that which occurs naturally and is approximately equal or proportional for all colours in the scene.

On the other hand, hue is a more critical factor. Although the hues of many natural objects such as foliage, fruit and flowers can vary appreciably with the character of the illumination, the season and the surroundings against which they are seen, for instance, grass may vary from yellowish-green to bluish-green, their 'average' colours are so familiar that their hues or dominant wavelengths in pictures must be in the correct region of the spectrum. A tomato is red rather than orange and certainly not purplish magenta. With pale unsaturated colours errors of hue in reproductions usually become markedly more conspicuous. The wrong kind of tint in the lighter tones of a picture may be glaringly obtrusive, such as a magenta cast in an intended pale blue sky or in flesh tones. We have mentioned early in Chapter 6 on Colour Measurement that the visual tolerance for flesh colours is small. Where neutral greys are involved apparent colour should be absent and this requires a careful balance between the primary colours used for additive and subtractive reproductions. Even so, the balance may be upset by viewing a reproduction under illumination different from that in which it was made. Hence the possible effects of the ambient lighting around the set on a television picture, mentioned on p. 165.

Lightness or luminance as the third attribute of colour is clearly important. Provided, however, that primary coloured materials of the highest available lightness (transmittance) coupled with thorough correction techniques are employed for reproduction and good white paper for a subtractive print or an adequate projection lamp for a transparency, shortcomings in lightness are likely to be small. The lightness of original objects does not often exceed that of the individual primary materials and correction methods are generally successful in reproducing the lightness of objects having other colours, though there may be some shortfall as regards apparent luminance in representations of beams of coloured light. But our impression of lightness in a reproduction can be modified by the background or surround, a dark surround making colours appear brighter and a light one making them look darker, as described under Simultaneous Contrast, pp. 67–68. Lightness also tends to be increased by viewing a picture in bright or intense illumination which often improves the apparent saturation of colours as well, due to the more directional than diffuse lighting; thus a scene appears more vivid and colourful in sunlight than in dull weather.

We may conclude from the above brief discussion that the order of importance of the three attributes of colour when appraising a reproduction is as follows:

(a) *Hue*. Appreciable distortions of hue are usually objectionable although small faults, except with the most familiar subjects, may not be noticeable. Tints and neutral greys are generally very important with regard to any hue and, as these are greatly affected by the overall colour balance in colour reproduction, they make such balance a prime consideration in reproduction processes.

(b) *Lightness*. Brightness or brilliance in a colour picture is usually regarded with favour, hence the popularity of glossy magazines and the preference for photographs taken in sunshine. For the same reason reproductions tend to look better the more strongly they are illuminated. Tonal contrast effects from surroundings may be used to heighten the apparent lightness and the influence of colour contrast on hue should be borne in mind. The effects of simultaneous contrast are almost certain to play a part within a reproduction itself.

(c) *Saturation*. All colour reproduction processes are inclined to produce losses in saturation but the variations in saturation of most colours that we see in common experience are so great that moderate reductions in a reproduction are acceptable or may be overlooked. Subdued colours are generally more agreeable than garishly vivid ones. It is to be expected that a picture will look more natural if all the colours are desaturated to about the same extent or proportion rather than differently giving some hues a false richness compared with others. Desaturation is often most noticeable with very pale colours which tend to become indistinguishable from white.

Pale coloured surface textures, such as that of skin, depend on very small gradations of hue, lightness and saturation which are easily lost in a reproduction due to the limited colour resolution of the process. Correct colour rendering is normally required in advertisements of manufactured products but small losses of saturation may often be accepted whereas inaccuracies of hue may not.

It might be thought that exact colour reproduction should always be the aim, yet, surprisingly perhaps, several fairly recent scientific studies have shown that this is not essential and, indeed, in many cases does not give the most estimable results. In the first place there are the physiological inaccuracies of visual colour rendering due to the overlapping of the sensitivities of the retinal cones (p. 83), which tends to make all colours appear less saturated or vivid than would be expected purely from their physical radiations. Secondly, and frequently more important, are the effects of adaptation of the eye. It is comparatively rare for a reproduction to be viewed under precisely the same conditions as the original scene. Even when it is, the edge, surround, border or frame of the reproduction introduces visual modifications, and allowances or corrections have to be made for the fact that a reproduction is

normally two-dimensional whereas many original scenes are three-dimensional. The appearance of a picture is greatly affected by the viewing conditions, including the colour and intensity of the illumination. Thus a colour photograph of a light-coloured garment taken in bright sunlight on grass might show an overall greenish tint which, though a true physical record of the scene, would be regarded as unpleasant. Yet the adaptation of the eye enables screen projections of colour transparencies showing sunlit scenes to be satisfying from projection lamps of modest power enormously below that of sunlight.

Thirdly, there are psychological influences arising from aesthetic and personal preferences and prejudices. Hence, for example, the objective scientific studies referred to above showed that the colours considered most desirable in reproductions of several familiar objects, such as flesh, blue sky and green grass, differ from typical measured values for the original colours. Most of us believe that we are able to appraise other peoples' colour pictures of objects and scenes we have not seen. This implies that memory and mental association play a large part in our judgement, the colour sensations produced by a picture being subconsciously compared with those experienced before when looking at similar things. But, as mentioned on p. 33 with reference to colour matching, our colour standards based on memory are far from precise and tolerances are often quite large. So it does not follow that exact physical colour reproduction will provide the most acceptable or realistic presentation. The human eye is the ultimate judge, even when for critical purposes a reproduction and the original are compared side by side.

Nevertheless, physical experiments, measurements and quantities are the only logical means for studying and largely enabling us to understand the nature of colour and light, the properties of materials, the imperfections of colour reproduction systems and the intricacies of colour vision. Undoubtedly, without the information derived from measurement, particularly colorimetry, the development of colour reproduction methods by photography, printing and television to their present successful stages would not have been possible, and such physical studies are clearly necessary if further improvements in these methods are to be made. Most of all, there remains ample scope for scientific investigation into the complex relationship that is still rather vague between physical objective measurements and the visual subjective appearance of colour reproductions. The accurate assessment of the appearance of colour pictures is perplexed by many factors and personal opinions, thus involving obscure psychological as well as physiological and physical phenomena. So we return to the fundamental principle that colour is an optical and mental sensation.

BIBLIOGRAPHY FOR FURTHER READING

Physical Aspects of Colour. P. J. Bouma (Philips-Macmillan, London) 1947.
An Introduction to Colour. R. M. Evans (Chapman and Hall, London: Wiley, New York) 1948.
Colour in Theory and Practice. H. D. Murray (Chapman and Hall, London) 1952.
Light, Colour and Vision. Y. Le Grand (Chapman and Hall, London) 1957.
Colour in Business, Science and Industry. D. B. Judd and G. Wyszecki (Wiley, New York and London) 2nd Edition 1963.
Principles of Colour Technology. F. W. Billmeyer and M. Saltzman (Wiley, New York and London) 1966.

Report on Defective Colour Vision in Industry. The Colour Group (Physical Society, London) 1946.
Researches in Normal and Defective Colour Vision. W. D. Wright (Kimpton, London) 1946.
Photometry and the Eye. W. D. Wright (Hatton Press, London) 1949.
Receptors and Sensory Perception. R. Granit (Yale University Press, New Haven) 1955.

Report on Colour Terminology. The Colour Group (Physical Society, London) 1948.
Glossary of Colour Terms Used in Science and Industry. British Standard 1611, 1953.
C.I.E. International Lighting Vocabulary. (C.I.E., Paris) 3rd Edition, 1967.
Photometry. J. W. T. Walsh (Constable, London) 1953.
The C.I.E. International Colour System Explained. G. J. Chamberlin (Tintometer Ltd., Salisbury) 1955.
An Introduction to the C.I.E. System. F. J. Heath (Tintometer Ltd., Salisbury) 1967.
Colour Science. W. S. Stiles and G. Wyszecki (Wiley, New York and London) 1967.
The Measurement of Colour. W. D. Wright (Hilger, London) 4th Edition 1969.

The Reproduction of Colour in Photography, Printing and Television. R. W. G. Hunt (Fountain Press, London) 2nd Edition 1967.
Principles of Colour Reproduction. J. A. C. Yule (Wiley, New York and London) 1967.

Principles of Colour Photography. R. M. Evans, W. T. Hanson and W. L. Brewer (Chapman and Hall, London; Wiley, New York) 1953.

Colour Cinematography. A. Cornwell-Clyne (Chapman and Hall, London) 3rd Edition 1951.

Principles of Cinematography. L. J. Wheeler (Fountain Press, London) 3rd Edition 1963.

Eye, Film and Camera in Colour Photography. R. M. Evans (Wiley, New York) 1959.

Manual of Colour Photography. E. S. Bomback (Fountain Press, London) 1964.

The Theory of the Photographic Process. C. E. K. Mees and T. H. James (Macmillan, New York) 3rd Edition 1966.

The Science of Photography. H. Baines (Fountain Press, London) 2nd Edition revised E. S. Bomback 1969.

Colour Television Explained. W. A. Holm (Cleaver-Hume Press, London) 1963.

Beginner's Guide to Colour Television. T. L. Squires (Newnes, London) 1964.

Colour Television: the N.T.S.C. System, Principles and Practice. P. S. Carnt and G. B. Townsend (Iliffe, London) 1961.

Colour Television with Particular Reference to the P.A.L. System. G. N. Patchett (Norman Price, London) 1967.

Principles of Colour Television Systems. C. R. G. Reed (Pitman, London) 1969.

Modern Illustration Processes. C. W. Gamble (Pitman, London) 2nd Edition 1953.

Ilford Graphic Arts Manual. H. M. Cartwright (Ilford, London) Vol. 1, 1961. Vol. 2, 1966.

Practical Printing and Binding. Expert sectional authors (Odhams, London) 3rd Edition 1965.

Lithographer's Manual. Editor C. Shapiro (Graphic Arts Technical Foundation, Pittsburgh) 1966.

Printing Inks and Colour. Proceedings of Fifth International Conference of Printing Research Institutes. Editor W. H. Banks (Pergamon Press, London, New York, Paris, Frankfurt) 1961.

Halftone Printing, Proceedings of Seventh International Conference of Printing Research Institutes. Editor W. H. Banks (Pergamon Press, London, New York, Paris, Frankfurt) 1964.

Penrose Annual (Lund Humphries, London).

INDEX

Abney, William, 57

abridged spectrophotometers, 99, 111–114, 142

absorption coefficient, 27–29
factor, 20
of light, 18–25, 27–30, 34, 35, 36–37, 56, 77–80, 82, 134, 151–152, 168, 171–178, 208, 210, 214
in colour vision, 56
selective, 20–22, 43

absorptivity, 20, 27–29, 44

adaptation, of the eye, 63–69, 84, 88, 165, 167, 208, 221
to colour, 65–67
to illumination intensity, 63–65

additive processes, 57, 72–77, 80, 83–84, 94–96, 118–119, 121–122, 129, 130, 133–134, 141, 143–169, 207, 219, 220, Frontispiece, Plates 15 and 25
deficiencies in, 151–152, 168–169
colorimeters, 89, 94–103, 127, 136
colour photography, 76, 77, 143–152, 168, 179, 188, 201, Plate 25
primaries, 73, 75, 80, 82, 83, 84, 94–96, 117, 118, 119, 120, 121, 122, 123, 125, 127, 130, 134, 135–136, 143, 148, 151, 152, 156, 158, 159, 161, 162, 164, 167, 168, 171, 183, 185, 220
secondaries, 80

aesthetic considerations, 8–9, 70–71, 222

after-images, 66, 167

Agfacolor mosaic plate, 150
negative and reversal films, 188, 190

air with fine particles, 47

aluminium, 11, 39, 44, 160, 195, 198
foil, 38

American Standards Association, 91

amplitude of wave motion, 5, 13, 153, 158, 165

analogous colours, 70, Plates 13 and 14

angle of viewing in matching colorimeters, 104

Ångström, Å, unit, 6

aniline mauve, 1

anomalous trichromats, 59

antimony sulphide, 154

artificial light sources, 13–14, 31, 50, Plate 2
influence on colour, 31–33, 50, 62, 64

atlases, of colours, 89–94

Autochrome mosaic plate, 150

autolithography, 195

balanced trichromatic inks, 212

bandwidth of radio and television transmission, 153, 157–158

barium sulphide, phosphorescence of, 52

Bausch and Lomb spectrophotometer, 111

Beckman spectrophotometer, 111

beetles, scales of, 38, 41

bird of paradise, 1

black body emission, 14–16, 118
image, in colour printing, 204, 214, 216–218
materials, 19, 115, Plate 18
velvet, 19

blackness, 19, 32, 37, 78, 79, 81, 82, 171

blind spot, of retina, 55

blood, colour of, 86
stains, fluorescence of, 50

blooming, of lenses, 45

blue effects, 79, 80, 81, 132, 167, 176
materials, 21, 22, 23, 24, 25, 27, 28, 30, 31, 32, 39, 70, 71, 75, 78, 79, 80, 115, 123, Plate 22
tinted materials, 25, 220

Bostrom test, for colour vision, 61

brightness, definition, 24, 30, 88
of surroundings, 64–65, 221, 222

British Colour Council, 93

225

British Standards Institution, 2, 87, 93, 223
bronze blue, 39
bronzing, 39–40
brown materials, 24, 26
Browning, E. B., 31

cadmium sulphide, 161
 yellow, 115–116, Plate 20
caesium, 155
calcium fluoride, 43, 52
 sulphide, 52
camera, Technicolor, 184, 185
cameras, colour television, 44, 154–157, 158–159, 184–185
 one-shot, 44, 156, 182, 183–185
 photomechanical, 203, 205
 Polaroid-Land, 191
carbon black, 19, 150
 disulphide, 11
Carbro process, 179–180
Cary spectrophotometer, 111
cathode rays, 159
 -ray tubes, 50, 145, 146–147, 159–164
Cellophane, 17, 197
ceramics, printing of, 192, 198
chartreuse effect, 29
chemi-luminescence, 52
Chinese blue, 40
chroma, Munsell, 91–93
chromatic aberration, 69–70, 149
chromaticity, 88, 126–127, 130, 133, 134, 135, 160, 164, 176, 217
 chart, C.I.E., see C.I.E. chromaticity chart
 coordinates, 119–121, 126, 128, 129, 131, 135–137, 141, 142, 157, 158
 triangle, 118–121, 126, 134, 135
 uniform charts, 132–133
Chromatron television tube, 146
chrome green, 116, Plate 23
 yellow, 213
chromic chloride, 29
chrominance signals, 157–159, 164, 165
chromo lithography, 211, 213
chromoscopes, 144
C.I.E., Commission Internationale de l'Eclairage, 2, 50, 87, 116, 117, 123, 124, 130, 133, 137, 164
 chromaticity chart, 123–126, 128–129, 130, 131, 132–134, 137, 165, 168, 206, 219

International Lighting Vocabulary, 87, 223
 primary stimuli, X, Y, Z, 123–126, 127, 130, 135–136, 137, 138
 primary stimuli, U, V, W, 133
 real primary stimuli, 63, 117, 135–136
 specifications, 77, 91, 93, 95, 97, 100, 104, 105, 106, 110, 114, 117, 131, 132, 133, 134, 136–142, 164
 system, 89, 91, 95, 96, 98, 101, 102, 116–142, 157, 158, 164, 207, 223
cinematography, 77, 83, 143, 144, 151, 154, 167, 180, 182, 184, 188
citrine materials, 24
closed circuit television, 145, 156
cold colours, 71
collotype printing process, 198–199
Color-Eye colorimeters, 98, 99–101, 142
colorimetric measurement (colorimetry), 69, 89, 94–106, 114, 118, 121, 123, 126, 127, 130, 131, 132, 135, 136–137, 142
Colormaster colorimeter, 98–99
Colormate colorimeter, 100, 101
Color Rule, Davidson and Hemmendinger, 61
colour atlases, 89–94
 attributes of, 30, 87–88, 130, 219–221
 balance, 37, 145, 165, 166, 176, 178, 192, 212, 216, 220, 221
 by polarized light, 17
 comparator, 106
 contrast, 37–38, 65–69, 167, 221, Plates 7, 10 and 11
 correction, by filters, 102, 106, 149
 by fluorescence, 51
 by masking, 177–179, 189, 190–191, 207, 212, 214, 215, 216, 217, 218
 by scanners, 205, 207, 214–216, 218
 in printing, 210–218
 couplers, 177, 179, 186–191, 214
 defective vision (colour blindness), 58–61, 114
 derivations, 183
 development, 177, 179, 185–191
 dictionaries, 85, 93
 difference in fine patterns, 68, Plate 12
 signals, 157–159, 164, 165
 disc, 76–77, 96, 144–145
 discrimination on C.I.E. chart, 132–133

colour atlases— *continued*

dominant wavelength of. 28, 88, 115, 116, 128–130, 131. 220

fading of, 31, 206

fastness, 31, 212

fatigue, 65–66, 68. Plates 6 and 7

filters, see filters

gamuts, of reproduction methods, 76, 83, 94, 134, 161, 164, 168, 176, 206, 209

haloes, 66, 70

harmony, 70–71, Plates 13 and 14

interest and importance of, 1–2

lightness, see lightness

matching, see matching

functions, 97, 102, 117, 136, 137–141, 142

measurement, 2, 21, 57, 62, 69, 85–142, 222, Plates 17–24

mixing, 21, 22, 36–37, 72–84, 94–96, 118–119, 121–122, 133–134, 141–142, 143, 166–168, 170, 171, 201, 207, Plates 15, 16, 28 and 29

mosaics, 77, 148–152, 162–163, 169, 170, 201, 207, 215, Plate 25

names, 85

nature of, 7, 222

negative–positive systems, 145, 151, 177, 189–191, 192. Plate 27

of daylight, 7, 13

of fireworks, 14

of metals, 38–39

of sky, 46–47, 168, 219, 220, 222

of thin films, 27–29, 40–46

photography, see photography

physical factors of, 35, 221–222

physiological qualities of, 35, 54–71, 83–84, 94, 201, 221–222

printing, see printing

psychological qualities of, 18, 35, 64–69, 70–71, 84, 167–168, 222

pure. 22

purity of, 30, 88, 91, 116, 128–130, 131

quality, 30, 86, 87, 88, 126, 130, 131, 132, 133, 135, 176, 216, 222

receptors, of retinal cones, 56–58

sensitivities of, see cones

rendering, in printing, 204, 206–210

of illumination, 31–33, 50, 61, 85, 86, 114, 165–166, 191–192, 219, 220, 221, 222

reversal systems, 186–189, 190, 191, Plate 26

saturation, see saturation

shade of, see shade

simultaneous contrast of, 38, 67–69, 220, 221, Plates 7, 10 and 11

solid, C.I.E., 133

Munsell, 91–93, 133

Ostwald, 89–90

study of, 2, 62, 222

television, see television

temperature, 14–16

meters, 16

temperatures of light sources, 15–16, 117–118, 166

terminology, 2, 3, 22, 24, 27, 29–30, 87–88, 223

tints, see tints and tinted materials

tolerances, 86, 132–133, 219–222

triangle, 118–121, 123–126, 133, 134

vision, 36, 53–71, 73, 76, 80, 94, 97, 114, 116, 137, 222

tests, 60–61

visual appraisal of, 218–222

wavelengths of, 13, 120, 125, 128–129, 137, Plate 1

coloured materials, general properties, 2. 18–35. 71, 87–88, 115–116, 122–123, 169, 170–176, 209, 210, 218, 219–222, Plates 17–24

use of, in colour mixing, 22, 77–83, 134, 170–176, Plate 16

colourless materials, 19, 23

vision, 55, 59

Columbia Broadcasting System, 164

complementary colours, 36–38, 41, 65, 66, 69, 73, 80, 89, 90, 91, 119, 121, 157, 167, 177, 180, 187, 189, 217. Plates 6 and 7

cones, retinal, 54–58, 59, 62–63, 73

sensitivities of, 55–58, 62, 63, 83–84, 114, 168, 171, 221

conservation of energy, law of, 41, 45

contact screens, in printing, 203

contrast or tone, correction of, 158, 164, 183, 203, 206, 207, 213, 216

control-grid, of television receivers, 159, 160, 164

copper, 38, 193, 194, 196, 197, 199, 200, 205,

sulphate, 25

correlated colour temperatures. 15–16, 118, 166
couplers, coloured. 190–191
 in developers. 177, 179, 186–188
 in film. 177, 179, 186, 188–191, 214
crimson materials, 21, 23
crossed Polaroids, 17
cryolite, 44
cyan materials, 74, 78, 79, 80, 81, 82, 170, 171–179, 182, 187, 190, 211, 212, 214, 216
 sensation or stimulus, 73, 74, 75, 80, 118–119, 121, 123, 167, 168

D lines, 13
Davidson and Hemmendinger Color Rule, 61
daylight, colour of, 7, 13
 temperature of, 15, 16, 118
 films, 191–192
 representation of, 117–118
 spectral energy distribution of, 15
defective colour vision, 58–61, 113
definition of fine detail, 146, 152, 153, 156, 157, 158, 161, 169, 170, 183, 185, 188, 198, 203, 209, 216
derivations, colour, 183
desaturated colours, 26, 176, 206, 208, 209, 219, 221, Plates 21 and 24
deuteranopia (green blindness), 59
diamonds, phosphorescence of, 52
dichroic mirrors, 44, 156, 161, 166, 183, 184, 185
dichroism, 28–29, 44, 218
dichromated colloids, 199–200
dichromatic vision, 59
dichromats, 59
dictionaries of colours, 85, 93
diffraction, of light, 12, 45
 grating, 11–12, 45, 107, 110, 111
 spectra, 12, 45
Dioptochrome mosaic plate, 151
dispersion, of light, 11, 69, 72, Plate 1
distribution coefficients, 137–141, 142
dominant wavelength, 28, 88, 115, 116, 128–130, 131, 220
Donaldson, R., 96
Donaldson colorimeter, 96
dot reduction, in printing, 213
drum scanners, in printing, 215
Dufay, Louis, 151
Dufaycolor mosaic film, 151, Plate 25

Du Hauron, L. D., 148, 149, 170, 179, 183, 185
Duxochrome process, 179
dye couplers, in photography, see couplers
 sensitization, of photographic emulsions, 76, 149, 184, 186, 187
 transfer process, 180–182, 183
dyed fabrics, 18, 34, 51, 78
dyeing, 26, 30, 134

electric lighting, 13, 31
electrical discharge lamps, 13
electron gun, 147, 153, 154, 155, 160, 162–163, 164
electronic colour scanners, 205, 207, 214–216, 217, 218
 engraving machines, 205, 215
 masking, for printing, 215–216, 218
electrotyping, 194
emerald green, 116, Plate 21
eosin, 49
epithelium, 54
exact colour reproduction, 45, 83, 84, 86, 169, 199, 221–222
eye, adaptation of sensitivity, 24, 63–69, 84, 88, 165, 167, 208, 221
 colour matching functions of, see colour matching functions
 fovea of, 54, 55, 104, 135
 iris of, 53, 54, 64
 lens of, 53, 54, 64, 69
 physiology of, 53–58, 69, 71, 83
 retina of, 53–58, 64, 66, 68, 70, 77, 104
 sensitivity of, 7, 19, 33, 35, 55, 56–58, 62–70, 83–84, 86, 97, 123, 132, 138, 142, 149, 158, 168, 185, 221

fading, of colour, 31, 206
fastness, of colour (light resistance), 31, 212
fibre fineness, in fabrics, 26
 optics, 101–102
 colorimeters, 101, 102–103, 105
field sequential colour systems, 145, 156, 161, 164
film thickness, effect of, 27–29, 218
filters, artificial daylight, 34
 colour, 26, 27, 74, 75, 76, 82, 84, 101, 102, 104, 105, 106, 112–114, 116, 117, 139–141, 146, 149, 167, 168,

filters, colour—*continued*
179, 184, 187, 192, 204, 217,
Plates 16 and 23
interference, 44, 99, 114, 142
trichromatic, 37, 82, 95, 96, 97, 98,
99, 100, 103, 104, 105, 118, 142,
143, 144, 145, 146, 148, 150, 151–
152, 156, 166, 168–169, 170, 177,
180, 181, 182, 183, 184, 204, 210–
211, 214, 215, 216, 218
fine etching, in printing, 213
patterns, colour differences in, 68,
Plate 12
Finlay, 150
Fischer, R., 186
flare, 45
flat-bed cylinder printing presses, 194,
198
scanners, in printing, 215
flesh tints and tones, 69, 86, 116, 167,
220, 222, Plate 24
flexographic printing presses, 194–195
fluorescence, 49–52, 142, 153, 160, 162,
164
fluorescent lamps, 14, 16, 35, 50, 118
artificial daylight, 16, 34, 50
lighting, colour rendering of, 16, 50, 85
maps, 51–52
pigments, 51, 52, 118, 198, 208
water-colour paints, 51
fluorspar, 49
fog lamps, 47
foliage, colours of, 18, 60, 67, 86, 168,
219, 220, 222
forme, in printing, 193–194, 212
four-colour printing, 204, 216–218
fovea centralis, 54, 55, 104, 135
Fox Talbot, 196
frequency, definition, 6
of light, 6
of television transmission, 152, 153,
165
relationship with wavelength, 6
fruit, colours of, 64, 116, 131, 220, Plate
24
fuchsin, 38

galena, 38
gamuts of reproducible colours, 76, 83,
94, 134, 161, 164, 168, 176, 206,
209
gas lighting, 13, 31

gelatin, dichromated, 199, 200
dye imbibition methods, 180–183
relief methods, 179–180, 181, 198
German Standards Association, 93
gloss, 8–9, 38–39, 206, 209, 210
glossy materials, reflection of, 8–9, 26,
38–39
Goethe, 167
gold, 38, 44, 184
leaf, 38
Graphic Arts Technical Foundation,
212
graphite, 38
green materials, 21, 23, 24, 31, 34, 44,
79, 116, 123, Plates 21 and 23
effects, 22, 74–75, 78, 80, 81, 132, 167,
176, Plates 9 and 10
grey materials, 19–20, 24, 115, 130,
Plate 18
effects, 77, 104, 165, 201, 203, 206, 208,
216, 217, 220, Plate 8
Guild, J., 58, 96
Guild colorimeter, 96
Gutenberg, J., 193

hair, colours of, 18, 26
half-tone, contact screens, 203–204
illustrations, 193, 195, 196, 206, 207,
208, 217, Plates 28 and 29
method and screens, 198, 201–205, 206,
207, 208, 210, 211, 213, 218
principle, 197, 201, 203
screen angles, 204, 206
haloes, of colour, 66, 70
Hardy, A. C., 109
Hardy spectrophotometer, 108–110
harmony, of colours, 70–71, Plates 13
and 14
Harrison, V. G. W., 39
Helmholtz, 56
hue, 21, 29, 30, 31, 81, 87, 88, 90, 115,
116, 119, 128, 129, 130, 131, 132,
133, 158, 169, 176, 206, 212, 220,
221, Plate 3
definition, 21, 30, 87
harmony of, 70, Plate 13
matching of, 56, 105, 133
Munsell, 91–93
simultaneous contrast of, 38, 67–69,
220, 221, Plates 7, 10 and 11
spectral discrimination of, 83
Hunt, R. W. G., 165, 223

I

illuminants, standard, see standard illuminants
illumination, colour rendering of, see colour rendering
spectral energy distribution of, see spectral energy distributions
image-orthicon tube, 155, 156
imperfections of trichromatic reproduction processes, see trichromatic reproduction
indigo, 38
infra-red, 4, 6, 149
integral tripack photographic materials, 182, 184, 185–191, 206, Plates 26 and 27
integrating sphere, 96, 99, 109, 110, 113, 114, 142
interference colours, 40–46
effects, applications of, 44–46
filters, 44, 99, 114, 142
in television, see television
interlacing, in television, 154
inter-image effects, 191
Intertype composing machines, 193
invert half-tone, in photogravure, 197, 203
ionosphere, 152
iris, of eye, 53, 54, 64
Ishihara test, for colour vision, 60
isochromes, isotints, isotones, Ostwald, 90

Johnson Colour Screen Process, 150
Joly, Professor, 149
Jordan, L. A., 18
just noticeable colour difference, j.n.d., 132–133
juxtaposition, law of, 68

Karl Klic, 196
Kelvin temperature scale, 16
Kinemacolor, 144
Kodachrome systems, 186–188
Kodacolor systems, 145, 146, 188, 190
Kodak Autoscreen film, 204
video colour negative analyser, 145

Lambert's law, 27
Land, E. H., 167
lateral reversal, 191, 203

Lawrence television tube, 146–147
lead chromate, 213
oxide, 155
least perceptible colour difference, l.p.d., 132–133
lens, of eye, 53, 54, 64, 69
lenses, anti-reflection coatings, 45
chromatic aberration of, 69–70, 149
colour corrected, 149, 154
lenticular screen method, 145–146, 162, 169
letterpress printing process, 192–194, 196, 201, 202, 205, 207, 208, 209, Plate 29
surfaces, 192–194, 199, 201–205, 212, 213, 215, 217, 218
light, absorption of, see absorption and absorptivity
diffraction of, see diffraction
dispersion of, 11, 69, 72, 107, 111, Plate 1
nature of, 4–6, 7, 222
north sky, 13, 16, 33, 118
overcast sky (average daylight), 15, 117, 118
polarization of, 17
primaries, see additive primaries
reflection of, see reflection
refraction of, see refraction
scattering by fine particles, 23, 26, 46–47, 219
sources, colour temperatures of, 15–16, 117–118, 166
stimulus, see stimulus
transmission of, see transmission
velocity of, 4, 6, 9
wave-band, 5, 6, 7, 13
lightness, 24, 29, 30, 38, 59, 62–65, 67, 68, 79, 81, 87, 88, 90, 92, 105, 115, 116, 123, 130, 133, 158, 209, 212, 216, 220–221, Plates 4, 21, 22 and 23
definition, 24, 30, 87
and wavelength, 62–63, 83, 138, 142
line spectra, 13–14, Plate 2
Linotype composing machines, 193
Lippman, G., 45
Lippman colour photography, 45–46
lithographic printing process, 192, 195–196, 198, 201, 202, 205, 207, 208, 209, 211–212, 217, Plates 28 and 29

lithographic printing process—*continued*
 plates, 192, 195–196, 199–200, 201–204, 212, 213, 217
Lovibond Tintometers, 93, 104–106, 133
Lumière brothers, 150
luminance, 24, 63, 88, 118, 128, 130, 132, 134, 137, 138, 139, 155, 157, 158, 161, 165, 169, 209, 216–217, 220 221
 factor, 88, 91, 115, 123, 127, 130–131, 132, 133, 137, 141, 157
 signal, 156, 157–158, 164, 216
luminosity, 24, 87, 136
 and wavelength, 62–63, 138, 139, 158
luminous paints, 52
lustre, metallic, 38–39
 non-metallic, 38

MacAdam, D. L., 133
madder lake, 28, 116, Plate 20
magenta materials, 23, 37, 70, 79, 80, 81, 82, 116, 125, 170, 171–176, 177, 178, 187, 190, 212, 214, 218, Plate 20
 sensation or stimulus, 36, 73, 75, 84, 118, 119, 122, 129
magnesium, 193, 199
 fluoride, 45
 oxide, 19, 97, 107, 131
malachite green, 29, 38
maps, fluorescent, 51–52
Marconi television camera, 184–185
masking, colour correction by, 177–179, 189, 190–191, 207, 212, 214, 215, 216, 217, 218
 electronic, 215–216, 218
 unsharp, 183
matching, of colours, 30, 33–35, 59, 60, 61, 66, 68–69, 94–96, 104–105, 114, 117, 119, 120, 121–122, 126–127, 129, 134, 135–137, 138, 219, 222
 cabinets for, 35
 illumination/viewing angles, 34, 96, 104, 110
 metameric, 34–35, 61, 114, Plate 17
 methods of colour measurement, 89–106
matrixing, in television, 155
matt surfaces, 8, 9, 40, 93, 96, 195
Maxwell disc, 76

Maxwell, J. Clerk, 76, 144, 148
measurement of colour, 2, 57, 62, 69, 85–142, 222, Plates 17–24
 applications and importance, 85–86
 colorimetric methods, 69, 89, 94–106, 118, 121, 123, 127, 130, 131, 132, 135, 136–137, 142
 matching methods, 89–106
 spectrophotometric methods, 99, 106–115, 118, 128, 137–142
memory, 64, 71, 84, 86, 167, 222
 matching, 33
mercury vapour lighting, 14, 32, 33, 50, 199
 spectrum, 13–14, Plate 2
metallic reflection, 38–39
metameric pairs, 34, 61, 114, Plate 17
metamerism, 34–35, 98, Plate 17
mineral oils, fluorescence of, 49
mixing, of colours, see colour mixing
mixtures, fluorescence of, 49
moiré patterns, 204
monochromatic light, 20–21, 36, 37, 73, 74, 84, 107, 121, 168
monochromats, 59
monopack photographic materials, 179, 182, 185–191, Plates 26 and 27
Monotype composing machines, 193
moonlight, 32, 55
mosaic colour mixing, 77, 201, 207, 215
 screen methods, 148–152, 162–163, 169, 170, Plate 25
mother-of-pearl, 38, 41
Multimask film, Gevaert, 214
Munsell, A. H., 91
Munsell system, 91–93, 100, 133

names of colours, 85
nanometre, nm, unit, 6
National Television System Committee (N.T.S.C.), 164–165
negative–positive systems, of photography, 145, 151, 177, 189–191, 192, Plate 27
neon lamps, 47
 spectrum, 14, Plate 2
Neugebauer, H. E. J., 207, 215
Newton, Isaac, 12, 40, 72
Newton's rings, 40, 44
nomograms, 105, 106, 133
non-spectral colours, 122, 125, 126, 128

objective terms, 88
observer, C.I.E. standard, see standard observer
offset lithography, see lithographic printing
olive green materials, 24, 116, Plate 23
one-shot cameras, 44, 156, 182, 183–185
opaque substances, 9, 26, 82, 213
optical bleaches, 51
Optical HRR test, for colour vision, 61
ordinary photographic emulsions, 149, 180, 184, 187
orthochromatic photographic emulsions, 149, 187
Ostwald system, 89–91, 93
Ostwald, Wilhelm, 89, 90

Paint Research Association, 101, 102, 106
painting, 18, 22, 24, 26, 28, 34, 38, 39, 69, 70, 71, 78, 79, 80, 82, 170, 183, 219
 reproduction of, 195, 198, 212
paints, 9, 18, 24, 25, 35, 39, 77, 78, 79, 80, 81, 82, 86, 115, 134, 206, 219
P.A.L. television system, 164–165
panchromatic photographic emulsions, 149, 155, 177, 182, 183, 204, 210
paper, 8, 19, 35, 51, 64, 67, 68, 86, 170, 189, 191, 192, 196, 201, 207–210, 213, 218
 absorbency of, 210
 additive prints on, 152, 169
 smoothness of, 196, 201, 208–209
 whiteness of, 8, 19, 51, 64, 170, 189, 201, 208, 209, 210, Plate 18
peacock, colours of tail, 41
Perkin, W. H., 1
persistence of vision, 77, 144, 154
phase of wave motion, change of, 42–43
 of television signals, 158, 165
phosphorescence, 52
phosphors, 50, 62, 146, 147, 152, 158, 159–163, 164, 206
phosphorus, phosphorescence of, 52
photocomposing, for printing, 200
photo-conductive film, 154–155
photoelectric cells, 4, 89, 97, 98, 100, 103, 107, 109, 111, 112, 154, 205, 215
 sensitivities of, 97
 colorimeters, 97–103, 142
 spectrophotometers, 106–114, 142

photo-emissive film, 155
photoengraving, 163, 193, 194
photographic chemical reversal, 148, 177
 colour development, 177, 179, 185–191
 emulsions, 149, 179, 180, 181, 182, 184, 186, 187, 188, 189, 190, 191, 199, 204, 210, 217, 219
photography, colour, 2, 44, 45–46, 76, 77, 83, 85, 122, 143–152, 168, 170, 171, 176, 177, 179–192, 201, 206, 218, 219, 222, Plates 25, 26 and 27
photogravure printing process, 192, 196–197, 205, 207, 208, 212–213, Plate 29
 screen, 196–197, 200, 202, 207, 208, 218
 surfaces, 192, 196–197, 200, 203, 204–205, 213, 218
photomechanical processes, 163, 191, 195, 196, 198, 199–205, 210, 211, 214, 217, 218
 process cameras, 203, 205
photometers, 88, 100, 109, 130
physical colour properties of materials, see coloured materials
Physical Society, 58, 61, 223
physiology of colour vision, 35, 53–71, 83–84, 94, 201, 221–222
pigmentary primaries, see subtractive primaries
pink, 25, 87, 119, 167, 176
 couplers, 190
PIRA, 32, 39
plastics, 25, 26, 86, 192, 194, 198, 199. 205
platen printing presses, 194
plumage, of birds, 1, 38, 41
plumbicon tube, 155, 156
pointillistes, 148
powdered substances, 25–26
 effect of particle size, 26, 82
polar coordinates, 128, 129
polarized light, 17
Polaroid film, 17
 -Land camera, 191
Pretema Spectromat, 113, 114
posters, colour printing of, 31, 196, 198, 201
primaries, additive, see additive primaries
 subtractive, see subtractive primaries
 two-colour additive, 167
primary coloured substances, 22, 79.

primary coloured substances—*continued* 81–82, 134, 170–179, 180, 182, 186, 188, 189, 190, 206–207, 212, 216, 217, 218, 219, 220
 stimuli, real (C.I.E.), see C.I.E. primary stimuli
 X, Y, Z, see C.I.E. primary stimuli
 U, V, W, „ „ „ „
 printing, colour, 2, 12, 28, 37, 51, 83, 85, 122, 143, 170–177, 182, 183, 192–218, 222, Plates 28 and 29
 inks, 9, 18, 24, 35, 37, 39, 51, 77, 78, 79, 81, 82, 86, 115, 131, 196, 197, 198, 205–207, 208, 209, 210–213, 216–218
 plates, 192, 193, 194, 195, 196, 197, 198, 204–205, 213–216, 217, 218
 presses, 194–195, 196, 197, 198, 205, 217
 prints, influence of paper, 207–210, 218
 photographic, 67, 152, 169, 170, 189–192, 219, 220
prism, dispersion of light by, 11, 45, 69, 72, 107, 111
protonopia (red blindness), 59
psychological effects, 18, 35, 64–69, 70–71, 84, 167–168, 222
purity, of colour, 30, 88, 91, 116, 128–130, 131
Purkinje effect, 63
purple materials, 23, 24, 71, 79, 212, Plate 22
 sensation or stimulus, 23, 36, 70, 71, 73, 75, 79, 118, 119, 122, 125, 128, 129, 176

quantity of reflected or transmitted light, 19–20, 22–30, 53, 64–65, 79, 122–123, 130–131, 168–169, 171–176
quinine, fluorescence of, 49

radar, 5, 152
rainbow, 47–49, 219
 arc, 49
red effects, 24, 47, 71, 80, 81, 87, 130, 132, 167, 176
 materials, 21, 23, 27, 28, 29, 31, 32, 40, 63, 78, 79, 115, 122, 125, Plate 19
recording spectrophotometers, 108–111, 113, 114, 141

reflection of light, 8–9, 10, 18–20, 42–43, 101, 102
 by coloured materials, 2, 20–27, 29–30, 31–32, 34–35, 71, 87–88, 115–116, 122–123, 169, 170–176, 209, Plates 17–24
 by raindrops, 47–49
 diffuse, 8–9, 39, 40, 96, 99, 209
 factor (reflectance), 20, 23, 88, 107, 109, 110, 111, 113, 114, 115, 130–131, 137, 139–140, 142, 220
 metallic, 38–39
 specular, 8–9, 26, 39, 40, 209
 through surface films, 35, 41–43, 152, 209
 total internal, 101
refraction of light, 8, 9–10, 11, 43, 47, 101
 angle of, 9, 101
 by raindrops, 47–49
refractive index, 10, 43, 44, 101, 102
retina, 53–58, 64, 66, 68, 70, 77, 104
retouching, in printing, 198, 213, 218
reversal photographic systems, 186–189, 191, Plate 26
rhodopsin, 54
rods, retinal, 54–56, 57, 62–63
rotary printing presses, 194, 195, 196, 197, 205
russet materials, 24

saturation of colours, 27, 29, 30, 81, 87, 88, 89, 90, 91, 92, 93, 96, 105, 115, 116, 118–119, 121, 122–123, 128–130, 131, 132, 133, 158, 168–169, 176, 206, 208, 209, 210, 219–221, Plates 5 and 23
 definition, 27, 30, 87
scanners, in colour printing, 205, 207, 214–216, 217, 218
scanning in television, 153–154, 155, 159–160, 161, 162–163, 165, 185
scattering of light, 8, 9, 10, 23, 26, 46–47, 78, 82, 134, 209, 219
 on retina, 68
screen printing process, 197–198, 203
screens, half-tone, 198, 201–204, 205, 206, 218, Plate 29
 lenticular, 145–146
 mosaic, 148–152, Plate 25
 photogravure, 196–197, 200, 202, 207, 208, 218, Plate 29

screens—*continued*
 television, 50, 146–147, 152, 159–160, 161, 162–163, 164, 206, Frontispiece
S.E.C.A.M. television system, 164, 165
secondary colours, 22, 80, 211–212, 216–217, 218
selenium, 154
Senefelder, A., 195
shade of colour, 24, 30, 70, 81, 85, 90, 91, Plates 4 and 21
shadow mask television tube, 147, 161–164
shadows, 12, 67, 203
sheen, 9, 40
shot effect in textiles, 39
show-cards, colour printing of, 198
sight, sensation of, 7, 53
signal glasses, 85, 117, 139–141
silver, 44
simultaneous contrast, 38, 67–69, 220, 221, Plates, 7, 10 and 11
skin textures, reproduction of, 221
sky, colours of, 46–47, 168, 219, 220, 222
 on moon, 46
snow, 8, 19
soap bubbles, 40, 41
sodium vapour lighting, 13, 32, 33
 spectrum, 13, Plate 2
spectral energy distributions, 13, 15, 33, 35, 114, 117, 118, 126, 137, 138, 139, 142
 locus, 121–123, 124, 125, 126, 128, 129, 130, 135, 168, 219
 sensitivities of photoelectric cells, 97
 of retinal cones, see cones
 of television camera tubes, 155, 156
 wavelengths, 13, 125, 132, 137
spectrography, 14
spectrophotometric measurement, 21, 99, 106–116, 118, 128, 137–142, 171–176
 curves, 30, 106, 108, 110, 111–116, 134, 137, 139, 140, 141, 142, 171–175, Plates 17–24
spectrum of white light, 11–13, 72, 107, 108, 109, 110, 111, 121, 137, 152, 219, Plate 1
 normal, 12
 of chemical element, 14, Plate 2
 sequence of colours in, 12

wavelength bands of, 13
stage lighting, 76
standard illuminants, 96, 98, 102, 105, 114, 117–118, 126, 128, 131, 137, 138, 139, 140, 141, 165
 observer, 97, 117, 126, 127, 130, 135, 137, 142
standardised colours, 85, 86, 104, 116–117, 132, 133, 165
 printing inks, 131, 212–213, 218
 real primary stimuli (C.I.E.), 63, 117, 135–136
 terminology, 2, 22, 24, 27, 29–30, 87–88, 223
step-and-repeat plate making machines, 195
stereotyping, 194
Stiles, W. S., 142, 223
stimulus, light, 7, 29, 34, 69, 94, 117, 126, 135–136, 137, 159, 168, 171
strontium sulphide, phosphorescence of, 52
subjective terms, 87–88
 methods of matching, 35, 61, 66, 68–69, 89, 95–97
subtractive processes, 72, 77–84, 104, 122, 134, 141–142, 143, 159, 169, 170–222, Plates 16, 26, 27, 28 and 29
 deficiencies in, 134, 169, 170–179, 189, 190, 199, 206–207, 210–212, 214, 216, 218, 219
 colorimeters, 89, 104–106
 colour photography, 152, 170–177, 179–192, 206, 218, 219, Plates 26 and 27
 printing, see printing
 primaries, 22, 79, 80–81, 82, 104, 134, 170–179, 182, 185, 187, 189, 204, 206–207, 212, 214, 217, 218, 219 220
 secondaries, 22, 80, 211–212, 216–217, 218
successive contrast, 65–66, Plate 6
 frame method, 77, 144–145, 156
sunlight, representation of, 117, 118
sunrise, sunset, colours of, 47
surface coatings, 35, 43, 208, 209, 210
 reflections, 25–26, 38–40, 209, 219
surrounds, effects of, 64, 65, 66–68, 69, 157, 220, 221, 222

Technicolor camera, 184, 185
 process, 180, 182
television cameras, 44, 144–145, 152,
 153, 154–157, 158–159, 166, 183,
 184–185
 colour systems, 77, 85, 122, 144–145,
 152–154, 156–159, 164–166, 222
 transmission, 152–153, 156, 157–
 159, 164–165, 166, 216
 compatibility, 145, 157
 interference in, 153, 157, 165, 166
 interlacing, 154
 receivers, 50, 62, 77, 144–145, 146 -147,
 152, 153–154, 158, 159–164, 166,
 206, 219, Frontispiece
 mosaic screen of, 162–163, 201
 scanning, 153–154, 155, 160, 162–163,
 165, 185, Frontispiece
terminology, see colour terminology
tertiary colours, 22, 24, Plate 23
tests for colour vision, 60–61
textiles, colours of, 18, 34, 68, 77, 86, 99
 effect of fibre fineness, 26
 fine patterns in, 68, 77, Plate 12
 printing of, 192, 198
 scattering of light by, 8, 78, 209
 shot effect in, 39
thin films, colours of, 28–29, 40–44, 45
 measurement of thickness, 44
tin, 39
 -plate, printing on, 192, 196
Tintometers, Lovibond, 93, 104–106,
 133
tints and tinted materials, 25, 26, 27, 65,
 68, 69, 70, 76, 81, 90, 91, 168,
 208, 220, 221, Plates 5 and 21
tobacco smoke, colour of, 47
tomato, C.I.E. values for, 131
 colour of, 220, Plate 24
tonal contrast, 67–69, Plates 8, 9 and 11
tone, correction of, see contrast
 correction
transformation equations, 136
translucent materials, 9, 210
transmission of light, 9, 18–20
 by coloured materials, 2, 20–27, 28–30,
 31, 35, 71, 87–88, 115–116, 122–
 123, 170–176, 209, 210, 218, Plate
 23
 factor (transmittance), 20, 23, 88, 110,
 113, 115, 130–131, 137, 139–141,
 142, 220

transparencies, 40, 67, 150, 170, 178,
 182, 183, 187, 188, 189, 190, 191,
 200, 206, 209, 210, 214, 215, 219,
 220, 222, Plate 26
transparent materials, 9, 23, 26, 78, 82,
 116, 171, 197, 209
trichromatic colour reproduction, 2, 37,
 56, 57, 75–76, 79–81, 83, 134,
 143–166, 168–169, 170–222,
 Plates 15 and 16
 imperfections in, 84, 134, 151–152,
 168–169, 170–179, 189, 199, 206–
 207, 210–212, 216, 218, 219, 222
 visual appraisal of, 218–222
 visual limitations of, 83–84, 168, 221
 equations, 126, 135–136
 vision, 56–58, 59, 66, 73, 76, 80, 94,
 97, 114, 137
Trilac spectrophotometer, 110
Tri-Mask film, Kodak, 214
Trinitron television tube, 147, 161
Trinoscope television receiver, 161
tripack photographic materials, 179, 182,
 184, 185–191, 206, Plates 26 and
 27
tristimulus integrators, 109, 110, 114,
 141
 values, 77, 95, 97, 99, 110, 114, 127–
 128, 130, 131, 136–142, 158
tritanopes, 59
tungsten filament lamp, 13, 15, 16, 35,
 61, 117, 126, 165, 168, 191
 light films, 191–192
turquoise blue, 85, 93, 125
 C.I.E. values for, 131
two-colour reproductions, 166–168
type alloys, 193

ultramarine, 32, 115, Plate 22
ultra-violet, 4, 6, 14, 49, 50, 51, 52, 76,
 118, 149, 199, 219
under-colour removal, in printing, 216,
 217–218
Unicam spectrophotometer, 111
uniform chromaticity charts, 132–133
unsharp masking, 183
unmatchable colours, 122–123, 168–169,
 219
U, V, W primary stimuli, 133

value, Munsell, 91–93
vermilion, 31, 115, 116, Plate 19

vidicon tube, 154–155, 156
viewing conditions, 24, 32, 33–35, 55, 64–65, 67–69, 117, 169, 219, 220, 221
 angle in matching colorimeters, 104, 135
violet materials, 24, Plate 22
 of the spectrum, 24
visual appraisal of colour, 219–222
 attributes of colour, 30, 87–88, 130, 219–221
 colorimeters, 89, 95, 96–97
 limitations of trichromatic reproduction, 83–84, 168, 221
 purple, 54, 55, 56
 quality of colours, see colour quality
 spectrophotometers, 106
Vivex process, 179

warm colours, 71
water-colour paints, 78
 fluorescent. 51
water with fine suspension, 47
wavelength, definition, 5
 and lightness, see lightness
 effect in interference, 40–43
 of electromagnetic vibrations, 5
 of light, 5, 6, 7, 13
 of radio and television transmission, 152–153
 of spectral colours, 13, 120, 125, 128–129, 137, Plate 1
 measurement of light, 44
wave motion, 17, 41

phase, change of, 42–43
white, ideal, 97, 135, 137, 138
 materials, 8, 19, 23, 51, 80, 97, 107, 115. 189, 208, 209, Plate 18
 standard, 97, 100, 104, 107, 113, 131, 136, 139
whiteness, sensation of, 7, 8, 19, 36, 51, 57, 64–65, 68, 70, 73, 75, 77, 94, 119, 165, 167, 170, 208
wings of insects, 41
Wright, W. D., 87, 142, 223
writing ink, fluorescence of, 49, 50
Wyszecki, G., 142, 223

X-rays, 4, 5
X, Y, Z primary stimuli, see C.I.E. primary stimuli

yellow filter, 27–28, 74, 82, 149, 187, 188, 204, 217
 materials, 20, 21–22, 23, 24, 25, 27–28, 71, 73, 74, 75, 78, 79, 80, 116, 122, 170, 171–176, 180. 187. 190. 212, 213, Plates 20 and 24
 sensation or stimulus, 22, 56–57, 73, 74, 75, 118, 208
 spot (fovea), 55
 tinted materials, 25, 190, 208
Young, Thomas, 56

Zeiss spectrophotometer, 111
zinc. 39, 193, 195, 198, 199
 sulphide, 44, 52, 161